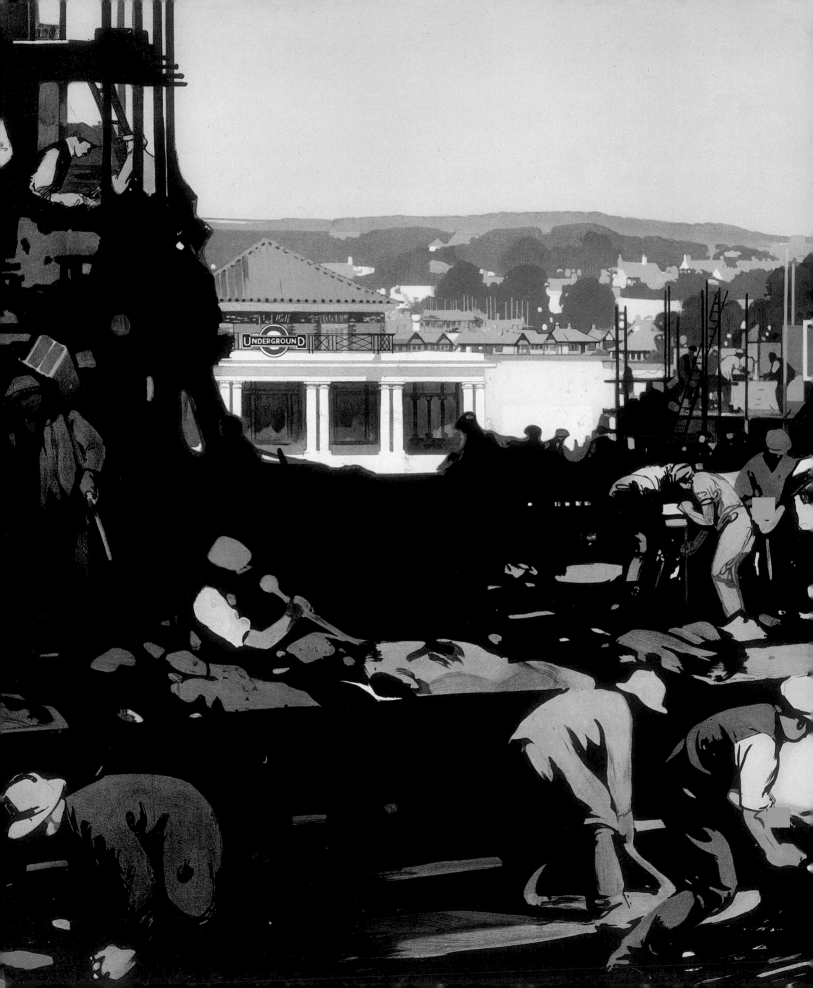

LONDON TRANSPORT
POSTERS
a Century of Art and Design

Edited by David Bownes and Oliver Green

with contributions by Jonathan Black, David Bownes,
Emmanuelle Dirix, Claire Dobbin, Catherine Flood, Oliver Green,
Bex Lewis, Alan Powers, Paul Rennie and Brian Webb

LUND HUMPHRIES in association with LONDON TRANSPORT MUSEUM

First published in 2008 by Lund Humphries
in association with London Transport Museum

Lund Humphries
Gower House
Croft Road
Aldershot
Hampshire GU11 3HR

Lund Humphries
Suite 420
101 Cherry Street
Burlington
VT 05401-4405
USA

www.lundhumphries.com

Lund Humphries is part of Ashgate Publishing

British Library Cataloguing-in-Publication Data:

London Transport posters : a century of art and design
1. London Transport Board – Posters 2. Urban transportation
– England – London – Posters 3. Posters – England – London
– 20th century
I. Bownes, David II. Green, Oliver III. Black, Jonathan,
1969–
741.6'74'09421

ISBN 9780853319849 (hardback)
ISBN 9780853319856 (paperback)

Library of Congress Control Number: 2008923674

Edited by Abigail Grater
Designed by Nigel Soper, set in New Johnston
Originated by MRM Graphics Ltd, Winslow, Bucks
Printed in Singapore

Endpapers:
Front: Underground map 1908
Back: Underground map 2008

CONTENTS

FOREWORD

Frank Pick: A Personal Tribute

Follow the Way Out sign at Golders Green station, circle behind the depot, walk down Corringham Road and enjoy a stroll across Hampstead Heath. On the other side, you will find Wildwood Road and, at No.15, a blue plaque that reads: 'Frank Pick (1878–1941), Pioneer of good design for London Transport, lived here.'

Why that epithet? Frank Pick, the greatest Managing Director of what was (and will be again) the greatest urban transport system in the world, surely deserves a more generous reference. Pick, of course, would have disagreed. First, he would have declined the plaque, but, having no choice in the matter, he would have recognised no higher praise.

Frank Pick's big idea, his great gift to London Transport and industry generally, was the insight that good design should be the unifying principle for running any enterprise. As a founding member of the Design and Industries Association, he believed that the application of good design – 'fitness for purpose and pleasantness in use' – to every object and activity would yield efficiency, economy and the most pleasing service to the public. Although he had no formal training in architecture or design (he was a solicitor, bless him), he had the confidence and coherence of vision to elevate London Transport to its place of pre-eminence.

The manifestations of Pick's 'Total Design', what today would be called his management philosophy, are ubiquitous: good signage, Beck's map, the Johnston typeface, Piccadilly Circus ticket hall, Arnos Grove, 55 Broadway and a century of poster design celebrated with this book. What is chronicled here, therefore, must be understood as a further manifestation of the essence of the enterprise and not dismissed as an interesting and tasteful sideline. If you can appreciate what is true and pleasing in what is presented here, you can run a railway.

Tim O'Toole
Managing Director
London Underground

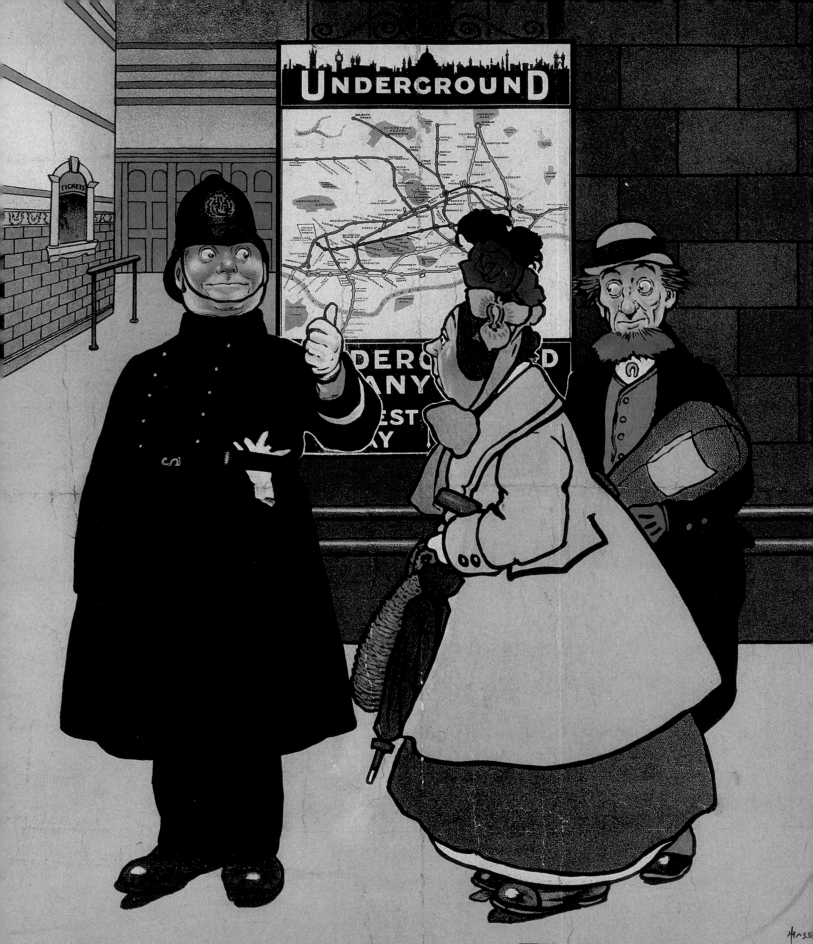

INTRODUCTION

David Bownes and Oliver Green

THIS BOOK CELEBRATES a century of outstanding graphic design commissioned by London Transport, its predecessor companies and its present-day counterpart, Transport for London. No comparable organisation, whether public, private or a mixture of the two, can boast such a rich and sustained visual heritage.

The selected artworks and posters, many published here for the first time since they were originally created, reflect a dazzling variety of period styles and techniques. They also reflect the Underground and London Transport's commitment to employing the very best artists of the day, including both established and emerging talent.

This roll of honour reads like a *Who's Who* of twentieth-century graphic design, and includes John Hassall, Fred Taylor, Frank Brangwyn, Edward McKnight Kauffer, Austin Cooper, Man Ray, Tom Purvis, Edward Bawden, Hans Schleger ('Zero'), Tom Eckersley, Abram Games and David Gentleman. It also includes many well-known names more closely associated with the world of fine art, such as Laura Knight, Eric Kennington, Edward Wadsworth, Graham Sutherland, Paul Nash, William Roberts, John Bellany, Howard Hodgkin and David Shrigley, persuaded to produce poster designs because of the Underground's unique reputation.

There are also many exceptional pieces of work created for London Transport by artists who did not become famous, but whose graphic talent deserves belated celebration. This is particularly true of women artists like Dora Batty, Herry Perry and Margaret Calkin James whose design skills were first recognised and employed more than seventy years ago and can now be appreciated anew.

Equally remarkable is the incredible versatility displayed by key poster artists over their long careers designing for the Underground. Kauffer and Cooper, justly regarded as two of the greatest names in graphic design working in London during the last century, were masters at adapting their style to suit both the subject matter and prevailing artistic trends. Others, like Fred Taylor and Walter Spradbery, were reliable professionals, able to turn out intricate designs selling everything from day trips to suburban bliss.

Any publication dealing with so vast a subject can only serve as an introduction to the themes discussed. Ten authors, reflecting a range of museum, academic, historical and design backgrounds, present their own interpretation of significant developments in LT's poster history. Catherine Flood establishes the international and uniquely British context for the Underground's first pictorial posters commissioned in 1908. Oliver Green discusses the seminal role of Frank Pick in bringing together applied art and design in the commercial context of the Underground. It was Pick who established London Transport's reputation as the leading patron of graphic art and publicity in the first half of the twentieth century.

The transition from commissioned artwork to finished poster is analysed and explained by Alan Powers, while David Bownes and Emmanuelle Dirix explore the ways audiences were developed through specific campaigns to target markets. The training and background of the artists themselves is examined in two complementary essays by Paul Rennie and Jonathan

Black, which look at the influence and development of the London art schools and the European avant-garde in the interwar period, and their close relationship with London Transport's design culture.

The different approaches to Underground poster campaigns adopted during the two world wars are contrasted by Bex Lewis and David Bownes. This chapter lays the foundation for Brian Webb's survey of poster design from 1945 to the first decade of the twenty-first century. The book closes with Claire Dobbin's analysis of public and private responses to London's transport posters over the last hundred years, and asks whether it has provided, in Frank Pick's phrase, 'art for all'.

The majority of images reproduced are drawn from London Transport Museum's definitive archive of more than 5000 different posters and 800 artworks, spanning the period from 1908 to 2008. The collection is supported by an extensive photographic archive, showing many of the posters *in situ*, together with a complete black-and-white print collection of all posters (including letterpress examples) produced from 1908 to c.1960.

Taken as a whole, this resource represents the most complete graphic archive of its kind assembled by a single organisation over so long a period to be found anywhere in the world. It is like a slice of London life through the whole of the twentieth century to which new work is being continually added in the twenty-first.

A selection of posters and artwork from the collection can always be seen on public display in the London Transport Museum at Covent Garden, where some of the exhibits are changed regularly for conservation care and variety. The whole collection can be viewed online at www.ltmuseum.co.uk. Original items can be studied at the Museum Depot, LTM's collections centre and store at Acton Town, by appointment.

Other notable collections of Underground posters and artwork are held by the Victoria & Albert Museum, much of it donated by Frank Pick and his successors at London Transport. Related collections, illustrating contemporary posters produced by many of the same artists, can be found at the National Railway Museum, National Motor Museum (Shell-Mex archive), National Archives (Empire Marketing Board archive) and the Imperial War Museum.

Transport company names

The focus of this book is on posters produced by the bus, tram, Tube and railway companies which merged to form London Transport (LT) in 1933, and LT's subsequent poster policy. A detailed listing of each company, with amalgamation dates, is outside the scope of the current work, but can be traced in section two of the Bibliography. The main companies referred to in the current work are:

The Underground Electric Railways of London Ltd (UERL)
Often shortened to the Underground or Underground Group, this private company existed from 1902 to 1933 and included most of the deep-level Tube railways, the District Railway, and many of the principal tram and bus operators, including the London General Omnibus Company.

Metropolitan Railway
Opened in 1863, the Metropolitan was the world's first underground railway. It remained independent of the Underground Group until their amalgamation in 1933.

London County Council Tramways
The LCC was London's biggest tramway operator. The LCC's extensive tram network was transferred to London Transport in 1933.

London Passenger Transport Board
Formed in 1933, the LPTB (or LT for short) was an amalgamation of several public transport organisations to create a publicly accountable body for London's tram, bus and underground network. The title 'London Transport' was retained for almost seventy years, despite successive changes in higher organisation. In 2000, the system became part of Transport for London (TfL), with an enlarged remit to include river services, taxis, street management and some overground railways.

Poster sizes
Transport posters were originally printed in imperial sizes, referred to by the size of the paper sheet. These descriptive sizes are retained throughout this book, together with dimensions in millimetres.

The standard poster size used by the Underground is 40 x 25 inch (1016 x 635mm) 'double royal' — a format used almost exclusively by railway companies. Larger 40 x 50 inch (1016 x 1270mm) 'quad royal' and 60 x 40 inch (1524 x 1016mm) 'four-sheet' posters were occasionally used on hoardings at Underground stations and elsewhere.

Smaller 30 x 20 inch (762 x 508mm) 'double-crown' posters were originally produced for display on the front panels of buses and the side panels of trams. 'Panel posters', produced mainly in the 1920s and 1930s for Underground car interiors, vary slightly in size as they were not designed to fit standard frame or wall space but were displayed on the glass screens just inside the doors. Other non-standard posters include those produced during wartime (due to paper shortages) and for display on noticeboards at stations and in staff areas.

TIMELINE KEY DATES AND EVENTS

pre-1900s

1863 Metropolitan Railway opens in London between Paddington and Farringdon. This is the world's first urban underground railway, and uses steam trains.

1884 The Circle line is completed, linking the Metropolitan and District Railways in central London. Both underground railways are also extended with overground lines through outer London and into the surrounding country-side, encouraging suburban development.

1890 City & South London Railway, the first deep level Tube line, opened between Stockwell and the City. This is the world's first electric underground railway. It is now part of the Northern line.

1900s

1900 Central London Railway, known as the Twopenny Tube, opens.

1901 First electric tram routes open in London.

1902 Establishment of the Underground Electric Railways of London (UERL).

1905 Metropolitan and District steam underground lines are electrified. District now part of UERL but Metropolitan remains independent.

1906-07 UERL opens Bakerloo, Piccadilly and Hampstead Tube lines.

1908 Frank Pick given responsibility for UERL publicity and commissions his first Underground posters. Start of co-ordinated marketing across the Underground railways through lettering, maps and distinctive signage, including first version of what became the roundel symbol.

1910s

1912 London General Omnibus Company (LGOC), the Capital's main bus operator, taken over by UERL. Frank Pick responsible for traffic development in enlarged UERL Combine, promoting and co-ordinating the companies' bus, tram and Underground services.

1914-18 First World War.

1915 Design & Industries Association (DIA) established. Pick is a founding member.

1915 Edward McKnight Kauffer designs first posters for UERL.

1915 Metropolitan Railway publishes first Metro-land brochure.

1916 Edward Johnston completes new Underground letter face for Pick.

1917 First known exhibition of Underground poster art held at the Mansard Gallery , Tottenham Court Road, London.

1920s

1924-26 Underground extensions north to Edgware and south to Morden completed.

1928 Rebuilt Piccadilly Circus station opened, new showpiece hub of the Underground.

1928 Pick becomes Managing Director of UERL.

1928 Exhibition at Burlington House celebrates 20 years of Underground posters.

1929 New Underground head office building at 55 Broadway over St.James's Park station completed. Architect Charles Holden.

No Need to Ask a P'liceman! (detail) John Hassall, 1908

1930s

1930 Green Line coach services introduced from London to towns in the Home Counties.

1931 First electric trolleybuses in London. Replace most of London's trams 1935-40.

1932-33 Piccadilly line western and northern extensions completed. Best known of the new stations in Holden's distinctive architectural style.

1933 First publication of Harry Beck's classic diagrammatic Underground map.

1933 London Passenger Transport Board (LPTB) created as a single public corporation to run all bus, tram and underground railway services in London.

1935 Christian Barman appointed Publicity Officer under Pick (in role until1941).

1940s

1939-45 Second World War.

1940 Pick leaves London Transport.

1941 H T Carr becomes LT Acting Publicity Officer (in role until 1947).

1947 Harold F Hutchison becomes LT Publicity Officer (in role until 1966).

1948 LT nationalised along with the four mainline railway companies.

1949 Exhibition of London Transport poster artworks, Art for All, is held at the V&A.

1950s

1951 Festival of Britain.

1952 London's last trams replaced by diesel buses.

1959 Routemaster (RM) buses enter service, replacing trolleybuses in London by 1962.

1960s

1963 An exhibition of posters held at the Royal Institute Galleries as part of the Underground centenary celebrations.

1966 Bryce Beaumont becomes LT Publicity Officer (in role until 1975).

1968-69 Victoria line opened, first computer controlled underground railway in the world, with automatic trains and ticket gates.

1970s

1975 Michael Levey becomes LT Publicity Officer (in role until 1979).

1977 Piccadilly line extended to Heathrow Airport and later to Terminal 4 (1986) and Terminal 5 (2008).

1979 Jubilee line opens.

1980s

1980 Nick Lewis becomes LT Advertising & Publicity Officer (responsible for poster commissioning until 1992).

1986 Henry Fitzhugh becomes Marketing & Development Director (in role until 1992) and introduces Art on the Underground poster commissioning initiative.

1987 Docklands Light Railway (DLR) opened. More than doubled in length with a series of extensions ever since.

1990s

1992 Art poster commissioning passes to Jeremy Rewse-Davies, LT Design Director 1988-1999.

1998 First art poster commissioned by London Transport Museum.

1999 Jubilee line extension (JLE) opened with dramatic new station architecture and design between Westminster and Stratford.

2000s

2000 Transport for London (TfL) created. TfL is responsible to the Mayor of London and has a much wider remit than LT. As well as bus and Underground services, TfL manages the DLR, Tramlink, taxis and private hire (through the Public Carriage Office), river services, cycling, main roads and traffic control and Victoria coach station.

2000 Platform for Art set up as London Underground's official public art programme.

2007 London Overground created as part of TfL to run some suburban railway services.

2008 Exhibition of poster artworks at London Transport Museum (until 2009).

A Fair Average Conduct Helps the Service (detail)
Lunt Roberts, 1927

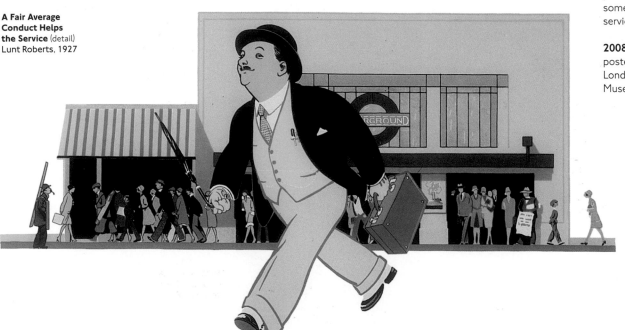

PICTORIAL POSTERS
IN BRITAIN AT THE TURN OF THE TWENTIETH CENTURY

Catherine Flood

B Y THE OPENING YEARS of the twentieth century, advertising posters were part of the fabric and spectacle of the British cityscape. *Living London*, a celebratory investigation of the capital published in 1903, imagines the Londoner confronted by a 'foreign friend, who having done London with his red guide book under his arm wants to understand something more of the living side of the great city'. The author recommends strolling with your friend through the streets to discover the alternative sights and attractions of the modern metropolis:

> The first thing to attract your foreign companion's attention may be a
> huge London hoarding on which the staff of the advertising contractor
> are busily engaged in fixing the posters plain and pictorial, artistic and
> the reverse which are such a feature of the capital.[1]

The vocabulary used to describe posters in contemporary accounts suggests an intense effect — an assault on the senses. Posters are 'furnaces of colour'. They 'shout' from the hoardings, and are the 'brass-band of advertising'. They are 'blinding' and 'hit the passer-by right in the eyeball'. The 'Yellow Girl' in Dudley Hardy's *To-day* poster (plate 1) was described as possessing such an irrepress-ible visceral presence that she seemed to step right out of the hoarding and to

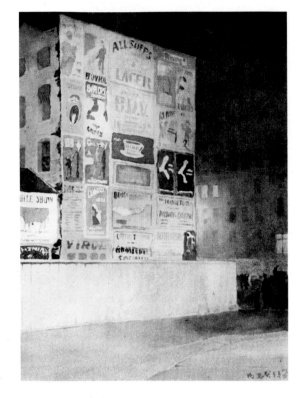

1 **To-day**
Dudley Hardy, 1893

2972mm x 1905mm
Published by *To-day* magazine
Printed by David Allen & Sons

2 **A London Hoarding**
Illustration by Yoshio Markino
in W.J. Loftie, *The Colour of
London*, 1907

3 King's Cross station,
Metropolitan Railway, under
construction, about 1862

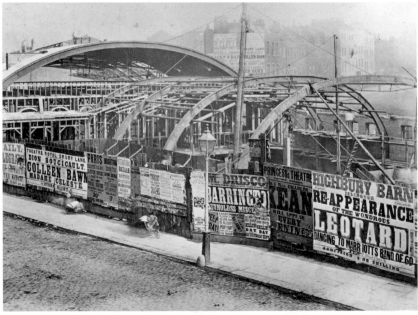

dance 'with mincing steps along the decorous streets of London'.[2] On photographic postcards of streets and railway stations, crude hand-tinting often picks out posters in splashes of red and yellow as the dominant source of urban colour. In Yoshio Markino's 1907 illustration of a London hoarding, the posters appear to glow through the fog (plate 2).

Nineteenth-century London had been liberally placarded, predominantly with letterpress announcements in a text-only format (see plate 3). However, towards the end of the century the inroad of pictorial advertising into the hoardings and the scale, colour impact and design of colour lithographic posters represented something insistently modern and comment-worthy.

By the time the Underground Group initiated its poster campaign in 1908, pictorial posters were

already a powerful force in public advertising, but the relationship between poster design and commerce was formative and improvised. According to the advertising agent S.H. Benson there were 'few things advertisers differ upon more than the question of pictorial advertisements'.[3] The quality of designs varied widely and posters were simultaneously dubbed 'the art gallery of the street' and 'the horrors on the hoardings'. It was a period when people were becoming alive to the possibilities of visual promotion: 'We are beginning to see that people are influenced more through the eye than any other organ of the body'.[4] In many activities looking for publicity, from the suffragettes to Selfridges, advertisers were exploring ways to claim a visual identity and presence within London.

The arrival of the pictorial lithographic poster

Pictorial lithographic posters are known in Britain from the mid-nineteenth century, but the medium received a massive impetus towards the end of the century from a number of technological, economic and imaginative developments. From around the 1890s there was a new pace and urgency to advertising as growth in production and the imposition of foreign tariffs drove British manufacturers to channel energy and money into stimulating domestic consumer markets. In this atmosphere the poster offered the advertiser a public voice that was inescapable. In the words of one printing firm, posters 'accompanied the housewife all the way from her front door to the shop window'[5]. The construction of vast station interiors and the hoardings that shielded urban development presented ideal public surfaces across which to communicate, and billposting was organised into a reputable trade hiring out and regulating posting space, lending

posters in turn a greater respectability. The impulse behind poster design was competitive – a poster had to catch the attention of the viewer on the move, standing out from any combination of juxtaposed rivals. The search for impact shifted up a gear as technical improvements in colour lithography and machine printing made it economically viable to produce large-scale pictorial posters in full colour.

Early British lithographic posters were frequently rendered in the gaudy, often sentimentalised, style of chromolithography familiar from commercial ephemera such as greetings cards and scraps. Others employed a medley of elaborate lettering and vignettes reminiscent of lithographic sheet music covers. Serious artists were rarely involved with poster design. Pears Soap stood out in the 1880s when the brand reproduced oil paintings by eminent Royal Academicians on a series of its posters, provoking a publicity-rich furore over the harnessing of art to commerce.

At the same time in France, however, the lithographer Jules Chéret had begun working with posters as a specific and creative medium. He approached colour lithography as an autographic process, working directly on the stone to achieve gestural strokes and 'butterfly' colours that contemporary viewers described as pyrotechnic (see plate 4). In the 1890s a number of avant-garde Paris-based artists, including Henri de Toulouse-Lautrec, Eugène Grasset, Pierre Bonnard, Théophile-Alexandre Steinlen and Alphonse Mucha, followed Chéret's lead, applying a range of formal influences to the challenge of poster design. The asymmetry and flat treatment of space in Japanese prints, the strong outlines and colour masses of stained glass and the stark contrast of the silhouette were among the solutions fed into poster designs that were intended to compel attention through a bold decorative effect.

4 **Folies-Bergère:**
L'Arc en Ciel
Jules Chéret, 1893

1133mm x 835mm
Published by the Folies-Bergère
Printed by Chaix

The poster craze

As a collision of high art and mass print culture that engaged the subjects, materials and physical locations of the urban crowd, the experimental French poster seemed to offer a truly modern artistic medium and a progressive challenge to the conventions of the art academies. As Aubrey Beardsley explained with relish: 'The critics can discover no brush work to prate of, the painter looks askance upon a thing that achieves publicity without a frame, and beauty without modelling'[6] The fashionable Paris art world took note and for a few years a culture of collecting, specialist criticism and scholarship surrounded the poster, claiming it as a legitimate art object. Posters were located both on hoardings and within exhibitions, publications, print shops and collectors' portfolios. The avant-garde Paris gallery Salon des Cent both commissioned posters to advertise its exhibitions and included them within the displays.

Interest in the French poster spread abroad and developed into an international 'poster craze' in America and Europe. Excitement about the artistic poster had reached Britain by the mid-1890s. Two poster exhibitions were held at the Royal Aquarium, London in 1894–6 and Charles Hiatt published the first English-language book on the subject, *Picture Posters*, in 1895. The first British artists to attract critical attention for their posters were Aubrey Beardsley, Dudley Hardy, the Beggarstaffs (brothers-in-law James Pryde and William Nicholson) and, slightly later, John Hassall. Commentators were keen to read national characteristics into poster design and the work of the Beggarstaffs was hailed as promising a native style. The extreme reduction of detail in their designs was striking and original and was interpreted as a counterbalance to the aspect of decadent display detected in French posters (see plate 5).

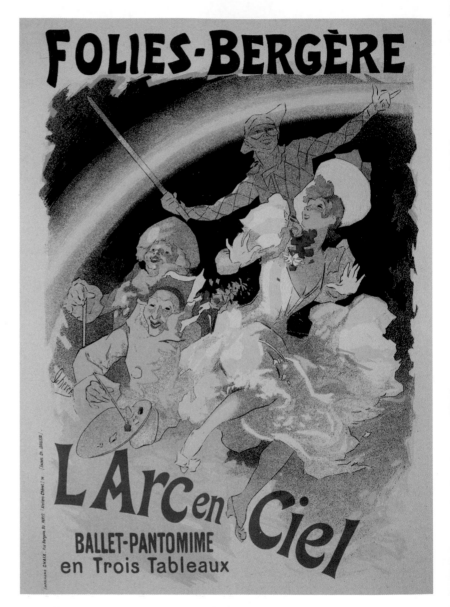

5 **Don Quixote**
The Beggarstaff brothers
(James Pryde and William
Nicholson), 1895

2050mm x 2085mm
Unused poster artwork

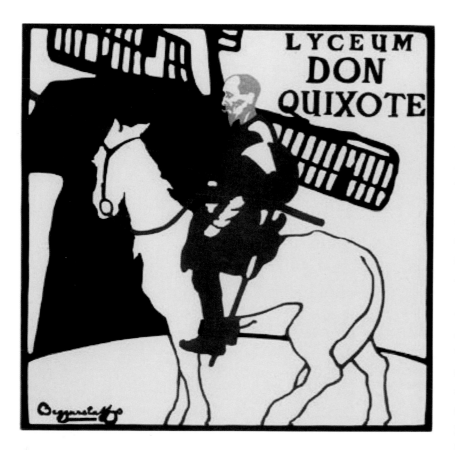

However, advertisers judged the Beggarstaffs' designs too cryptic, morbid even, to resonate with the public and only seven of their posters ever made it onto the hoardings. Some of the designs rejected by commercial clients were resuscitated in the pages of art journals and gained the Beggarstaffs an international reputation, but they designed their last poster in 1899 just as the boom in collecting was subsiding. As Charles Hiatt regretted, aesthetic concerns had carried poster design beyond current commercial realities. The artistic posters of the 1890s had a far-reaching influence on future graphic design, but their direct short-term effects were limited. Artistic posters were described as 'oases' among the 'commonly painful' pictorial advertisements on British streets. However, a trickle-down effect in pictorial style is evidenced by Charles Hiatt identifying 'bastard imitations' of Chéret, Mucha, the Beggarstaffs and Hassall in 1900.

British poster design in the early twentieth century

After the heady artistic aspirations for the poster, there was space around the turn of the century for a more pragmatic consideration of how the new discoveries in poster design would play out in the commercial world. A shift in thinking is evident from a comparison of two articles on posters in the *Art Journal*. The first, written in 1895 in the midst of the poster craze, was a purely aesthetic examination of the French 'masters'. The second, published in 1906, confronted the way forward for British poster design in terms of the relationship between designers and advertising clients. In 1900 the first International Advertisers Exhibition was held at Crystal Palace, and a newly formed British Poster Academy formed part of the exhibition the following year. The declared aim of these initiatives was to reach beyond the connoisseur to educate advertisers and the public in good poster design. However, the general quality of submissions was considered disappointing, displaying in the judges' opinion plagiarism, a lack of good drawing and care in execution, crudities in colour schemes and tasteless lettering.

The Beggarstaffs were widely regarded as the high-water mark in British poster design, but it was John Hassall who provided a more practical model of the artistic poster designer in the following decade. It is his career that reveals more about the commercial dynamics of turn-of-the-century poster design. Whereas the Beggarstaffs had been guided into poster work by the designer and theatre director Edward Gordon Craig, and experimented

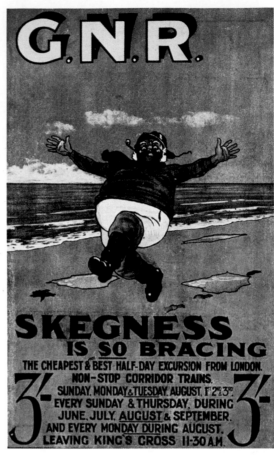

6 John Hassall
Caricature by Strickland
published in *Vanity Fair*, 1912

7 Skegness is So Bracing
John Hassall, 1908

Double royal
(1016mm x 635mm)
Published by the Great Northern
Railway Company
Printed by Johnson, Riddle &
Company Ltd

with a technique of cut-out work and stencil, Hassall began more typically in a contract with David Allen & Sons, one of the big printing firms, producing gouache poster designs to order for their clients. An accelerating reputation allowed him to develop a more fully freelance profile.

Hassall's success was based on his willingness to engage with both the product and the public. His style interpreted the bold decorative effects of the artistic poster in a more popular, frequently humorous idiom and his biographer noted in 1907 that '[i]t is Hassall's especial merit in the eyes of the British Public that he never soars above their heads'.[7] He explained his approach to poster design in a frank interview with the journal *Modern Business*: 'The idea is everything … and should emphasise as far as possible the leading selling point … one might make a very artistic poster without making a good selling poster.'[8] All aspects of Hassall's posters were calculated for life on the hoardings – down to a

knowledge of which inks were most durable. The 1912 *Vanity Fair* caricature of Hassall (plate 6) captures the unique persona he cultivated – this was a combination of bohemian eccentric and military man of action, that amplified both his artistic and business credentials. Interviews invariably mention Hassall's renown for being able to turn around a successful poster in a matter of hours – an ability corroborated by an entry in his diary suggesting that the famous *Skegness is So Bracing* poster (plate 7) was completed the same morning it was requested. Hassall felt strongly that poster design required a specific training and technique that could be hindered by the 'conventional training of the artist at the schools'[9] and he founded The New Art School specifically to develop young poster designers.

Hassall was one of a small number of respected artists at this period who combined a serious output in poster design and press advertising with a more traditional repertoire in painting and illustration. The

8 **Humours No.5: At the Royal Academy**
Tony Sarg, 1913

Double royal
(1016mm x 635mm)
Published by UERL
Printed by Johnson, Riddle &
Company Ltd

nucleus of this group – including Hassall, Dudley Hardy, Phil May, Cecil Aldin and Tom Browne – were all members of the London Sketch Club where they met weekly to make timed sketches on a set theme as well as to socialise. Their collective interest in humorous illustration led to humour being identified as one of the most successful characteristics in British poster design. Fred Taylor, Alfred Leete and Tony Sarg (see plate 8), who along with Hassall designed some of the early Underground posters, were also prominent members of the club.

The London Sketch Club had broken away from the eminent and more conservative Langham Sketch Club in 1898. Its members embodied a new mould of young artists with a more open attitude towards commercial work as a remunerative option and who approached drawing for advertisements as a logical extension of black-and-white illustration. Their careers were intimately connected with a new populist brand of newspapers and magazines that contained increasing levels of both illustration and advertising. The exposure of their commercial work turned the Sketch Club designers into household names, and their public profile was increased through the publication of human-interest style interviews (another development of the new breed of journalism) and press reports of the Sketch Club's social antics. Their exhibited work also found a degree of approval by virtue of being contemporary but not radical. Some reviewers noted a resonance between Sketch Club members' practice of timed sketching, the demands of commercial style and a freer, more modern approach to painting.

These men, however, were the exception. The majority of poster designers working for printing firms had a lowlier status and were not always permitted to sign their work. David Allen & Sons had a permanent staff of poster designers, some

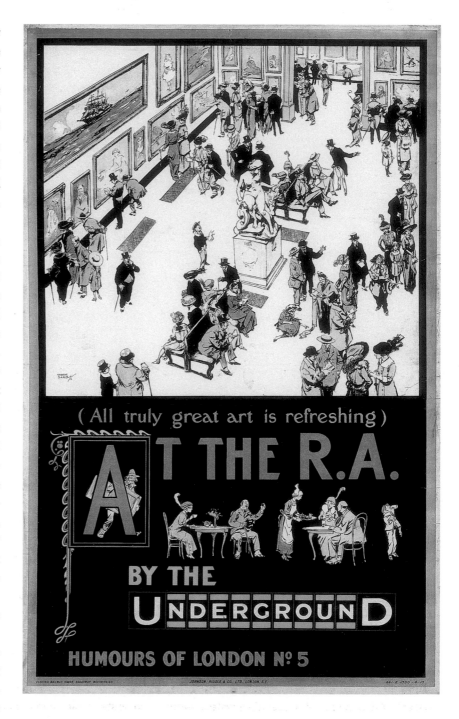

of whom worked in a studio on the company's premises while more prestigious commissions were sent out to well-known, and more costly, designers such as Hassall. Poster advertising in Britain was starting to become more organised. David Allen & Sons offered clients a complete service from briefing artists through to billposting, and developing advertising agencies such as S.H. Benson's included posters in co-ordinated campaigns orchestrated across all advertising media. However, the 1906 article on posters in the *Art Journal* identified as the principal factor restricting the development of British poster art the position of printers and advertising agents as middlemen, who separated the poster designer from the advertising client. The lack of direct discussion between artist and advertising client, and the practice of printers to modify artists' designs, were the principal complaints. The business world remained sceptical about the value of a poster image. S.H. Benson advised in 1904 that 'perhaps the wisest course is not to depend on the illustration to sell the goods — not to sacrifice the argument for the sake of the art'.[10]

During the first decade of the twentieth century the creative impetus in poster design shifted to Germany, where interest in the artistic poster had begun slightly later but had proved more sustained and far-reaching. Institutions such as the Deutscher Werkbund (literally 'German league of work') founded in 1907 and the touring Deutsches Museum für Kunst in Handel und Gewerbe (the German Museum for Art in Trade and Industry) championed the relationship between businessman and artist. At prestigious printing firms such as Hollerbaum & Schmidt in Berlin, artists worked directly on the lithographic stone and expert printing was combined with a high quality and integrity of design in commercial posters.

Posters in the public sphere

Posters are part of the urban experience, and for many turn-of-the-century observers the significance of the poster lay in its impact on the spaces it colonised. Some accepted public advertising as a defining feature of the visual city — 'one of the mnemonic notes that call up London to the Londoner'.[11] Indeed, as London shifted shape during these years and areas such as the West End were extensively rebuilt, the constant presence of advertisements may well have represented the thread of urban normality. On the street, posters could blend with the culture of daily life.

However, a vocal section of the public resisted outdoor advertising as a disfigurement of the environment — an offence against taste and an intrusion of private commercial interests into public space. The Society for Checking the Abuses of Public Advertising channelled these feelings into a parliamentary lobby. In a more personal voice G.K. Chesterton wrote of his irritation with the triviality of posters and their artificial, commercial colouring of the street: 'There is nothing wrong with Reckitt's Blue except that it is not Reckitt's. Blue does not belong to Reckitt's, but to the sky. … Even the finest posters are only very little things on a very large scale.'[12] Posters' relationship to urban poverty was another contentious issue. Some idealised posters as a source of culture and education for the poor. Others felt a dissonance in the public promotion of commodities and entertainments that many could not afford.

Like the mainline railway stations and embankments, the Underground was a key site for poster display and presented a focus for emotions about advertising. Both before and after the Underground Group began to develop its own poster campaign, the company generated significant revenue by renting poster space to other advertisers. Photographs

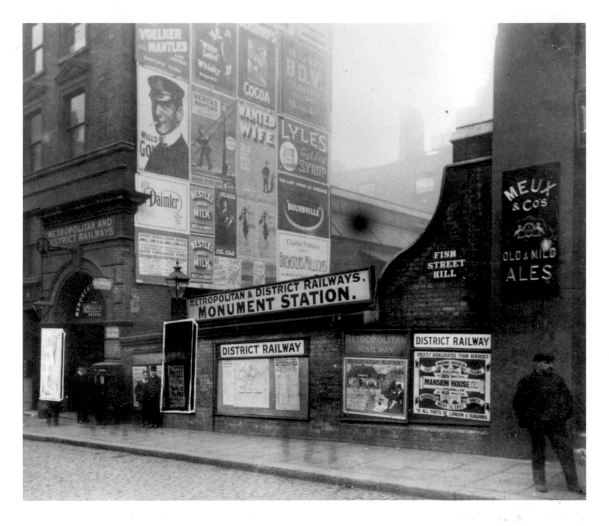

9 Monument Underground station, 1907

Sites for newly branded 'UNDERGROUND' poster frames have been highlighted on either side of the station entrance in this early UERL record photograph.

from the period capture Underground station entrances, lifts and platforms as overwhelmingly graphic environments (see plate 9). When the Bakerloo line opened in 1906 there was a short delay before advertisements were posted and an exchange of letters in *The Times* debated the strangely nude walls. The first letter mistakenly congratulated the railway's directors for their restraint in not 'defacing' their platforms and cars with advertisements. 'An Architect' added that 'placarding a station all over with blatant pictorial advertisements involves a complete destruction of the appearance of neatness, cleanliness and finish'. However, the last letter in the debate championed the visual entertainment provided by posters on the Underground: 'Changing at Oxford Circus from the new tube to the Central London; one leaves an oppressive waste of bare walls and is suddenly surrounded by old friends'. [13]

Advertising the Underground

When Frank Pick took on responsibility for Underground Group publicity in 1908, the company was facing the prospect of bankruptcy if passenger traffic did not increase. The Underground Group had opened three new electric lines in 1906–7, but these were viewed as an alien insertion in London and an unpatriotic example of American investment (see chapter 2). The Tube lines confronted the public with new technology — descent in electric lifts and travel in fast, deep-level trains. For travellers used to the sulphurous atmosphere of the pre-electric underground railways, the new lines even smelt different. Letterpress bills were already being used to impart information, but Pick sensed the potential for modern pictorial posters to go beyond simply announcing the Underground. The poster campaign he initiated aimed at changing the way the public felt

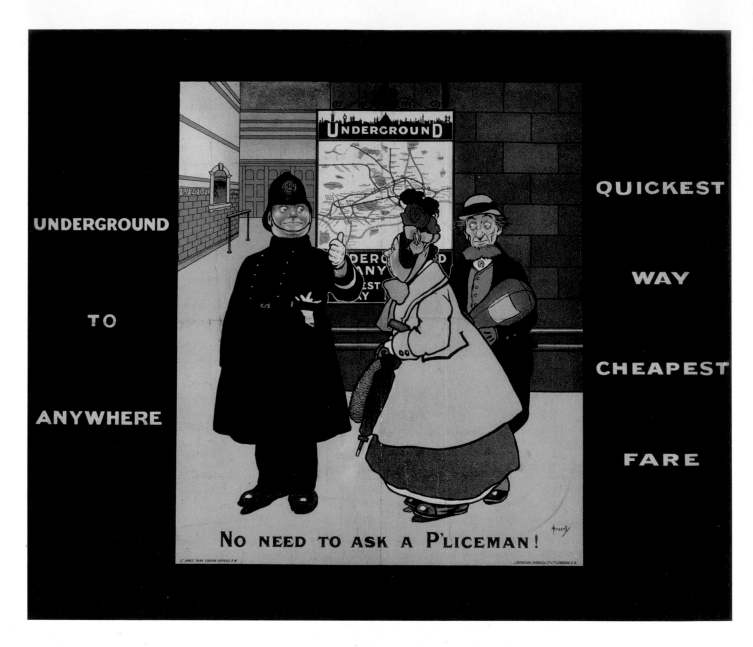

about the Underground and presenting a new idea of London that had the Underground at its core.

Traditionally regarded as the first pictorial posters presented under the new 'UNDERGROUND' legend, *No Need to Ask a P'liceman!* was commissioned in March 1908 from John Hassall (plates 10 and 11). Pick had the example of the mainline railway companies before him which were making energetic use of pictorial posters; yet there were still doubts expressed by British businessmen at this period about whether poster advertising paid. Hassall, however, had a reputation as a sound commercial

choice. His posters were described as 'business building' and in 1910 the newspaper *T.P.'s Weekly* stated that 'no commodity can be considered up-to-date which has not its Hassall poster'.[14] A few weeks before *No Need to Ask a P'liceman!* was commissioned, the Great Northern Railway had obtained *Skegness is So Bracing* from Hassall through the same printing firm, Johnson, Riddle & Company.

Hassall's poster promotes the Underground map and through it the newly integrated system. Every element aims at a popular and inclusive appeal. The advertising copy 'Underground to Anywhere,

10 No Need to Ask a P'liceman!
John Hassall, 1908

533mm x 600mm
Published by UERL
Printed by Johnson, Riddle & Company Ltd

11 No Need to Ask a P'liceman!
John Hassall, 1908

Original artwork for the UERL poster (693mm x 505mm)

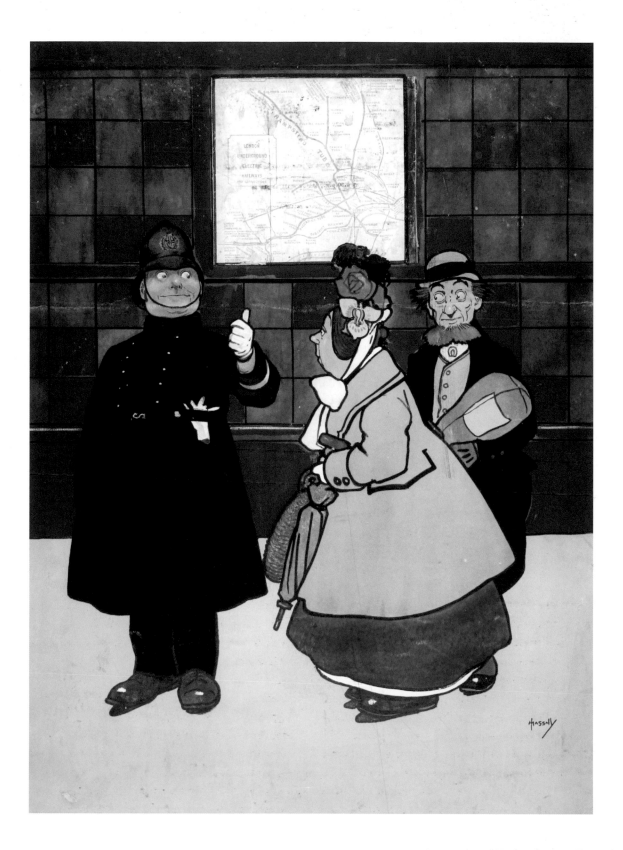

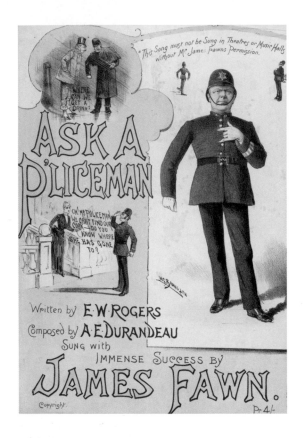

Quickest Way, Cheapest Fare' was supplied by a 14-year-old schoolboy, Edward Parrington, in an *Evening News* competition to find a slogan – a participatory tactic encouraging the public to own the message. 'No Need to ask a P'liceman!' was a reference to a hugely popular music-hall ballad 'Ask a P'liceman' (plate 12). Indeed, Hassall's brand of pictorial humour is rooted in the gestures, expressions and lowly characters of music-hall comedy.

The presence of the policeman gives the scene a resoundingly London flavour. The 'bobby' was an iconic figure of London life and a character frequently usurped for comedy. Hassall himself was known for dressing up as a policeman at London Sketch Club spoof theatricals. When the country folk in the poster ask directions, the policeman silently jerks his thumb at the Underground map behind, which replaces his function as way-finder and mirrors his status as an emblem of London. In the printed poster a ticket office and a more definite representation of the map (also printed by Johnson, Riddle & Company) have been added to Hassall's original

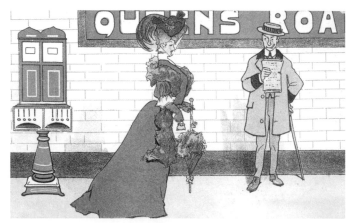
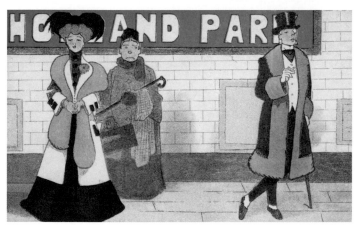
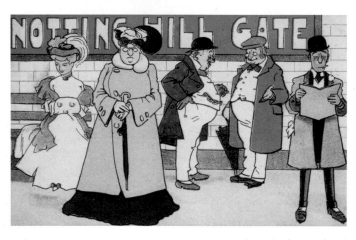

15 Postcards showing stations on the newly opened Central London Railway, c.1900

design so that the scene is now more literally placed.

While the core of the message is a reassurance that the Underground system is easy to use and provides all the information you need, the joke is that the elderly country couple are unsure how to negotiate their journey. An 1899 French travel poster promoting London as a tourist destination had featured a fashionable young woman asking directions from an attentive policeman on a London street (plate 13). In Hassall's poster, the Underground map renders asking a policeman the out-of-date way to navigate the city. By drawing on the humorous trope of provincials and 'country cousins' he suggests

that familiarity with the Underground is now part of the savoir-faire of the modern Londoner. A Punch cartoon from the following year demonstrates the same vein of humour – to the proud Londoner the Underground map appears simple, but it is not so obvious to friends up from the country (plate 14).

Several early Underground posters address issues of the Underground as a social space. American-style classless carriages were a startling innovation for the Edwardian traveller: 'The office boy finding that these trains have no third class carriages, has sat him down in great content beside the City magnate, and still the heavens do not fall!'[15] In G.K. Chesterton's 1908

16 Underground for Business or Pleasure
F.E. Witney, 1913

Double royal
(635mm x 1016mm)
Published by UERL
Printed by Johnson, Riddle & Company Ltd

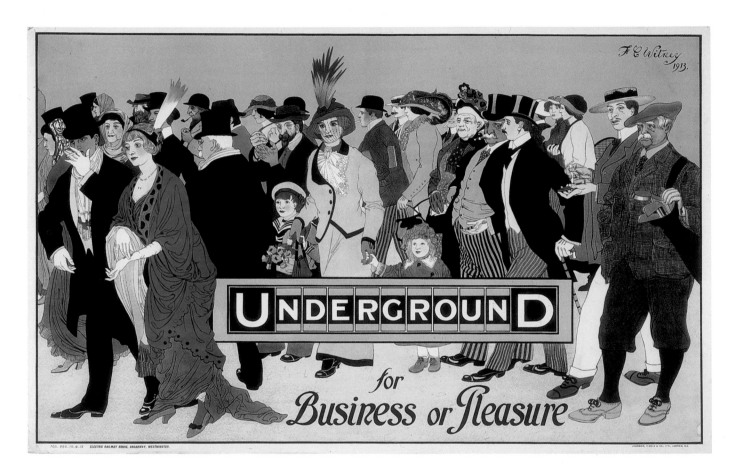

anarchist thriller *The Man Who Was Thursday*, the functioning of the Underground system is quoted as a symbol of perfect, poetic order. However, the human element of Underground travel seems to have threatened chaos. A series of comic postcards, published around 1900, characterised each station on the newly opened Central London Railway (the 'Twopenny Tube') by the visitors, workforce and residents distilled from the local area (plate 15). Different types and classes, who might otherwise never encounter each other, intermingle on the platform and there is a hint of social disruption where unaccompanied wealthy women attract a socially mixed and public male gaze. Like the postcards, the poster

Underground for Business or Pleasure (plate 16) depicts a range of types socially pinpointed by their clothing and accessories. However, in the poster there is no suggestion of interaction – the variegated passengers are self-contained units in the crowd. *The Way for All* promotes the kind of middle-class woman that the commercial world was just starting to define as a legitimate urban pleasure-seeker, and urban traveller. A comparison of the poster (plate 17) with the original artwork (plate 18) reveals that the direction of her glance has been modified so that she no longer catches the viewer's eye. She is a bold modern constituent of public travel and her disengaged gaze assures absolute propriety. Rendered in a

17 The Way for All
Alfred France, 1911

Double royal
(1016mm x 635mm)
Published by UERL
Printed by Johnson, Riddle &
Company Ltd

18 The Way for All
Alfred France, 1911

Original artwork for the UERL
poster (1016mm x 635mm)

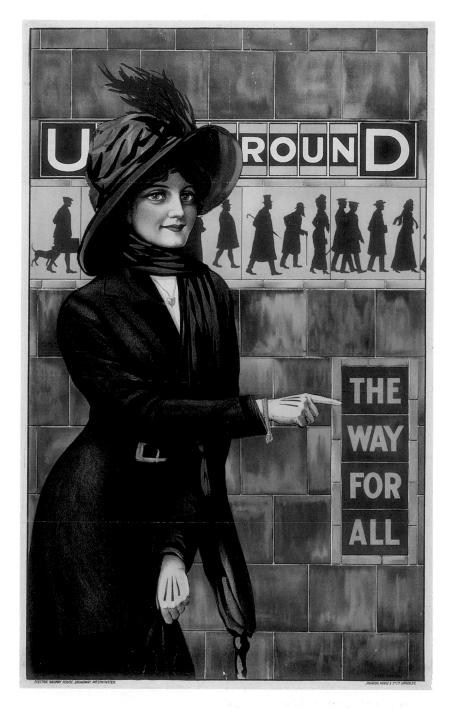

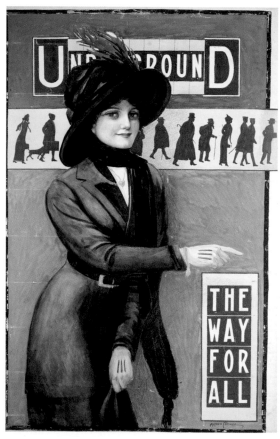

bright, illustrative style, these posters proclaim that the Underground is suitable for everyone – a diverse, heterosocial, even glamorous environment, but one that is not socially challenging.

Right from 1908 the predominant strand of Pick's poster campaign was to sell the Underground through its destinations, aiming to inspire customers to make journeys that had not yet crossed their minds. In addition to the commercial sense of this approach, Pick believed that the wellbeing of a city was threatened when it grew too large to be 'comprehended and understood'.[16] Posters were a means of telling Londoners about their city and bringing it into focus. Early Underground posters featured a full range of

19 Teddington Lock
Harry Mitton Wilson, 1912

Double royal
(1016mm x 635mm)
Published by UERL
Printed by Waterlow & Sons Ltd

20 Burnham Beeches
Walter E. Spradbery, 1913

Double crown
(762mm x 508mm).
Published by UERL
Printed by the Photochrom
Company Ltd

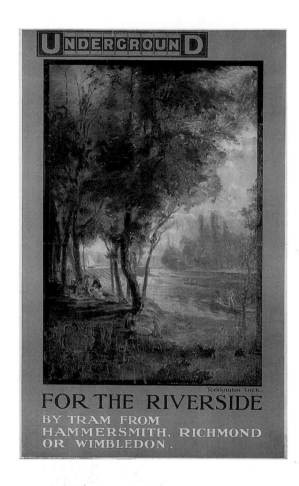

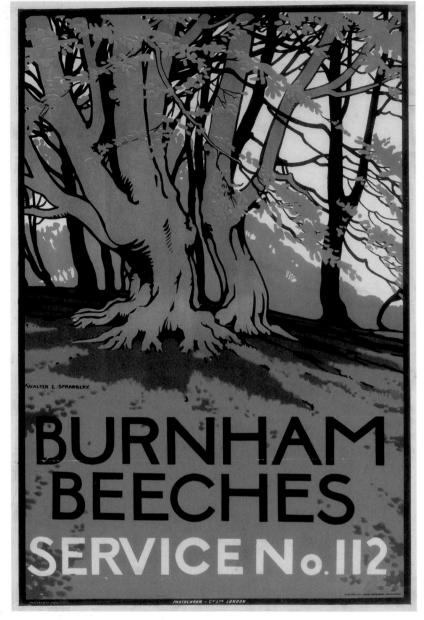

urban attractions as well as inviting passengers to escape to green spaces on the outskirts of the city.

In January 1915 the Victoria & Albert Museum curator Martin Hardie, who had already accepted the gift of some Underground posters, reported on a telephone conversation with Pick: 'His policy is one of constant change to keep public interest alive.' Posters should not constitute 'stale food for the public', and a poster's life span was set at three months.[17] London was presented as a living city, constantly refreshed and changing. The same principle

of variety governed the choice of pictorial styles. Working from the viewpoint that 'everyone is different and responds to different suggestions',[18] the Underground posters alternated styles. Posters advertising rural destinations frequently relied on a self-contained landscape scene but a range of pictorial approaches were interchanged. *Teddington Lock* (plate 19) reproduces an oil painting by Harry Mitton Wilson and is exactly the kind of image the public would have expected to see on the walls of the Royal Academy, where Wilson regularly exhibited.

21 Hatfield by Motor-bus
Charles Sharland, 1913

Double crown
(762mm x 508mm)
Published by UERL
Printed by Waterlow & Sons Ltd

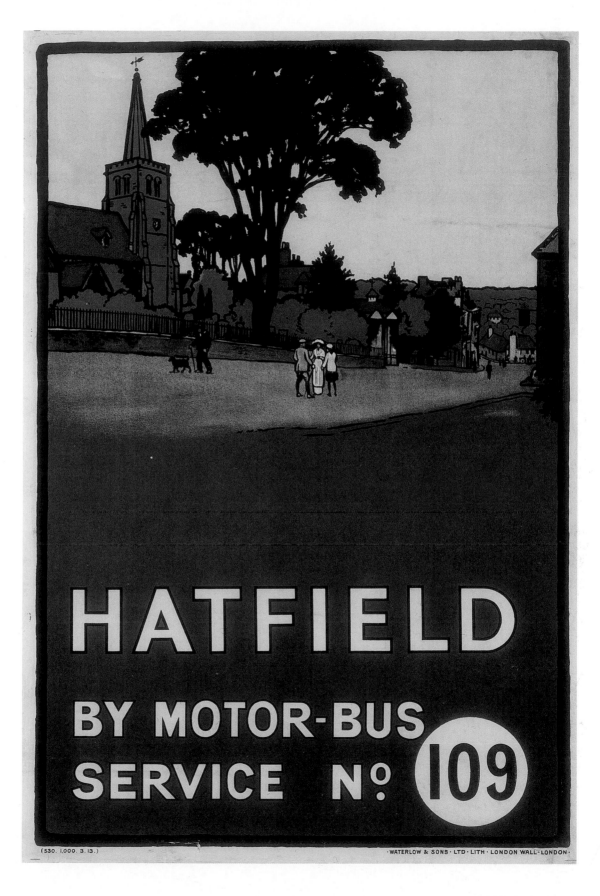

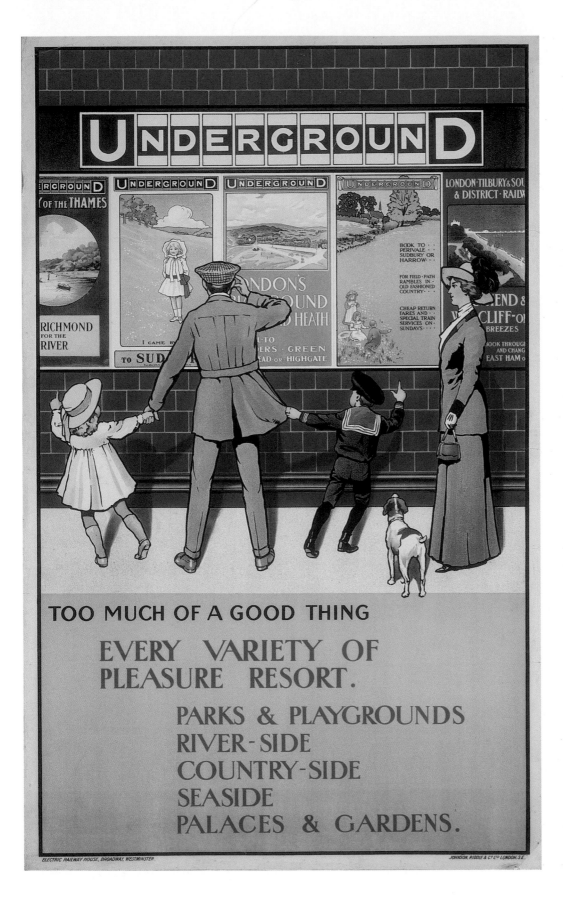

22 Too Much of a Good Thing
John Henry Lloyd, 1910

Double royal
(1016mm x 635mm)
Published by UERL
Printed by Johnson, Riddle &
Company Ltd

The posters depicted are
(from left to right):
Valley of the Thames (Charles
Sharland, 1908); *I Came by
Underground to Sudbury* (Alfred
France, 1910); *London's
Playground: Hampstead Heath*
(artist unknown, 1908); *Book to
Perivale, Sudbury or Harrow*
(Charles Sharland, 1909); and
Southend and Westcliff-on-Sea
(artist unknown, 1908).

**23 The Moving Spirit
of London**
Thomas Robert Way, 1910

Panel poster
(518mm x 216mm)
Published by UERL
Printed by T.R. Way &
Company Ltd

By contrast, *Burnham Beeches* (plate 20) by Walter
E. Spradbery applies a decorative modern poster
technique with reduced detail and strong colour con-
trasts. A similar style was employed by Charles
Sharland, the most prolific poster artist to work for
the Underground in the pre-First World War period
(see plate 21).

 Too Much of a Good Thing (plate 22) is a self-
reflexive poster depicting a family in excursion
clothing consulting destination posters (all examples
of actual Underground posters). It celebrates an
abundance of destinations, but also an abundance
of posters as the family enjoys the visual pleasures of
browsing open-air scenes. Conscious of the debates
about the disreputable nature of poster display,
Frank Pick had moved quickly to improve the organ-
isation and aggregate impression of posters on
the Underground. But he also understood posters'
positive potential to generate goodwill between
viewers and their environment. Landscape imagery
in particular had a claim to improving the man-made
environment of the underground. In a lecture on
'Taste' to the Royal Academy c.1905, George Clausen
explained the appeal of landscape painting in terms
of an escapism from the urban realities of the man
'who goes to his office in the morning by the tube'.[19]

 Many of the early Underground posters were
artistically undistinguished and Pick later admitted
that it was 'after many fumbling experiments' that
he 'arrived at some notion of what poster advertising
ought to be'.[20] However, early on he began to
develop an interest in the design qualities of the
Underground posters. The first manifestation of this
seems to have been an attention to the technique of
lithography. From 1910 a number of Underground
posters were designed by Thomas Robert Way and
printed by T.R. Way & Company. It was an interest-
ing firm for the Underground to commission.

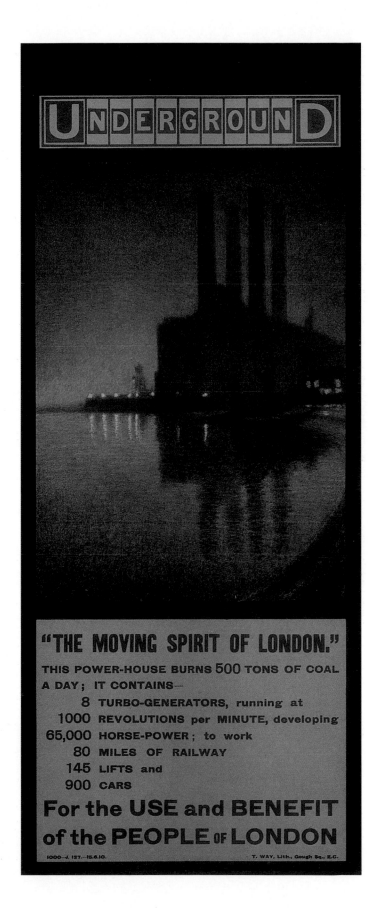

24 **Underground for the Centre of All Things: Charing Cross**
Joseph Pennell, 1913

Double royal
(1016mm x 635mm)
Published by UERL
Printed by the Westminster Press

Thomas Robert Way was a leading expert in lithography who, together with his father Thomas Way, had been responsible for encouraging some of the best artists of the day to work with the technique – most notably James McNeill Whistler. Way was best known for a series of limited-edition books on London illustrated with his own lithographs – in which Pick may have seen a potential for Underground advertising. The atmospheric mood in the poster *The Moving Spirit of London* (plate 23) has echoes of Whistler, who was the principal artistic influence on Way. The image romanticises the public-spirited message that the Underground pioneers technology for the good of London. Ironically, Whistler himself vociferously opposed the building of Lots Road power station, featured in the poster, as it spoilt his view of the Chelsea shoreline.

Way was also a member of the Senefelder Club (see chapter 4) which was dedicated to the advancement of artistic lithography (see chapter 3), and it is possible that he introduced Pick to their work. The Senefelder Club produced a series of London scenes for Underground posters in 1913 (see, for example, plate 24). They are striking images, although are essentially fine art prints used as posters (a set of signed proofs was presented to the Victoria & Albert Museum). The commission demonstrated Pick's growing interest in collaborating directly with artists over Underground advertising. Echoing the analysis in the 1906 *Art Journal*, Pick was beginning to feel that gaining access to artists through printers was unsatisfactory. In notes for a lecture given in 1915 he described the role of the poster designer in a printing firm as a 'drudge' who was treated as 'an inferior person not to be gravely considered'.[21] Pick cited German posters as the best examples of pre-war poster design and may have been influenced by Deutscher Werkbund thinking about the integral role

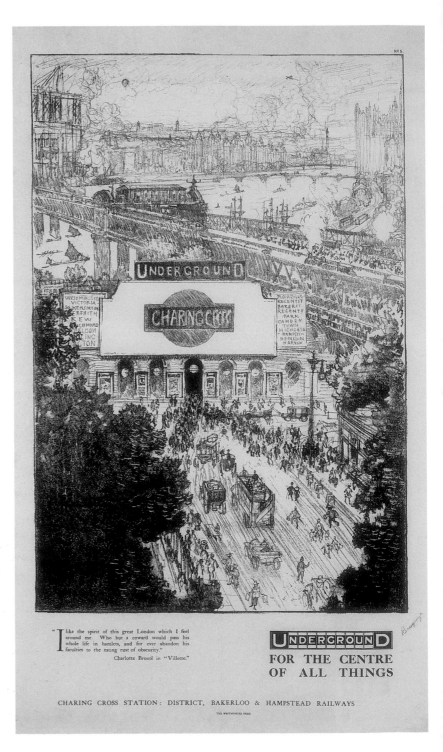

of the designer. He was later involved in the Design and Industries Association, largely modelled on the Werkbund.

When Frank Pick wrote to the Victoria & Albert Museum's director Cecil Harcourt Smith in 1909 requesting details about the state opening of the Museum's new buildings 'in order that we may advertise the event in connection with the District Railway', the Museum seemed perplexed by the promotional opportunity and replied diffidently that 'as the Museum will … not be open to the public on the day of the opening, I should have supposed that it was hardly worth your while to advertise the event'.[22] It is a measure of the impact the Underground poster campaign had on the psychology of London in its first few years that by the beginning of 1915 the Victoria & Albert Museum were lobbying Pick (who was described on file at the Museum as 'a very active and enterprising advertiser') for a poster featuring the Museum. From 1911 Pick also encouraged curator Martin Hardie to develop a policy of collecting posters at the Victoria & Albert Museum by donating batches of Underground posters (together with some examples of other travel posters) and offering to advise on the acquisition of 'commercial lithography'. Hardie went on to become a strong advocate and scholar of the poster and his work laid the seeds of the national poster collection at the Victoria & Albert Museum.

Pick's donations to the Museum also suggest a level of pride in the early Underground posters. In the years before the First World War, he had applied himself to both the possibilities and the problems of the modern pictorial poster. The poster craze of the 1890s had been an enlightening but unsustained period of private collecting and predominantly artistic interest. As a highly practical and prolific commercial advertiser with a growing commitment to the integration of art and business and an active role in encouraging poster artists and museum collecting, Pick was beginning to help develop more solid foundations for the British poster as an applied art.

Notes

1. G.R. Sims (ed.), *Living London*, 3 vols, Cassell, London, 1902–3, iii (1903), p.216.
2. A.E. Johnson, *Dudley Hardy*, A. & C. Black, London, 1909, p.39.
3. S.H. Benson, *Force in Advertising*, London, 1904, p.38.
4. Unknown, 'The reign of the artistic', *Success Magazine*, reprinted in *Retail Trader*, 19 May 1910, p.16, quoted in Erika Diane Rappaport, *Shopping for Pleasure: Women in the Making of London's West End*, Princeton University Press, Princeton, 2000. p.159
5. W.E.D. Allen, *David Allens: The History of a Family Firm 1857–1957*, John Murray, London, 1957, p.140.
6. Aubrey Beardsley, 'The art of the hoarding', *New Review*, July 1894.

7. A.E. Johnson, *John Hassall*, A. & C. Black, London, 1907 p.2.
8. John Hassall quoted in G. Edgar, 'Business Builders XX. Mr John Hassall RI, a character sketch', in an undated extract from *Modern Business*, c.1910, pp 104-5, in the John Hassall Collection, University of Essex.
9. 'Business Builders', p.105.
10. Benson, *Force in Advertising*, p.38.
11. T. Burke, *London in My Time*, Rich & Cowan, London, 1934, p.23.
12. G.K. Chesterton, *What's Wrong with the World*, Bernhard Tauchnitz, Leipzig, 1910, p.208.
13. *The Times*, 24 March and 17 April 1906.
14. *T.P.'s Weekly*, 2 December 1910.
15. Sims (ed.), *Living London*, p.151.

16. Frank Pick quoted in Christian Barman, *The Man Who Built London Transport: A Biography of Frank Pick*, David & Charles, Newton Abbot, c.1979, p.38.
17. V&A Archive: MA/1/L/1907, 4 January 1915.
18. Frank Pick quoted in Barman, *The Man Who Built London Transport*, p.32.
19. G. Clausen, *Royal Academy Lectures on Painting*, Methuen, London, 1913, p.237.
20. Pick, quoted in Barman, *The Man Who Built London Transport*, p.36.
21. F. Pick, 'Art in commerce and in life', March 1916, lecture notes for an audience in Leicester, Frank Pick Archive, London Transport Museum.
22. V&A Archive: MA/1/L/1907, 1 June 1909 and 12 June 1909.

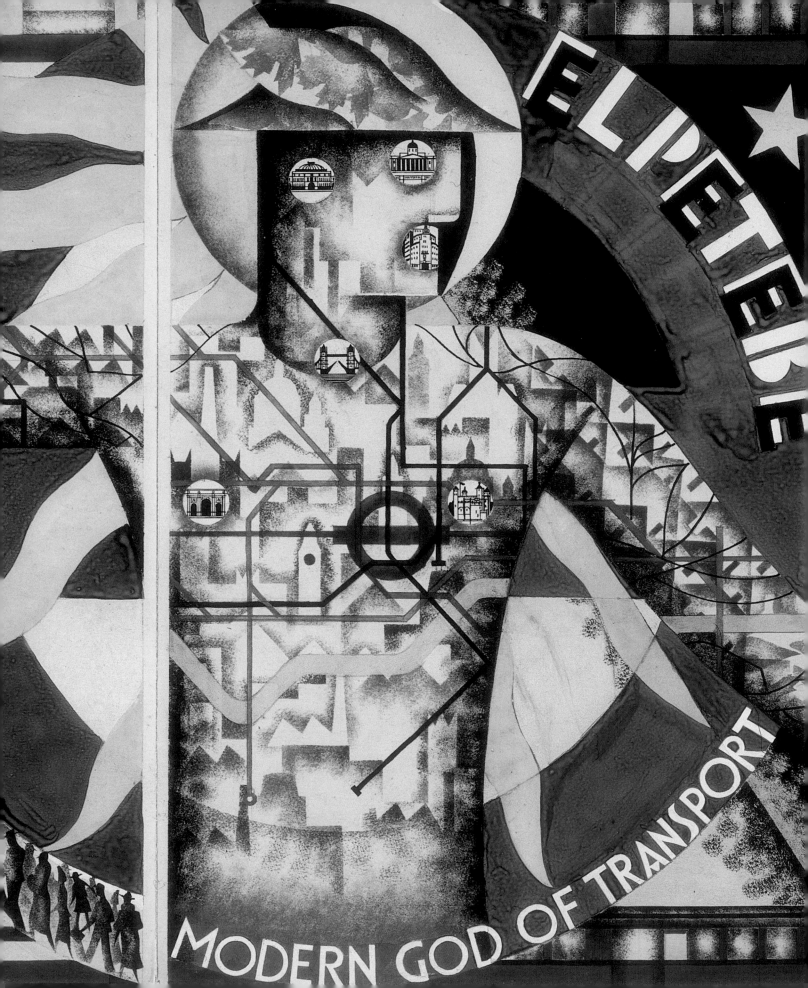

Art is not just a few pictures in museums and picture galleries … art is all the things made in our time.

<div align="right">ERIC GILL, 1932[1]</div>

APPEARANCE VALUES:
FRANK PICK AND THE ART OF LONDON TRANSPORT

Oliver Green

IN THE 1920S AND 1930S the London Underground and its successor London Transport came to epitomise all that was modern, progressive and civilised in twentieth-century urban society. It appeared to offer a model of integrated operation and practice, demonstrating how a complex business and public service organisation could be managed efficiently without becoming a soulless bureaucracy. Design and commerce were brought together through applied art and technology, enabling continuous business improvement and community benefit for all.

This was certainly Frank Pick's vision. Addressing the Royal Society of Arts in December 1935, eighteen months after becoming London Transport's first Chief Executive, Pick ended his talk with the dramatic claim that:

> … underneath all the commercial activities of the Board, underneath all its engineering and operation, there is the revelation and realisation of something which is in the nature of a work of art … it is, in fact, a conception of a metropolis as a centre of life, of civilisation, more intense, more eager, more vitalising than has ever so far obtained.[2]

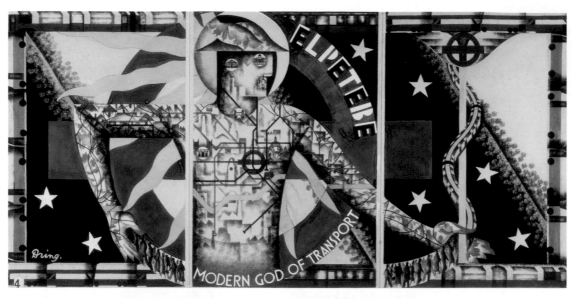

25 LPTB: Modern God of Transport
Lilian Dring, *c*.1938
(379mm x 762mm)
Unused poster artwork

This design for a triple poster featuring Mercury as a Modern God of Transport seems to encapsulate perfectly Pick's vision of London Transport as a work of art. Practical as ever, he told the artist he 'dared not' use her dramatic design because of the cost.

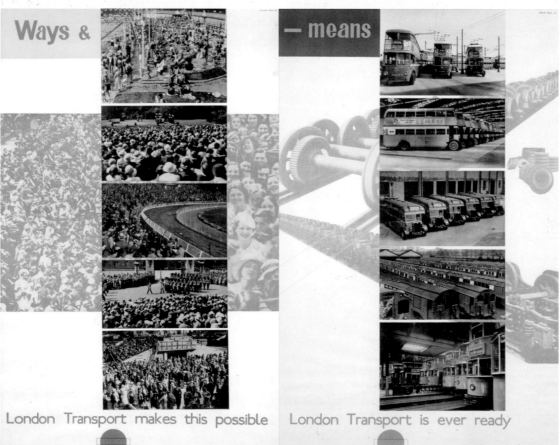

26 Ways and Means
Richard Beck, 1938

Pair poster – each double royal (1016mm x 635mm)
Published by London Transport
Printed by the Baynard Press

A modern Medici

It was a unique circumstance for a public transport organisation to have developed in this way, and without Pick's involvement it would certainly not have happened as it did. There is probably no comparable example anywhere of a single private or public body becoming as influential and taking on such an ambitious artistic role in shaping the appearance, development and environment of a world city.

When Pick left London Transport five years later in 1940 the picture had changed. Britain was at war and its capital city faced potential destruction under aerial attack from the Luftwaffe. Pick was in poor health and clearly depressed, no longer confident in himself or his abandoned project to transform urban society through its transport system. He and his home in Hampstead Garden Suburb had a lucky escape in one of the early bombing raids of the Blitz, which destroyed a neighbour's empty property and badly damaged his own. Pick died of a cerebral haemorrhage in the same house just over a year later in November 1941, at a time when the future still looked bleak for everything he had worked for and believed in.

In 1942, Nikolaus Pevsner wrote the first full appreciation of Pick's achievements in a special tribute article in the *Architectural Review*. Pevsner saw him as a 'modern Medici', an outstanding patron of the best

27 Modernism on the Underground

Power: The Nerve Centre of London's Underground
Edward McKnight Kauffer, 1931

Double royal
(1016mm x 635mm)
Published by UERL
Printed by Vincent Brooks, Day & Son Ltd

Speed Underground
Alan Rogers, 1930

Double royal
(1016mm x 635mm)
Published by UERL
Printed by Broadway Press Ltd

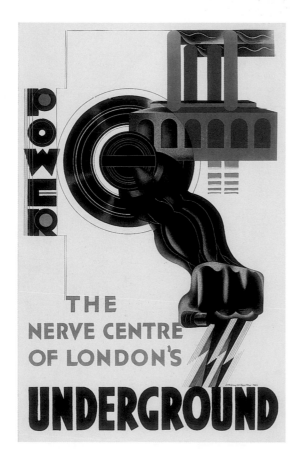

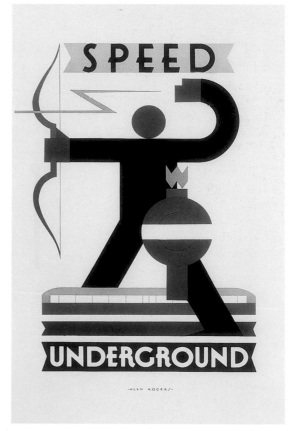

public art, architecture and design. Through the work and inspiration of this one man, he believed that London Transport had become a powerhouse of 'civilised urbanity and humane common sense ... the most efficacious centre of visual education in England'.[3]

Yet Pick had received no public honour or wide recognition in his lifetime. Ironically, the only state award he was given came from overseas, when he was awarded the Soviet Order of Merit in recognition of the consultancy advice provided by London Underground through him on the planning and construction of the Moscow Metro in the 1930s. Despite his influence and impact as a transport and design manager and commissioner, he had remained a comparatively unknown figure to the public at large. This was partly because of his self-effacing personality. Pick did not enjoy the limelight and was not comfortable in social situations, unlike his suave and politically astute Chairman, Lord Ashfield. He was by nature shy and austere, with few close friends or confidants. Even to those who had worked under or with him for years, Pick was something of an enigma, demanding and hard to please, admired but not necessarily liked.

Christian Barman, Pick's Publicity Officer at London Transport from 1935 to 1940, probably got to know him as well as any of his colleagues. Writing in the *Architectural Review* after Pick's death, Barman described him in glowing terms as 'a new type of business executive, cultured, sensitive and creative in the highest sense'. But even Barman admits in his frustratingly patchy biography of Pick, completed nearly forty years later, that 'I had never met a man about whom so many people had so many different views'.[4]

Drawn from life

In 1928, when Pick turned 50 and had just been appointed Managing Director of the Underground Group, *Commercial Art* magazine ran a profile of him in its 'Celebrities of Advertising' series. The feature includes a cartoon of Pick at his desk with a nicely caricatured Underground poster on the office wall behind him. This artist's impression of Pick is possibly unique. Although he commissioned hundreds of poster artworks, there is no known portrait of the man himself in life, and only a handful of photographs. When London Transport belatedly decided in the 1950s to commission a portrait of its former Chief Executive, the chosen artist had to work from one of these rather stiff official images, with predictably uninspired results.

There is a slightly jokey pen picture of Pick alongside the *Commercial Art* cartoon. The writer describes him as giving 'the impression of alert efficiency, and also of something more than efficiency. He is creative as well as competent, and he knows how to interest multitudes as well as see that they are conveyed in

28 Frank Pick (left) and Lord Ashfield, *c*.1923
This 'formidable pair', as Labour politician Herbert Morrison described them, created London Transport together. They were a brilliant combination, but had completely different personal style and character, as this photograph suggests.

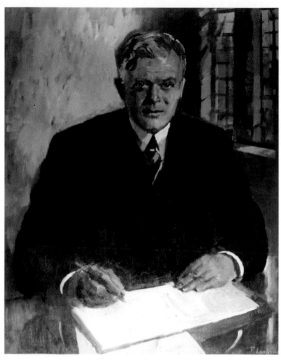

29 Frank Pick

The cartoon shows Pick at 50, as caricatured in *Commercial Art* magazine by 'Bil', 1928. The portrait in oils was painted in 1958 by Patrick Larking from an official photograph taken when Pick became Vice-Chairman in 1933.

vehicles without being killed. A succession of first-rate artists have found themselves in the posters he has commissioned, and the wait on the platform is turned from tedium to pleasure by the perpetual revelation it displays of weekend landscapes. It is a delight to go through the caverns measureless to man of which he is the overseer even so far as Morden'.[5]

A civilising agent

Pick was in his prime at this stage in his career, and his impact had already been far deeper and more interesting than his own rather buttoned-up appearance and character might suggest. An exhibition at Burlington House in November 1928 celebrated twenty years of Underground posters going back to what Pick called his 'first fumbling experiments' in using pictorial images as publicity soon after joining the company in 1906. His artistic vision had widened with his rapid promotion and broader responsibilities. At the same time the reputation of the Underground as a 'civilising agent' for the city had grown through Pick's work and influence.

One month later the new showpiece hub of the Tube system, the rebuilt Piccadilly Circus station,

was opened by the Mayor of Westminster. The circular entrance hall and subway below the famous road intersection and Eros statue was at the symbolic heart of London. It had an inviting underground 'ambulatory' around the booking office, with wall panels of travertine marble, and large brightly lit display windows. This was carefully designed to give the impression of an elegant shopping street at night. The showcases advertised the wares of Swan & Edgar and other well-known West End stores above. After buying a ticket, the passenger stepped onto an escalator lit by decorative bronze uplighters, to be whisked down to the platforms under murals showing Underground destinations and a giant illustrated map of the world centring on the capital of the British Empire. Experiencing this new artistic Underground environment soon became an attraction in itself, and was much admired by visitors to London. Among the latter were Soviet engineers sent to inspect the London Underground, who were particularly impressed by the new escalators at Piccadilly Circus. This led Krushchev, who was in charge of building the Moscow Metro, to persuade Stalin that they should use escalators instead of lifts at all their new stations.[6]

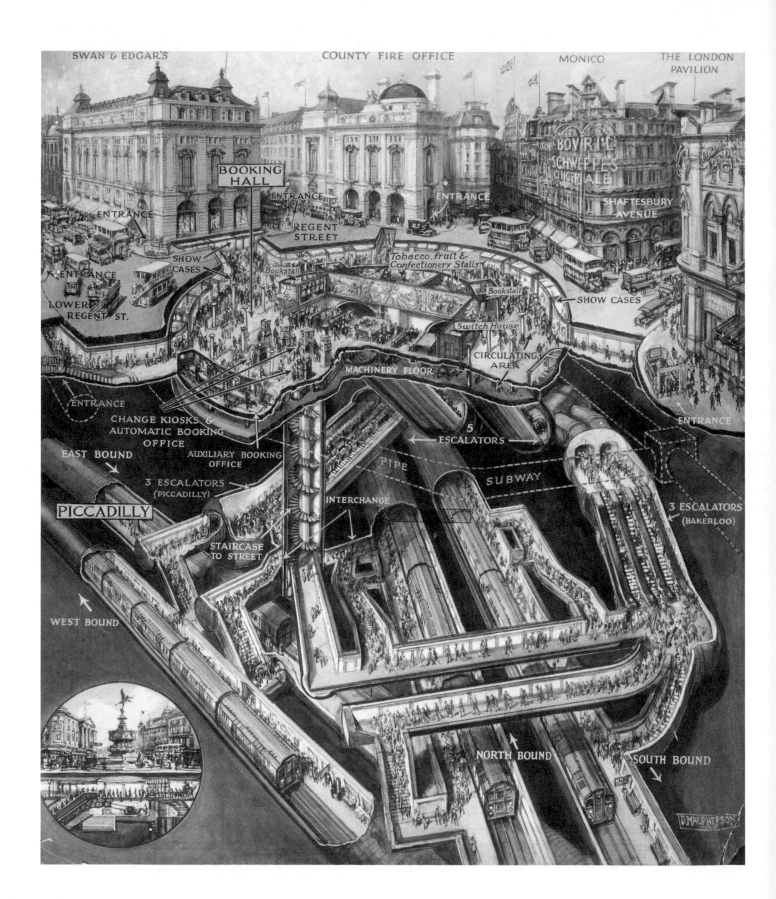

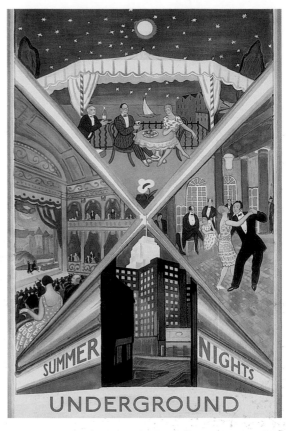

30 The rebuilt Piccadilly Circus station brought together art, design and engineering at the heart of London. This impressive cutaway illustration by D. Macpherson commissioned by the Underground in 1928 for the opening was reproduced in newspapers, books and magazines.

31 **London's Underground Always At Your Service**
Maurice Beck, 1932
Double royal (1016mm x 635mm)
Published by UERL
Printed by Waterlow & Sons Ltd

32 **Summer Nights**
Vladimir Polunin, 1930
Double royal (1016mm x 635mm)
Published by UERL
Printed by Waterlow & Sons Ltd

Two posters featuring the new Underground headquarters building by Charles Holden at 55 Broadway, over St James's Park station.

Within a few months of the opening of the remodelled Piccadilly Circus station, another innovative and award-winning piece of architecture and engineering, the new Underground headquarters building at 55 Broadway, was completed. At ten storeys, this was London's largest and tallest office block and the city's first American-style skyscraper. Its steel frame was clad in white Portland stone, with four wings rising in steps to a central tower from a difficult triangular site over St James's Park Underground station. The cruciform shape of the building allowed maximum daylight to reach the offices of each wing and the exterior was decorated with ten Modernist sculptures by artists including Henry Moore, Eric Gill and Jacob Epstein. Again, it represented a carefully planned fusion of modern functionality and artistic design. Unfortunately the project did not meet with universal approval, and Epstein's *Night* and *Day* figures were attacked by some critics as primitive and obscene. Pick did not much like them himself, but loyally supported his architect, Charles Holden, who had commissioned the controversial Epstein before. Pick's offer to resign over the matter, which in retrospect appears to have been a storm in a teacup, was not accepted by the Underground Board.[7]

Holden, who was the architect commissioned by Pick for Piccadilly as well as for 55 Broadway, was developing a distinctive house style for all the Underground's new buildings at this time. The two men shared a design philosophy and what Pick later described as a 'common aim of trying to find a proper solution to the problems of everyday life'.[8] This was a characteristically modest description of what one historian has described as a much larger vision, Pick's 'mission to democratise art and aestheticise civilisation'[9] or at least to achieve this in London.

The Danish town planner Steen Eiler Rasmussen, whose classic study *London: The Unique City* first appeared (in Danish) in 1934, recommends a visit to Piccadilly Circus as 'an excellent illustration of what the Underground has done for modern civilisation'.[10] London writer and journalist James Bone,[11] in his introduction to the English-language edition of

Rasmussen's influential book in 1937, pointed out that 'the underground railway system, for the first time in a London book, is appreciated (here) at its proper value as one of the modern Seven Wonders of the World'. Both of these writers knew Pick well and enthusiastically endorsed his major contribution to the city's planning and environment. Holden recalled after Pick's death that it had been an 'inspiration' to work with him on the development of the Underground's architecture and design. 'He was always ready to start out on some new adventure and the opportunities for adventure were many and various ... it was certainly never allowed to be dull.'[12]

There is no single and straightforward explanation of how all this came about, nor of how effective Pick's 'mission' was to transform London and give its citizens a visual education in applied art and design in the process. Pick's background, training and profession make the development of his career and life's work an extremely unusual and unlikely path.

Pick's background

The Pick family had no connection at all with the worlds of transport, art or advertising, and Frank was brought up a long way from London. He was born in 1878, the eldest of five children raised by Francis and Fanny Pick. His father ran a draper's shop in Spalding, Lincolnshire. The family moved to York in 1883, where young Frank won a scholarship to St Peter's School and was a regular attender at Congregational chapel. It was the Salem Chapel that had a much deeper influence on him than his schooling, and it was here in York that Pick began to develop his fastidious sense of moral conscience and social duty. On leaving school, he began work as an articled clerk to a local solicitor and studied for a law degree, but after qualifying and taking a first-class honours degree, he decided not to become a lawyer. Instead,

in 1902 Pick got a job with the North Eastern Railway (NER), whose headquarters were in York, working in the company's newly established traffic statistics office.

The North Eastern was not one of the larger railway companies, but it had a high reputation for efficiency and progressive management under the leadership of Sir George Gibb. In 1904, the NER opened one of the first British suburban electric networks around Newcastle and Tyneside. Pick in his trainee role with the company was at this time studying and appreciating the benefits of statistical analysis in planning, running and improving a railway. This was his early education in modern business methods, but at this stage it had no connection at all with art and design. He was soon working as personal assistant to Gibb, the NER General Manager, at the head office in York.

The move to London

At the end of 1905 Gibb was head-hunted to run the Underground Electric Railways of London. A few months later Pick was invited to join him at the UERL. Although it was Gibb who brought Pick from York to London, it was another dynamo of a General Manager appointed by the American directors of the Underground in 1907 who soon gave Pick the opportunity to progress and develop. This was Albert Stanley, the future Lord Ashfield, who arrived in London from New Jersey with a brief to sort out the UERL's desperate financial situation.

In just five years the UERL, having electrified the old steam District Railway since its creation in 1902 and opened three new electric Tubes – the Bakerloo, Piccadilly and Hampstead lines – at huge expense, was close to bankruptcy. Unlike the old guard of British railway managers, Stanley had an astute American appreciation of the value of marketing and

33 Frank Pick as Commercial Manager of the Underground Group, c.1912

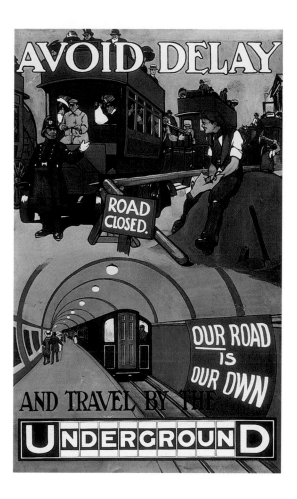

public relations in business. These were concepts still generally unknown and rarely taken seriously in the traditional world of railways. Pick was soon able to combine Gibb's meticulous use of statistics in forward planning with Stanley's broader ambition and opportunism to help turn the Underground's fortunes round.

In 1908 Stanley gave Pick responsibility for all the Underground's publicity. It was an important role, because early traffic results on the three new UERL Tubes which had opened in 1906–7 had been disappointingly low. The company needed more passengers to stay afloat. Having been outspokenly critical of early UERL publicity when he arrived, Pick was given the task of doing the job better. In 1908 he was put in charge of all traffic promotion and development. Stanley succeeded Gibb as UERL Managing Director in 1910. Two years later, when Stanley engineered a takeover of the London

General Omnibus Company (LGOC), the city's main bus company, Pick was made Commercial Manager of the much-enlarged UERL Combine. This led him to start developing and promoting the buses and Underground as integrated and co-ordinated services.

Pick's initial use of pictorial posters was driven entirely by the UERL's immediate business objectives. As Christian Barman comments in his biography:

> Pick had no intention of turning the Underground into a picture gallery; he was never willing to do that at any time. It was necessary that each poster should earn its keep in a commercial sense; its job was to make people want to get around, to travel to places that were easy to get to by Underground, by bus, by tram.[13]

Increasing revenue by encouraging traffic came first, and pictorial posters were a means to this end, rather than a simple exercise in artistic patronage.

Pick always maintained that an effective poster had to have meaning and purpose. 'In this it is unlike a great many modern pictures,' he wrote. 'The very essence of a poster is that it should mean something and as its purpose is that the meaning should be turned into action, it must mean that something most vividly and convincingly.'[14] From his first 'fumbling experiments' of 1908 onwards, Pick tried out new approaches to every aspect of poster publicity – subject, artist, production, display, target market and variety – until he 'arrived at some notion of what poster advertising ought to be. Everyone seemed to be quite pleased with what I did, and I got a reputation that really sprang out of nothing'.[15]

Needless to say, it was not as simple as that, and a comparison between the Underground's early publicity and the posters produced by other railways and commercial advertisers shows how Pick's inspired approach stood out from the field. Many of the mainline railway companies had been using pictorial posters for some years, including his old employers the North Eastern, but the quality was variable and their impact was difficult to measure (a particular frustration for a keen statistician like Pick). Railway posters were often a jumble of images and a mass of unclear text, difficult to read at a distance and full of mixed messages. Even those that promoted the delights of a visit to a seaside resort, the most common single subject, showed little creativity, distinction or development. Early examples from the 1900s often showed a view of the bay or seafront, but even by the 1930s most had not progressed beyond the basic 'bathing beauty' style, as Pick later described them.

Pick soon took the Underground poster beyond

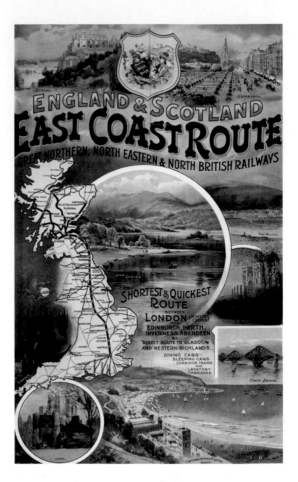

35 England and Scotland, East Coast Route
Artist unknown, c.1900

Double royal
(1016mm x 635mm)
Published by Great Northern Railway, North Eastern Railway and North British Railway
Printed by McCorquodale & Company Ltd

A typical early pictorial poster produced by a printer on behalf of three mainline railway companies including the North Eastern, where Pick began his transport career. Instead of a clear message, the design offers a confusing mix of information through different typefaces and cameo illustrations – a visual and marketing disaster.

this pedestrian approach as he began to realise that this was potentially a much more powerful and sophisticated medium of visual communication. Unlike most commercial advertisers, he was not selling a single product, nor did he have any direct competitors in the market once the UERL had merged with the LGOC. He could raise income from selling poster *space* on his vehicles and stations to commercial advertisers, but the Underground could also use posters more effectively itself.

Posters with a purpose

Pick believed that any successful poster had first to attract and hold attention. Beyond that, good posters should concisely convey useful information which would influence or inform the viewer with a particular purpose in mind. For the Underground 'it may be supposed that their purpose is immediately directed to securing passengers', he wrote after nearly twenty years of commissioning. 'In some instances this has

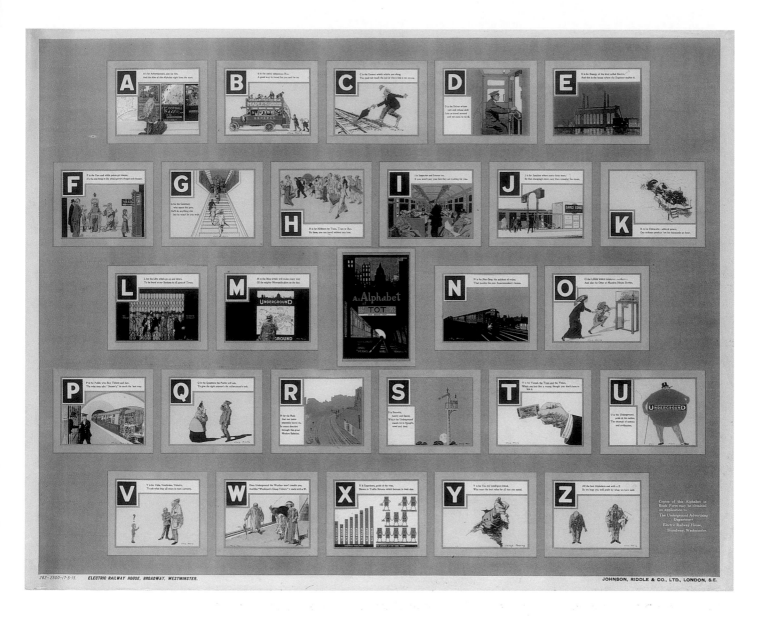

36 ABC alphabet of TOT
Charles Pears, 1915

Quad royal
(1016mm x 1270mm)
Published by UERL
Printed by Johnson,
Riddle & Company Ltd

been the case but in as many instances the purpose has been the establishment of goodwill and good understanding between the passengers and the companies. A transport service is continually open to criticism and much of the criticism arises from lack of knowledge. Every passenger is a potential critic; many passengers are dynamic ones. So there has been an attempt to place before the public all the pertinent facts underlying the services of the Underground in an attractive and readily comprehendable form. Even when the purpose has been to secure passengers it has been the practice to proceed by indirect means. To create a feeling of restlessness, a distaste for the immediate surroundings, to revive that desire

for change which all inherit from their barbarian ancestors'[16] A poster, in other words, is as much about suggestion as about plain facts.

The 'lack of knowledge' that Pick refers to here was more heartfelt than a sense that there was a basic shortage of information about transport services. Coming from a small-scale and cohesive community himself, Pick was very conscious of how alienating and overwhelming a vast city like London could be. It was difficult to take in and comprehend, as he recalled from his first trip to the capital from York as a schoolboy. But he was also excited by London's rich variety and learning opportunities. Self-improvement through study and education, as well

as the practical application of art, were all important to Pick.

His Underground poster programme came to represent something much bigger than the company balance sheet. As Michael Robbins has expressed it, 'he wanted his actions in business life to be coherent and consistent with his ideas about human life, and he was constantly thinking of the possibilities of harnessing commercial methods to the achievement of large social objectives'.[17] The posters developed from being straightforward publicity to helping Londoners and visitors understand and enjoy life in the great metropolis. It meant public transport was not just a way of getting about in the city but could become, both conceptually and physically, what Pick called 'the framework upon which the town is built',[18] a key element in civic progress.

Ordered display

There was no model or example for Pick to follow in this process and he learned as he went along. Some of the new ideas in marketing and display in his early years at the Underground are often wrongly attributed to him personally, but he clearly had a major role in many of the innovations, which followed in quick succession. The use of the new 'UNDERGROUND' lettering outside stations, in posters and on pocket maps introduced the first brand identity across the different lines in 1908.

The earliest version of what eventually became the Underground's iconic symbol appeared in the same year. It was used initially as a station platform nameplate with white lettering on a blue bar across a solid red disc. This was part of plans to separate out information signage clearly, commercial advertising and the Underground's own publicity posters with a rational grid display system. It was a radical change which gave Pick's stations a far more ordered and

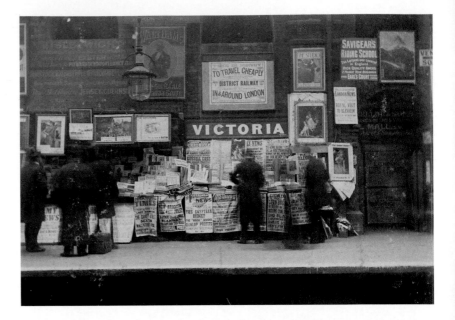

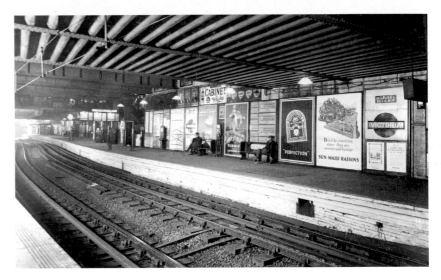

organised appearance than the old steam underground, which had the same air of cluttered chaos as most surface railway stations.

The bar and solid disc station names soon developed into the familiar bar and circle symbol now called 'the roundel' but originally often referred to as 'the bull's-eye'. There is still dispute about the origin of the design, but it was clearly inspired by the distinctive simplicity of some other existing graphic devices like the YMCA bar and triangle and the Plimsoll line on ships. Pick did not design or even commission it, but oversaw the development of the idea because he recognised the need for it.

37 Victoria District Railway station before and after rationalisation of information signage and advertising space. The earlier photograph (top) shows the chaotic look of the District and Circle platform in 1896 before electrification and Pick's arrival. The later view taken in 1924 shows the platform about 15 years after Pick's improvements.

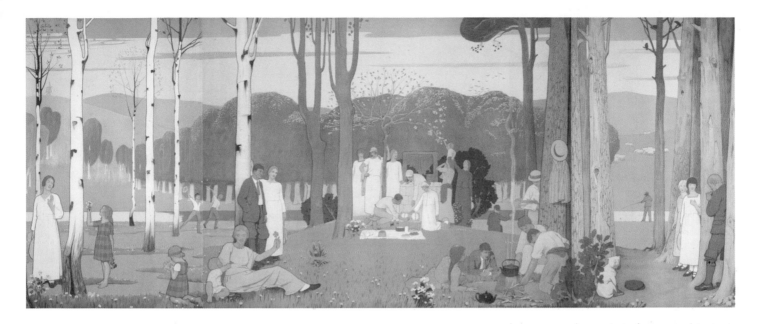

Art and design

As well as improving display presentation, Pick turned his attention to the quality of design and production of the posters he commissioned. He familiarised himself with lithographic printing methods and, in his search for new and improved poster design, came into contact with the artists, teachers and craftsmen associated with the design reform movement (described in chapter 4). Although he had not studied art or design history in any detail, and approached it from the perspective of a business manager wanting to make the best use of applied art, Pick's emerging design philosophy was not far removed from the more progressive elements of the Arts and Crafts Movement.

Some of the conflicts and frustrations that Pick experienced in his career came out of the built-in contradictions that emerged from this movement in the early twentieth century. They were characterised by difficulties in resolving some apparently irreconcilable and antagonistic tendencies in reform. Pick, like many others, often found himself drawn in two directions towards philosophical opposites. Social progress and romantic tradition, radicalism and conservatism, socialism and capitalism, efficient large-scale industrial production and individual craft skills, the creative metropolis and the manageable civic community. Practical and decisive though he was,

Pick never resolved these opposite attractions to his own satisfaction.

Medieval modernism

Pick was attracted to the idea that moral and civic harmony could be achieved through integrating art and design with everyday life. Similar thoughts had been expressed by Victorian reformers like John Ruskin and William Morris, but Pick was concerned to give these values practical application in society through a large, modern organisation. Like many others of his generation who brought Arts and Crafts beliefs beyond Morris into the twentieth century, Pick was both a traditionalist and a progressive. This ambivalent thinking about the past and present has been given the rather appropriate name of 'medieval modernism'.[19]

The organisation that came to represent an influential range of these views was the Design and Industries Association (DIA), set up in 1915 to promote the integration of art with industry, commerce and education. Pick was an early and active member, meeting through it many who shared his ideas and in some cases became involved in art and design projects with the Underground. The DIA became his spiritual home. Of all the like-minded medieval modernists that came under the DIA umbrella, Pick had by far the greatest influence on art and design in industry because of his position at the Underground.

DESIGN IN BRITISH GOODS

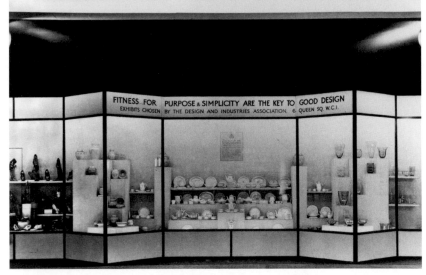

39 Photographs and a poster for three exhibitions in Charing Cross booking hall during the 1930s: 'Design in British Goods', (organised by the DIA in 1932), 'The Highway Code', (display designed by Hans Schleger for the Ministry of Transport in 1937), and **Cable and Wireless** (double royal poster by Percy Ford, 1936).

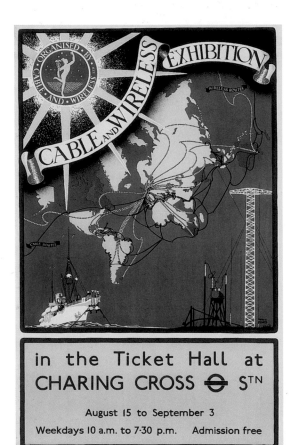

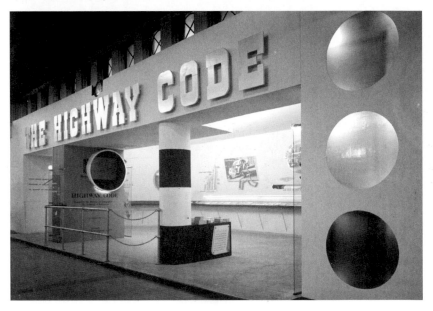

DIA members closely associated with Pick included architect Charles Holden, designers Gregory Brown, Harold Stabler, Ernest Jackson and Claud Lovat Fraser, and art school heads W.R. Lethaby (London Central) (see chapter 4), Fred V. Burridge (Lethaby's successor), W.B. Dalton (Camberwell) and B.J. Fletcher (Leicester and Birmingham). There were also leading retailers and manufacturers like Ambrose Heal (of Heal's furniture), H. Gordon Selfridge (of Selfridges), C.H. St John Hornby (of WH Smith) and Harry Peach (of Dryad cane furniture).

Pick later served as DIA Chairman in the 1920s, and wrote and lectured on the association's behalf. When he became the DIA's President in 1932 he was still deeply committed to its ideals. 'Fitness for purpose must transcend the merely practical and serve a moral and spiritual order as well,' he wrote. 'There is moral and spiritual fitness to be satisfied. We know it sure enough when we see it.'[20]

When the Government finally set up a national Council for Art and Industry in 1934 (forerunner of the Design Council), Pick was an obvious choice as

Chairman. It was yet more work on top of his new Chief Executive role at London Transport, but to Pick it was a natural extension of his interests and deeply held convictions. He also saw it as part of LT's wider civic responsibility to encourage and facilitate social improvement. Display space was made available in the large booking hall at Charing Cross station (now Embankment) for a series of free public exhibitions on worthy topics from 'Design in Household Goods' to plans for a London Green Belt and the new Highway Code. Many of these displays, sponsored by public and private bodies from the London County Council to the Cable & Wireless Company, gave new opportunities for designers who were also working on associated LT poster commissions.

The writing on the wall

'Art must come down from her pedestal and work for a living,' Pick had announced in an early DIA address in 1916.[21] Even at this stage, Pick was already applying the DIA's creed of 'fitness for purpose' to his own work. He was commissioning practical art and design on behalf of the Underground more purposefully than ever during the initial months of the First World War. A major step forward was to persuade Edward Johnston, a brilliant calligrapher with a conservative craftsman's dislike for modern industrial production, to design a distinctive new letterface for the Underground's station signage and publicity.

Pick wanted a design with, as he put it, 'the bold simplicity of the authentic lettering of the finest periods' and yet 'belonging unmistakably to the twentieth century'.[22] Johnston had made a detailed study of early letter forms and met Pick's requirements by turning to classical Roman capitals for his inspiration and proportions. Once these had been established, the Underground face, he claimed,

'designed itself', though getting to this stage took him nearly three years. The drawings he finally presented to Pick in 1916 were based on squares and circles, Johnston's 'O' being a perfect circle and his capital 'M' a square with the diagonal strokes meeting precisely in the centre of the letter.

The Johnston typeface was a copyright design for the exclusive use of the Underground Group, one of the earliest expressions of corporate identity in this country. Its major progeny in Britain was Gill Sans, designed by artist-craftsman Eric Gill for the Monotype Corporation in 1928. Gill Sans was adopted by the London & North Eastern Railway for all its signage, and the lettering soon became a standard typeface throughout the printing industry.

Gill had been a pupil of Johnston, and freely acknowledged that his own typeface was in fact a close variant on Johnston's classic Underground design. Gill's only direct involvement with the Underground was his commission to produce two of the 'wind' sculptures for the exterior of Pick's new headquarters building at 55 Broadway. Gill later gave Pick the maquette for his *North Wind*, which Pick had built into the garage wall at his Hampstead Garden Suburb home.

Johnston Sans was being used for all the Underground Group's signage by the early 1920s. Johnston undertook variations on his family of typefaces, including its integration into the standard bar and circle, agonising over every change and development. His lettering was soon also being applied to most Underground posters, but Pick never insisted on this for every design. He never dictated in his commissions and would give artists considerable flexibility within a brief.

At around the same time that Johnston was working on his Underground letterface, Pick discovered the artist who was to become one of the

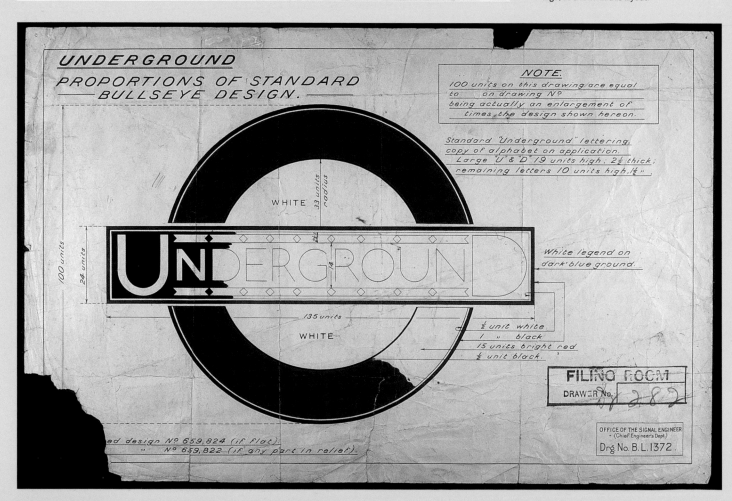

40 Edward Johnston, creator of the Underground's classic sans-serif display letterface. His original hand-drawn alphabet, shown here with his notes, was submitted to Pick in 1916. In the 1920s Johnston adapted his lettering to work with a redesigned bar and circle logo, as shown in this layout.

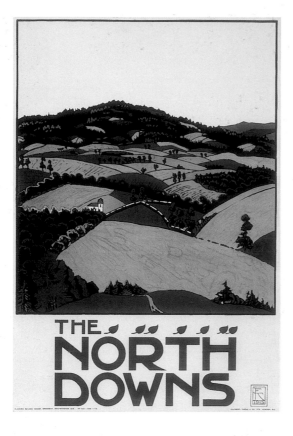

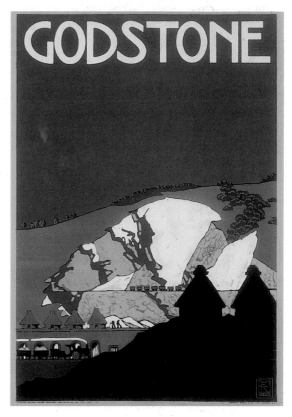

41 Photograph of a bus staff canteen decorated with two of Kauffer's original poster series c.1917. The location is probably the LGOC training centre in Milman Street, Chelsea, where over 1700 women had been recruited as wartime 'conductorettes' by the end of 1916.

North Downs
Edward McKnight Kauffer, 1915

Double crown (508mm x 762mm)
Published by UERL
Printed by Johnson, Riddle & Company Ltd

Godstone
Edward McKnight Kauffer, 1916

Double crown (508mm x 762mm)
Published by UERL
Printed by Johnson, Riddle & Company Ltd

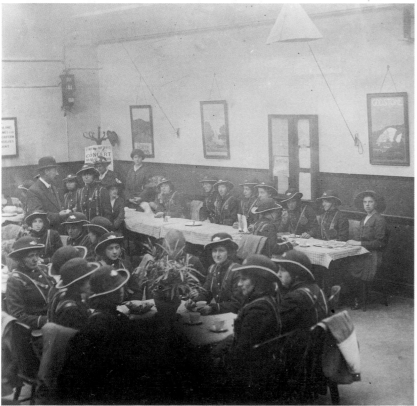

greatest poster designers of the interwar period. Edward McKnight Kauffer came to London from Paris when the First World War broke out and apparently approached Pick for work on the recommendation of John Hassall. He produced his first set of posters for Pick in 1915–16, some of which brightened the wartime canteens of bus and Underground staff as well as station platforms (see plate 41). Even in the early 1920s, when Kauffer had moved on to more avant-garde experiments in graphic design, his original Underground productions were still being used by Pick's DIA colleague Ambrose Heal as room set decoration in his fashionable furniture catalogues (see chapter 10).

Pick had already developed spin-offs from his Underground poster publicity before and during the early months of the First World War. This included astute niche marketing to children, or more accurately to parents through their children. An illustrated Underground alphabet by Charles Pears was designed as a large-format poster but could also be bought as a booklet. This was sold in

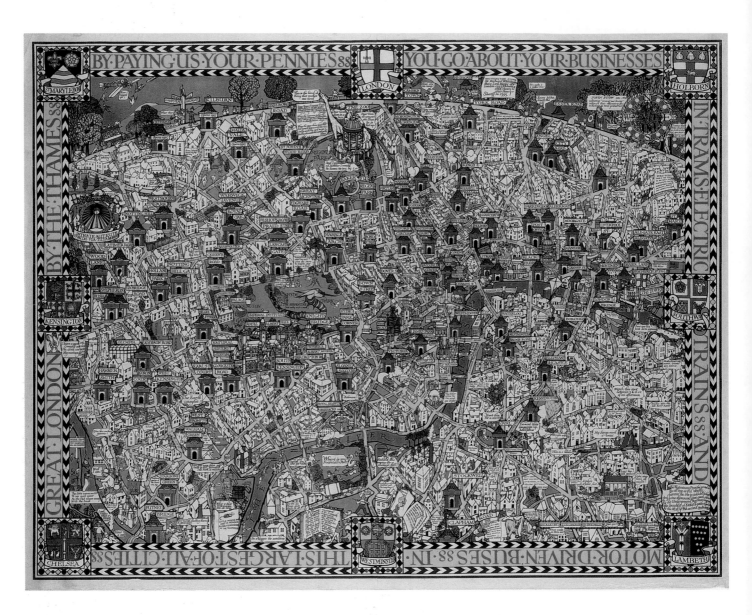

aid of the benevolent fund T.O.T. (Train, Omnibus, Tram), set up to support the families of UERL staff killed or injured in the conflict (see plate 36).

Illustrated poster maps by Macdonald Gill, older brother of Eric, appeared on station platforms more for decoration than information, and these too were available to buy for home and school decoration. Pick's posters migrated beyond their Underground environment in various planned or fortuitous ways from an early stage in his growing publicity programme.

The Golden Age

Pick and Ashfield both spent time away from Underground management working on Government business during the latter part of the First World War. Even after the Armistice had taken place in November 1918, it was many months before post-war development plans for the UERL could be implemented. Virtually no publicity posters were issued throughout the whole of 1919, but from 1920 Pick's programme was restarted, with a close convergence

42 By Paying Us Your Pennies
Macdonald Gill, 1913

Quad royal
(1016mm x 1270mm)
Published by UERL
Printed by the
Westminster Press

The first of Gill's popular illustrated map posters. They were available for purchase and were probably more effective as branded home and school decoration than as travel information aids on stations.

43 Three posters from 1920 when Pick relaunched the UERL's publicity programme. Herrick's poster incorporates a number of well-known advertising characters such as the Bisto Kids, Bibendum the Michelin Man, Johnny Walker, Nipper the HMV dog and the Kodak girl. The strongest brand of all is the Underground, which can sell promotional space to all of them

International Advertising Exhibition, Frederick Charles Herrick, 1920

Quad royal
(1016mm x 1270mm)
Published by UERL
Printed by the Baynard Press

Then – 1558:
Commerce and Barter

Now – 1920: Commerce and shopping now
Cyril A Wilkinson, 1920

Each double royal
(1016mm x 635mm)
Published by UERL
Printed by Vincent Brooks,
Day & Son Ltd

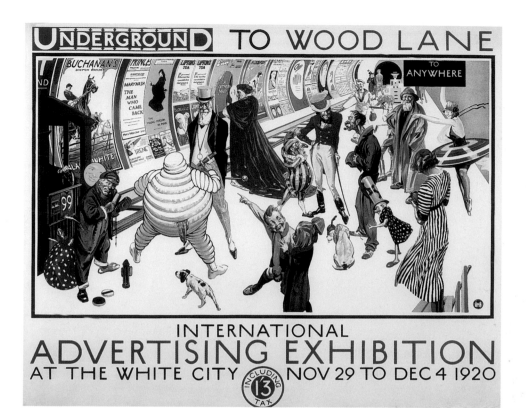

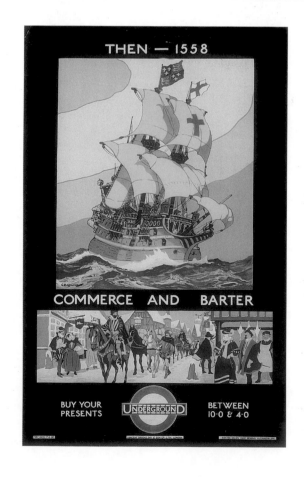

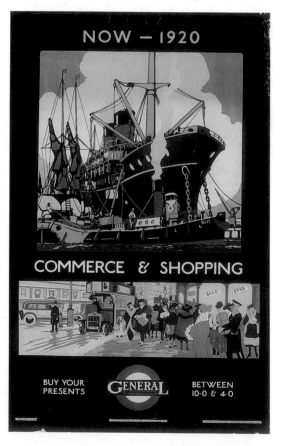

44 A rare example of a poster commission that reflected Pick's own artistic taste. In 1936 he bought an oil painting by McIntosh Patrick of a winter landscape in Perthshire. About a year later the artist was invited to design a country walks poster for London Transport. He chose to paint this rural scene at Harrow Weald, which was split to make two posters.

Longer Days are Here Again

Happy Scenes of Cheer Again
James McIntosh Patrick, 1938

Each double royal (1016mm x 635mm)
Published by London Transport
Printed by Waterlow & Sons Ltd

between the Underground and commercial advertising. There was no sense of competition between them as it was clear that encouraging renewed consumer spending in the shops would benefit the economy all round – transport providers, retailers and manufacturers alike.

The Underground entered its golden age of poster production in the 1920s, both in terms of quality and quantity. Pick was soon commissioning fifty or more pictorial posters a year and experimenting with a growing range of designers and subjects. 'Good posters are a gamble,' he wrote; 'a lot to choose from is an important consideration, but it is expensive. The Underground probably buy almost twice as many designs as they use. There is no way of avoiding this.'[23]

Pick was discerning in his selection, but prepared to consider anything that worked, whether he actually liked it or not. Although his personal taste tended towards the simple, undecorated styles in art, architecture and design, he recognised that with posters variety was an important factor in conveying the message. 'There is room in posters for all styles,' he argued in the same 1927 talk; 'they are the most eclectic form of art. It is possible to move from literal representation to the wildest impressionism so long as the subject remains understandable to the man in the street.'

Hence the astonishing range of the Underground's poster output in Pick's time, which has never been matched by any other company or organisation. Where Pick and the Underground led by example, others followed with similar, but generally less ambitious promotional campaigns.[24] During the 1920s, Pick's initiative and the Underground's growing reputation for delivering the best in advertising and publicity encouraged others to make better and more creative use of posters, though rarely on the

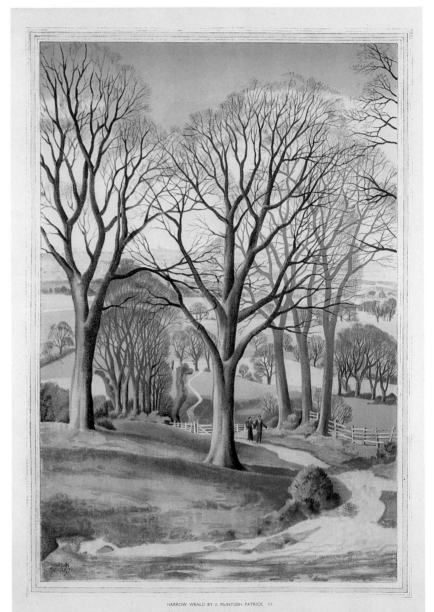

HARROW WEALD BY J. McINTOSH PATRICK (1)

LONGER DAYS ARE HERE AGAIN

COUNTRY WALKS–SERIES 1, 2 & 3 ★ 3ᴰ EACH AT BOOKSTALLS

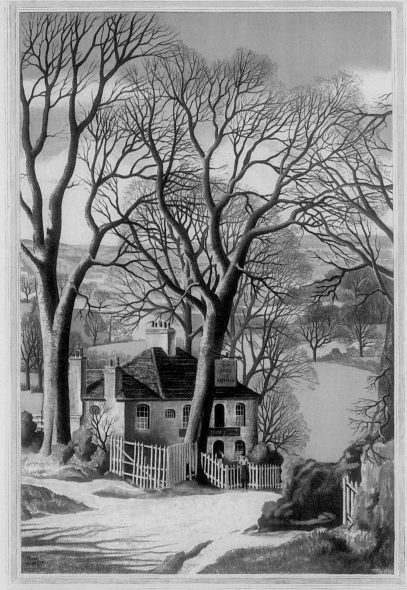

HARROW WEALD BY J. McINTOSH PATRICK (R)

HAPPY SCENES
OF CHEER AGAIN

GREEN LINE COACH GUIDE ★ TWOPENCE AT BOOKSTALLS

same scale. Of the 'Big Four' mainline companies, only the London & North Eastern Railway's poster art commissioned by William Teasdale after 1923 approached the quality of the Underground's, but the LNER's range remained quite limited. Jack Beddington, Shell's Publicity Manager from 1929, brought a distinctive approach to the oil company's advertising by commissioning quality artworks from many of the artists already used by the Underground. The Shell commissions were generally used as large mobile bills mounted on the sides of the company's delivery lorries rather than being mounted on static poster sites.

When the Government set up the Empire Marketing Board in 1926 to promote trade in British Empire goods and products, Pick was asked to advise on its poster programme. Despite his growing responsibilities at the Underground, Pick took this on energetically outside his normal office hours, chairing the committee and quickly developing a major campaign of poster publicity. Giant posters for Empire goods appeared on specially designed roadside poster sites, again mainly using Pick's growing roster of new and established Underground artists to provide the visual designs. Unlike most of the Underground's publicity, the EMB posters now appear to be the most blatant propaganda for British imperialism, but at the time a belief in the value and benefits of Empire was almost unquestioned.[25]

During the 1920s, Pick rose from Joint Assistant MD to become Managing Director of the Underground in 1928, with Ashfield continuing as UERL Chairman. Pick's administrative ability and attention to both the broad scope and the detail, allied to Ashfield's more intuitive political approach to affairs, was a powerful combination. The creation of London Transport in 1933 as a single public authority to run all the capital's

**45 From Euston to
Clapham Common, the
Transformation is Complete**
Richard T. Cooper, 1924

Double royal
(1016mm x 635mm)
Published by UERL
Printed by Johnson,
Riddle & Company Ltd

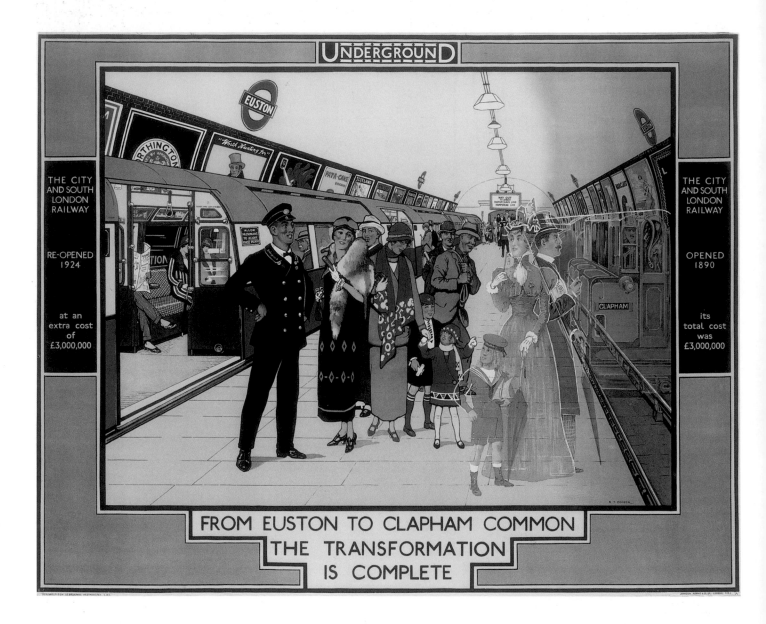

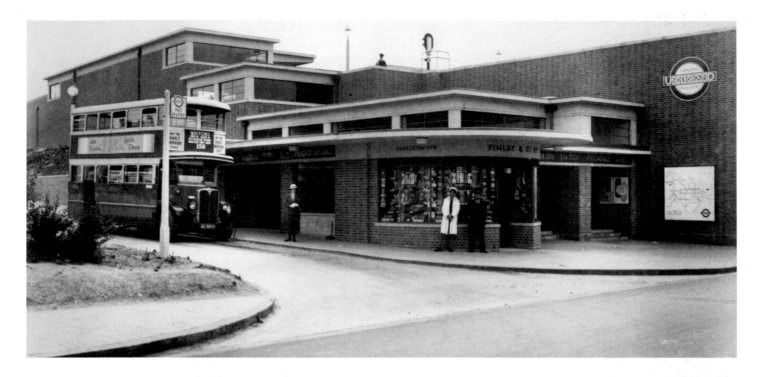

46 Pick's legacy
The photograph shows South Harrow station in 1935, an environment entirely reshaped by London Transport's architects, engineers and designers. This includes Holden's new station buildings, Johnston's lettering and 'roundel' symbol, Beck's new diagrammatic map and the latest Kauffer posters

The Seen,
James Fitton, 1948

Each double royal
(1016mm x 635mm)
Published by LT
Printed by The Baynard Press
James Fitton, 1948
Pair poster – each double royal
(1016mm x 635mm)
Published by London Transport
Printed by the Baynard Press

This poster appeared ten years after Pick's address on the importance of London Transport's 'appearance values' and eight years after he had left the organisation, but underlines how strongly that design culture had become embedded.

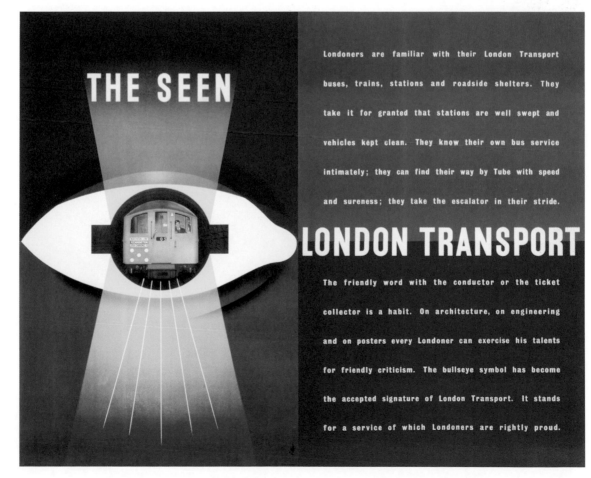

THE SEEN

LONDON TRANSPORT

Londoners are familiar with their London Transport buses, trains, stations and roadside shelters. They take it for granted that stations are well swept and vehicles kept clean. They know their own bus service intimately; they can find their way by Tube with speed and sureness; they take the escalator in their stride.

The friendly word with the conductor or the ticket collector is a habit. On architecture, on engineering and on posters every Londoner can exercise his talents for friendly criticism. The bullseye symbol has become the accepted signature of London Transport. It stands for a service of which Londoners are rightly proud.

bus, tram and underground railway services was only secured through their joint efforts.

With each successive Underground extension or infrastructure modernisation scheme in the 1920s and 1930s, Pick was concerned to plan, learn and ensure better-quality design in the final results. High standards and continuous improvement were almost an obsession, though he worried that 'progress is always towards greater cost, never towards cheaper production'.[26]

The poster programme might be considered a rather trivial and insignificant part of London's transport operations. The planning, cost and work involved was a fraction of that dedicated by the Underground and London Transport to structural engineering, station architecture or improved vehicle and rolling-stock design. But to Pick, the art of the poster was a critical part of what he referred to as London Transport's 'appearance values'. First impressions, as the saying goes, are lasting impressions, and he still believed after thirty years' commissioning that the posters had a powerful significance as visual communicators. Along with LT's distinctive symbol, lettering and map, the posters, in their prime positions on station walls and bus shelters, conveyed the essence of London Transport's role and purpose to both Londoners and visitors to the city.

Addressing the third annual conference of LT senior staff in 1938, Pick explained what he meant about the importance of keeping up appearance values, but also confessed to moments of 'weariness and disappointment' when improvements seemed elusive: 'Perfection always escapes and always will.' He asked grumpily 'whether modernism has spoilt our taste and whether for the mere sake of upsetting convention we profess to appraise as art mere engineering or even mere accident?'

Was their task worthwhile? Pick believed it to be about something more than appearance and the superficial. 'Behind the seen there is the unseen … an affirmation that life is worthwhile, muddled and anxious as it is. The Board's undertaking is a declaration of faith that its task is worthwhile, that its labours shall eventually contribute their appointed share to the transformation of our urban civilisation into some fine flower of accomplishment.'[27]

Frank Pick's sentiments no doubt came across to some as high-minded and overblown, but his achievement was considerable and impressive. He had fostered over nearly four decades an extremely powerful culture of rigorous design standards and public service that has probably never been equalled. That culture remained deeply embedded in London Transport for many years after his departure from the organisation in 1940, and through the difficult period of post-war austerity. Even today, more than sixty years after his death, the spirit of Pick is still celebrated and sustained in the challenge of moving London.

Notes

1. Eric Gill, *The Architect*, 24 June 1932, p.466.
2. Frank Pick, 'The organisation of transport', *Journal of the Royal Society of Arts*, vol.LXXXIV, 3 January 1936, pp 207–21.
3. *Architectural Review*, vol.XCII, 1942, reprinted in N. Pevsner, *Studies in Art, Architecture and Design, Vol.2: Victorian and After*, Thames & Hudson, London, 1968, pp 190–209.
4. C. Barman, *The Man Who Built London Transport: A Biography of Frank Pick*, David & Charles, Newton Abbot, 1979.
5. *Commercial Art* IV, 1928, pp 168–70.
6. See Krushchev's recollections in *Krushchev Remembers*, Little, Brown & Company, Boston, 1971.
7. The whole episode is well described by Richard Cork in his essay 'Overhead sculpture for the underground railway' in *British Sculpture in the Twentieth Century*, exh.cat., Whitechapel Art Gallery, 1981, pp 90–101. For a contemporary view of 55 Broadway, see Walter Bayes, 'Sense and sensibility: the new head offices of the Underground Railways', *Architectural Review*, November 1929, pp 225–41.
8. Pick quoted in the *Journal of the Royal Institute of British Architects*, 25 April 1936. For details of Pick and Holden's architectural partnership, see Eitan Karol, *Charles Holden*, Shaun Tyas, Donington, 2007, pp 259–383 and David Lawrence, *Charles Holden's Underground Architecture*, Capital Transport, Harrow Weald, 2008.
9. M.T. Saler, *The Avant-Garde in Interwar England: Medieval Modernism and the London Underground*, Oxford University Press, Oxford and London, 1999.
10. S.E. Rasmussen, *London: The Unique City*, Jonathan Cape, London, 1937.
11. An article in the *Manchester Guardian*, 17 August 1928 quoted by Saler calls Pick the 'Khalif of London' whose 'attractive, idiosyncratic and very forceful personality is little known to the public except by results'. This piece was anonymous, but was no doubt written by Bone.
12. Charles Holden, *Architects' Journal* 96, 26 March 1942.
13. Barman, *The Man Who Built London Transport*.
14. Frank Pick, 'The meaning of posters', notes for a talk at the YMCA, 11 December 1922. Like all his notes in the Pick Archive at the London Transport Museum (LTM), these are neatly written with a fountain pen in green ink.
15. Pick, unreferenced quote in Barman, *The Man Who Built London Transport*, p.36.
16. Frank Pick, 'Underground posters', handwritten notes for a lecture, 1927, Pick Archive, LTM.
17. M. Robbins, entry on Pick in *Oxford Dictionary of National Biography*, Oxford University Press, Oxford, 2004.
18. Pick, unreferenced lecture comment quoted in Barman, *The Man Who Built London Transport*, p.73.
19. The term was coined by Michael T. Saler. See Saler, *The Avant-Garde in Interwar England: Medieval Modernism and the London Underground*.
20. Frank Pick, 'The meaning and purpose of design', lecture notes, c.1932, Pick Archive, LTM. For Pick's wider involvement in promoting 'visual education', see I. Grosvenor, 'The art of seeing: promoting design in education in 1930s England', *Paedagogica Historica*, vol.41, no.4, 2005.
21. Frank Pick, *Art and Commerce*, February 1916, p.16, Pick Archive, LTM. Pevsner provides a useful summary of the aims and achievements of the DIA in a 1964 essay reprinted in *Studies in Art, Architecture & Design, Vol.2: Victorian and After*.
22. Pick quoted in Barman, *The Man Who Built London Transport*, p.43.
23. Pick, 'Underground posters'.
24. For mainline railway posters by the LNER and others, see B. Cole and R. Durack, *Railway Posters 1923–1947*, Laurence King, London, 1992. On Shell posters see R. Artmonsky, *Jack Beddington, The Footnote Man*, Artmonsky Arts, London, 2006.
25. For a perceptive assessment of the EMB's brief period of existence, see S. Constantine, *Buy and Build: The Advertising Posters of the Empire Marketing Board*, HMSO, London, 1986.
26. Pick quoted by Lord Ashfield in his Chairman's address to the London Transport 3rd Annual Conference of Members and Officers, LPTB, 1938, LTM Library.
27. F. Pick, 'Appearance values', London Transport 3rd Annual Staff Conference, 1938, LTM Library.

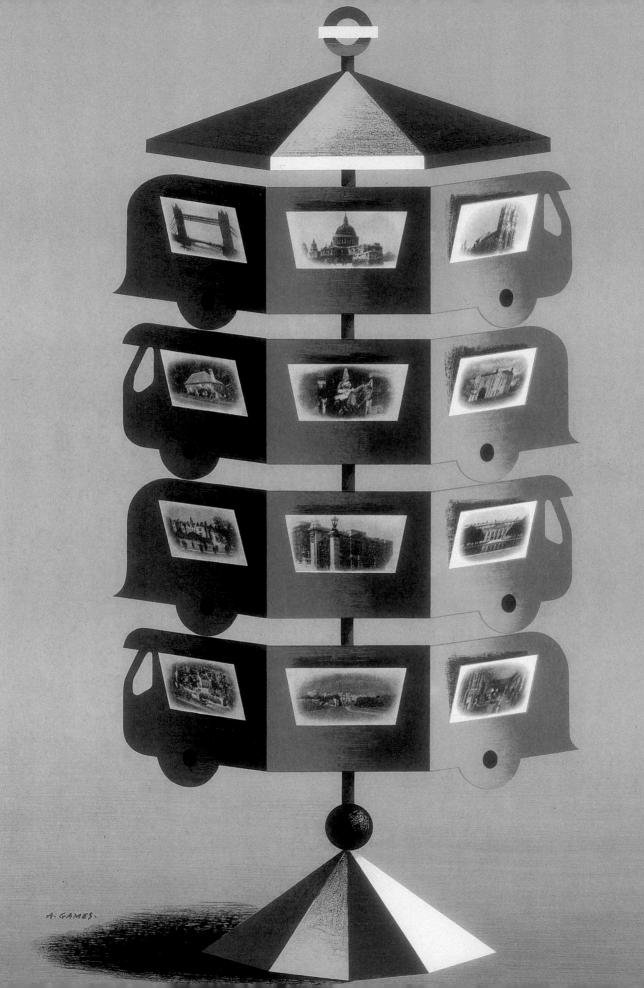

A. GAMES.

ARTIST AND PRINTER:
POSTER PRODUCTION 1900-70

Alan Powers

IN THE CRITICAL and historical literature of the poster, the question of technical production is invariably subsidiary to issues of social content and artistic form. This is understandable, since the technicalities of printing are relatively complex, even for the artist, let alone for the general reader.

Printing techniques change over time, and although what is described here could still be recreated in a studio environment, it ceased to be the mainstream of the printing trade at least 50 years ago. On the other hand, the ethos of the earlier twentieth century was that the artist should either be a craftsman or see the production of his work from a craft viewpoint, so that successful adaptation to the demands of printing could make the difference between a successful poster and a failure.

Printing processes

There are four fundamental alternative processes in the history of printing: intaglio; relief; surface; and screen. The first two occurred historically about the same time in the western world. Intaglio is a term that covers images produced on metal surfaces, such as etching, engraving and mezzotint, which are printed from ink worked into the lines below the surface of the plate. It is a delicate medium, but slow and relatively expensive to use at all stages of production, and limited in respect of size. Relief printing – which includes woodcut, wood engraving and linocut – uses the surface of the material to hold the ink while the white areas of the design are cut away. It has advantages over intaglio of economy, scale and speed of printing; at the same time, it also has limitations for a poster artist, although for the printing of text it dominated the five centuries after the invention of printing in the West.

In the 1890s photographic techniques gradually came to the fore to replace wood engraving in journalism, advertising and book illustration. Photo-mechanical relief etching, a way of making images photographically on metal for relief printing, could produce a copy of a drawing or a photograph, including the potential to reproduce the effect of a full range of colours, and the skill of the engraver transferred from that of hand and eye to that of a technician in chemicals and metals. The cost of making large 'process blocks' and printing them in 'register' were deterrents to the adoption of this form of printing for large-scale images such as posters, however.

Surface or planographic printing is really the same thing as lithography, which was invented at the end of the eighteenth century in Bavaria, by Alois Senefelder. Although accounts differ as to the manner and date of his discovery, he seems to have stumbled across the technique by accident when scribbling down a washing bill on a piece of smooth stone – 'lithos' in Greek means stone. He thought he might be able to etch the stone like metal, but discovered that the water-absorbent surface of the stone allowed him to ink up the drawing without the ink being picked up on the damped stone. This could be printed in a press similar to an etching press, but the wiping stage was eliminated. In addition, the kinds of drawing that could be made on the stone were more varied than those that could be done on metal plates for intaglio printing, although it was discovered quite early that a grained metal, usually zinc, could act as an alternative to stone and was considerably easier to move and store, at least in larger sizes. Lithography began to spread across Europe and America as a medium for map making, music printing and occasionally for fine artists, although its potential for the printed word was for many decades neglected owing to the widespread use of relief printing (or letterpress as it is known when words are the main content) in the printing trade. Many printing houses combined letterpress and lithography under the same roof, although the apprenticeship training for entering the print trade required men to choose one technique or the other.

Contemporary sources tell us that nine out of ten posters in 1927 were produced by lithography.[1] In a more technically developed form, lithography remains the almost universal method for all the commercial printing that we encounter in the twenty-first century, when presses run four colours in rapid succession from plates that run without damping, and are created from computer files.

Screen (often called silk-screen) printing was a late arrival, although it had a long ancestry, especially in the East. It involves passing ink through a tight mesh, like an artist's stretched canvas. Parts of the

surface of the mesh can be screened (hence the name) to prevent the passage of ink. When introduced in the 1930s, the range of masking techniques was limited, and silk-screen developed a reputation as a hard-edged medium, although it was good at creating solid areas of strong colour, beloved of poster artists of the 1960s. In the hands of fine artists, it advanced rapidly, to incorporate a sophisticated range of photographic processes and to challenge lithography in the sphere of fine-art limited editions. In 1950, a poster of the Lord Mayor's Show by Francis P. Carr was screen-printed by Tribe Bros., a printer in Stamford Road, North London, apparently the first in the UK to employ the method.[2] The flat colours, designed in the colourful, loosely drawn manner of Raoul Dufy, lack the sophistication found in later screen printing, and lithography remained the dominant process.

From black-and-white to colour printing in lithography

Much early lithography was in black, through which the medium's greater freedom of mark-making (compared to previous printing processes) could be displayed to best advantage when the drawing was made by the artist in person. In many cases, as with wood engraving and intaglio during the nineteenth century, a more or less skilled interpretive artist translated the original work for reproduction, and usually aimed to eliminate the graphic 'handwriting' of the original. There was a great difference, therefore, between the fine colour lithography displayed in the luxurious books of David Roberts or Edward Lear, and those that were cheaply mass-produced. *The Times* Printing Supplement of 1912 condemned the standard practice in colour and monochrome work:

> When artists could no longer be persuaded to draw on chalk stones, mechanics were trained to 'stipple' on polished ones. Stippling was valid for technical and commercial illustrations, but it was hard to see all the vigour and freedom of an oil or water colour reduced to the smoothness of porcelain. It was a triumph of endurance — for the stippler — but was it art? Was it science?[3] [Plate 47]

Purists in the early twentieth century, including the members of the Senefelder Club (see chapter 4), disapproved of colour lithography, or 'chromolithography' ('chromo' for short), the term applied to the cheaper products.

47 'Specimens of Stipples, Rulings, and Textures for Colour Work', from David Cumming, *Handbook of Lithography*, A. & C. Black, London, 1904

A major technical change occurred in 1908 when offset printing became common. This technique, first developed for printing on tin plate, meant that the paper, rather than being placed in direct contact with the plate or stone, received the ink from an intermediary surface, a smooth rubber roller (plate 48). This increased the range of papers suitable for printing, allowing rougher surfaces that more closely resembled artists' drawing papers. The *Encyclopædia Britannica* stated, in 1910, 'colour work that has for so long been confined to coated or burnished papers will be available on surfaces such as the artists themselves use'.[4] A further advantage was that the design on the plate no longer needed to be drawn in reverse.

While offset printing prepared the ground for the flowering of poster art in the twentieth century, there remained an anxiety about the role of the interpretive artist. The skills needed to create an image for a poster, and those needed to translate it into print, were not necessarily found in the same person, since they depended on different mentalities and training. Today, we are used to the idea of the artist providing a colour original, which is processed for printing entirely by machinery. For a combination of reasons, including existing trade practices and the limitations of coloured inks, photomechanical methods, which were available before 1914, remained secondary to the skilled task of visually separating out the different colour constituents – usually into a minimum of four, representing the three primaries (cyan, magenta, yellow) plus black – to achieve anything like a full chromatic range. This was the skill of the trade lithographer, who would trace over the artist's original to make a key outline, on which different areas were shown, rather as in a 'painting by numbers' kit.

There were artistic risks involved in the translation process, and the preference of some of the best poster artists for simple outline shapes in flat colours can be explained as a failsafe method of avoiding the intrusive hand of the printer's studio. Thus, in the 1890s, the Beggarstaff brothers demonstrated the value of using fewer colours, more in the manner of a designer than a painter, similar to Japanese woodblock printing with its use of large, flat areas of

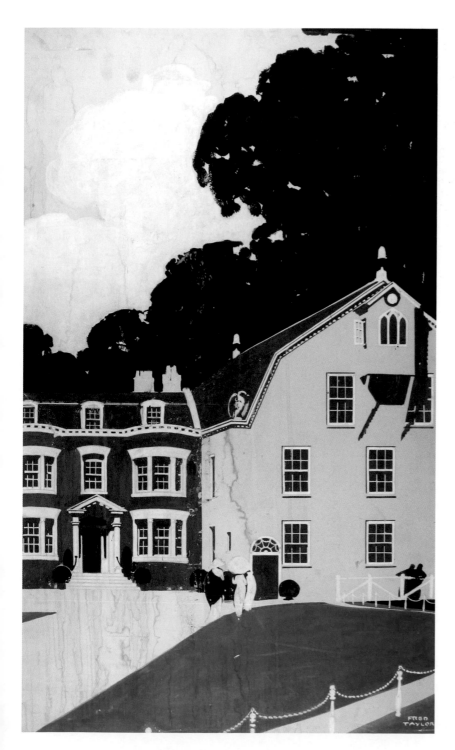

49 Artwork for *Farningham*
Fred Taylor, 1914
(733mm x 459mm)

colour. This simplified style remained popular with artists such as Fred Taylor between the wars (plate 49). Artists could specify particular colour mixtures for the areas indicated, and when these were mixed straight from the ink tin by a skilled printer, they were capable of creating a stronger effect than any colour formed by a dot screen, even today.

To reproduce the full tonal range of a painting required more colour 'workings' than the four that are the invariable standard today. Part of the artist-designer's skill was to estimate how their work would translate into print, and how to get the best value out of a limited colour range, since each extra colour increased the cost. This constraint undoubtedly affected the nature of poster design throughout the period in question, leading naturally towards the Modernist effects introduced to London Underground by Edward McKnight Kauffer and other artists whose simplifications of form and reduction in the number of colours we now recognise as Art Deco (see plate 50). As late as 1954, this was still an issue when Tom Eckersley, a master of simplification (see plate 51), wrote: 'The good designer can achieve far more with two colours than the poor one with twelve, since it is not the number of colours you use but the way in which you employ them that governs the result.'[5]

Lithography and the artist in early twentieth-century Britain

Historians of the poster unanimously recognise the superiority of poster printing in France and other European countries in the 1890s. Names such as Toulouse-Lautrec, Chéret and Mucha confirm the impression. In London only the short-lived partnership of the Beggarstaff brothers, with their small number of strikingly simplified silhouette images from the 1890s, stands comparison. Some comparable examples could be found, including a few posters by

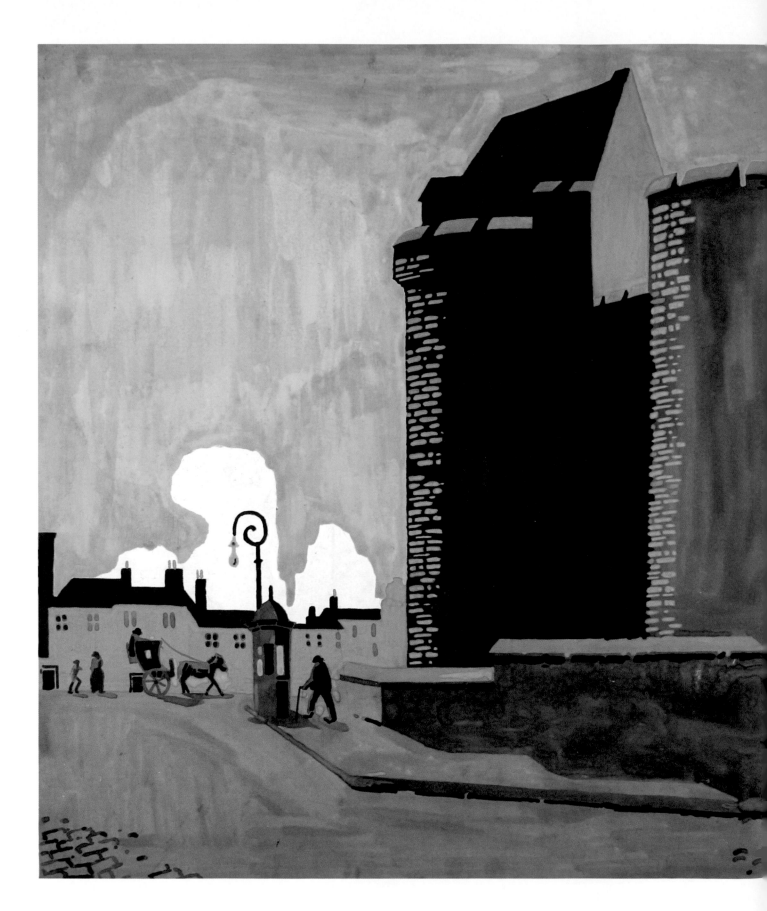

50 Artwork for *Windsor*
Edward McKnight Kauffer,
1920
(536mm x 508mm)

51 *Radiolympia*
Tom Eckersley and Eric
Lombers, 1937
Panel poster (255mm x 305mm)
Published by London Transport
Two-colour poster printed by
the Dangerfield Printing
Company Ltd

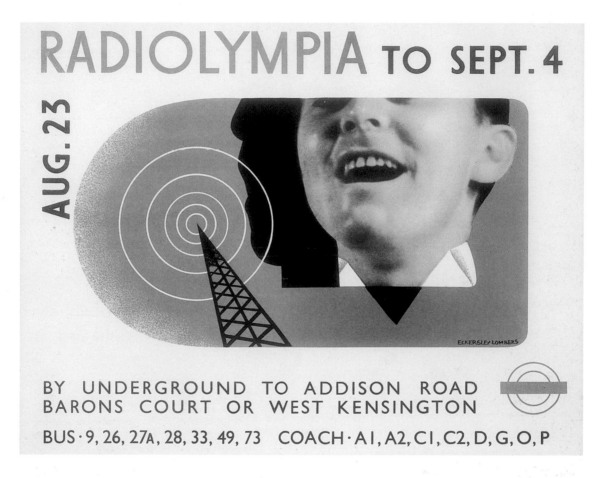

Charles Rennie Mackintosh in Glasgow, but their advantage was in stiffness and flatness rather than in flexibility of expression. The use of a heavy black outline was common at the time and, as the writer W.G. Raffé described in 1927, 'the black is used to cover patches of colour which meet, or overlap, or leave a slight gap. This was the technical value of the "black outline" school twenty years ago, for this outline was able in some measure to correct slight errors of imposition, and to give a sharp and decisive effect to the colour.'[6]

Colour itself was rediscovered with the help of offset lithography, and a new sensibility was formed along with it. As *The Times* claimed in 1912, the first appearance of printing had destroyed the coloured book made by hand, and it had taken nearly five centuries to recover:

It is scarcely too much to say that in printing, and indeed by its aid, we are attaining to a renaissance of the age of colour. Life may be dull enough, so dull, indeed, that the 'monotone' illustration has long been appropriate to its monotony; but Nature is always colour. The perfectionment of technical methods during the grey epoch has now made possible a realistic revelation of Nature as she is.[7]

52 'Specimens of Coloured Inks used in Chromo-Printing', from David Cumming, *Handbook of Lithography*, A. & C. Black, London, 1904

This statement touches on several of Frank Pick's concerns in an interesting way: first, his attachment to the ideal of the Middle Ages as an instrument of reforming the industrial world, as ascribed to him so convincingly by Michael T. Saler; and second, the affinity between colour and nature, which formed such a large part of his advertising programme.[8] The use of colour depended largely on the development of coloured printing inks, although many were still traditional pigments derived from plant or animal sources. In 1911, the *Encyclopædia Britannica* listed the colours in use as lamp-black for black, and carmine or cochineal for red. Indigo or Prussian blue were used, and for yellow, lead chromate or yellow ochre. Green and purple were made by mixtures.[9] The chromates were cheap and reliable. The reds were expensive, but much progress was made from 1880 onwards in adapting and mixing traditional pigments such as vermillion and carmine with metallic salts to make more versatile dyes, known as the lake colours; many of these were by then chemical syntheses made from coal tar, but some, such as the brilliant geranium lake, were neither quick-drying nor light-fast, both necessary qualities for poster printing. Blues and greens similarly required careful selection and combination (see plate 52).

In France, the artists drew directly onto stone or plate at the printer's works, so that the sheets of paper displayed in the streets counted as original prints, and were eagerly collected. In Britain, tighter trade practices meant that the normal procedure was for the 'lithographic artists' at the printing works to take a full-colour image by an outside artist or designer and break it down into a series of different colour 'workings', each designed to print as overlays like a precisely calculated jigsaw. This was generally

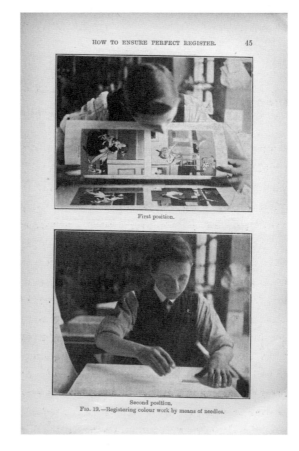

HOW TO ENSURE PERFECT REGISTER. 45

First position.

Second position.
Fig. 19.—Registering colour work by means of needles.

53 The litho artist at work: 'How to Ensure Perfect Register', from Henry J. Rhodes, *The Art of Lithography*, Scott, Greenwood & Son, London, 1924

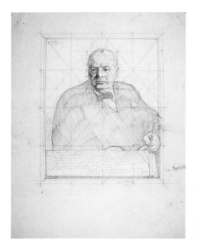

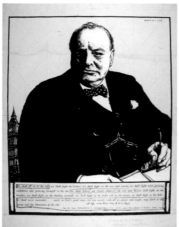

54 **Stages in the production of *Our Heritage: Winston Churchill***
Robert Sargent Austin, 1943

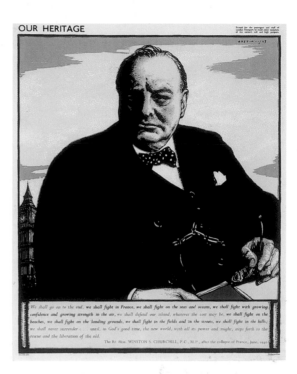

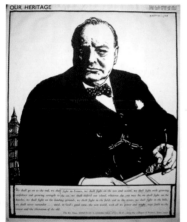

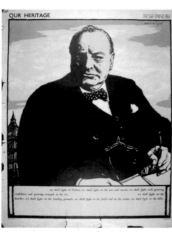

done with great skill, but the norm was for a design in the manner of a conventional painting, with a full range of tone and colour, to be transferred into a print medium which was better suited to a more simplified and textured (or, as one might say, 'graphic') form of expression. In the case of Robert Austin's poster of Winston Churchill (1943), one can study the development of the design from a pencil study (derived from a photograph), through a black-ink artwork and a single-colour proof on which the text has been fitted, to the final poster (plate 54).

W.G. Raffé describes three alternative ways in which an artist could transmit their image to print. The first was to consign a single original sketch to the 'litho draughtsman' for 'hand-copying or tracing, with liabilities to error' (see plate 53). Raffé was expressing a common prejudice against this way of working, based on the same impulse for authenticity that drove the Arts and Crafts Movement.

The second method was photolithography, which allowed the printer to transfer a photograph (of any description, including a photograph of a piece of artwork) onto a lithographic plate, and therefore had enormous potential. This method was definitely available by 1912 but was not as much used for many years as one would imagine – although, as *The Times* went on to explain, American colour printing had long surpassed British in the use of scientific methods. This, paradoxically, may have been an advantage so far as the design and production of posters before the mid-century was concerned. Eventually, after the Second World War, completely mechanical processes became normal in Britain, but one feels that there was a loss of the ingenuity and immediacy that came from artists needing to know how their work would be printed, and designing to gain the best advantage from the limitations of obsolescent machinery and old-fashioned workmen.

55 **The Roads are Never Up
on the Underground**
Alfred Leete, 1928
Artwork (635mm x 540mm)
and printed poster
(double royal (1016mm x 635m))
Published by UERL
Printed by John Waddington Ltd

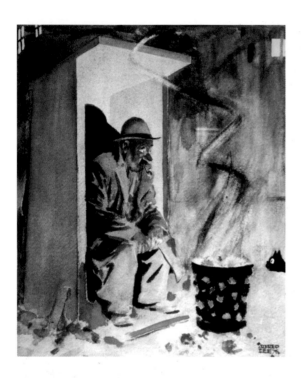

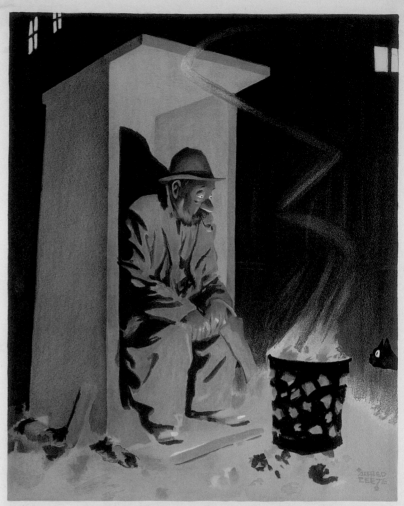

What Raffé did not reckon with was the possibility that the 'litho draughtsman' could become skilled and sensitive enough to avoid distortion of the artist's work, and at the same time bring to the analysis of colour separation an intuition and understanding of the tricks of human perception and varying lighting conditions not available even to the most advanced plate camera. The extent of the transformation can be seen by comparing the artwork by Alfred Leete for *The Roads are Never Up on the Underground* (1928) with the actual poster, which is dominated by the warm glow of the brazier, and is much more eye-catching (plate 55). Recommending aspiring poster artists to get their feet in the doors of printing works, Eckersley wrote: 'more than reading all the instructions in the world, I have found most printers very helpful during my own career.'[10]

In the third method listed by Raffé, 'the designer can himself draw on the stone, or on suitable litho paper ready for accurate facsimile transfer'. This was in the spirit of the Arts and Crafts Movement that informed Frank Pick's artistic vision for the Underground, attempting to harness old and new for the good of society, and retain a sense of grounding in real objects and materials. Raffé suggests that the artist should draw a black image on transfer paper.

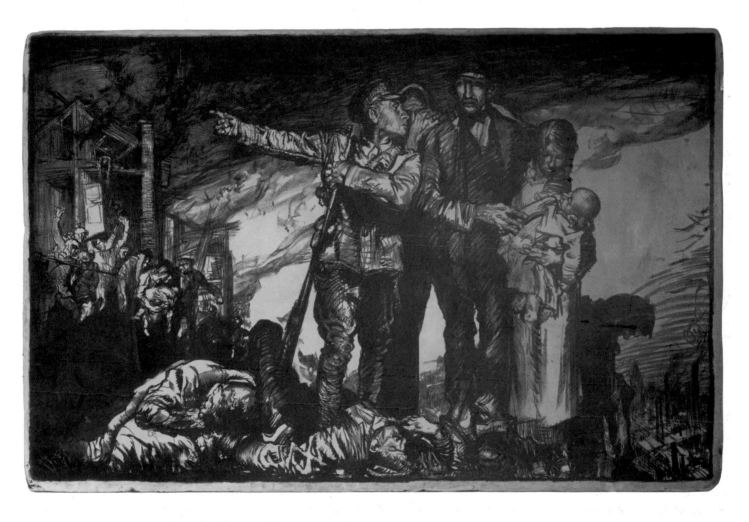

After this has been laid onto the plate and proofed, the artist can then work over it in colour, and the printer can interpret the coloured areas for additional workings. As Raffé comments, 'This method has been used by Brangwyn, Frank Mason, Spencer Pryse, and others for work in several colours.'[11] It is unusual that several large stones by Frank Brangwyn have survived in the Victoria & Albert Museum (see plate 56), since the normal practice was to grind down the surface so that the stone could be reused.

A watercolour wash effect was declared preferable to an opaque treatment. Rather than using an 'extender' in the ink, a neutral medium which would reduce colour-fastness, it was better for the litho draughtsman to create a broken surface. For this purpose, a number of methods could be used, including lines, stipples, or dabbings with gum to resist a wash of litho ink applied over the top. The lithography expert and author Thomas Griffits (see chapter 4) developed a tool he called a 'jumper' which was run over the surface of the litho stone (it did not work on plate), creating sharp-edged highlights in solid tonal areas, as seen in the work of Barnett Freedman, who learnt from Griffits how to use it.

57 **Flowers**
Ivon Hitchens, 1951
Artwork (1016mm x 635mm)
and poster (double royal
(1016mm x 635mm))
Published by London Transport
Printed by the Baynard Press

Autolithography as an ideal

The Arts and Crafts ideal indicated that artists should cut out intermediaries who came between them and the finished piece, in order that the 'hand of the artist' should be evident in the final work. When the printed piece exactly conveys the touch of the artist, the result is called 'autolithography'. In practice, the majority of artists working in the period 1900 to 1950 did not draw directly onto stone or plate for their posters, even if there was a body of literature exhorting them to do so, much of which was written by those few who had succeeded in mastering the process. The difficulties were partly artistic and partly organisational. Artistically, it was necessary to gain experience of making marks onto plate, stone or transfer paper – a convenient material originating soon after the discovery of lithography, prepared by the printer, from which the drawing could be pressed onto the printing surface in reverse. Solid areas were simplest, but shading with crayon, brush, stipple or airbrush took more skill. Single-colour work was relatively simple, but conceiving a design in several colours, especially where overlaid colour combinations were wanted, was a more difficult matter, in which a printer's advice was needed.

The question of working directly with a printer was less controllable. Each artist who drew their own 'colour separations', let alone plates, was taking work away from the unionised 'litho artists' employed by the company, and it required tactful negotiation by a master printer to gain agreement of his workforce to such an intrusion by non-union labour. Only those artists whose skill was admired, and who could be relied upon to fit into the culture and avoid making trouble, were likely to be admitted. In the late 1930s, when John Piper wanted to produce a nursery frieze for the company Contemporary Lithographs which was too long for production at his usual printer, the Curwen Press, he had to be more or less smuggled into the works of Waterlow & Sons after hours to work directly on plates.

The artist who broke through first was Barnett Freedman, with the help of Thomas Griffits, then the master lithographer at Vincent Brooks, Day & Son, at the request of Richard de la Mare, a director of the publisher Faber & Faber. Freedman wrote that Griffits

graphic or redrawn in the studio, which some artists could count a privilege in itself. The truth of this was borne out some two years later, when Griffits reproduced a painting by Ivon Hitchens for a poster called *Flowers* (see plate 57), and Harold Hutchison, the Publicity Officer at LT from 1947, wrote from London Transport to the artist to say that 'for my own part, I simply cannot tell which is the original and which is the proof until I get within inches of the canvas, so I hope you will be pleased'. Hitchens agreed, replying that he wanted to write to thank 'the lithographer of my poster (it really is <u>his</u> poster)'. Hutchison stated that Griffits was 'in my opinion the best lithographer in England. He did this job personally, and I agree with you in thinking that it is his masterpiece.'[13]

In 1940, Griffits' book *The Technique of Colour Printing by Lithography* was published, not by a specialised technical press, but by the mainstream house of Faber & Faber, for whom Griffits had printed many of Barnett Freedman's book jackets. The book carried an Introduction by Frank Pick, cementing the association with the Undergound. Pick repeated the credo of autolithography, that however skilful the craftsman, it would be 'much better that the artist should learn the technology and be able himself to carry out that part of the lithographic work which is itself creative'.[14] Regretting the limited achievements to date, a verdict we might find hard to accept, Pick looked ahead to a further golden age of autolithography, but it was not to be. Art schools continued to teach lithography, but usually more on a trade than an artistic basis. By the mid-1950s, however, the situation reversed, and the art schools became engaged for a couple of decades in the new world of the limited-edition print rather than commercial production.

By 1951, in fact, Harold Hutchison was writing to the artist Bernard Cheese to warn him off from attempting autolithography, stating: 'we prefer artists

had 'a just and sympathetic understanding of the artist's aim, and such a profound knowledge of the workings of lithography, that a lithographic copy done by his hand, or under his supervision, invariably retains the vitality of the original work.'[12]

Griffits, who later moved to the Baynard Press, was one of the lithographic technicians favoured by London Underground for its work, be it autolitho-

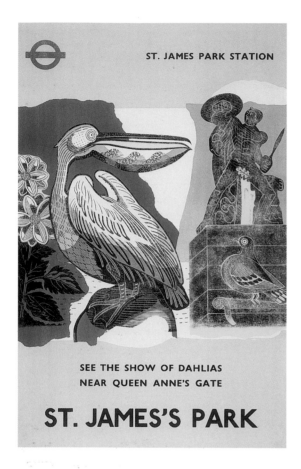

58 **St James's Park; Pelican**
Edward Bawden, 1936

Double royal
(1016mm x 635mm)
Published by London Transport
Printed by the Curwen Press

men. He also enjoyed the company of artists and achieved distinction for the company by his selection of them. Curwen was a founder member of the Design and Industries Association, along with Frank Pick, and received many varied printing commissions from London Transport, including posters from the 1920s onwards. Posters by Edward Bawden were produced by a special transfer process devised by Curwen himself for reproducing from Bawden's linocut originals, retaining the effect of a 'starved' ink surface that brought essential life to the images of St James's Park (plate 58) and other London attractions. Even so, not many appear to have enjoyed the privilege rapturously recalled in later years by Lynton Lamb:

> I have the happiest memories of North Street, Plaistow in the 1930s. It was bliss in that dawn to be alive: artists flocked, like herring gulls following a plough, to work and watch each other work at North Street As a new boy among the delights of print making, I owed much to the kindness and lively interest of Harold Curwen, Oliver Simon, and seasoned members of their staff, who had been told to help us. I remember in particular, a splendid example of the old school of litho draughtsmen, known to me affectionately as Wally Gapp. [16]

to work to a finished drawing rather than to draw their design on the plates themselves. We have never, in fact, found that autolithography saved us much time or money, it complicates last-minute alterations or amendments to the design and it makes difficulties with our printers who have their own highly skilled lithographic artists.'[15] This is a useful corrective to the many voices speaking in favour of autolithography. Partly owing to more aggressive union restrictions in the post-war years, it became increasingly difficult to slip the occasional artist in by the back door.

The Curwen Press, mentioned earlier, did most to proselytise autolithography and make space for artists. This was because Harold Curwen worked hard at industrial relations and was trusted by his

Only after 1935, however, was a genuinely proactive approach taken to inviting artists, owing partly to the introduction of new equipment. Around 1936, for example, not only Lamb, but Eric Ravilious, Graham Sutherland, Edward Ardizzone and John Piper all began to practise lithography at the Curwen works in Plaistow, East London, mainly with a view

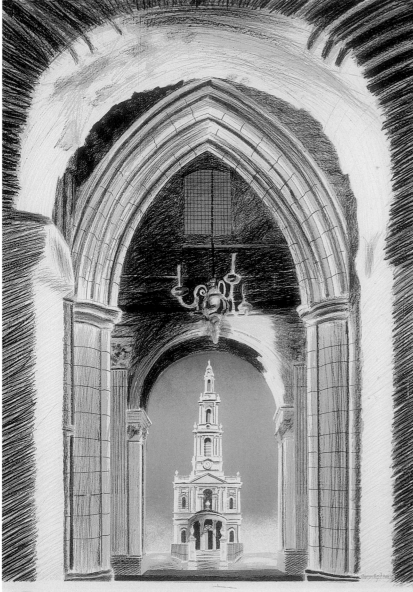

59 **Christian Heritage Year**
Glynn Boyd Harte, 1984
Double royal
(1016mm x 635mm)
Published by London Transport
Drawn on film at the Curwen
Studio; printed by W.S. Cowell

This is Britain's Christian Heritage Year. There is an audio-visual celebration of our Christian tradition in St. Mary-le-Strand until November; a moving testimony to men and women who have influenced us all. See it; and see the milestones of nineteen centuries of Christianity in London.

Open Mondays to Saturdays 10am to 8pm. Sundays 2pm to 8pm. ⊖ Temple. For further information telephone 01-493 9827

diverging to the point where it was no longer possible to house them in the same space. In response, the Curwen Studio was created, to serve the needs of artists in the manner of Parisian lithographic ateliers. Under the leadership of Stanley Jones, an artist who learned the technicalities of the business, it has continued to flourish. From Curwen Studio came what was probably the last-ever example of a poster produced from hand-drawn colour separations: Glynn Boyd Harte's for Christian Heritage Year, in 1984, drawn on film at Curwen and printed by W.S. Cowell of Ipswich (plate 59). The crayoned overlays, typical of this skilled lithographic artist's work, are tell-tale signs of the print's by-then anachronistic origins in a period when it was normal simply to reproduce a painting with a white border.

Liaison with artists

The 1930s were a difficult period for most artists to earn a living, and a London Transport poster was a valuable source of income. Records of payments may be more readily found in artists' personal papers than in the official minutes and letters of the LT Publicity Committee, although a payment for a sketch for a Zoo poster (not actually produced) by Orovida Pissarro in 1915 gives the fee as 8 guineas (£8.40).[17] In 1935, the minutes of the Publicity Committee give a table of fees to artists, arranged in terms of four different size categories and three different payment scales, depending on the artist's standing. Reading from least to most, a small design for a press advertisement by a relative unknown would earn four guineas (£4.20), while a quad-royal poster by a celebrity would earn £94.10s (£94.50).[18] By comparison, watercolours by Eric Ravilious in the same year were priced at 12 guineas (£12.60), from which expenses and commission would be deducted. For many artists, a poster was therefore a commission

to book production, but occasionally for posters. The 'Contemporary Lithographs' series in 1937 included work by these artists in an effort to sell large-size, colourful original prints to schools in place of mechanical reproductions, thus affirming the closeness of poster to fine art, or vice versa.

In 1958, Curwen recognised that general trade lithography and specialised fine-art lithography were

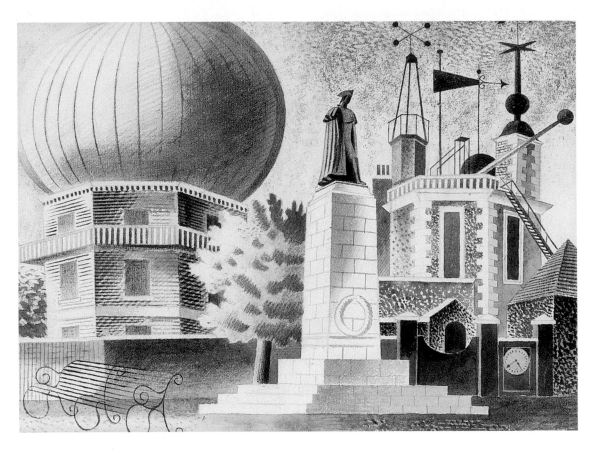

60 **Greenwich Observatory**
Eric Ravilious, 1937
Watercolour (190mm x 295mm)

well worth having. In 1952, a cancellation fee for John Nash, owing to a budget cut, amounted to £75.

Sketches and samples were presented to the Publicity Committee at London Transport which met once or twice a month. During the 1930s, it often consisted only of Frank Pick and one other officer. Although no longer directly involved in poster commissions by this stage, Pick was active in suggesting some artists and rejecting others. A letter written by Harold Hutchison to artist Anthony Gilbert in 1943, after Pick's death, indicates that Lord Ashfield was taking an interest, for it encouraged artists to work full size, even at the rough stage, on the basis that 'our chairman likes to see things as they will appear and we always seem to have trouble reproducing from anything below actual size'.[19] It may be assumed that most of the comments on individual designs, between the artist and the publicity officers, were not written down. The minutes often record approval or disapproval, but without much more explanation, except in rare cases, such as one in 1938

when Frances Bennett's *Spring is in the Air* was approved 'subject to the drawing being altered so that the lamb looks alive and not stuffed'.[20] It might be doubted whether this was achieved even then. When Ravilious was commissioned by Christian Barman in 1937 to produce two poster images of Greenwich (plate 60), the work was rejected, and Barman wrote to him: 'Although I greatly like the drawing I have here, I think it is completely useless for the purpose of attracting traffic to Greenwich. Kensal Green Cemetery with a stiff East wind blowing would be just about equivalent in traffic value.'[21]

When working 'directly', it is normal for the artist to pass the work at proof stage prior to editioning. This involvement remained crucial, even when the printer had made the colour separations. The post-war correspondence with artists includes many exchanges about proof correction, such as a letter from Eckersley in 1976 concerning four colour corrections for his well-known *Ceremonial London*, printed by Walter Brian Ltd (plate 61). It was not

61 Ceremonial London
Tom Eckersley, 1976

Artwork (714mm x 448mm)
and poster (double royal
(1016mm x 635mm))
Published by London Transport
Printed by Walter Brian Ltd

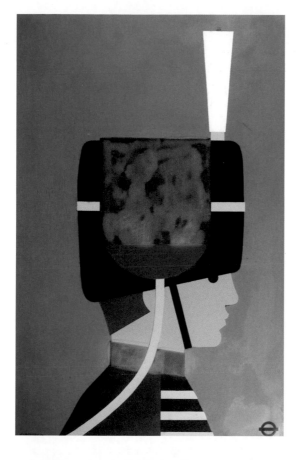

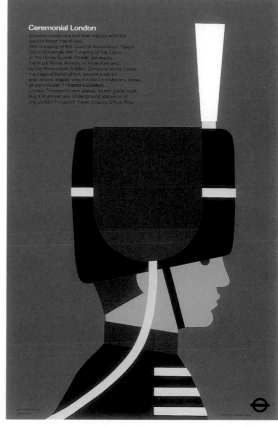

**62 Royal London:
Kensington Palace**
Sheila Robinson, 1953

Double royal
(1016mm x 635mm)
Published by London Transport
Printed by the Curwen Press

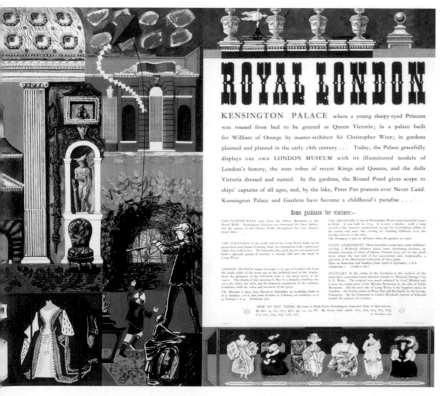

unknown for the printer to offer improvements, as Herbert Simon of the Curwen Press did for Sheila Robinson's *Royal London: Kensington Palace* (1953, plate 62), suggesting: 'you will find the blue in the lower panel is a good deal stronger than the artist's but I think this is right, and it seems to me to add unity to the design. If, however, a lighter blue is preferred it can be had.'[22]

Sometimes artistic temperament had to be soothed, as when Abram Games complained about the varying quality of the greens in a poster in 1951 (probably *See London by London Transport Coach*, see plate 63), and LT's Publicity Officer Harold Hutchison replied: 'Waterlow's admit their mistake, but unfortunately there is no possibility of re-running ... only an expert like yourself may possibly be disappointed.'[23]

Provision could be made for artists to see the work on press, as in the case of Pat Keely's *Twenty Miles London Bus Tour* of 1962, printed by Waterlow & Sons, of which the artist reported: 'I worked closely with them and one has to be there when the machine

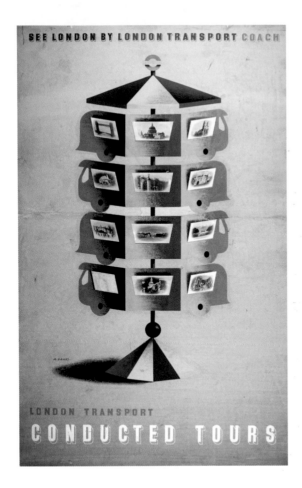

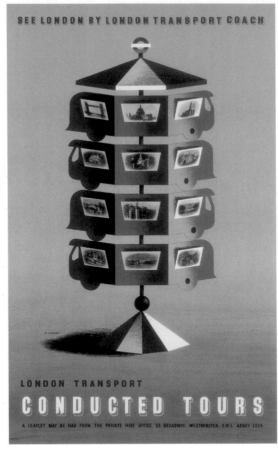

is ready, otherwise it goes on to another job and you may not get it back for a day or two.' He tried to recoup the cost he believed he had saved in avoiding the proof stage, a request declined by Harold Hutchison who replied: 'We are always only too happy to arrange for an artist to see his work through the press and we value his advice, but we do this because most artists are anxious to ensure the best of reproductions in their own interests as well as ours.'[24]

Mixed media and camera-ready

While a purist approach to lithography would indicate that the artist should draw everything, commercial art was used to combining mechanical (especially photographic) and hand-drawn imagery. The effects might well be largely kitsch, but designers and artists in the Modern Movement used these techniques with a more knowing quality of dissociation, including the shock tactics of Surrealism, that became popular in the 1930s. As Paul Rennie notes,

Paul Nash was early in this field in Britain and Kauffer and others followed (see chapter 4). With the emphasis of this book being on posters by artists, it is easy to forget that around half the posters produced by London Transport in the 1930s were entirely photographic, featuring the work of Maurice Beck and others.[25]

A unique mixed-media experiment was undertaken by the artist John Farleigh, with a series on flowers in 1937 (see plate 64), which he described in his book, *Graven Image*. Farleigh practised as an engraver and felt that 'a mixture of wood and lithography would give the contrasting qualities of softness and hardness that are so peculiar to plant form'.[26] He aimed to use each medium to its best advantage, and so selected side-grain wood for the line work of the dark-green printing, which he offset as a key image onto lino for a second colour. These were not printed directly, but transferred to litho plates, while the other colours were drawn direct

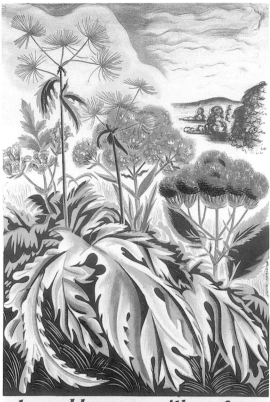

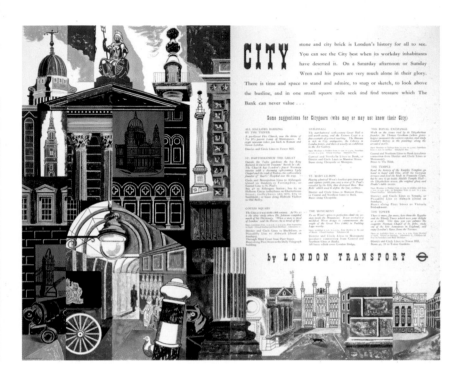

64 Strong Blossoms
John Farleigh, 1937
Double royal
(1016mm x 635mm)
Published by London Transport
Printed by the Curwen Press

65 City
Edward Bawden, 1952
Pair poster – each double royal
(1016mm x 635mm)
Published by London Transport
Printed by the Curwen Press

onto plates. 'The design suffered to a certain extent and became less exciting than the method,' Farleigh admitted; 'however, it was worth it: I enjoyed myself, and the posters were not too bad.'[27]

In 1959, the artist Michael Rothenstein, then beginning his long-lasting engagement with studio printmaking, offered Harold Hutchison a series of possible themes, adding that he could also do the actual printing: 'We would, of course, print a poster here (at a cost much below Curwen Press) tho' ours would be an original job printed direct from lino blocks.'[28] His offer was not taken up.

In the post-war period, the artist came closer to preparing what was known until recently as 'camera-ready' artwork, even if it was due to be interpreted by the hand and eye of the litho artist. This was the case with Edward Bawden's fine poster, *City* (1952), which he designed at full size: 'I propose to do lino cuts of those details which are drawn in pen & ink, the remainder of the cut paper work, I want to

paint.'[29] This was superbly interpreted and printed by Curwen (plate 65).

An extreme case of 'camera-ready' artwork was the mosaic by Hans Unger and Eberhard Schulze for three posters – *Guardsman* (1962), *Zoo Aquarium* (1963) and *Busabout* (1970, plate 66) – the last of these being the most adventurous, since it relies on the shadow on the white mosaic to create an almost trompe-l'oeil effect.

Sourcing print

A small number of printers have been mentioned by name so far, but the actual number of firms used by London Transport at various times was extensive. There seems to be little evidence for their choices. It was not a case of accepting the cheapest quote, and there appears to have been a policy against placing too much work with any single company. Perhaps, since one assumes that an Underground commission brought prestige, it was necessary to keep all the

printers in a state of expectancy. The prewar minutes of the Publicity Committee say nothing significant about the selection process. What might be considered the 'top' printers were possibly reserved for the best artists or the most complex jobs, as some of the case histories such as the Hitchens *Flowers* and the Bawden *City* indicate. Curwen's reputation for high prices, mentioned by Rothenstein, was something they could sustain owing to the quality of the work, but their proportion of Underground commissions was modest in comparison to the amount of work given by the organisation to other printers.

A document of 1945 offers some sense of comparability between four printers who had presumably been asked to submit quotations. None of these is a well-known name. Three companies quoted very similar prices (around £150 for 1000 copies of two posters printed together) on a basis of six or seven workings; the fourth quoted over £200. The paper, a valuable resource at the end of the war, was usually provided by the Underground itself. One of these printers, Fosh & Cross of Mansell Street, East London (see plate 67), became a regular supplier.

As printing began to enter a period of drastic technical change in the 1970s, many of the old firms changed or disappeared – even Curwen, which was taken over and asset-stripped in 1983. A note from Michael Levey at London Transport to Abram Games in 1976 shows the old skills just about hanging on. For his Zoo poster, 'the printers will be Impress Ltd. of Acton. They have done excellent work for us since the demise of the late lamented Johnson, Riddle & Co.'[30] Glynn Boyd Harte's poster, mentioned earlier, was printed shortly before the dissolution of Cowell's, a house that carried the torch for autolithography in the post-war period. It is a world unlikely to return, and we may regret losing the brilliance of colour achieved by separate printings

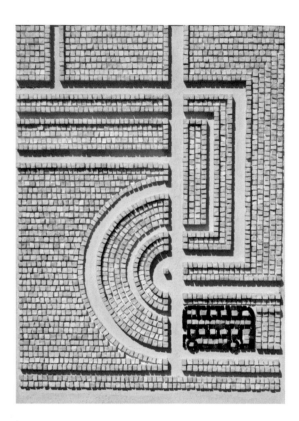

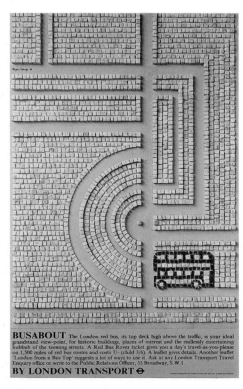

66 Busabout
Hans Unger and Eberhardt Schulze, 1970
Artwork mosaic (1056mm x 730mm) and poster (double royal (1016mm x 635mm))
Published by London Transport
Printed by Sir Joseph Causton & Sons Ltd

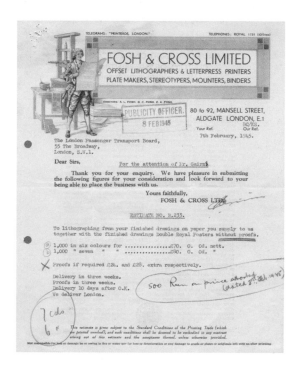

67 Letter from Fosh & Cross, printers, showing the company's letterhead.

in specially mixed colours devised by skilled artists and pressmen before four-colour 'process' turned everything into dots.

Those prone to nostalgia may feel braced by Edward Bawden's comment to Oliver Green after visiting the London Transport Museum in 1984:

The early posters seemed to me after four or five decades to be ridiculously self-consciously arty, the personality of the artist too much in evidence, in fact, back in the Underground at Covent Garden station I felt happier because the present-day posters make no aesthetic demands, – pure advertising stuff and nothing else, requiring neither to be liked or disliked.[31]

Notes

1. W.G. Raffé, *Poster Design*, Chapman & Hall, London, 1929, p.155.
2. See letters between Harold Hutchison and Arthur Symes of *Display* magazine, November 1950, London Transport Museum (LTM) Archive, LTM 2007/1755.
3. *The Times*, 10 September 1912, p.19.
4. *Encyclopædia Britannica*, 11th Edition, 1910–11, 'Lithography'.
5. T. Eckersley, *Poster Design*, The Studio, London, p.13.
6. Raffé, *Poster Design*, pp 154–5.
7. *The Times*, 10 September 1912, p.19.
8. Michael T. Saler, *The Avant-Garde in Interwar England: Medieval Modernism and the London Underground*, Oxford University Press, Oxford and London, 1999.
9. *Encyclopædia Britannica*, 11th Edition, 1910–11, 'Ink'.
10. Eckersley, *Poster Design*, p.12.
11. Raffé, *Poster Design*, pp 155–6.
12. Barnett Freedman, 'Lithography, a painter's excursion' in *Signature* 2, 1935, pp 13–14.
13. Hutchison to Hitchens, 14 June 1951,

LTM 2007/5387; Hitchens to Hutchison, 27 October 1951, 2007/5391; Hutchison to Hitchens, 31 October 1951, LTM 2007/5392.
14. Thomas Griffits, 'The printing of posters', in H.F. Hutchison and J. Laver (eds), *Art for All*, exh.cat., Art & Technics, London, 1949, p.28.
15. Harold Hutchison to Bernard Cheese, 7 December 1951, LTM 2007/488.
16. Lynton Lamb to Pat Gilmour, 24 October 1976, Tate Gallery TG92/316/13 Lynton Lamb.
17. Advertising Manager, London Electric Railway Company, to Orovida Pissarro, 8 December 1915, LTM 2007/5819.
18. Meeting of London Transport's Vice-Chairman's Publicity Committee (VCPC), 4 July 1935, Transport for London Archives, LT 606/009, 226.
19. Harold Hutchison to Anthony Gilbert, 13 August 1943, LTM 2007/3058.
20. VCPC, 17 February 1938, Item 894, LT 606/026.
21. Christian Barman to Eric Ravilious, 17 November 1937, East Sussex Record Office. The letter is ambiguous since it

mentions only one drawing, while two exist in the collection, and neither is necessarily the one referred to.
22. Herbert Simon to Harold Hutchison, 1 July 1953, LTM 2007/5839.
23. Harold Hutchison to Abram Games, 25 May 1951, LTM 2006/15234.
24. Keely to Hutchison, 4 June 1962, LTM 2007/5617; Hutchison to Keely, 6 June 1962, LTM 2007/5618.
25. The statistic is based on minutes of the VCPC, 4 January 1934, LT 606/08.
26. J. Farleigh, *Graven Image*, Macmillan, London, 1939, p.379.
27. ibid p.381.
28. Michael Rothenstein to Harold Hutchison, 22 July 1959, LTM 2007/5843.
29. Edward Bawden to Harold Hutchison, 27 November 1951, LTM 2007/1095. The original artwork is in the North West Essex Art Collection at the Fry Art Gallery, Saffron Walden.
30. Michael Levey to Abram Games, 12 April 1976, LTM 2006/15243.
31. Edward Bawden to Oliver Green, 22 March 1984, LTM 2007/1090.

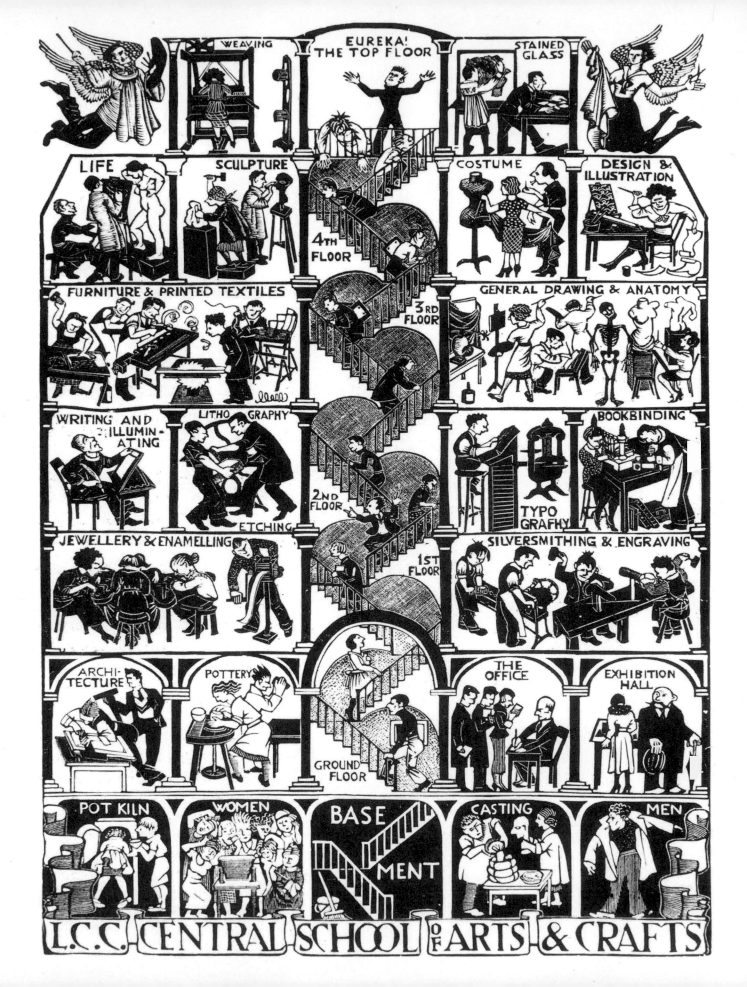

Opposite:
**68 LCC Central School
of Arts and Crafts**
Engraving by Herry Perry, 1929

THE NEW PUBLICITY:
DESIGN REFORM,
COMMERCIAL ART
AND DESIGN EDUCATION 1910–39

Paul Rennie

FRANK PICK WAS described by Nikolaus Pevsner as 'the greatest patron of the arts and indeed the ideal patron of the age'.[1] This chapter examines the relationship between Pick, the design reform movement in Britain and the students and staff of London's great art schools. This unique triangulation asserts the ambition of Pick's project and confirms Pevsner's opinion.

The story is divided into two main sections. The first part traces the practical consequences of design reform in poster art through the example of Frank Pick and his colleagues in the design reform movement. The second section describes how the success of this project provided a foundation for the transformation of commercial art through its evolution towards a process of assembly and technocratic specification. These activities became identified, by the end of the 1930s, with the practice of graphic design. The role of the art schools as an engine of change and as a laboratory of new ideas is presented as a consistent backdrop to this narrative.[2]

The second generation of underground lines in London were developed from the 1890s as deep-level electric Tubes. From the passenger's point of view, this environment was very different and considerably more comfortable than the earlier

Metropolitan and District Railways. Those original underground lines, engineered by cut-and-cover from the 1860s, were only just below street level. Quite apart from the environmental issues of smoke and soot from the steam trains and the dim gas lighting, the old stations provided a much more limited display environment. These spaces were nevertheless popular with advertisers, and every potential display surface was always cluttered, even after electrification in 1905.

In contrast, the deep Tube lines could provide a concentrated visual experience from the station entrance, down the lift or escalator, to the platform and destination. The brightly coloured advertising material helped make the descent into the deeper, more claustrophobic environment of the Tube more tolerable for the general public. The planned arrangement of advertising kept the stations neat and tidy and maximised the impact of display.

Frank Pick realised that there would never be enough paid commercial advertising to fill all the spaces on his platforms. This was especially so at the higher rates demanded by his rational display system, and was one of the reasons he developed his own poster-commissioning programme alongside the commercial advertising. Pick began by identifying themes and places – the river and London's historic sites – that were big enough to be of general interest across the Underground Group.

In addition to the shortage of advertisers, Pick soon discovered that there was also a shortage of able lithographic artists. Without access to a reliable supply of correctly trained artists, his developing plan for a uniformly high standard of display across the whole network would founder. It was entirely pragmatic that, in these circumstances, Pick should find common cause with others already involved in the design reform movement.

Advertising, education and lithography

It is important to acknowledge that Frank Pick did not invent the Underground poster. Long before his arrival, the underground railways had made extensive use of poster publicity, though early poster notices usually took the form of letterpress announcements in text only. These were designed and produced by printers rather than artists.

Pick can certainly be credited with steering the evolution of the Underground poster towards greater pictorial content. Furthermore, the visual content of Pick's publicity campaigns favoured the expressive and artistic potential of lithography through the use of artist-designers. However, it should be emphasised that Pick's approach to the problem of publicity was always pragmatic as well as idealistic. His strategy was informed, right from the start, by a scientific interest in efficiency. Good design, Pick believed, would prove itself by better results. Accordingly, he steered his publicity strategy towards what he believed worked.

It was not surprising that Pick, identified as both advertising patron and moderniser, should be one of the founding members of the Design and Industries Association in 1915 (see chapter 2). Based on the successful German model of the Deutscher Werkbund (see chapter 1), founded eight years earlier, the DIA's aims were summarised in the slogan 'fitness for purpose', an expression often used by Pick and his colleagues. Ironically, it was the outbreak of war with Germany in 1914 that accelerated the push to create a similar organisation to encourage good design in British industry.

The aftermath of the First World War provided an urgent context for design reform under the banner of Modernism. The Modernist phenomenon played itself out very differently amongst the major protagonists of the war. In Germany and Russia, experiments in

Modernist construction were a positive consequence of military defeat, political upheaval and economic isolation. In Britain, and with great-power status retained, Modernism and design reform evolved rather differently. There was a more complex, and often contradictory interplay between reform and tradition, craft and industry, progress and the past. Ideas of progress and modernity in applied art and design were often intertwined with romantic calls for a return to pre-industrial moral and community values.

In its earliest years, the DIA's most active spokesman was William Richard Lethaby. Lethaby was personally connected to the nineteenth-century design reform movement. He was a friend of William Morris and an influential member of the Arts and Crafts community. Lethaby had helped found the Art Workers Guild in 1884 and, after his appointment as Art Inspector to the Technical Education Board at the newly formed London County Council (LCC), he played a crucial role in establishing the LCC's Central School of Arts and Crafts (plate 68). Lethaby was the school's first Principal, from 1902, and was also Professor of Design at the Royal College of Art.[3]

The Central School's new building was opened on Southampton Row in Bloomsbury alongside the entrance to the Kingsway Subway, the key north–south link in the LCC's huge new electric tramway system for Edwardian London. Progressive art and craft education and the application of new technology to urban transport were in close proximity at the start of the twentieth century, but few could see any obvious connection between them.

Lethaby understood the widely held distinction between the activities of design and production to be a false one. He considered that the artist and artisan should be usefully reconciled in the production of better everyday artefacts. His educational reforms were always an attempt to synthesise these activities and break down these false barriers. The organisation of the Central School pioneered the creation of studio environments where makers and designers could work alongside each other.

Lethaby was also an outspoken critic of the visual clutter of advertising and the generally poor standard of poster advertising design and display. Allowing artists access to the expressive potential of lithography, as evidenced by Pick's efforts, could only enhance the effective display and aesthetics of advertising. Lethaby was conscious of a widespread disparity between the status of fine art and that of design in education. He viewed this as a matter of national significance requiring urgent reform. Pick, on the other hand, initially saw this as a matter of maladministration rather than anything more malign, although he later argued strongly for educational reform. For both Lethaby and Pick, the process of modernisation, based on rational policy decisions, was founded on the effective and measurable difference those policies made.

It was in this spirit of practical engagement that Lethaby was, from 1910, at the forefront of a campaign to promote the artistic and expressive potential of lithography. This was done through the auspices of the Senefelder Club, founded by Joseph Pennell and Ernest Jackson, and with the collaboration of colleagues at the Central School. Jackson introduced Pick to the artists of the Senefelder Club. Amongst the group were Gerald Spencer Pryse and A.S. Hartrick, both colleagues of Lethaby from the Central School. When the DIA was formed in 1915, it was no surprise that Pick and Lethaby found that they were agreed on the interconnection of design reform, education and the significance of a visual print culture.[4]

The printing of posters on a commercial basis was beyond the capability of the studio facilities of

the Senefelder Club's membership. To enable the members' engagement with commercial printing, Vincent Brooks was appointed printer to the club in 1912. Brooks was a commercial printer whose lithography firm was later to grow to become Vincent Brooks, Day & Son, a name found on many of the Underground Group's posters. Brooks encouraged the practice of autolithography (see chapter 3), and employed the printer Thomas Griffits, who became a significant colleague for the artist-lithographers of the 1920s. Griffits began his career with Brooks preparing the lithographic portraits and caricatures after 'Spy' for *Vanity Fair*. He eventually became the most expert lithographic technician of his generation and collaborated extensively with many artist-designers working at Brooks and with Fred Phillips at the Baynard Press.

The competitive instincts that distinguish commercial activity were dissipated by the common cause of design reform. Furthermore, those printers and publishers within the movement could enjoy the fellowship of the Double Crown Club. Accordingly, Vincent Brooks, Fred Phillips and Harold Curwen were colleagues, collaborators and friendly rivals in print.

R.G. Praill, printer at the Avenue Press, devised a process by which dramatic and expressive designs could be produced economically. The process made use of a single detailed drawing in black against a background of one or perhaps two colours. The low cost of this approach made it attractive to advertisers and of practical benefit to members of the design reform movement. When C.R.W. Nevinson wanted to learn lithography, he turned to Praill at the Avenue Press. Similarly, Tom Purvis learnt lithography with Praill.[5] Frank Brangwyn perfected this approach to poster composition (see plate 69), and Pryse (see plate 70), Hartrick, Jackson and James Kerr-Lawson – all colleagues at the Central School and in

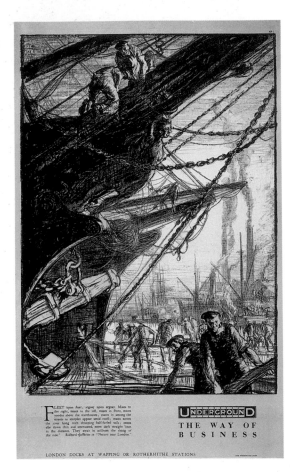

69 Underground, The Way of Business
Frank Brangwyn, 1913

Double royal
(1016mm x 635mm)
Published by UERL
Printed by the Westminster Press

the Senefelder Club – produced posters for Pick using this style.[6]

A number of large-format (four-sheet) landscape prints were commissioned by Pick in 1914 as 'windows' on to London and its surrounding countryside (see plate 71). During the First World War some of these were devised for display not on Underground stations but in military billets overseas as 'reminders of home', soft but patriotic images of landscape propaganda.

It was natural that the more adventurous artist-lithographers should attempt to extend the expressive potential of lithography through the use of a wider range of colours. After the first, black and white, phase of reform a second phase occurred. Thomas Robert Way, whose firm had worked with Whistler, was at the forefront of this initiative (see chapter 1).

Elijah Albert Cox had worked as Brangwyn's assistant, and developed the style pioneered by

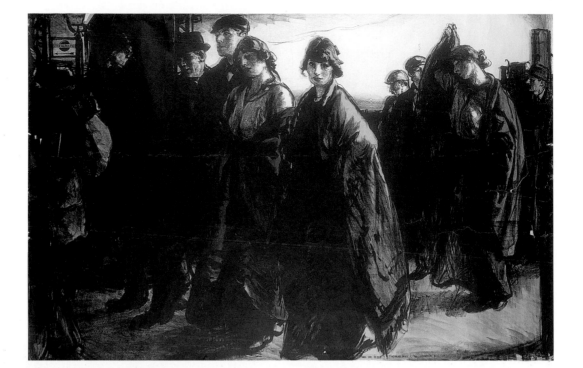

70 Workers' Way
Gerald Spencer Pryse, 1913

Four sheet
(1016mm x 1524mm)
Published by UERL
Printed by T.R. Way
& Company Ltd

71 Teddington: Riverside
Anthony Raine Barker, 1914

Four sheet
(1016mm x 1524mm)
Published by UERL
Printed by Johnson, Riddle
& Company Ltd

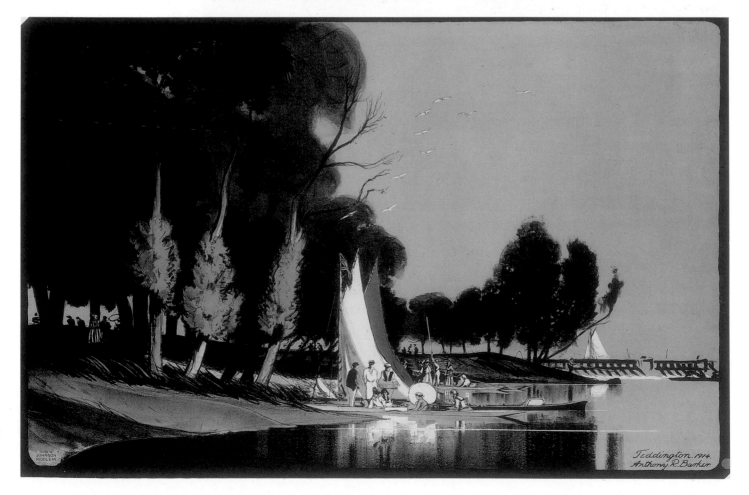

Brangwyn so that expressive drawing was combined with areas of bright colour (see plate 72). The complexity of design composition in colour lithography derives from the process requiring a separate working for each colour. The early pioneers of commercial colour lithography were able to develop amazingly complex poster designs worked with great sophistication, as evidenced by the designs of Charles Sims (see plate 73) and Philip Connard.[7]

Noel Rooke, another member of Central School staff and a key figure in the revival of wood-engraving and book arts, promoted a simplified form of poster design derived from coloured wood-cut prints (see plate 74). In this way, colour, simplicity and economy were combined to practical effect.

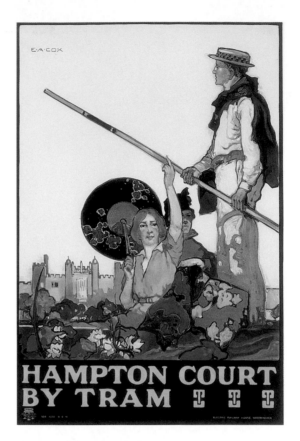

72 Hampton Court by Tram
Elijah Albert Cox, 1916
Double crown
(762mm x 508mm)
Published by UERL
Printed by the Avenue Press

**73 The Land of Nod
(A Reminder of Home)**
Charles Sims, 1917
Double royal
(635mm x 1016mm)
Published by UERL
Printed by the Avenue Press

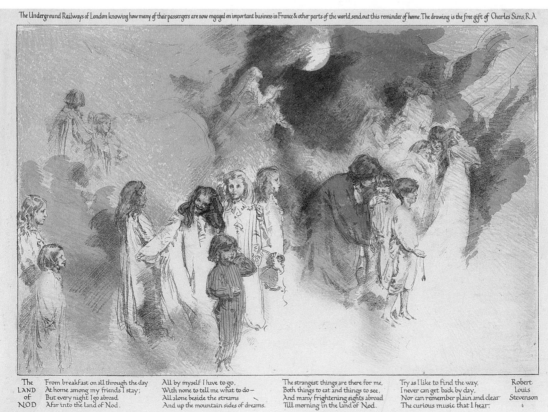

74 Virginia Water
Noel Rooke, 1922

Double crown
(762mm x 508mm)
Published by UERL
Printed by the Baynard Press

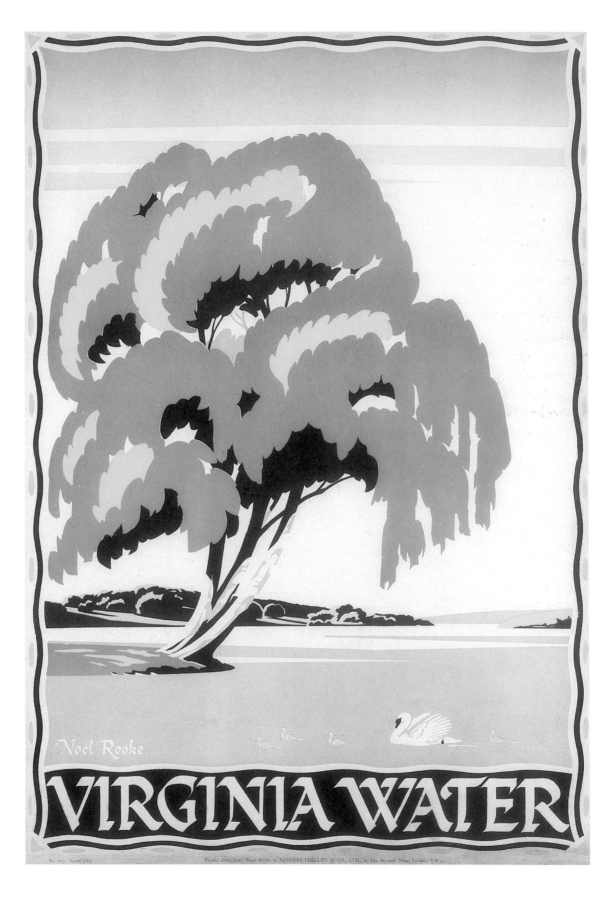

**75 London's Tramways:
Theatreland**
John Farleigh, 1923
(730mm x 360mm)
Published by LCC
Printed by Vincent Brooks,
Day & Son Ltd

The Central School and
LCC Tramway posters

In the 1920s, Fred V. Burridge, Principal of the Central
School, organised the production of an annual series
of simple black-and-white and coloured posters by
staff and students to publicise the LCC Tramways.
As the London County Council was involved in both
art education and transport, this was an entirely log-
ical connection, though it arose quite independently
of Pick. His privately owned Underground Group ran
most of the Tube lines, the District Railway, the main
bus company and three independent tram networks,
but they were all still in competition with the coun-
cil tramways. It was only with the creation of London
Transport in 1933 that the city's public transport was
merged into a single public corporation. By then
many former Central students had already moved on
from designing LCC Tramways posters (see plates 75
and 76) to wider commissions with the Underground.

A list of the LCC Tramways posters and their
Central School designers, compiled by Walter Shaw
Sparrow in 1924, reveals a particularly high propor-
tion of female artists.[8] The 1920s were a period of
considerable social strain. Women's emancipation
had been dramatically advanced as a consequence
of war work, but post-war opportunities for eco-
nomic independence remained limited. Furthermore
those women who, by temperament and cultural for-
mation, anticipated marriage, home, hearth and
family were faced with catastrophically limited
options after the carnage of the war. The nascent
creative economy provided one of the few routes
out of this impasse.

The Central School pioneered a form of egalitarian
coeducation with classes in which young men and
women mixed. Additionally, the low fees payable by
students further enlivened the social mix. This made
the School especially attractive to women and to

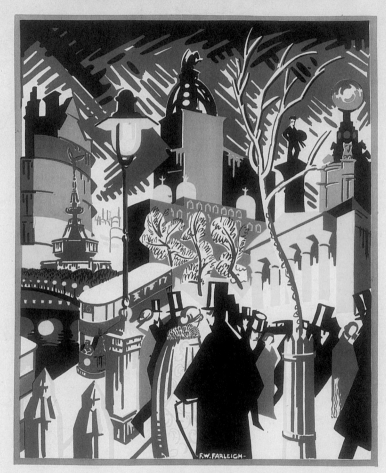

students from East London. A system of grants and bursaries was available to help students from poorer backgrounds. Several of the artists considered here, Freedman and Farleigh in particular, were beneficiaries of this system. It would be fair to characterise the School's demographic as projecting an air of unconventionality and inclusiveness that anticipated the youth culture of the 1960s. The resulting Bohemianism was, appropriately, less elevated than its Hampstead or Holland Park and Hammersmith predecessors of the late Victorian period.

The Central nurtured the first cohort of female artist-designers that included Enid Marx, Margaret Calkin James, Dora Batty, Pearl Binder, Freda Lingstrom and Betty Swanwick. All of them went on to do poster work for the Underground Group and London Transport. Some of them were also skilled textile designers. Enid Marx later produced seating moquette designs for London Transport and Dora Batty became Head of Textiles at the Central School.

The aftermath of the First World War also presented other opportunities. Francis Spear, who designed one of the Tramways posters whilst a Central student, went on to make his living, during the 1920s and 1930s, as a designer of stained-glass memorials. John Farleigh was introduced to wood-engraving by Noel Rooke while studying at the Central between 1920 and 1922. The LCC Tramways used several of Farleigh's student designs, in both colour and black-and-white. Farleigh returned to the Central as a tutor in 1925 and became a senior member of staff. He produced posters for London Transport at regular intervals throughout the 1930s and right up to 1964. In the late 1930s, when class sizes at the Central had become too large for individual tutorials, Farleigh was one of the first of the teaching staff to pioneer group criticism sessions with the students.

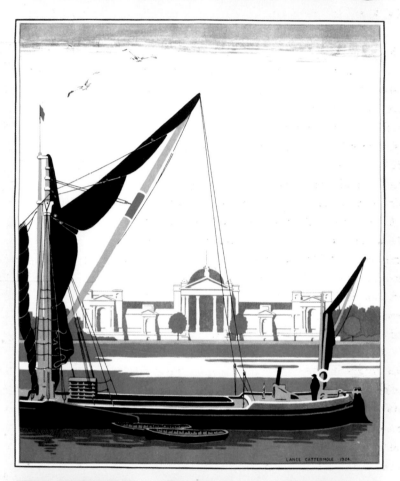

LONDON'S TRAMWAYS

TATE GALLERY
ALL TRAM SERVICES TO VICTORIA
ALIGHT AT GROSVENOR RD.

DESIGNED AT THE L.C.C. CENTRAL SCHOOL OF ARTS AND CRAFTS

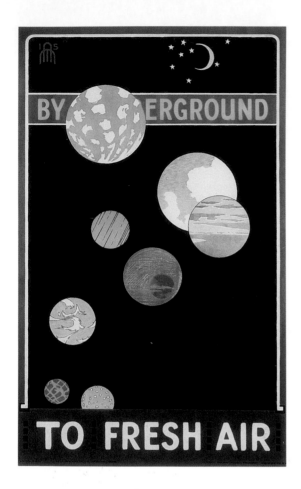

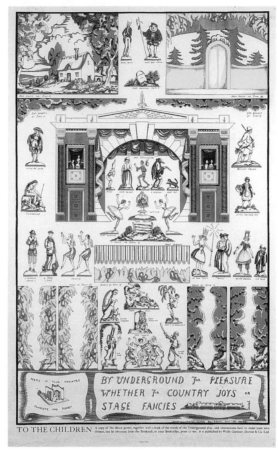

Commercial art

Four important reviews of the poster scene in Britain were published in 1924. These were Edward McKnight Kauffer's *Art of the Poster*, Percy V. Bradshaw's *Art in Advertising*, Walter Shaw Sparrow's *Advertising and British Art* and the first volume of *The Studio*'s annual review of posters and their designers, edited by Sydney R. Jones.[9] The titles tell us that, quite apart from an outbreak of publishing enthusiasm, each of these authors was at pains to stress the link between art and the advertising poster. In addition to these books, the publishing industry produced a series of new magazines, including *Commercial Art*, that testify to the widespread interest in design during the 1920s and into the 1930s. It certainly looked as though the objectives of the design reform movement had, by this time, become firmly established, if not completely achieved. The next stage in the development of poster design was to extend the reach of design reform in the graphic

arts through the transformation of commercial art.

The historical development of the poster has usually been described, in terms of design, as moving towards a complete integration of image and text. The processes of lithography facilitated this integration by making no distinction between the marks required for lettering or image.

The modern poster had, by 1910 in France and Germany, found an expressive means of combining economy, visual simplification and conceptual sophistication. In addition, the aesthetic simplifications driven by the requirement for commercial economy in lithography edged the design of posters towards an increasingly radical simplification of colour and form. The objectives of design reform in the graphic arts after 1918 became about achieving a balance between simplification and expression. This synthesis, pioneered most forcefully by McKnight Kauffer, expresses the British response to Modernism. An avant-garde poster design for the Underground by Maxwell Armfield in

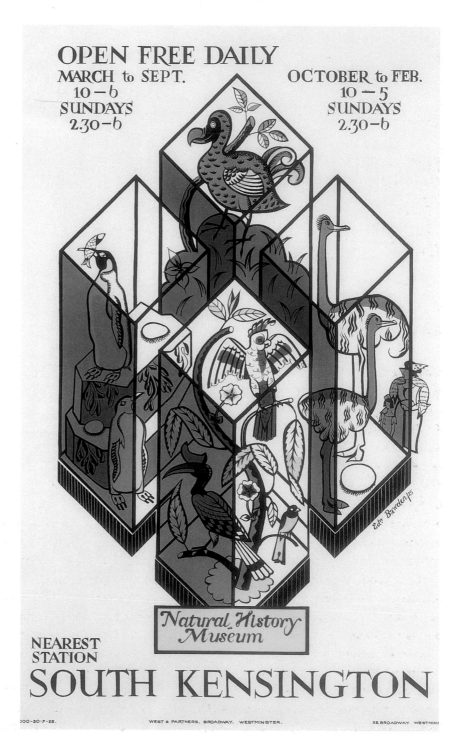

79 The Natural History Museum
Edward Bawden, 1925
Double crown
(762mm x 508mm)
Published by UERL
Printed by West & Partners

1915 (plate 77) shows that Pick was alive to the dramatic potential of modern art in commercial design from a very early date.

Harold Curwen of the Curwen Press, who had inherited a Victorian printing works in east London that specialised in traditional letterpress and lithographic sheet-music printing, attempted to implement Lethaby's ideas in a practical, professional and commercial environment from 1916 onwards (see chapter 3). The introduction of artists to his Plaistow factory transformed the visual quality of the Curwen output and at the same time provided an entry point for artists into the industry.[10]

William Rothenstein was part of a highly influential family of artists, printers and publishers. His brother Albert Rutherston was an artist and illustrator who, from 1919, worked with the Curwen Press. Rutherston (see plate 78) was friends with Lovat Fraser and a member, like Noel Rooke, of the Gordon Craig theatrical set. William's sons John and Michael were both later influential in very different ways in the art world – John as Director of the Tate Gallery and Michael as an artist and printmaker.

William had worked as an artist-lithographer and it was natural, after his appointment as Principal of the Royal College of Art in 1920, that he should extend the Senefelder and Central project to the RCA. Rothenstein was especially influential through his connections to the Curwen Press, where his nephew Oliver Simon was a Director.

Rothenstein was instrumental in appointing Paul Nash to the teaching staff at the RCA in 1924. Nash gave classes in design and introduced a stellar generation of artist-designers to the Curwen Press. Eric Ravilious, Edward Bawden, Enid Marx and Barnett Freedman were all his students (see, for example, plate 79). Douglas Percy Bliss, a friend and colleague of Bawden and Ravilious, gives a compelling account

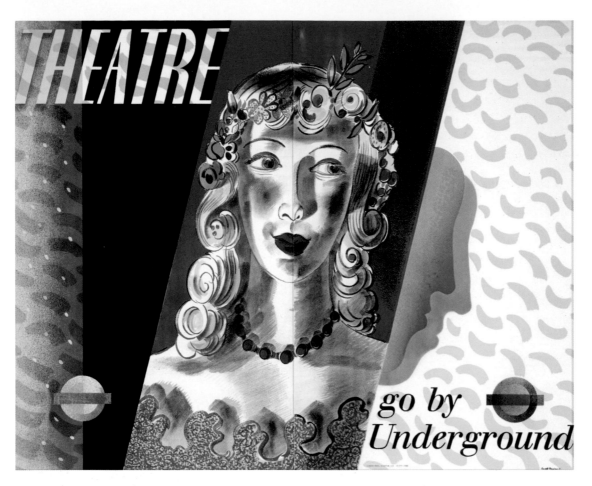

80 **Theatre by Underground**
Barnett Freedman, 1936

Pair poster – quad royal
(1016mm x 1270mm)
on two sheets
Published by London Transport
Printed by the Curwen Press

of classes at the RCA at this time in his memoir of Edward Bawden.[11]

Rothenstein intervened personally to allow Freedman entry to the RCA. Freedman was born into East End poverty and spent a lengthy period out of school and hospitalised. He was given paper and crayons and taught himself to draw. His lack of formal education might have limited his progress but for his exceptional ability in drawing. He enrolled for evening art classes at St Martin's College of Art and progressed to the RCA in what was an early, but not unique, example of widening participation. Freedman showed an amazing aptitude for lithography, and in the later 1930s and 1940s effectively became the senior spokesman for autolithography as promoted by the Curwen Press. His poster designs for London Transport are a *tour de force* of lithographic technique and are further embellished by the use of unusual inks and spot-varnish effects (see plate 80).[12]

James Fitton was a student and member of staff

at the Central School. His engagement with lithography exploited its potential for producing inexpensive prints so as to provide real-life images of working-class life. Spencer Pryse, a close colleague of Fitton's at the Central, had already made practical political use of lithography. Many of Fitton's poster designs address safety themes using information graphics derived from political propaganda.

Fitton established the Artists International in 1933, along with James Boswell and James Holland, as a means of mobilising the artistic community in support of left-wing politics. The association between the Central School and the Left derived, in part at least, from its socially diverse student demographic. Later, the radical potential of art and design students played itself out, in the different cultural contexts of the 1960s and 1970s, through the hedonistic lifestyle choices of the Summer of Love, punk and art-school cool.

Another group of artist-designers developed at

81 By Green Line Coach to Ongar
Clive Gardiner, 1937

Double royal
(1016mm x 635mm)
Published by London Transport
Printed by the Baynard Press

82 From Field to Field
Graham Sutherland, 1936

Pair poster – each double royal
(1016mm x 635mm)
Published by London Transport
Printed by Waterlow
& Sons Ltd

Goldsmiths' College in the School of Fine Art. The Goldsmiths' group, clustered around Clive Gardiner, included Betty Swanwick and Graham Sutherland (see plates 81 and 82). Goldsmiths' had attached itself, more than the Central School, to the etching boom of the early twentieth century. When the market in etched prints collapsed in the 1920s, the artist-printmakers of Goldsmiths' transferred some of their efforts to lithography, poster design and the evolution of the lithographic poster-print.[13]

A dramatic new type of poster composition emerged from the Grosvenor School of Modern Art

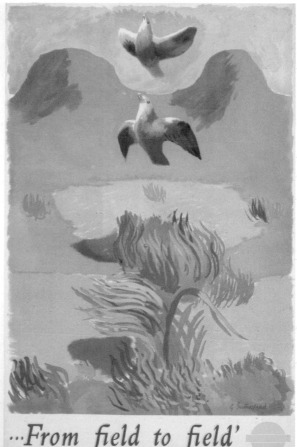

83 **Aldershot Tattoo**
Andrew Power (Sybil Andrews &
Cyril Power), 1934

Double royal
(1016mm x 635mm)
Published by London Transport
Printed by Waterlow & Sons Ltd

84 **America**
Austin Cooper, 1930

Double royal
(1016mm x 635mm)
Published by UERL
Printed by the Baynard Press

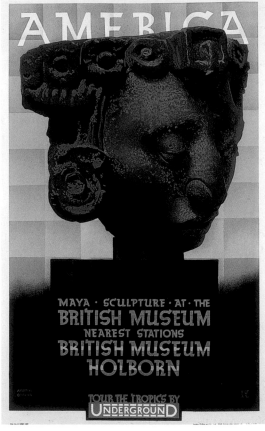

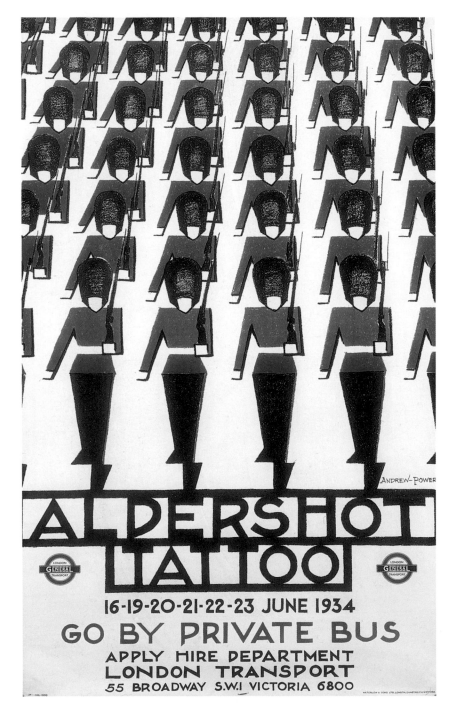

in the 1930s. Claude Flight, a tutor at the School, promoted the colour linocut as an inexpensive and contemporary form of printmaking. A dynamic, geometric, style became synonymous with a group of artists associated with Flight. Two of them, Cyril Power and Sybil Andrews, worked in collaboration to produce a series of posters for London Transport signed 'Andrew Power' (see plate 83).[14]

The most significant stylistic development in the commercial art of the 1930s was the increasingly widespread use of the airbrush in poster design. This new artist's tool allowed for the economical modelling of the flat colour demanded in commercial poster production. Its effects could quickly and

85 **Travels in Space**
Clifford & Rosemary Ellis, 1937
Double royal
(1016mm x 635mm)
Published by London Transport
Printed by the Curwen Press

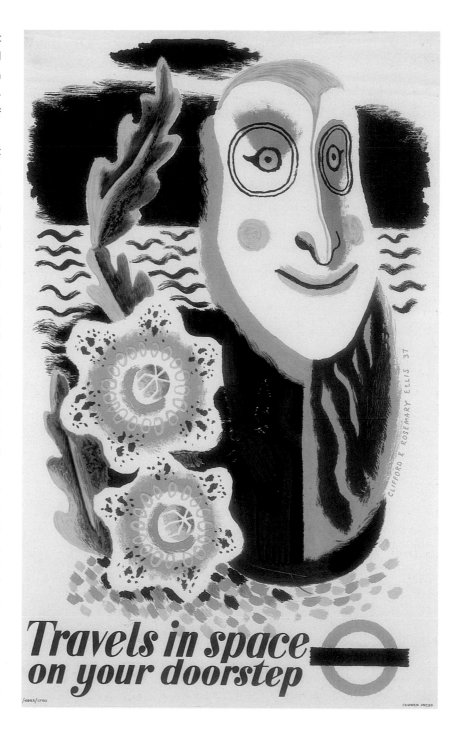

easily be reproduced in large-scale format so that it was ideally suited to the modern, Art Deco-inspired evolution of the poster. Austin Cooper, although self-taught, became a particular master of this technique and was one of the great poster designers of the 1930s (see plate 84).

Clifford Ellis attended St Martin's College of Art and, subsequently, the Regent Street Polytechnic, where he met Rosemary, his future wife. Together, they produced a number of posters for London Transport during the 1930s. The Ellises worked in a painterly style, effectively building up their designs as a succession of separate colour printings. These combined the expressive style of the early design reformers with a Fauvist-inspired colour palette.

Several of the artist-designers mentioned here helped develop a more subtle and indirect form of publicity. The posters of Clifford and Rosemary Ellis, Austin Cooper and Paul Nash, for example, often suggest ideas rather than products (see plates 85 and 86). The symbolic and Surrealist potential of the mysterious still-life images produced around themes of time, space and history speak of London's built and natural environment in allusive terms.

The artistic integration of disparate objects into a single coherent and meaningful sign, implicit in this approach to poster design, was a peculiarly English response to the emerging ideas of a psychological connection to place. The success of these mysterious and decorative images allowed the visual language of advertising in general to develop along more sophisticated lines than had previously been possible.

Photography and typography

In the 1930s, artists and designers began to experiment with the incorporation of photographic elements into the visual language of commercial art. The techniques of photomontage and collage were

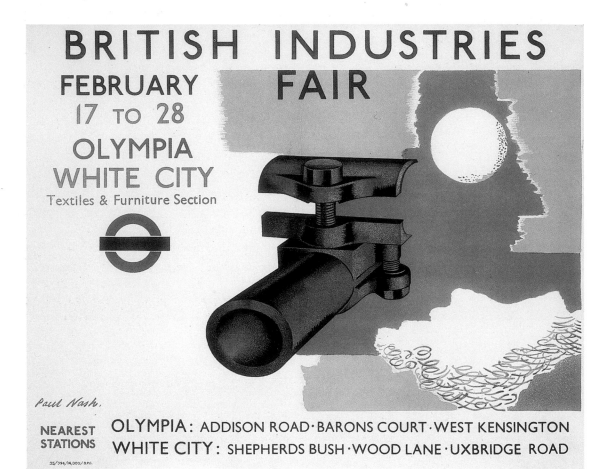

86 British Industries Fair
Paul Nash, 1935

Panel poster
(255mm x 330mm)
Published by London Transport
Printed by the Dangerfield
Printing Company Ltd

central to Surrealist and Dadaist concerns. Paul Nash was at the forefront, both as an artist and a writer, of practical attempts to integrate photography, fine art and design into a coherent whole (see plate 87). Nash was a member of Unit One (founded in 1934) and was on the organising committee of the famous London Surrealist Exhibition (1936). Nash's posters for London Transport exemplify the sense of experiment that is implicit in the attempt to create a new visual language for modern London.[15]

Edward McKnight Kauffer was another figure closely associated with the English Surrealists. Kauffer's reputation as London's top modern designer

was firmly established by the mid-1930s. He had been given a studio by his patron Peter Gregory, of the printers and publishers Lund Humphries, and developed this space as a gallery and laboratory of Modernist experimentation. Kauffer's studio in Bedford Square became a magnet for design students and for émigré designers arriving from mainland Europe.[16]

The consolidation of the city's Underground, bus and tram operations into London Transport in 1933 was an opportunity for Pick, as Chief Executive, to further integrate various design elements into what we would now understand as a coherent corporate identity. Independently of design reform in poster art,

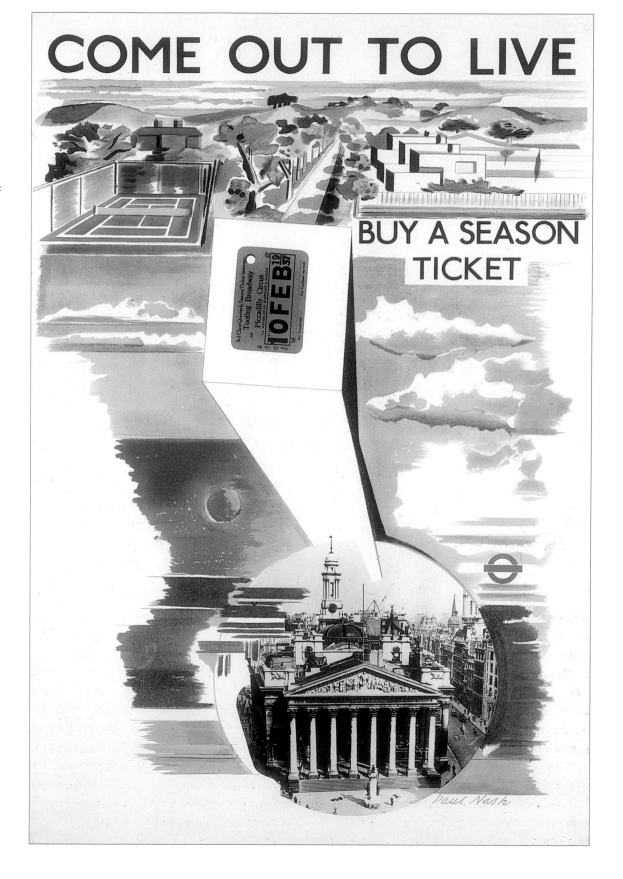

87 Come Out to Live
Paul Nash, 1936

Double royal
(1016mm x 635mm)
Published by London Transport
Printed by the Baynard Press

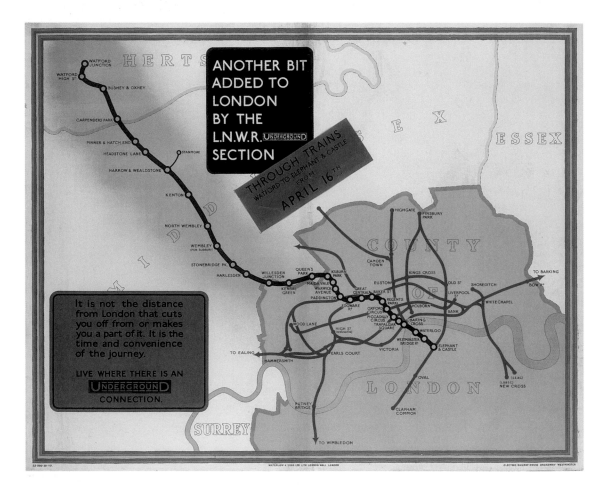

ANOTHER BIT ADDED TO LONDON BY THE L.N.W.R. UNDERGROUND SECTION

THROUGH TRAINS WATFORD TO ELEPHANT & CASTLE FROM APRIL 16TH

It is not the distance from London that cuts you off from or makes you a part of it. It is the time and convenience of the journey.

LIVE WHERE THERE IS AN UNDERGROUND CONNECTION.

88 **Another Bit Added to London by the LNWR Underground Section**
Artist unknown, 1917

Quad royal
(1016mm x 1270mm)
Published by UERL
Printed by Waterlow & Sons Ltd

Pick had already commissioned the Underground's own letterface for signs and posters from Edward Johnston, standardised the company's bar-and-circle logo and, after some hesitation, adopted the radical simplifications of Harry Beck's diagrammatic Tube map.

Pick commissioned the Underground typeface, Johnston Sans, from Edward Johnston during 1915 and 1916 (see chapter 2). It first appeared on posters the following year (see plate 88), although the letters took some time to take shape as Pick was anxious that travellers should be able to read typographic information and instructions as instantaneous signs. After a period of discussion between Pick, Johnston, Eric Gill and Gerard Meynell, it was decided that the design of a block letter would exemplify this fitness for purpose.[17] Johnston and Gill had come into contact when Gill enrolled as a student on Johnston's lettering and calligraphy classes at the Central School in 1899.

By the 1930s Gill was designing for the Monotype Corporation and, suddenly, block lettering and sans-serif types were everywhere.[18] Johnston, meanwhile, had overseen the integration of his Underground lettering with the bar-and-circle device. More than any other single graphic development, this combination of lettering and logo symbolised Modernity and appeared all over London on bus stops and Underground stations (see plate 89).

The Underground typeface generally worked

89 Chrysanthemums
Tom Purvis, 1932

Double royal
(1016mm x 635mm)
Published by UERL
Printed by Waterlow & Sons Ltd

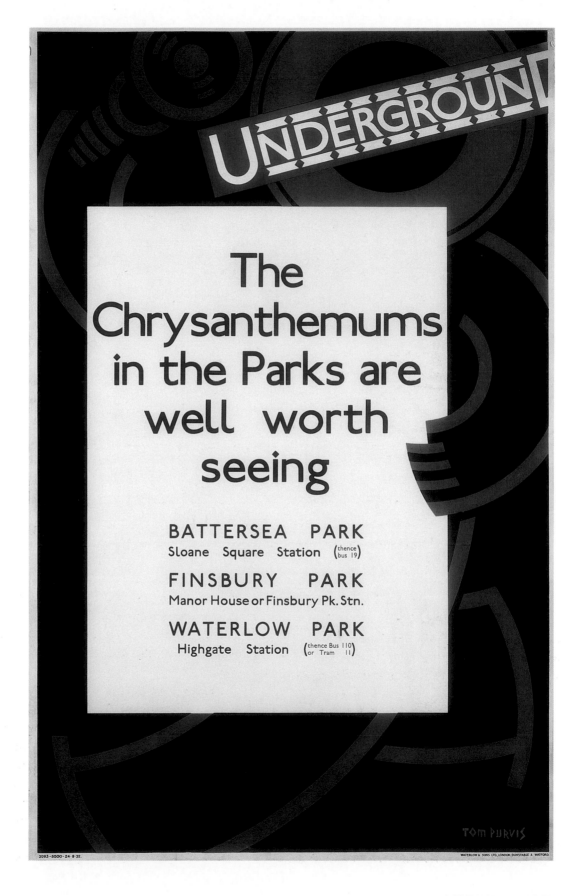

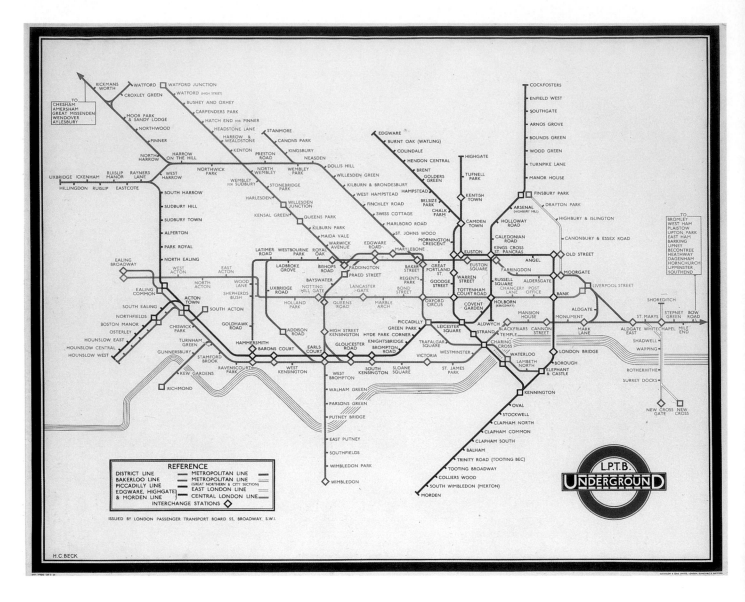

very well with the travelling public as it was progressively introduced across the system in the 1920s. From the user's perspective, the signage was clear, elegant and expressive of a no-nonsense modernity. This was, effectively, exactly what Pick had hoped for.[19] In the same way, the rationalism implicit in the simplifications of Harry Beck's diagrammatic map of the Underground from 1933 (plate 90) communicated a message of convenience, service and Modernity, prominently displayed in poster form at the entrance to all Tube stations.[20]

The availability of letterform, logo and map, in their standard Modernist forms, helped to transform graphic design into an activity of combination and assembly. Similarly, the development of photomechanical technologies further transformed the graphic environment. In all these cases, and for the reasons we have seen, London Transport was ideally placed to benefit from these transformations.

These opportunities saw the emergence of a new generation of graphic designers. Richard and Maurice Beck produced a number of posters for London Transport using photomontage embellished with fine airbrush technique (see plate 91). Tom Eckersley and Eric Lombers were young commercial artists who were open to the potential of photography and typography in reshaping the visual language of modern Britain. Together they produced several small

90 **Map of the Underground**
Henry C. Beck, 1933

Quad royal
(1016mm x 1270mm)
Published by London Transport
Printed by Waterlow & Sons Ltd

91 Becontree's New Park
Richard Beck (photo by Kate
Jacob), 1935
Panel poster
(255mm x 318mm)
Published by London Transport

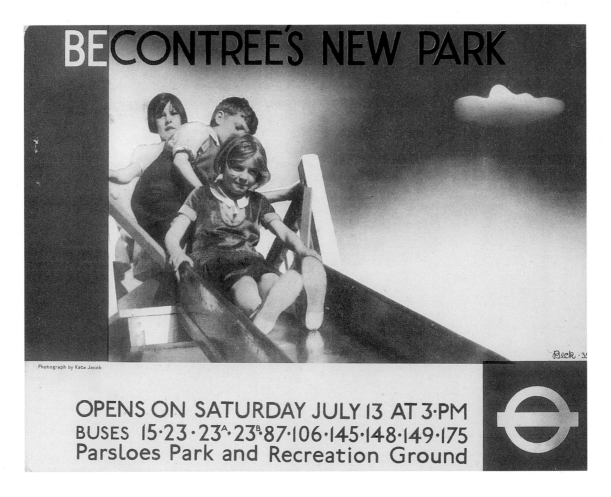

panel posters for London Transport in the 1930s that incorporate photographic elements so as to create powerful three-dimensional effects. Eckersley and Lombers used the platform of their classes at Westminster School of Art to promote the status of poster design.

The new design education, implicit in the technocratic assembly of photograph and typography, was also promoted through the London Reimann School. The School had its origins in Berlin at the beginning of the twentieth century and promoted a vocational training that responded to the changing demands of the market. Austin Cooper was Principal of the London establishment.[21]

Jesse Collins joined the staff at the Central School at the end of the 1930s. One of his challenges was to respond to a more competitive environment in design education. He helped prepare the school for the post-war transformations of commercial art and the emergence of graphic design (see plate 92).

By 1930 the objectives of design reform had been achieved. Lithography, at least in its auto-lithographic form, had been accepted as a legitimate means of artistic expression. With the help of Pick's patronage, these ideas had become integrated into the visual mainstream of commercial art. By the end of the 1930s, poster design had evolved

92 1939 Exhibition
Jesse Collins, 1939
Panel poster
(255mm x 318mm)
Published by London Transport
Printed by Waterlow & Sons Ltd

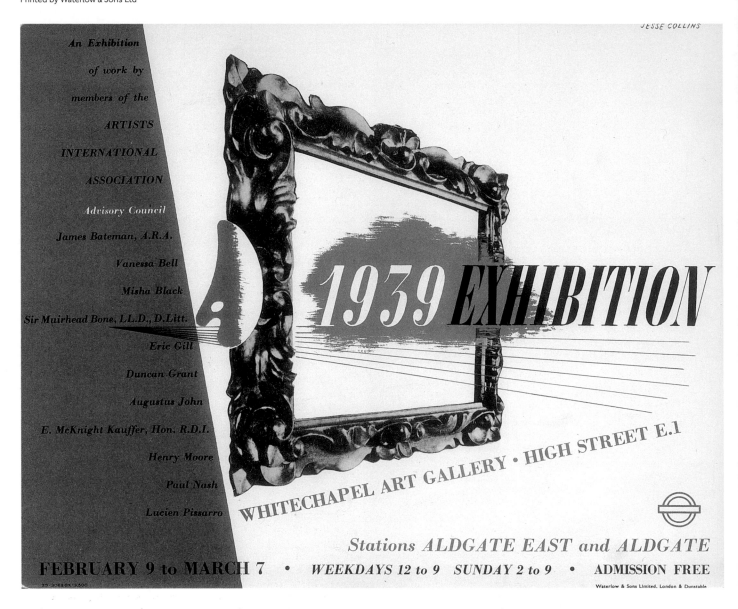

to become a hybrid of sophisticated elements drawn from the conjunction of fine art and technology.

The success of this project was reflected in the developing bibliography of the poster during the 1930s. The new books about posters shift their emphasis from the historical development of poster art to offering practical advice about lithography and design. The most significant of these, published in 1938, are by Tom Purvis and Austin Cooper.[22] Both promote an approach to design that assembles a poster from a choice of different elements. The successful integration of typographic, photographic and artistic parts into a coherent and meaningful whole had, by the end of the 1930s, become the benchmark of good design. Frank Pick's encouragement of design reform through the patronage and support of London's art schools was crucial in effecting this change and transforming the popular visual culture of London.

Notes

1. Nikolaus Pevsner, 'Patient progress: the life work of Frank Pick', *The Architectural Review*, 1942, vol.XCII, no.548. Pevsner was writing on the occasion of Pick's death in 1941.

2. Not all the main London art schools feature in this story. The main protagonists are the Central School and the Royal College of Art. The London College of Printing, for example, was a trade school that eschewed the main objectives of design reform until the 1960s when, under the guidance of Tom Eckersley, it played a crucial role in defining the graphic style of swinging London. Similarly, St Martin's came into its own during the 1950s when its proximity to Soho and the Institute of Contemporary Art (ICA) allowed it to play an important role in the evolution of pop culture. Paul Rennie gives a general account of the impact of the Central School illustration on advertising in S. Backemeyer (ed.), *Picture This: The Artist as Illustrator*, A. & C. Black, London, 2005.

3. The formation of the DIA and interactions of its guiding personalities is well documented. C. Barman, *The Man Who Built London Transport*, David & Charles, Newton Abbot, 1979, and M.T. Saler, *The Avant-Garde in Interwar England*, Oxford University Press, Oxford and London, 1999, include detailed accounts of Pick's role in the DIA.

4. Relations between Pick, Lethaby and Harold Curwen were especially sympathetic due to their shared backgrounds in religious Nonconformism. The practical consequence of this background was a design reform whose priorities acknowledged the campaign as having both an economic and a social value.

5. W. Shaw Sparrow, *Advertising and British Art*, John Lane, London, 1924, p.77.

6. The major figures of design reform in poster art are described and listed by Shaw Sparrow in *Advertising and British Art*, p.165.

7. Because of its complexity and sophistication, the technical process of colour lithographic printing is rarely described. H. Curwen, *Processes of Graphic Reproduction*, Faber & Faber, London, 1934 and T.E. Griffits, *The Technique of Colour Printing by Lithography*, Crosby Lockwood & Son, London, 1940 are standard texts. The gradual build-up of effects through overprinting may be seen through the examination of progressive proofs.

8. Artists listed and included in Shaw Sparrow, *Advertising and British Art*, p.172.

9. *The Studio* published their annual review of poster advertising and design under the title 'Modern Publicity'.

10. P. Gilmour, *Artists at Curwen*, Tate Gallery Publications, London, 1977 gives a detailed account of the interaction between artists and the Curwen Press. H. Simon, *Song and Words*, Allen & Unwin, London, 1973, and O. Simon, *Printer and Playground*, Faber & Faber, London, 1956 offer different perspectives on this story.

11. D.P. Bliss, *Edward Bawden*, Pendomer Press, Godalming, 1979, p.18.

12. I. Rogerson, *Barnett Freedman*, Fleece Press, Huddersfield, 2006 describes Freedman's skill as a lithographer.

13. For an account of the poster-print, see: P. Rennie, 'The poster-print', ch.7, in R. Garton (ed.), *British Printmakers*, Scolar Press, London, 1992.

14. S. Coppel, *Linocuts of the Machine Age*, Scolar Press, Aldershot, 1995 describes the Grosvenor School and its students in detail.

15. The bibliography devoted to Paul Nash is now quite extensive. Paul Nash, *Outline: An Autobiography, and Other Writings*, Faber & Faber, London, 1949 provides a good starting point for further study.

16. M. Haworth-Booth, *E. McKnight Kauffer*, V&A Publications, London, 2005, establishes the significance of Kauffer as a central figure in the Modernist community in Britain.

17. Justin Howes (*Johnston's Underground Type*, Capital Transport, Harrow Weald, 2000) describes the evolution of Johnston's Underground typeface in detail.

18. The block letter and sans-serif typeface became the default for Modernising corporations during the 1930s. The use of Gill Sans by the London & North Eastern Railway (LNER) gave the impression, to the general public at least, of typographic coherence from London to Edinburgh.

19. David Lawrence (*A Logo for London: The London Transport System*, Capital Transport, Harrow Weald, 2000) has described the evolution of the roundel in detail.

20. Ken Garland has described the work of Harry Beck in detail in *Mr Beck's Underground Map*, Capital Transport, Harrow Weald, 1994.

21. The Reimann School (Berlin) is described by J. Aynsley in *Graphic Design in Germany*, University of California Press, Berkeley, 2000.

22. Tom Purvis, *Poster Progress*, The Studio, London, 1938; Austin Cooper, *Making a Poster*, The Studio, London, 1938.

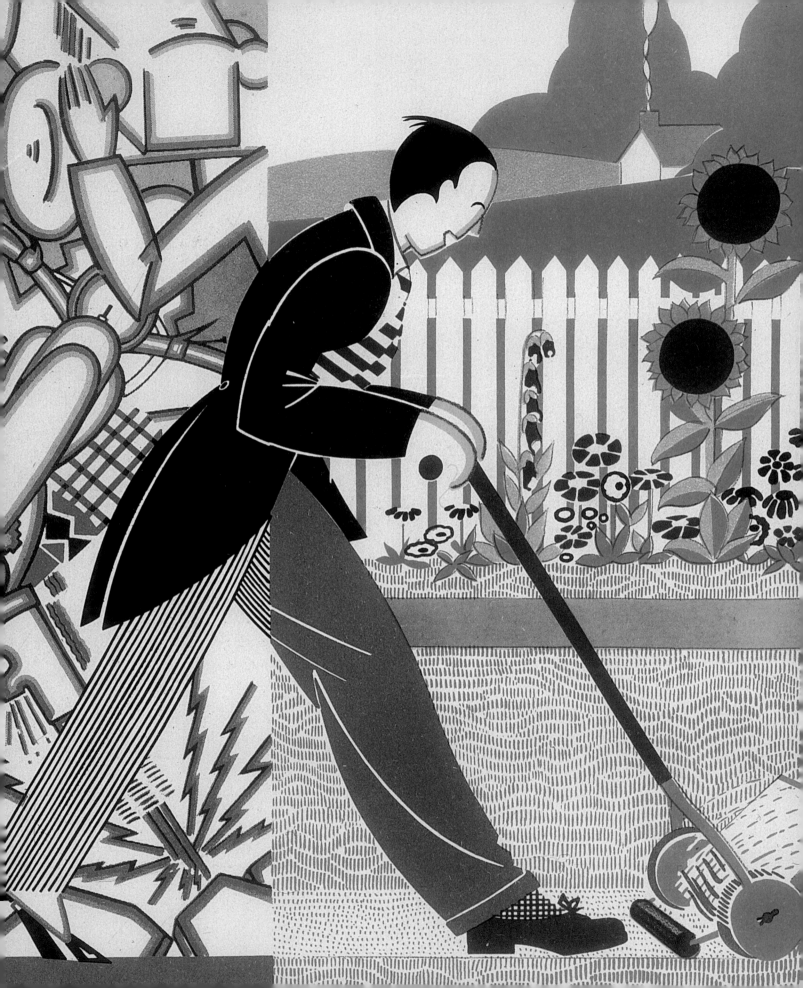

SELLING THE UNDERGROUND SUBURBS 1908-33

David Bownes

RAILWAY POSTERS WERE designed to sell a service or convey a message. This simple truth is often forgotten in discussing the artistic merits of poster design and Frank Pick's legendary role as a patron of art. Yet of the many poster campaigns commissioned by Pick and his contemporaries, the intensive drive to sell the transport-created suburbs of early-twentieth-century London was perhaps the most remarkable and, ultimately, successful of all.

From tentative beginnings in the 1900s, to the housing boom of the 1920s and 1930s, the Underground Group and Metropolitan Railway were far ahead of their rivals in using posters and associated publicity to sell an aspirational vision of suburban life. The Underground, in particular, engaged many of its brightest stars to persuade Londoners of the benefits of commuting, including the superb architectural draughtsman Fred Taylor and the landscape artist Walter Spradbery. Other dependable veterans, such as Charles Paine, produced outstanding designs stressing the modernity and convenience of living near the Underground.

Throughout, the target audience was primarily middle class.[1] Prior to the First World War, this group included both renters and buyers. Afterwards, the emphasis

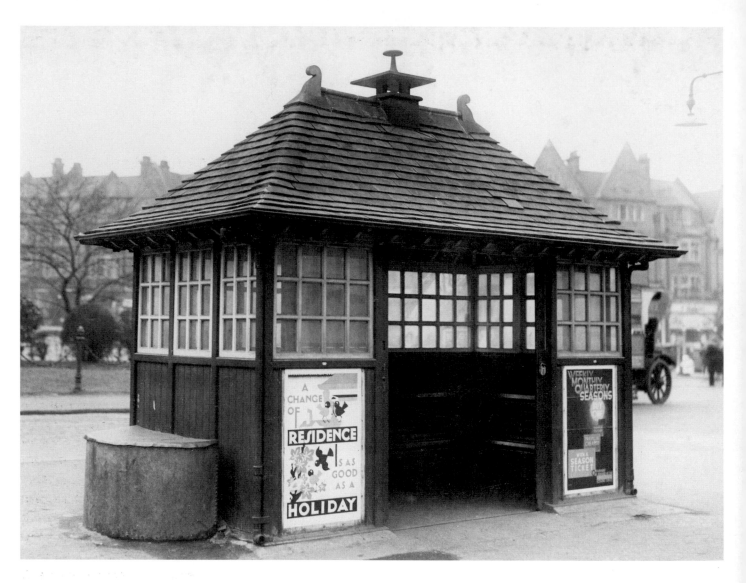

shifted to home ownership, although the approach to selling the suburbs remained largely unchanged, characterised by depictions of domestic bliss and harmony with nature. In this way, posters helped create a sense of identity for the new suburban communities based on an idealised concept of family life and physical health

Of course, the motivation behind the campaigns was financial rather than philanthropic. By developing new routes and improving services, the underground railways sought to populate once-rural districts with commuters tied to their services – a desire reflected in the frequent juxtaposition of posters selling suburbs and season tickets (see plate 93). It was a risky venture though, dependent on housing following where the rail companies led.

In this respect, broader economic factors were very much in the rail companies' favour. Rising wages (especially in middle-class jobs) and the relaxation of bank lending rules helped create an army of potential homeowners in the London area. Shorter working days also enabled commuters to travel further to work, while low building costs and government assistance to extend and electrify suburban railways provided additional stimuli for the interwar housing market.

The underground railways were well placed to capitalise on these conditions, as their frequent electric trains, direct to dozens of central London stations, made longer-distance commuting a viable proposition. In doing so, the modern concept of Greater London was born.

93 Posters displayed on a bus shelter at Golders Green, 8 March 1929. Charles Paine's housing poster (**A Change of Residence is as Good as a Holiday**) is on the left, mirrored on the right by Austin Cooper's design advertising Underground season tickets. By this date, both the bus operator (LGOC) and the Tube were owned by the same company. Interestingly, neither poster promotes bus services.

94 Golders Green
Artist unknown, 1908
Double royal
(1016mm x 635mm)
Published by UERL
Printed by Johnson, Riddle
& Company Ltd

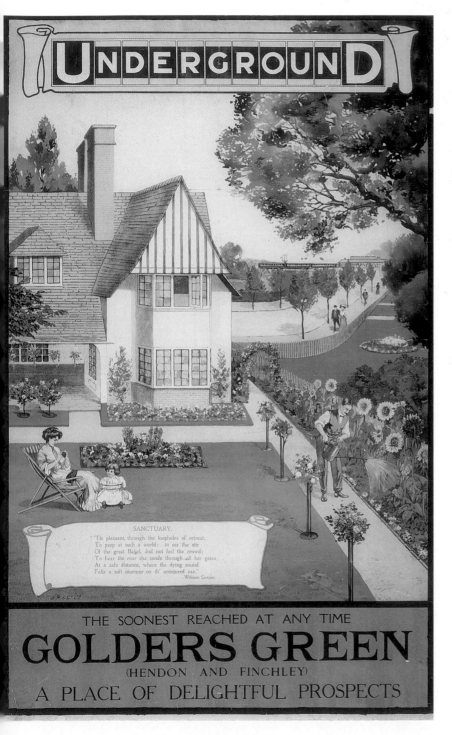

Golders Green for Healthy Homes

Golders Green, in north London, was the first Tube railway suburb. Its transformation from isolated rural hamlet to dormitory town was based on an established business model pioneered in Chicago, where electric 'street cars' were commonly used to open up rural districts for suburban housing, supported by publicity campaigns promising city-dwellers a more prosperous and healthier lifestyle as commuters.[2] In contrast, the early London Tubes had concentrated on relieving congestion within the existing built-up area, while mainline railways tended to regard suburban trains as a nuisance which interrupted more profitable traffic. Neither had invested much effort in encouraging passengers to live near the railway.

The American approach was brought to London by the ex-Chicago transport mogul, Charles Tyson Yerkes. By 1902, Yerkes had taken control of several unbuilt Tube lines and revived a dormant proposal to extend the Hampstead Tube overground to Golders Green with the intention of creating a new suburb. Yerkes died before the railway was completed, but American methods remained influential in the company he formed, thanks to the appointment of the American-trained General Manager, Albert Stanley (later Lord Ashfield).

By the time the Hampstead Tube opened in June 1907, a number of speculative houses had already been built around the site of Golders Green station and nearby at Hampstead Garden Suburb – an idealistic mixed-class settlement influenced by the 'garden city' philosophy of Ebenezer Howard. This low-density suburb soon became a favoured residence for middle-class intellectuals, successful artists and businessmen, including Frank Pick who moved there in about 1920. Golders Green itself experienced immediate, and unprecedented, growth, with both builders and the UERL anxious to attract middle-class residents.

The first poster for Golders Green (1908, plate

95 Tram Services to Finchley and Cricklewood
Artist unknown, 1909

Double royal
(1016mm x 635mm)
Published by UERL
Printed by Johnson, Riddle
& Company Ltd

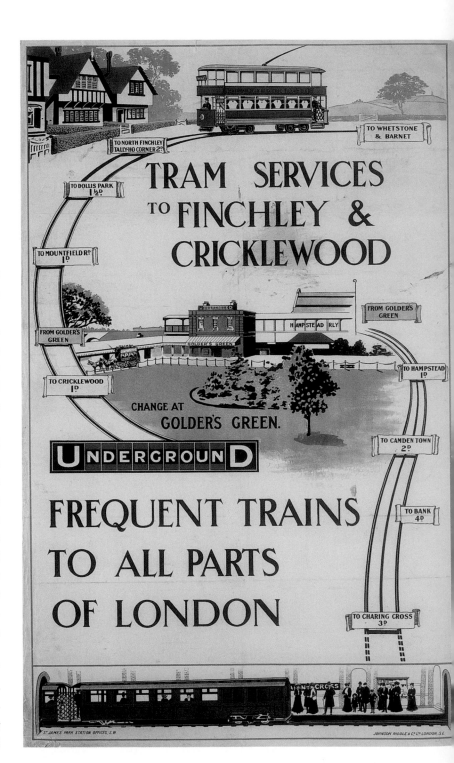

94) established a visual language for suburban selling repeated many times over the next 25 years. Central to the design is an artistic, rather than photographic, representation of an idyllic home in Hampstead Garden Suburb, with softer lines and fuller gardens than the newly built reality. The contented family group, centred on the garden, struck at the heart of middle-class values and strongly implies that a house on the Underground (represented by the station in the background) allows more time for homely pursuits. The message is more explicitly stated at the base of the poster, and reaffirmed in the extract from William Cowper in praise of finding a rural retreat from 'the great Babel' of the town.[3] The composition and text reflect American place-selling techniques, in which English poets (including Cowper) were quoted to similar effect.[4] The poster is also in tune with a new interest in homes and gardens, typified by the first Daily Mail Ideal Home Exhibition held in 1908 and the domestic design values of the Arts and Crafts Movement.

A second poster, from 1909, gives a more literal depiction of the transport services on offer (plate 95). Golders Green station was served by trams from North Finchley and Cricklewood, and by horse buses to Hendon. These services helped to develop the surrounding areas, and brought passengers to the Tube. Tram and Tube are shown making a physical link between the new houses at the top of the poster and Charing Cross station at the base. This is the only example of a Tube poster linking trams with suburban development, even though both services were operated by the Underground Group.

Related publicity stressed the 'pure bracing air' of the suburb and cannily referred to the opportunities for turning a quick profit, should the new homeowner decide to move.[5] The concern with healthy living was reiterated in a poster of 1910 entitled

96 Golder's Green for Healthy Homes
Artist unknown, 1910

Panel poster
(527mm x 215mm)
Published by UERL
Printed by Johnson, Riddle
& Company Ltd

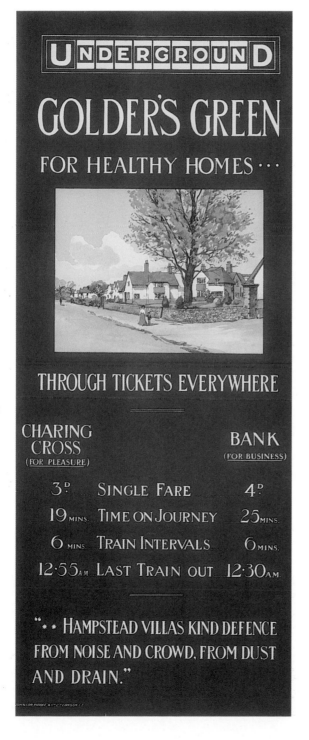

Golder's Green for Healthy Homes (plate 96). Once again, the houses shown are in the more desirable Hampstead Garden Suburb, rather than Golders Green itself. The view, of Temple Fortune Lane, was used elsewhere to advertise the availability of 'artistic houses' (designed here by E. Guy Dawber) and the sympathetic retention of ancient trees on the new estates.

The marketing message proved suitably seductive. By 1915, ten million journeys a year were being made from the station, resulting in the successful conclusion of the poster campaign. Golders Green had shown the way for Tube expansion, and the promotional methods trialled here were eagerly copied elsewhere after the First World War.

Houses to suit all classes

Despite the success of Golders Green, a transport-led housing boom was slow to materialise and needed active marketing. From 1907, the UERL published several booklets promoting existing residential districts, but passenger figures were disappointing.[6] In an effort to increase numbers, Frank Pick was appointed Traffic Development Officer in 1909 with a brief to publicise services.

Within a year, Pick commissioned half a dozen posters advertising a range of suburbs in north and west London. Between 1910 and 1916 the focus moved to 'the Healthy Districts in Middlesex', reached by the District Railway's overground trains (part of the Underground Group) and connecting services on the independent Metropolitan Railway.

The poster for Dollis Hill (1910, plate 97) is typical of this period. In a reversal of the traditional story of the country mouse visiting his urban cousin, an anaemic-looking town mouse is shown talking to his robust rural counterpart. The dialogue makes it clear that the country, or suburban, mouse has the

97 Live in a New Neighbourhood
Alfred France, 1910

Double royal
(1016mm x 635mm)
Published by UERL
Printed by Johnson,
Riddle & Company Ltd

The same image was used
to promote 'wooded'
Ruislip, and other versions
may have been printed.

98 Are You House Hunting?
Haddock, 1912

Double royal
(1016mm x 635mm)
Published by UERL
Printed by Johnson,
Riddle & Company Ltd

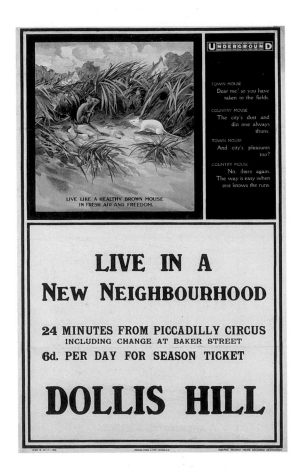

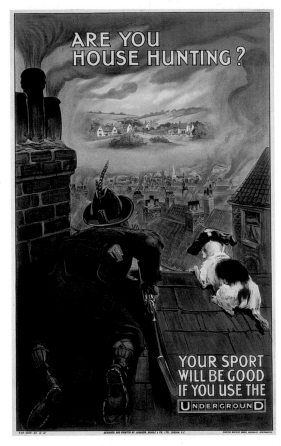

99 Reconstruction of poster
display at District Railway
stations, 1916

(top left) **Your Next Move
and Your Best is on to
Underground**
Fred Taylor, 1914

Double royal
(1016mm x 635mm)
Published by UERL
Printed by Johnson, Riddle &
Company Ltd

(top right) **What is
Home to You?**
P. Cottingham, 1915

Double royal
(1016mm x 635mm)
Published by UERL
Printed by Waterlow & Sons Ltd

(bottom) **A New
Neighbourhood:
Sudbury Hill**
Paul Rieth, 1916

Double royal
(635mm x 1016mm)
Published by UERL
Printed by Waterlow & Sons Ltd

best of both worlds — fresh air and easy access to the city. As the caption suggests, Dollis Hill was 'a new neighbourhood', built around a station opened in 1909. Other posters from this time stressed the lower living costs found in Middlesex, offering middle earners a more 'respectable' lifestyle than they could enjoy elsewhere.

Not all residential posters advertised a specific location. *Are You House Hunting?* (1912, plate 98) was designed for wide circulation. The armed house-hunter has several copies of *Homes on the Underground*, covering north and west London, in his jacket pocket. The smoky Victorian terraces of the foreground are contrasted with an idealised group of low-density, modern, semidetached houses set in lush countryside. Architecturally, the semis are rooted in the Arts and Crafts tradition, pioneered by C.F.A. Voysey and M.H. Baillie Scott and much favoured on the new garden-suburb estates. The same image was used for a promotional postcard with season ticket details printed on the reverse.

A similar generic poster was designed by Fred Taylor in 1914, and often displayed alongside one by P. Cottingham promoting season tickets as the quickest way home (plate 99). Taylor's design uses the image of a chessboard (later copied by the Metropolitan Railway) as a metaphor for 'your next move' and to convey the idea that houses on the Underground

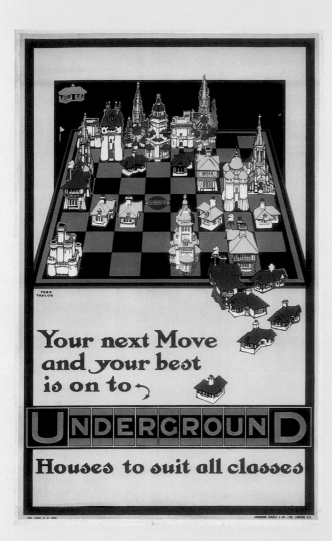

Your next Move
and your best
is on to →

UNDERGROUND

Houses to suit all classes

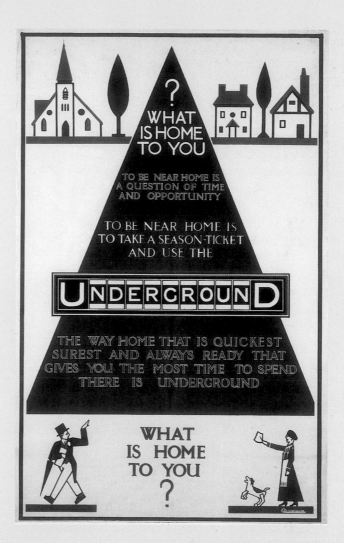

WHAT IS HOME TO YOU

TO BE NEAR HOME IS A QUESTION OF TIME AND OPPORTUNITY

TO BE NEAR HOME IS TO TAKE A SEASON-TICKET AND USE THE

UNDERGROUND

THE WAY HOME THAT IS QUICKEST SUREST AND ALWAYS READY THAT GIVES YOU THE MOST TIME TO SPEND THERE IS UNDERGROUND

WHAT IS HOME TO YOU ?

A NEW NEIGHBOURHOOD
SUDBURY HILL

LIVE WHERE IT IS ONLY A STEP ▨ ▨ ▨ ▨
FROM YOUR FRONT DOOR INTO THE COUNTRY

CHEAP SEASONS
CHEAP FARES
CHEAP RENTS
SPECIAL TRAINS
FOR WORKERS
MORNING & EVENING

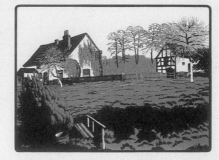

TRAINS EVERY
TWENTY MINUTES
THROUGHOUT
THE DAY
WORKMEN'S
TICKETS

WATERLOW & SONS LTD. LITH. LONDON WALL, LONDON. ELECTRIC RAILWAY HOUSE, BROADWAY, WESTMINSTER, S.W.

100 Metro-land
Michael Reilly, 1926
Double royal
(1016mm x 635mm)
Published by Metropolitan
Railway
Printed by S.C. Allen
& Company Ltd

are available 'to suit all classes' — although, in practice, suburban rents and house prices were well beyond the budgets of manual and semi-skilled workers.

Both posters were used in conjunction with an advertisement for Sudbury Hill, exhibited at District Railway stations in 1916 (plate 99).[7] In keeping with the egalitarian message of Taylor's design, the poster stresses the availability of cheap rents and workmen's fares, aimed, predominantly, at higher-paid, skilled workers. Once again, the nearness of the country is prominently marketed, illustrated by a farmhouse and rustic barn.

Wartime conditions gradually brought an end to suburban development, although three more housing posters were printed by the Underground. The first, in November 1916, showed a group of prize vegetables 'grown in Chiswick by an amateur', above a slogan urging passengers to 'live near the Underground and spend the minutes thus gained on the land. A season ticket and a vegetable garden are each a war economy'!

The others, published in 1917, promoted the newly opened route to Watford (via the London & North Western Railway), under the headings 'Live on the Hills. The higher up the fresher the air' and 'Live where there is an Underground connection' (see chapter 4, plate 88). It is hard, though, to imagine anyone contemplating moving home at that stage in the war, especially as house building had all but ceased.

Metro-land

Metro-land was the most famous place-selling campaign of its type, celebrated in song, poetry, novels, television and film.[8] Coined in 1915, 'Metro-land' originally described the parts of Middlesex, Hertfordshire and Buckinghamshire served by the Metropolitan Railway. Later, it became synonymous with the railway-created suburbia of northwest London and beyond.

Metro-land's origins lay in the ill-fated mainline

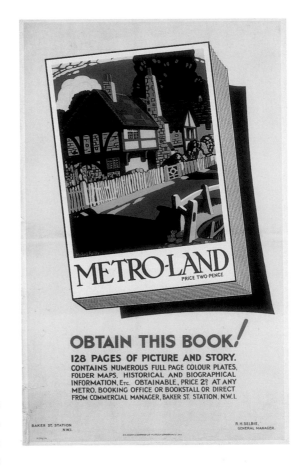

ambitions of the Metropolitan Railway (the world's first underground) during the nineteenth century. An overground extension north from Baker Street was intended to tap existing suburbs and create a new trunk route into London, but instead left the company with fifty miles of poorly used railway and large tracts of surplus land. From the 1880s, the Metropolitan Railway developed some of the land itself by exploiting unique privileges granted under its earlier Acts.[9]

Initial house building was limited in scale and erratically promoted. The appointment of Robert Selbie as the Metropolitan Railway's General Manager (1908–30) brought fresh impetus to the policy of suburban development at a time when the company

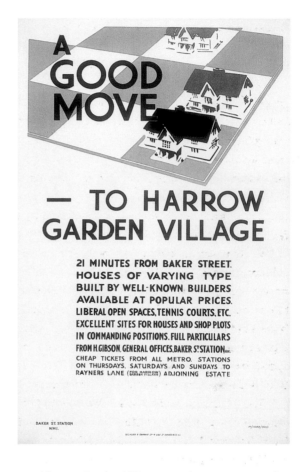

101 **A Good Move – to
Harrow Garden Village**
Artist unknown, *c.*1930
Double royal
(1016mm x 635mm)
Published by Metropolitan
Railway
Printed by S.C. Allen
& Company Ltd

needed to increase revenue. Publicity was transformed, with new publications aimed at middle-class home-seekers. One of the first posters produced under the new regime extolled the virtues of 'Healthy Harrow' (1909), while a poster map, *From City to Country Home* (1911), depicted every residential area on the line, no matter how far from London.

The famous *Metro-land* guidebook first appeared in 1915. Lavishly illustrated, the guide contained information on the countryside, historic towns and new estates making up Metro-land. Each edition was advertised by poster (see plate 100), and helped establish Metro-land as a coherent entity, crossing county and historic boundaries.

Soon the slogan 'Live in Metro-land' was reproduced everywhere, from luggage labels to carriage door handles. A subsidiary company, the Metropolitan Railway Country Estates (MRCE), was formed in 1919 to accelerate the programme of suburban development. Working in partnership with local builders, the MRCE developed estates stretching from Harrow to Uxbridge, Watford and Amersham. Earlier estates at Willesden, Wembley and Ruislip were also dramatically enlarged during the 1920s.

Metro-land appealed to a broad range of buyers, from skilled workers to city bankers, with homes priced at £700 to £4000. Yet it was the more expensive properties which initially dominated publicity, giving glamour to the more affordable semidetached houses on offer. The aspirational nature of Metro-land was encouraged in promotional literature, which referred to the larger houses as 'homesteads' and employed the language (if not the design values) of the garden city movement. Most of the direct selling was done via press advertisements and glossy brochures, with posters taking a supporting role to promote new areas for building or the recreational activities available (principally golf, fishing and walking).

Harrow Garden Village was characteristic of this approach. Started in 1929, the 211-acre site adjacent to Rayners Lane station in northwest London consisted mainly of three-bedroom semidetached houses for under £1000. An MRCE poster (plate 101) shows three untypical 'homesteads' as chess pieces, above an assurance that houses of varying types are available at 'popular prices' by 'well-known builders'.[10] Variety and quality were hallmarks of the MRCE estates, much valued by prospective buyers. Within five years the numbers using the station had risen from 22,000 to four million.

Metro-land transformed the finances of the Metropolitan Railway. An early-1930s poster boasted

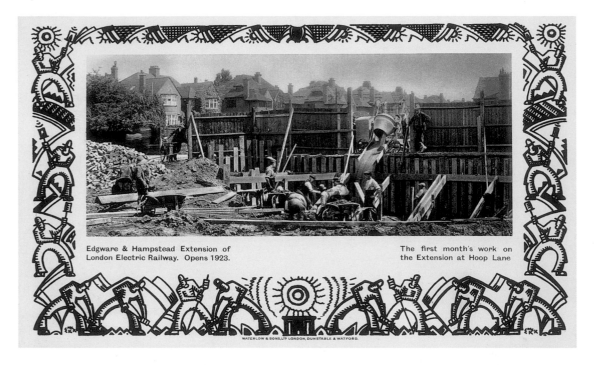

Edgware & Hampstead Extension of
London Electric Railway. Opens 1923.

The first month's work on
the Extension at Hoop Lane

WATERLOW & SONS,LT? LONDON, DUNSTABLE & WATFORD.

102 **Edgware and Hampstead
Extension of London Electric
Railway**
Edward McKnight Kauffer,
1923

Panel poster
(295mm x 465mm)
Published by UERL
Printed by Waterlow & Sons Ltd

that the company issued over 1.25 million weekly season tickets – a remarkable achievement in so short a time. In 1933, the Met became part of London Transport, ending the direct relationship between the railway and estate management. The famous slogan was quickly dropped, although two more posters appeared that year for *Homes in Metro-land*, with details available from LT's publicity office. The MRCE survived as a separate company and house building continued in the Metro-land area throughout the 1930s, with some districts experiencing a 150 per cent growth in population.

Live at Edgware

The UERL was slower off the mark than the Metropolitan Railway in resuscitating its prewar policy of suburban promotion. All this was to change, however, with the overground extension of the Tube from Golders Green to Edgware (1922–4), publicised at

each stage of development by a carefully thought-out poster campaign.

During the construction phase, experimental use was made of photographic panel posters to keep the public informed of progress. One of these, with pictorial border by Edward McKnight Kauffer, depicts the demolition of recently built houses in Golders Green to make way for the new railway (plate 102). Sensitive that such work might provoke hostility, the Underground had previously put up notices justifying the extension. One, entitled *The Growth of London*, warned: 'All development must be based on Railways. They alone can provide the speed and capacity necessary to a healthy Greater London. Motor Omnibus routes and Tramways are in the long run supplementary to them.' The best of the construction period posters, by Fred Taylor, shows a newly built station at the centre of frenzied house building activity (plate 103). Dominated by the roundel logo,

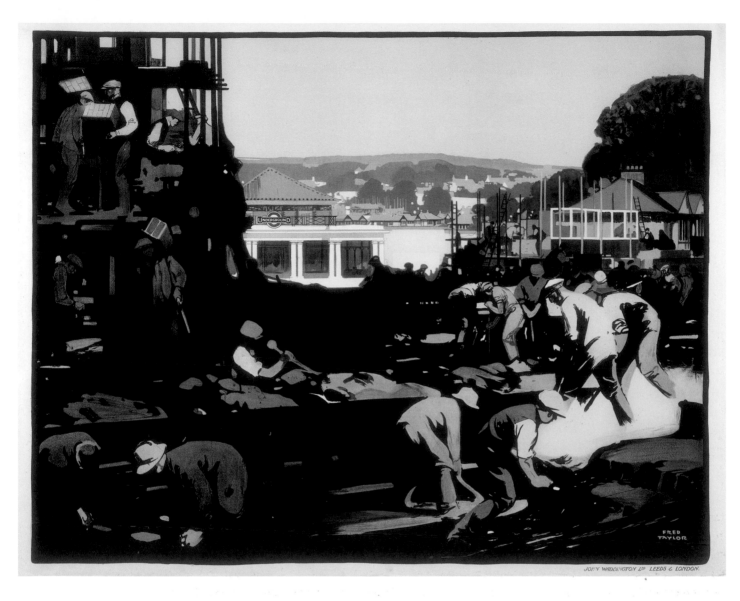

103 New Works
Fred Taylor, 1923

Quad royal
(1016mm x 1270mm)
Published by UERL
Printed by John Waddington Ltd

the station is positioned as both the agent of progress and a reassuring presence in the midst of a rapidly changing scene. No other words are necessary to convey the Tube's impact on the area.

The Tube reached Edgware in 1924, with intermediate stations at Brent, Hendon, Colindale and Burnt Oak. The Underground was confident that the extension would open up 'large tracts of rural territory ripe of housing development'.[11] But traffic results were disappointing, leading Pick to initiate the largest poster campaign for any residential district on the Underground.[12]

The campaign was influenced by the language of *Metro-land*, although the posters were generally of much higher quality. Some of the first stressed the 'old-world' charm of Edgware village and the surrounding countryside. Later, the slogan 'Live at Edgware' was widely used in posters and press advertisements.

Pick understood that a good poster should convey an idea, rather than simply sell a service or product. Central to the suburban dream was the desire to live in the country, yet remain within easy reach of work. Walter Spradbery's depiction of rural Edgware, served by 'fast trains every few minutes', is designed to stimulate this desire without actually focusing on the houses themselves (plate 104), while illustrated poster maps showed how convenient the

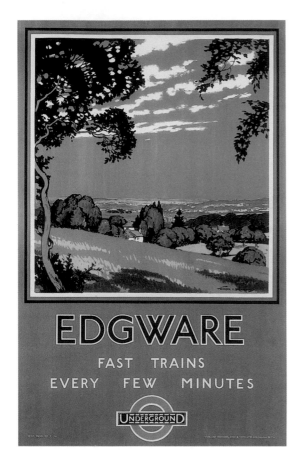

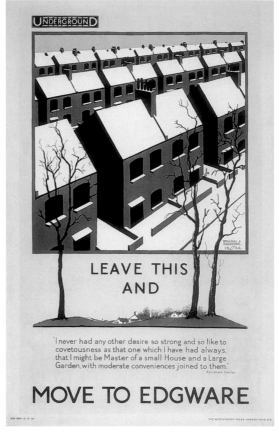

104 Edgware: Fast Trains Every Few Minutes
Walter E. Spradbery, 1924

Double royal
(1016mm x 635mm)
Published by UERL
Printed by Vincent Brooks,
Day & Son Ltd

105 Leave This and Move to Edgware
William A. Kermode, 1924

Double royal
(1016mm x 635mm)
Published by UERL
Printed by the Westminster
Press

new stations were for daily commuting and weekend rambles.[13]

Similarly, William Kermode's poster contrasts the dreary, grey streets of inner London with the spacious layout of suburbia (plate 105). The design is reminiscent of prewar posters, and similarly features an historic quote linking contemporary house-hunters with traditional values.[14] The emphasis on a 'small House and a Large Garden' was aimed at middle-class buyers, able to afford the £895 to £1250 price tag for an average Edgware semidetached home.

Continued development would soon obliterate most of rural Edgware, but this was initially ignored in favour of an idealised vision. This agrarian fantasy

reached absurd levels in a poster by Helen Bryce based on a Victorian sampler (plate 106), equating suburban man with a yeoman farmer keeping livestock in his garden! (In fact, suburban dwellers were rarely allowed to keep animals other than domestic pets. The keeping of poultry, for example, was often forbidden by restrictive covenant.) On a more serious note, Bryce links the 'fogs and smoke' of London with poor health, while in the suburbs families 'prosper beyond expectation'.

From 1925, Edgware was marketed as 'the new garden city', in the style of nearby Metro-land estates. More attention was given to press advertisements, which gave greater scope for detailed

106 Live at Edgware and Live!
Helen Bryce, 1925

Double royal
(1016mm x 635mm)
Published by UERL
Printed by Vincent Brooks,
Day & Son Ltd

107 Pipers Green: Edgware
John Dixon, 1928

Double royal
(1016mm x 635mm)
Published by UERL
Printed by John Waddington Ltd

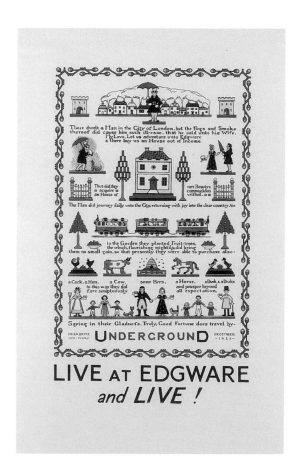

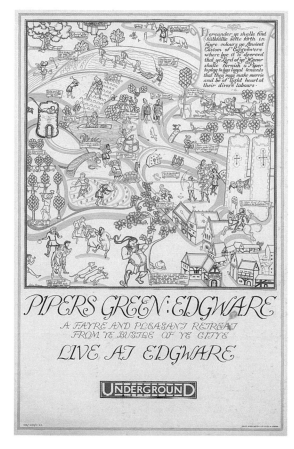

selling, although passenger numbers were initially slow to improve.[15] Even so, having established the Edgware brand in the public mind, and with new suburbs to promote elsewhere, the campaign was gradually wound down.

One of the final posters celebrates the ancient tradition of the Edgware Piper (1928, plate 107). The bogus medievalism of John Dixon's design was in tune with popular taste and gave historic context to an increasingly featureless suburb.

Edgware continued to grow throughout the 1930s. By 1936, the extension was carrying 24 million passengers a year. Edgware had shown that Tube suburbs, no matter how promising, needed active marketing to attract new residents.

London's freedom for the southwest suburbs

In South London, Pick was determined to extend the Underground from Clapham Common to Sutton. The proposal was fiercely opposed by the Southern Railway, which had its own plans for improving commuter services and regarded Surrey as outside the Underground's catchment area. An uneasy compromise saw the extension line terminated at rural Morden, several miles short of Pick's intended destination.

Work on the extension began in December 1923. As at Edgware, posters were used to keep the public informed of progress and to justify the extension.

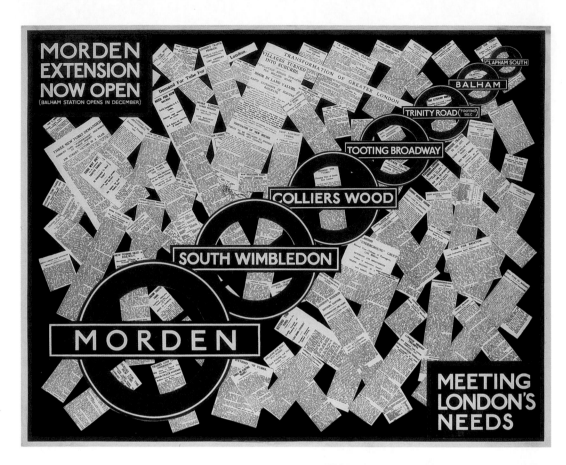

108 **Morden Extension Now Open**
Artist unknown, 1926

Quad royal
(1016mm x 1270mm)
Published by UERL
Printed by Waterlow & Sons Ltd

109 **London's Freedom for the South-west Suburbs**
Charles Paine, 1926

Double royal
(1016mm x 635mm)
Published by UERL
Printed by the Baynard Press

One of these, published when the line opened in 1926, imposed the names of the new stations on a background of press cuttings calling for new Tube routes in Greater London (plate 108). Others sought to show how the railway would help solve 'London's traffic puzzle' by improving services to existing suburbs (such as Balham) and by developing new areas with feeder buses to Morden.

Morden quickly developed into a prosperous suburban hub, requiring little additional publicity. A short-lived campaign stressed the benefits of direct trains to both the City and the West End, allowing commuters to live in semi-rural suburbia. Charles Paine's poster (plate 109) reinforces this message by contrasting the enormity of the city with a homely cottage in Morden. The unlikely image of the cottage (most new homes were mass-built semidetached houses) is complemented by the inclusion of a grazing cow, bizarrely positioned between Clapham and Wimbledon!

As the suburb rapidly lost any real sense of rural

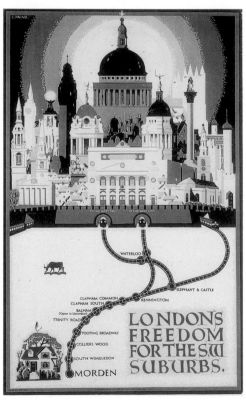

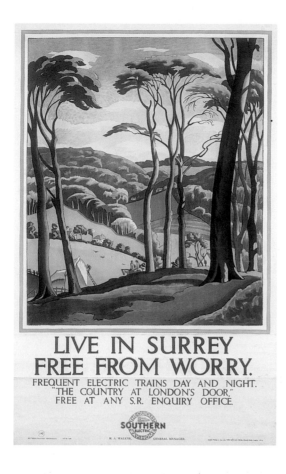

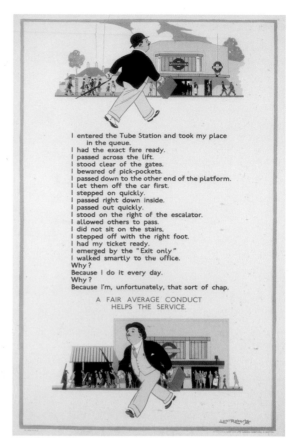

110 Live in Surrey Free from Worry
Ethelbert White, 1926

Double royal
(1016mm x 635mm)
Published by Southern Railway
Printed by the Baynard Press

111 A Fair Average Conduct Helps the Service
Lunt Roberts, 1927

Double royal
(1016mm x 635mm)
Published by UERL
Printed by Waterlow & Sons Ltd

112 Morden Underground Station March 1936
Described by John Betjeman as 'moderate Morden', the decidedly bland suburb soon lost any claims to semi-rural status – no matter what the posters may have suggested.

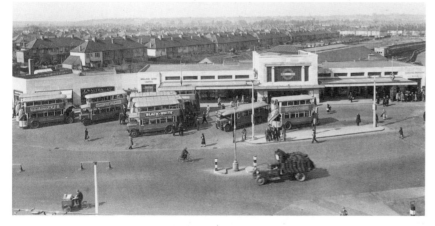

identity, posters were used to advertise bus services from Morden to unspoilt areas further afield. Although targeted at day-trippers from all over London, the effect was similar to earlier publicity in presenting Morden as convenient for both town and country pursuits.

The Underground's success was deeply resented by the Southern Railway, which was far more depend-ent on suburban traffic than its mainline rivals. The General Manager, Sir Herbert Walker, estimated that four million passengers had been lost to the Morden extension. He responded by appointing John Elliot, a journalist who had worked in New York, to reinvigorate SR publicity and promote the company's extensive electrification programme.[16] Despite rivalry between the two companies, Elliot was on friendly terms with Pick who offered advice on how best to conduct the campaign. The resulting posters by Ethelbert White (including *Live in Surrey Free from Worry*, plate 110) are very similar to Underground designs, including the use of a modified 'roundel' device for Southern Electric.[17]

Meanwhile, the success of the Underground's campaign enabled Pick to develop a more indirect approach to place selling than elsewhere. This can be seen in a widely distributed poster from 1927, featuring a middle-class commuter as an exemplar of courteous passenger behaviour (plate 111). Dressed in the uniform of the city man, he is shown entering

113 A Change of Residence is as Good as a Holiday
Charles Paine, 1929
Double royal
(1016mm x 635mm)
Published by UERL
Printed by the Baynard Press

114 Hounslow and Sudbury Hill
Christine H. Jackson, 1930
Panel posters
(each 508mm x 305mm)
Published by UERL
Printed by the Curwen Press

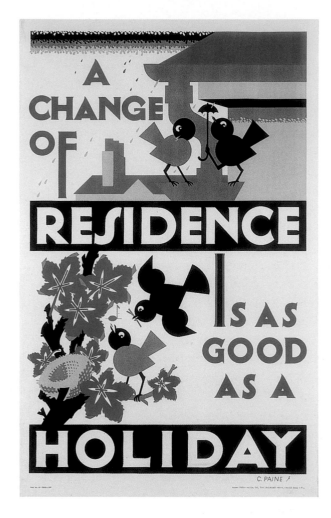

one of the distinctive new stations on the Morden line.[18] His respectful, regulated routine encapsulates middle-class values and helps establish the suburb (represented by roof-tiled semidetached houses) as the sort of place where such a person might live.

The Morden extension was almost too successful. Commuter trains became so overcrowded that the idea of encouraging more people to live on the line was soon dropped. Improvements to trains and infrastructure followed which, coupled with further house building, made the route one of the busiest on the Underground.

A change of residence is as good as a holiday

The intensive poster campaigns for Edgware and Morden were the last of their type. In the final years of the privately run Underground, direct place selling gave way to a more generic approach stressing the perceived benefits of suburban living, with only occasional reference to actual residential districts. This was partly due to increased advertising by the house builders themselves. It also reflected the buoyancy of the London-wide house market, which required broader marketing strategies than earlier estate- (or Tube line-) focused campaigns.

The trade 'slump' of the late 1920s, which caused real hardship in many parts of Britain, did little to dampen enthusiasm for home ownership in the capital, and may even have encouraged it. Londoners in middle-class occupations were largely untouched by the worst effects of the Depression and enjoyed increased purchasing power as prices fell, making investment in property more affordable than ever before.

Confidence in the housing market is evident in the Underground's poster campaign for 1929 – a year of high national unemployment. Charles Paine's design

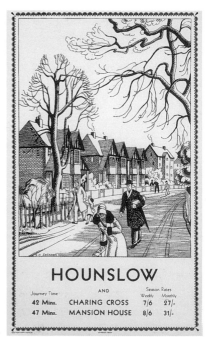

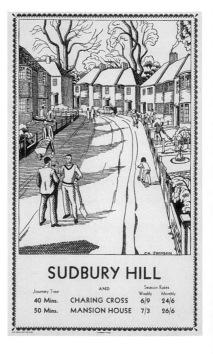

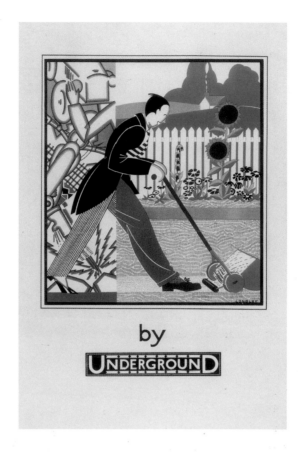

115 **Gardening by Underground**
Stanislaus S. Longley, 1933
Panel poster
(495mm x 318mm)
Published by UERL
Printed by Balding & Mansell

uses the traditional image of nesting birds as a metaphor for starting a new family in a new home (plate 113). Other posters from this time included a series of decorative maps by Herry Perry featuring residential districts in Harrow, Hounslow, Edgware and Morden.[19]

Similar areas were selected for a press and poster campaign the following year, illustrated by Christine Jackson (see plate 114). The emphasis, however, is less on location than on the generic depiction of suburban life. The design for Hounslow, for example, is one of the few Underground posters to show a typical suburban street of 1920s semidetached houses. Usually described as 'mock-Tudor', such houses were derided by critics for their fussy decoration and spurious appropriation of earlier styles.[20] Yet they proved extremely popular with middle-class buyers who preferred half-timbered gables and leaded bay windows to the severe, and 'foreign', functionalism of Modernist architecture.

The Hounslow poster provides an equally interesting commentary on the ritual of commuting. The suburban stereotype of the father figure as dependable breadwinner is reinforced by the inclusion of dutiful housewives waving their husbands off. The only woman joining the men is equipped for a holiday (rather than work) and anxiously checks her watch. Her worried demeanour is in marked contrast to the upright confidence of the city men, and helps underline the routine nature of their journey, compared with the unfamiliarity of hers.

Suburban values are also prominent in Christine Jackson's poster for Sudbury Hill. Set after work, almost everyone is gardening or engaged in outdoor pursuits. The impression is of a relaxed and friendly community, framed by mature background trees (an echo of pre-suburbia) and the manicured gardens of diligent suburbanites.

The garden had always been a major selling point of the new suburbs. For many, it was their first opportunity to own land, and provided a welcome, and creative, diversion from a day spent in the office. A reduction in office hours, and the introduction of British Summer Time in 1916, also meant that commuters had more time to spend in their gardens after work. The contrast between working life and homely recreation is clearly made in Stanislaus Longley's updating of the 1908 Golders Green poster showing the transformation of office clerk into contented gardener (plate 115).

Garden size was a sure indicator of social status, with only the most expensive detached properties boasting a large front lawn. *The Next Move* (plate 116) shows a young family moving into

116 The Next Move and Take a Season Ticket
Hendy, 1927

Double royal
(1016mm x 635mm)
Published by UERL
Printed by Vincent Brooks,
Day & Son Ltd

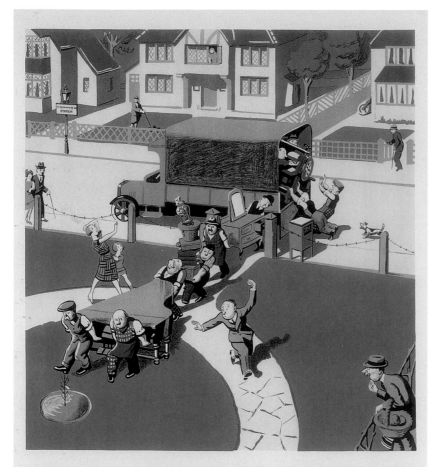

THE NEXT MOVE
AND TAKE A
SEASON TICKET

91·1000·20·1·27

VINCENT BROOKS, DAY & SON, LTD LITH, LONDON, W.C.2.

just such a house. Neighbours here seem more nosey than helpful, in what is meant to be a humorous take on the perils of moving. The poster skilfully appeals to its target audience by presenting suburban life as a mix of modern and conventional tastes. The couple's possessions, for example, are a combination of old and new (grand piano and cased gramophone), while mother and daughter have fashionable haircuts and clothes. In fact, suburbia's ability to seem both traditional (half-timbered rusticity) and modern (new build, near the Tube) lay at the heart of its popularity with middle-class buyers.

These posters were intended to stimulate a general desire to live near the Underground, without tying publicity to a specific area. More abstract designs from this period stressed the modernity and reliability of the Tube — essential prerequisites for anyone considering commuting long distances to work (see, for example, chapter 7, plate 149).

This shift in emphasis is apparent in the promotion of the Piccadilly line extensions of 1931–3. These extensions — which stretched southwards along the District line from Hammersmith to South Harrow and Hounslow West, and northwards from Finsbury Park to Cockfosters — were the Underground's final building programme before it became London Transport. The north section was built in open country, similar to the earlier Edgware and Morden extensions. Only one poster, a typographical design by Edward McKnight Kauffer (plate 117), links improved services with home ownership, while none of those celebrating the opening of the Cockfosters extension in 1933 mentions suburban development, even though this was the motive behind construction. Instead, self-consciously Modernist imagery informed the public of the Tube's arrival, in a manner which suggested that the Piccadilly line suburbs were fashionable places to live. It has even been argued that the intro-

117 **Underground Progress**
Edward McKnight Kauffer,
1931

Double royal
(1016mm x 635mm)
Published by UERL
Printed by Waterlow & Sons Ltd

Several versions of this poster
were produced, promoting other
stations on the Piccadilly line,
including Bounds Green, Arnos
Grove and Sudbury Town.

UNDERGROUND

A NEW HOME

A NEW RAILWAY

A NEW ENVIRONMENT

KNIGHTSBRIDGE 30 minutes
PICCADILLY 34 minutes
HOLBORN 38 minutes

PROGRESS

MOVE TO STH. HARROW
WITH THE UNDERGROUND
JUNE 1932

E McKnight Kauffer. 31.

WATERLOW & SONS LTD. LITH. LONDON, DUNSTABLE & WATFORD

duction of Harry Beck's famous diagrammatic Tube map in 1933 was part of the publicity drive, intended to misrepresent the real distance to places like Cockfosters and underplay the time taken to change trains at key stations – although there is no official evidence to support this.[21]

We are all Londoners now

The creation of the publicly owned London Passenger Transport Board in July 1933 marked the end of the Underground's use of posters to sell suburbia. Pick's own study of Metro-land finances led him to conclude that newspapers, rather than posters, were 'the most effective media for advertisements dealing with housing', with poster maps playing a supporting role only.[22] However, there were growing reasons for abandoning suburban marketing altogether, and both approaches were quickly dropped.

From the start, Lord Ashfield (as chairman of LT) questioned whether a public body should play any role promoting suburbs in which it had no direct financial interest and where the bulk of profits went to private speculators. The LT's Board may also have wished to distance itself from problems associated with the success of earlier Tube extensions, which had seen passenger complaints soar as a result of peak-time delays and overcrowding. Others, including Pick, were increasingly appalled by unchecked suburban sprawl and called for stricter government planning, rather than transport-led development.[23]

Consequently, Pick became more circumspect about actively selling the suburban dream, even though LT was as dependent as its predecessors on attracting new passengers by extending the network. Instead, poster publicity for transport investment, such as the £40million 'New Works Programme' (1935–40), stressed the general benefits of better services without reference to house-buying opportunities.[24]

118 Suburban
Horace Taylor, 1924
Double royal
(1016mm x 635mm)
Published by UERL
Printed by the Dangerfield
Printing Company Ltd

Only a black-and-white
reference photograph of this
poster, possibly produced for
the Edgware campaign, has
survived. The same border
design was used for posters
selling season tickets and the
reliability of the Tube.

The improvements helped stimulate a renewed housing boom in the mid-1930s, resulting in LT's only posters promoting suburban living, including a pair by Paul Nash entitled *Come Out to Live* and *Come In to Play* (see chapter 4, plate 87). These posters, however, were primarily designed to encourage those already living in the suburbs to make full use of their free time by buying a season ticket.

The housing boom was brought to an abrupt end by the declaration of war in 1939 and the introduction of stricter planning controls afterwards, including the imposition of the 'Green Belt' around London. Post-war housing policy focused instead on the reconstruction of the damaged inner city and the development of 'New Towns' outside the Green Belt, such as Stevenage in Hertfordshire and Crawley in Sussex. LT took no part in selling these residential districts – that became the responsibility of the government, local authorities and development agencies. This policy has continued to the present day, even where development has been enabled by public transport (such as the opening of the Docklands Light Railway to support the redevelopment of London's former docks in the 1980s).

Arguably, though, the poster campaigns of 1908–33 had so successfully sold the concept of living on the Underground that further promotion was unnecessary. As part of wider marketing strategies, posters undoubtedly increased season ticket sales (the principal criterion for success) by associating suburbia with middle-class values and aspirations.[25] Seen by millions, these colourful and dreamlike images masked the often drab reality of life on the new estates and helped establish the suburbs as desirable places to live, thereby changing London's residential and commuting patterns forever. 'Thanks to the Underground,' claimed a 1924 poster by Horace Taylor, 'we are all Londoners now' (plate 118).

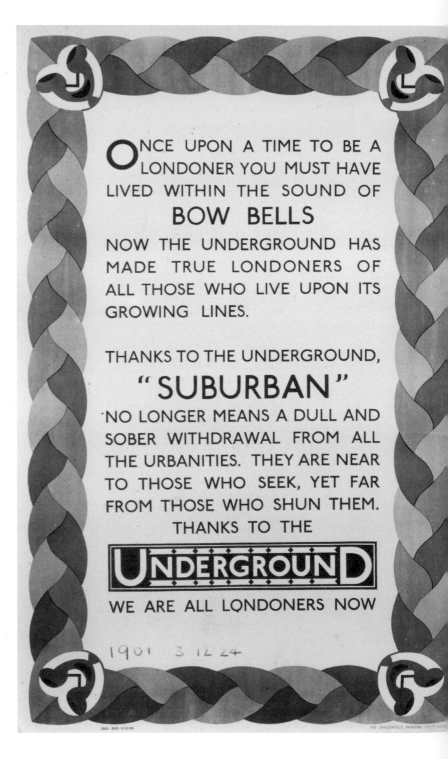

Notes

1. Little attempt was made to attract working-class council tenants to the new suburbs, even though a fifth of all new interwar housing was built by the London County Council, including new estates in suburbs served by the Underground, such as Burnt Oak and Morden (A. Jackson, *Semi-detached London: Suburban Development, Life and Transport, 1900–39*, Wild Swan, Didcot, 1991, chapter 9).

2. S. Ward, *Selling Places: The Marketing and Promotion of Towns and Cities, 1850–2000*, E. & F.N. Spon, London, 1998, especially chapter 5.

3. A similar message was used in a 1913 poster illustrating the Garden Suburb from Hampstead Heath, above the slogan: 'Live on the Underground and have more time at home.'

4. Ward, *Selling Places*, p.119.

5. *London's Latest Suburbs: An Illustrated Guide to the Residential Districts reached by the Hampstead Tube*, publisher unknown (probably UERL), London, 1910, p.18.

6. These included: *Healthy Homes: Illustrated Guide to London's Choicest Suburbs Made Easy of Access by the New Tube Railways*; *The Illustrated Property Register*; *Homes on the Underground*; and *Home! By Underground and Motor-Bus*.

7. Sudbury Hill station, near the end of the South Harrow branch of the District Railway, opened in 1903 prompting some residential development, but it was not until the 1920s that house building took off on a large scale (J.P. Thomas, *Handling London's Underground Traffic*, UERL, London, 1928, pp 226–9).

8. See, for example: *My Little Metro-land Home* (song, Henry Thraile and Boyle Lawrence, 1920); Evelyn Waugh's Lady Metroland character (*Decline and Fall*, 1928); *Metroland* (novel, Julian Barnes, 1980); and the poetry and prose of John Betjeman (especially *Middlesex*, *Harrow on the Hill*, *The Metropolitan Railway* and his script for the 1973 BBC documentary *Metro-Land – a Celebration of Suburbia*).

9. For a comprehensive account of the origins and marketing of Metro-land, see: A.A. Jackson, *London's Metro-land*, Capital History, Harrow Weald, 2006.

10. Principally T.F. Nash and E.S. Reid – the latter of whom lived on the estate.

11. *Opening of the Hendon – Edgware Extension of the Hampstead Line*, UERL, London, 1926, p.6.

12. Over 30 posters promoted the Edgware area from 1922 to 1930 – the majority in the period 1923–6.

13. See also: *Edgware for Rambles and Houses* (poster, 1924).

14. Extract from *The Garden* (1664) by Abraham Cowley (1618–67).

15. The Underground's chairman, Lord Ashfield, blamed land speculators for driving up house prices (Jackson, *Semi-detached London*, p.212).

16. Elliot's appointment marked a new era in SR publicity. High-quality posters and booklets accompanied each phase of the company's electrification programme. By the late 1930s, nearly a fifth of the Southern's revenue came from electrically operated suburban services (Jackson, *Semi-detached London*, p.187).

17. Pick congratulated Elliot on the success of the campaign, and later commissioned White to produce a design for the Underground. The two companies eventually patched up their differences and issued joint publicity in the 1930s (Sir John Elliot, *On and Off the Rails*, George Allen & Unwin, London, 1982, pp 22–3)

18. Possibly Clapham South. The stations on the Morden extension were designed by Charles Holden to 'show the purpose of the building in a manner combining simplicity and strength with grace and character' in order that the 'public should have no difficulty in recognizing an Underground station' (*Opening of the Morden Extension and the Kennington Loop*, UERL, London, 1926, p.20).

19. It is possible that areas were selected in preparation for future Tube development. Hounslow, Osterley, Sudbury Hill and South Harrow were all existing residential areas served by the District Railway. By the late 1920s, plans were underway to extend the Piccadilly line to these suburbs.

20. See: J. Carey, *The Intellectuals and the Masses: Pride and Prejudice among the Literary Intelligentsia, 1880–1939*, Faber & Faber, London, 1992, especially chapter 3; and P. Oliver, I. Davis and I. Bentley, *Dunroamin: The Suburban Semi and its Enemies*, Barrie & Jenkins, London, 1981.

21. A. Forty, *Objects of Desire: Design and Society, 1750–1980*, Thames & Hudson, London, 1986, pp 237–8.

22. Meeting of London Transport's Vice-Chairman's Publicity Committee (VCPC), August 1933, Transport for London Archives, LT 606/007, minutes 3 & 28. In the event, only a couple of press advertisements appeared in the early 1930s for ex-Metro-land estates.

23. C. Barman, *The Man Who Built London Transport: A Biography of Frank Pick*, David & Charles, Newton Abbot, 1979, pp 245–6. Pick's increasingly bizarre plans for restricting the growth of London were published after he left LT in 1940 (F. Pick, *Britain Must Rebuild: A Policy for Regional Planning*, Kegan Paul, London, 1941).

24. The case for continual Tube expansion to serve London's changing traffic needs was neatly summarised by F.A.A. Menzler on behalf of LT in 1937 (F.A.A. Menzler, 'The economic background: population, housing and industry', *Staff Meetings Session 1937–38*, London Transport, London, 1938).

25. The accounts for LT's first full year of operation record over 68.5 million passenger journeys made by season ticket holders – many of whom lived in the new suburbs (*London Passenger Transport Board, First Annual Report and Statement of Accounts and Statistics*, London, 1934, pp 52–4).

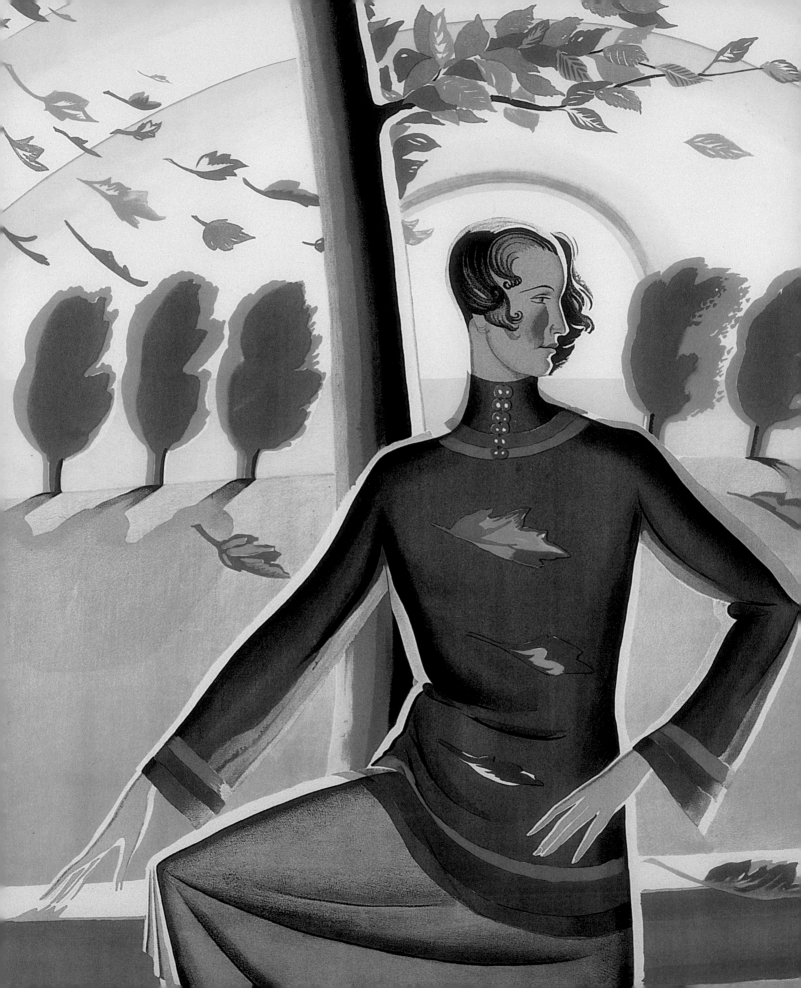

FASHIONING THE TUBE:

WOMEN AND TRANSPORT
POSTERS IN THE 1920s AND 1930s

Emmanuelle Dirix

THE TWO DECADES after the end of the First World War saw significant changes in the role of women in British society. This chapter looks at how that changing status was reflected in the content and design of posters produced by and for the London Underground. Women were increasingly recognised as an important market for advertisers in the new consumer society, and a new generation of trained women designers made a growing contribution to the posters and other publicity material aimed at that market.

The 'new' woman

In 1918, women over 30 (with property) were given the vote, and in 1928 suffrage was extended to all women over the age of 21. This, in addition to the opening up of certain professions, meant that women could no longer be denied an interest in politics and public life, and the traditional Edwardian/Victorian values of femininity were beginning to be challenged. The separation of the public and private

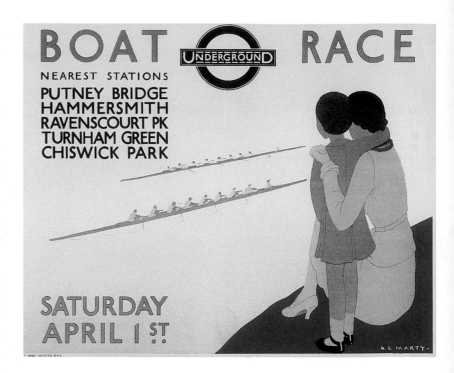

spheres and the cult of domesticity were increasingly seen as oppressive and old-fashioned.

In 1931 Rosita Forbes, writer for the *Daily Mirror*, reported: 'We've heard an inordinate amount about the Modern Woman. So much so that a thousand years hence scientists will doubtless imagine the twentieth century responsible for a new form of animal life and they will wonder why nothing remains of it.'[1]

This newly emerging 'Modern Woman' is hard to define. She was trapped with one foot in the past and one in the future. On the one hand, women had increased employment opportunities and the chance to carve out an independent life. On the other, the unease that was caused by this perceived feminine assault on the masculine world of work led more traditional camps to call for a return to domesticity and good old family values.

These conflicting stances are visually represented in contemporary media including London Underground posters. The types of women they depict highlight the complexity of the 'woman's issue'. From doting mother figures, as seen in the poster series by André Edouard Marty from 1933 (plate 119), to dutiful wives, as represented in Dora Batty's *For Picnics and Rambles* (plate 120), to independent 'garçonnes', such as the young lady in Dora Batty's *Summer for Roses* (plate 121): the modern woman could be all of these.

Even though some of the roles that women performed were far from modern, their representation differed significantly from earlier images in two respects. Firstly, these women are depicted in a highly modern design style, and in very different poses from their predecessors. This change had much to do with the explosive growth of the entertainment industry and, in particular, the influence of Hollywood films. Visually it is noted in more revealing

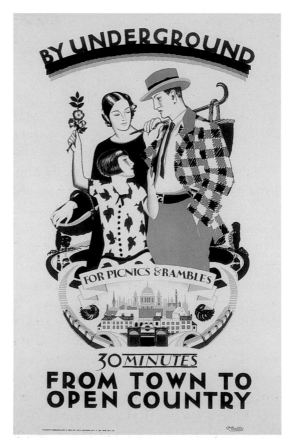

119 Boat Race
André Edouard Marty, 1933
Panel poster
(255mm x 318mm)
Published by UERL
Printed by the Dangerfield
Printing Company Ltd

**120 For Picnics and Rambles
from Town to Open Country**
Dora M. Batty, 1925
Double royal
(1016mm x 635mm)
Published by UERL
Printed by Vincent Brooks,
Day & Son Ltd

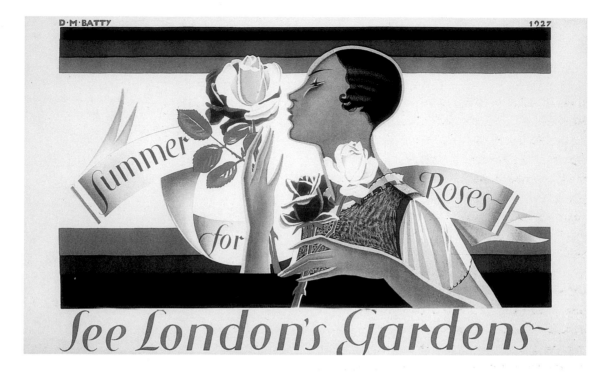

121 Summer for Roses
Dora M. Batty, 1927
Panel poster
(295mm x 465mm)
Published by UERL
Printed by the Baynard Press

clothing (the bias cut favoured in the late 1920s and 1930s clung to the contours of the body) and in much more assertive posture, directly influenced by the heroines of the silver screen.

Secondly, whilst Victorian images of women were mostly set in luxurious parlours and the safety and respectability of the home, these new women had shifted outdoors. Indeed, the posters of this era tell the story of modern women emerging from the home onto the city stage in ever-growing numbers, and with increasing but, by modern standards, still limited freedoms.

For many women, public transport had offered their first experience of modernity, and in particular of modern London. In the latter decades of the nineteenth century, new sites of modernity in the city, such as department stores, tearooms and women's clubs, offered safe and respectable spaces for women to frequent. Magazines such as *Queen* and *The Lady* promoted travelling on buses, trains and the underground by proclaiming them safe and respectable for middle- and upper-class women. Mass transportation and new reputable leisure venues

afforded women a measure of self-determination.

However, it was only after the First World War had put an end to chaperoning that women of a certain social group could enter the city independently without the risk of disrepute. Many made the most of this new-found freedom, either as day-trippers or as city workers.

The city has traditionally been a masculine space, represented and defined as a site of active production – the antithesis of perceived traditional feminine values. This female invasion of the masculine territory unsettled traditionalists. William Kerridge Haselden's poster from 1920 (plate 122) shows a fashionable but scatterbrained woman holding up queues of men eager to get to work, blissfully unaware of the frustration and upset she is causing her fellow passengers. Not only does the poster affirm the traditional gender roles of producer and consumer; it also shows the underlying unease of women's entering the male domain. Ridicule here can be interpreted as a defence mechanism, by projecting women as essentially flippant, vain and selfish creatures.

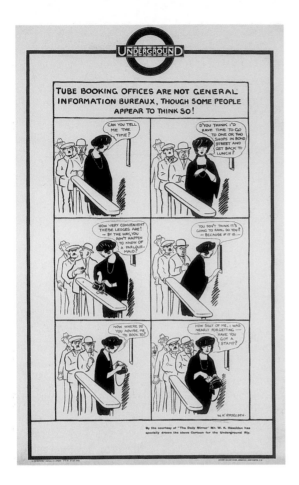

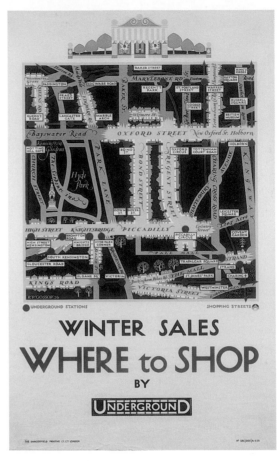

122 **Tube Booking Offices are Not General Information Bureaux**
William Kerridge Haselden, 1920

Double royal
(1016mm x 635mm)
Published by UERL
Printed by the Dangerfield
Printing Company Ltd

123 **Winter Sales: Where to Shop**
Reginald Percy Gossop, 1926

Double royal
(1016mm x 635mm)
Published by UERL
Printed by the Dangerfield
Printing Company Ltd

Whilst the above example signals some anguish at the woman entering the city, London Underground was certainly not trying to stop women from travelling. They just preferred the woman of leisure to travel at off-peak times. If anything, the interwar period saw a huge marketing push by the company to attract more female customers to boost takings during the day once the rush hour was over. The Underground was particularly interested in attracting middle-class women residing in the new suburbs with inducements for off-peak leisure trips. A plethora of posters stipulated not only how fast these ladies could travel from their homes to the heart of the city, but also what they could do when they got there. Favourite themes included visiting historic sites, museums, exhibitions, theatres, parks, department stores and attending events such as the Daily Mail Ideal Home Exhibition (perfect for picking up ideas on how to furnish one's mock-Tudor semi in Metro-land).

The pleasure of shopping

One type of poster specifically designed to appeal to women was that promoting fashionable shopping destinations (see plate 123). Such posters were instrumental in defining à-la-mode shopping locales, encouraged by the major stores themselves, which tried hard to attract middle-class women from the suburbs by offering modern conveniences (including tearooms and hairdressers) as part of the shopping experience. These services meant that shopping excursions were transformed from necessity into leisure activities, and London Underground was on hand helpfully to tell women where they could and should go.

Many posters glorified the pleasure of consumption, with women being seduced by the experience: fingering fabric, trying on beautiful dresses and searching through sales piles in pursuit of a bargain (see plates 124 and 125). Whilst stylistically these posters exemplify the modern, their content is rather more traditional in affirming the female as consumer,

**124 Touching the Riches
of London**
Frederick Charles Herrick,
1927

Double royal
(1016mm x 635mm)
Published by UERL
Printed by the Baynard Press

**125 To Summer Sales
by Underground**
Horace Taylor, 1926

Double royal
(1016mm x 635mm)
Published by UERL
Printed by Vincent Brooks,
Day & Son Ltd

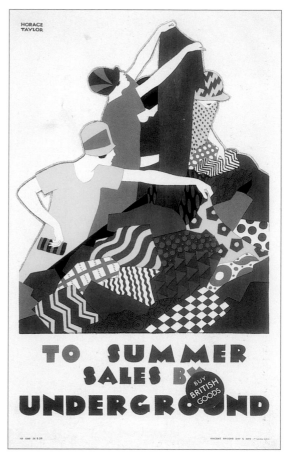

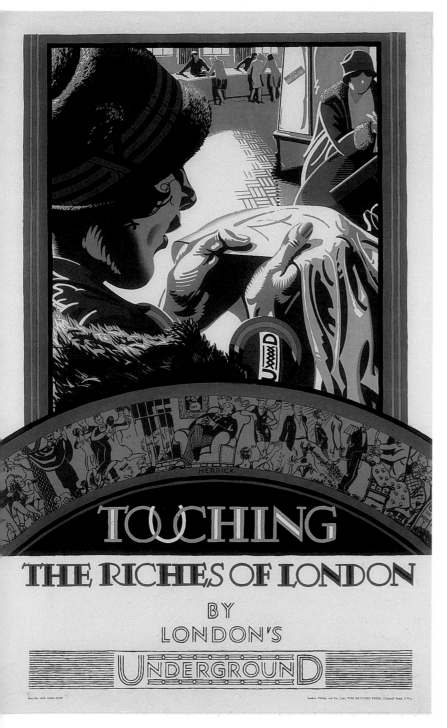

engaged in the frivolous act of frittering away money on luxuries. The stories they present are also highly aspirational, presenting us with beautiful young women, dressed in the latest fashions, adorned in jewellery and indulging in expensive pursuits including restaurant visits and attending theatre performances. In cases such as Frederick Charles Herrick's *The Riches of London* posters (see plates 124 and 126), this led to a fusion of women, luxury commodities and London Underground's corporate identity. These posters were regularly adapted to match seasonal shopping trends, especially during Christmas and sales periods.

Many of the posters published in this period bore more than a fleeting resemblance to up-market fashion illustrations. This was not accidental, as many advertisers and companies (including London Underground) were well aware of women's growing interest in and active involvement with fashion (see plate 127). Whilst fashion had almost exclusively

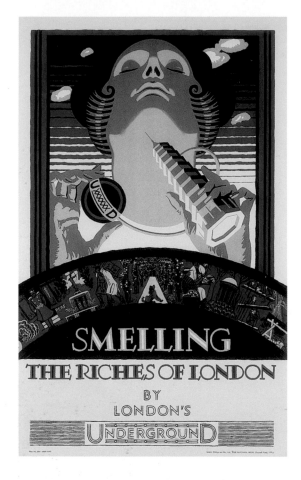

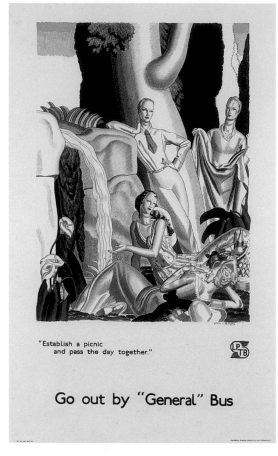

126 Smelling the Riches of London
Frederick Charles Herrick, 1927

Double royal
(1016mm x 635mm)
Published by UERL
Printed by the Baynard Press

127 Go Out by General Bus
Jean Dupas, 1933

Double royal
(1016mm x 635mm)
Published by London Transport
Printed by Johnson, Riddle & Company Ltd

been the privilege of the upper classes, the simplification of female attire, the advent of new materials such as rayon (artificial silk) and the availability of cheap ready-made clothing permitted a whole new group of women to actively engage in fashionable dressing. This newly extended audience of female consumers is reflected in the amount of space dedicated to fashion in newspapers, and in the emergence of new magazines devoted to the subject. It was also reflected in the extension of women's pages of newspapers, where alongside traditional features on cooking and housekeeping there were new sections discussing contemporary fashions and accompanied by plates (illustrations). Inevitably, this interest in fashion was exploited by advertisers who wished to attract female customers, by seducing them with stylish images of even more stylish women, whose looks and lifestyle they could aspire to and emulate.

In this vein, many transport posters functioned like fashion plates, freely available to the travelling public. Not only were they 'the art gallery of the city', they were also its 'fashion parade'. Lord Northcliffe, owner of the *Daily Mail*, was convinced that '[n]ine out of ten women would rather read about an evening dress costing a great deal of money than about a simple frock such as they could afford'.[2] The similarity of the posters to the up-market fashion plates is echoed not only in their subject matter but also in their adoption of the 'Style Moderne', exemplified in the choice of colour and stance of the figures.

Mary Koop's *Summer Sales Quickly Reached* juxtaposes a wide range of bright colours and patterns to command the viewer's attention (plate 128). It is not immediately obvious that the lively colour palette is in direct conflict with the subject matter of umbrellas, as the poster is designed to supersede such thoughts and seduce onlookers. In this way it operates like fashion advertising: a successful fashion

128 Summer Sales Quickly Reached
Mary Koop, 1925
Double royal
(1016mm x 635mm)
Published by UERL
Printed by the Dangerfield
Printing Company Ltd

129 There is Still the Country
Dora M. Batty, 1926
Double royal
(1016mm x 635mm)
Published by UERL
Printed by Vincent Brooks,
Day & Son Ltd

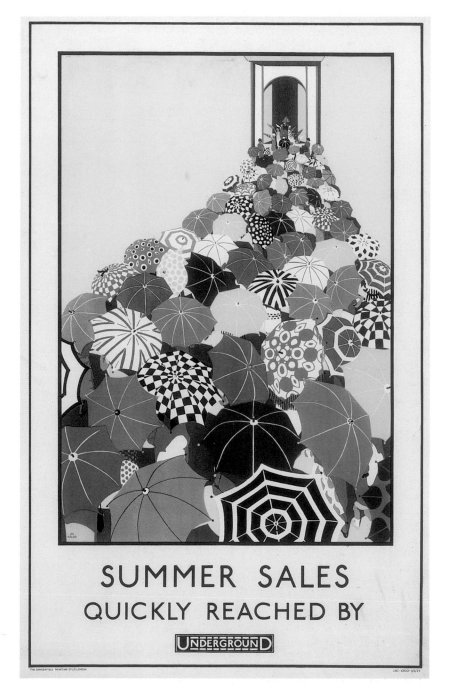

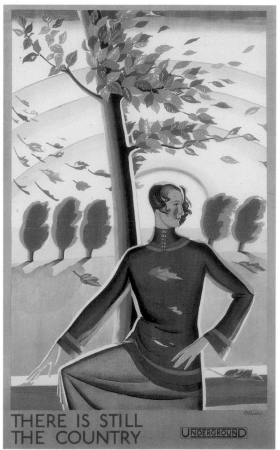

plate displaying a couture dress elicits a response of enchantment and a cry of 'I want!', not 'Will my hips look big in that?' or 'Is this appropriate for the weather?'.

Similarly, Dora Batty's poster *There is Still the Country* (plate 129) is only differentiated from a fashion plate by inclusion of the Underground corporate logo. The figure is dressed in the latest winter fashions, and she is positioned in such a way that the details of her jumper and skirt are shown off; this is aided by the shadow contour to represent the notion of movement and comfort, a device used in fashion illustration.

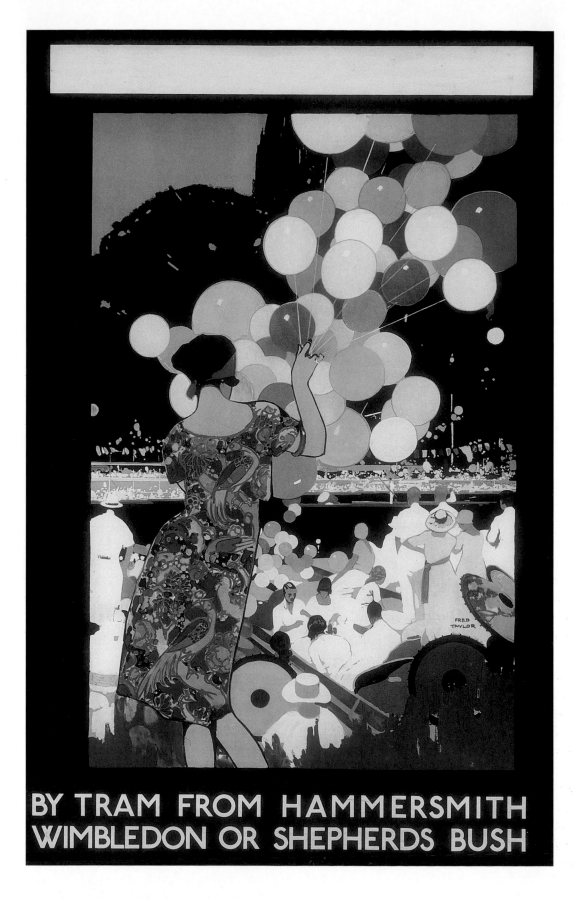

130 **By Tram from Hammersmith, Wimbledon or Shepherds Bush**
Fred Taylor, 1922

Double royal
(1016mm x 635mm)
Published by UERL
Printed by Vincent Brooks,
Day & Son Ltd

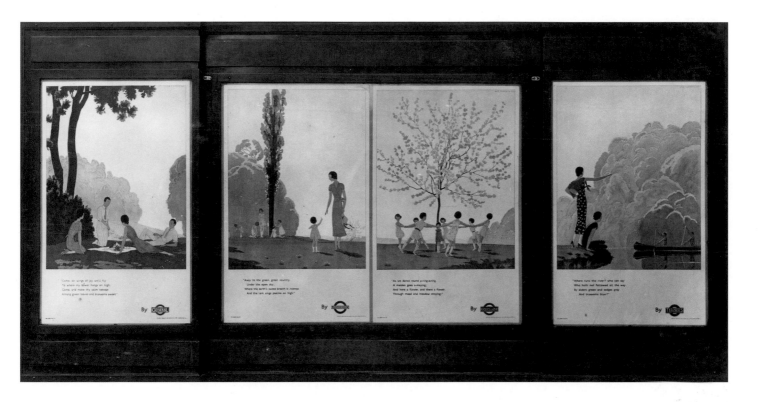

131 A sequence of posters displayed outside St James's Park Underground station in 1931. The four-panel bronze frame contains the series by André Edouard Marty: **Come on Wings of Joy**; **Rambling Parties**; **As We Dance Around**; and **Where Runs the River?**

In Fred Taylor's *By Tram from Hammersmith, Wimbledon or Shepherds Bush* (plate 130), all attention is drawn to the woman's sumptuous dress. The central position of the woman and the black outline of the figure set her apart from the rest of the scene and make her its focus, while the high degree of detail of the fabric pattern, visible down to the exotic birds, would easily lead one to mistake this for a fashion plate showcasing a dress instead of a day trip.

These similarities were not merely a successful marketing ploy. Many poster artists worked in other branches of the creative industries, including fashion illustration, and therefore had a professional knowledge of *haute couture*. Furthermore, several poster artists, including Walter Goetz and André Edouard Marty, had worked for high-society magazines including *Vogue*, *Gazette du Bon Ton*, *Vanity Fair* and *Harper's*

Bazaar. Like fashion plates, the posters were conceived to inform and/or convince the viewer of the advantages of the product advertised. Hence, by adopting this particular style, they were sure to appeal to a female audience (see plate 131).

In addition to being designed to please, there was a general understanding that posters should also perform an educating function. As the poster designer Horace Taylor explained, 'a kind of artless photographic picture is most widely appreciated. The modern middle-class Englishwoman is not as a rule interested in contemporary art or familiar with its idioms.' However, he considered that what the public likes is 'only of secondary importance', and that the key concern is what the public remembers. He concluded that a 'poster may be the pioneer and open up a new path', thus both achieving memorability

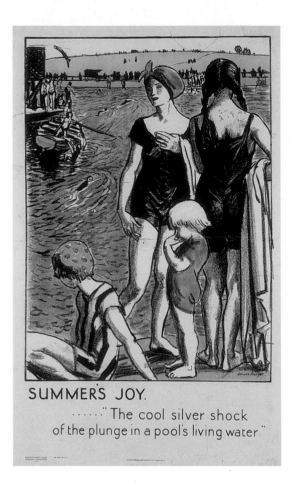

SUMMER'S JOY.

....." The cool silver shock of the plunge in a pool's living water "

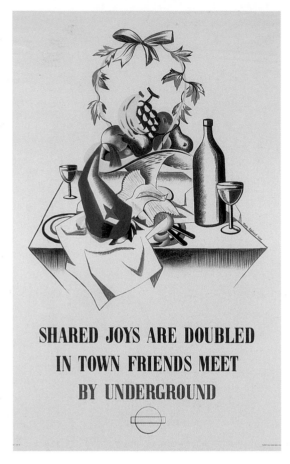

SHARED JOYS ARE DOUBLED IN TOWN FRIENDS MEET BY UNDERGROUND

132 Summer's Joy
Laura Knight, 1921
Double royal
(1016mm x 635mm)
Published by UERL
Printed by Vincent Brooks,
Day & Son Ltd

133 Shared Joys are Doubled
Mary Adshead, 1937
Double royal
(1016mm x 635mm)
Published by London Transport
Printed by Waterlow & Sons Ltd

and leaving a pleasant impression upon the mind.[3]

Indeed, at a time when Underground posters were competing for the public's attention with a wide variety of other commercial advertising – including in Tube and railway stations – it was of utmost importance that they differentiate themselves from the mass of pedestrian publicity. By 1929, the profusion of modern advertising in London had reached such a level that W.G. Raffé was worried that naïve travellers may be led to mistake the name of an advertised commodity for the name of the station at which they had arrived.[4] Many saw this mass advertising as a threat, and voices from several corners cried out for advertising to educate public taste rather than encourage consumerism. However, transport posters mostly fell outside this category: the more they resembled art, the more they appealed to 'that fraction of the middle class whose unease with the blatant commercialism of so much advertising was articulated'.[5]

Women designers

The role of the Modern woman in Underground publicity, however, was not confined to the subject of posters and a growing consumer audience. A staggering number of female artists were also designing posters in the 1920s and 1930s. As Paul Rennnie has shown (see chapter 4), the specific economic and social conditions established by the First World War provided new opportunities for women working in the design industry.

The traditional gender roles of producer and consumer may have been corroborated by posters of fashionable women out shopping whilst their husbands were at work, but when these designs were executed by female designers, such a reading becomes obsolete.

Dora Batty and Herry Perry, two of the most prolific female designers, produced nearly 100 Underground posters between them during the interwar period. Other notable women artists

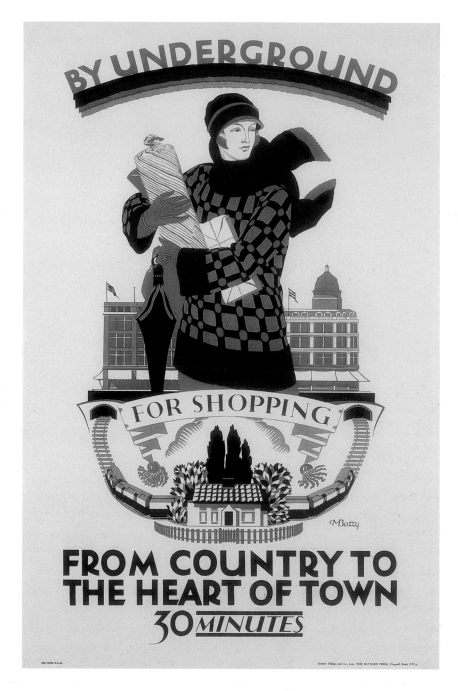

134 From Country to the Heart of Town for Shopping
Dora M. Batty, 1925
Double royal
(1016mm x 635mm)
Published by UERL
Printed by the Baynard Press

included Laura Knight (see plate 132), A.A. Moore, Betty Swanwick, Kathleen Burrell, sisters Doris and Anna Zinkeisen, Mary Adshead (see plate 133), Rosemary Ellis, Arnrid Johnston, Mona Moore, Margaret Calkin James and Freda Beard. Their work was innovative, versatile and well received by peers and the general public alike.

Although women had been involved in art and design education since the mid-nineteenth century, courses had focused on ostensibly 'feminine' disciplines, such as lace design, applying ornamental art, the painting of figurines and filling work. The experience acted as little more than finishing school for most women, or more specifically fee-paying middle-class girls, before they devoted themselves to a life of marriage and homemaking. By the interwar period this had changed dramatically; women were training to become artists and designers. Education was viewed as training for a real career, and with it a chance at social and financial independence. Many women were particularly drawn to graphic and commercial design classes, as advertising was considered 'a most democratic profession'.[6]

Dora Batty was one of the most versatile female designers working for the Underground in the interwar period. She was trained in a wide range of disciplines including textile and ceramic design, advertising graphics and book illustration. Her interest in textiles – a subject which she taught at the Central School of Arts and Crafts from 1932 and of which she was later head at the School – emerges in many of her poster designs for the Underground, in which stylish, confident women are dressed in luxurious outfits executed in great detail. In *From Country to the Heart of Town for Shopping* (plate 134), the young woman is wearing a jumper with a geometric pattern with matching scarf, hat and gloves. The detail of the twisted fabric around the waist, and the

effect this has on the pattern and the flowing line of the scarf – as if blowing in the wind – show not only a clear understanding of the qualities of textiles, but also great skill in the art of fashion illustration.

Attention and praise for Underground posters came not just from the pages of contemporary advertising and design publications, but also from the public. In both cases the names of artists were spoken of with regard to the quality of design or

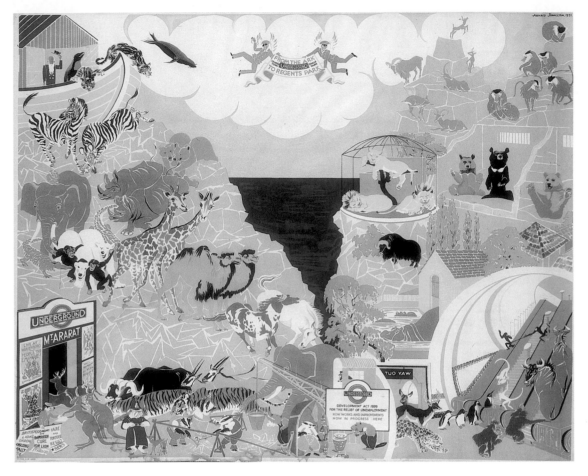

135 From the Ark to Regent's Park
Arnrid Banniza Johnston,
1931

Quad royal
(1016mm x 1270mm)
Published by UERL
Printed by the Baynard Press

appeal to the public, regardless of gender. Arnrid Johnston designed *From the Ark to Regent's Park* (plate 135) in 1931. The poster was reproduced in *T.O.T. Staff Magazine* as 'one of the most popular posters … as judged by demands made for copies by the public' (see chapter 10, plate 234).[7] In addition to work as a lithographer and sculptor, Johnston also wrote and illustrated several children's books.

According to the trade journal *Commercial Art* (1928), women poster designers were particularly competent at depicting animals, children and flowers – a statement which may appear patronising to readers today.[8] In fact, whilst posters such as Johnston's support this claim, Underground posters by women artists demonstrate more than competent handling of a much broader range of subjects (see plate 136).

Margaret Calkin James was another educated, prolific and versatile designer working for the Underground in the late 1920s and 1930s. She mastered contemporary conventions in poster art, working in simplified form and exaggerated colour, but also appropriated her extensive knowledge of calligraphy, textiles and book design, gained during her studies at the Central School and at Westminster School of Art. The success of her designs was down to her ability to match style with content. *Royal Tournament, Olympia* of 1932 (plate 137) presents a traditional event in a contemporary manner. The uniformed men on horseback form two vertical rows. The repetition of a single image suggests speed, movement and excitement, as well as creating an abstract pattern reminiscent of a woven textile design. Calkin James had a strong affinity with Arts and Crafts principles and founded the Rainbow Workshops, a venture similar to Roger Fry's Omega Workshop. She undertook commissions to produce publicity material for Shell-Mex, the BBC, the GPO and the Southern Railway, as well as the Underground.

**136 Motor Cycle and
Cycle Show**
Anna Katrina Zinkeisen, 1934

Panel poster
(268mm x 320mm)
Published by London Transport
Printed by the Dangerfield
Printing Company Ltd

**137 Royal Tournament,
Olympia**
Margaret Calkin James, 1932

Panel poster
(413mm x 305mm)
Published by UERL
Printed by the Curwen Press

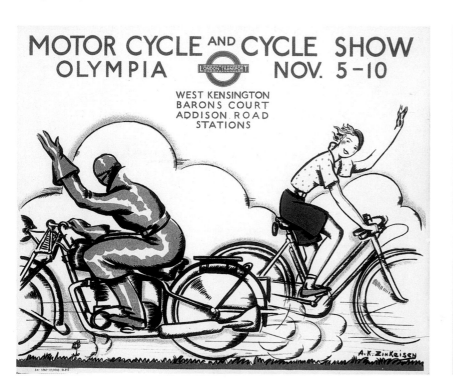

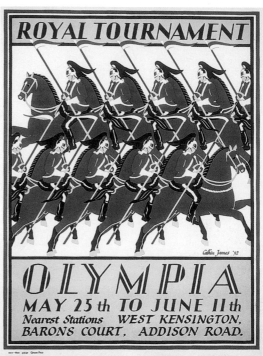

138 Derby Day
Herry Perry, 1928

Panel poster
(292mm x 469mm)
Published by UERL
Printed by Adams Bros and
Shardlow Ltd

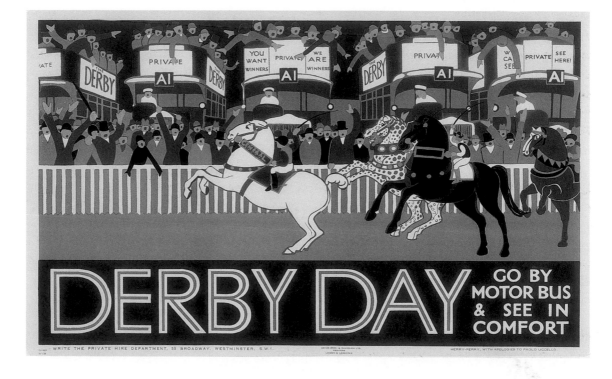

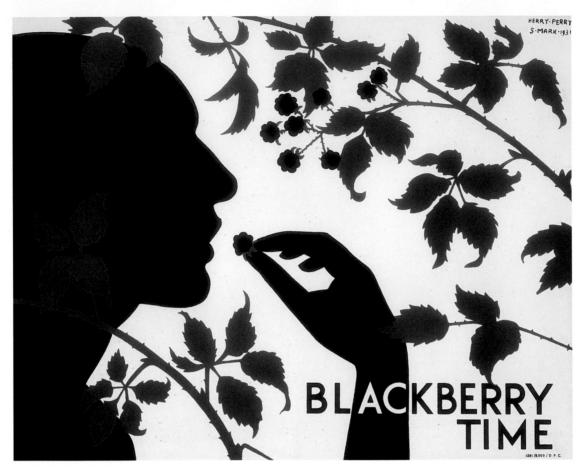

BLACKBERRY
TIME

139 **Blackberry Time**
Herry Perry, 1931
Panel poster
(255mm x 330mm)
Published by UERL
Printed by the Dangerfield
Printing Company Ltd

Herry (Heather) Perry, who specialised in wood engraving during her studies at the Central School of Arts and Crafts, is probably best known for her posters for Great Western Railway, London Midland & Scottish Railway and London Underground. She also worked as a book illustrator and designer of playing cards and pub signs. Her versatility as an artist is evident in her work for the underground, which often varies dramatically in style from poster to poster. *Derby Day* from 1928 is a mixture of a modern stylised aesthetic with a Victorian Gothic approach to composition and colour palette (plate 138). It is also a witty adaptation of a well-known Renaissance painting in London's National Gallery: Paolo Uccello's fifteenth-century mounted knights at the Battle of San Romano are transposed to the modern annual horse race on Epsom Downs.

Perry's *Blackberry Time* of 1931 (plate 139) depicts a Modern woman, with fashionably short bobbed hair and a streamlined shadow. The contrasting colour palette is minimal yet striking. One of her final posters, *Cup Final* of 1935 (plate 140) demonstrates a new departure and applies the avant-garde medium of collage to a more traditional subject matter.

In addition to working as designers, women occupied a variety of other positions within the advertising industry in the 1920s and 1930s. At a number of leading advertising agencies, these included quite senior posts. In 1925 Mrs Ethel M. Wood, Director of the advertising agency Messrs Samson Clark, published the essay 'Advertising as a career for women' in *Modern Advertising*. She extolled the virtues and advantages of a career in advertising for women and discussed the various options open to them, from agency work to product research, design and artwork.

A growing interest in behavioural psychology led to a conscious effort to identify consumer motivation. The woman as subject and consumer could greatly inform the woman as designer, offering invaluable

140 Cup Final
Herry Perry, 1935

Panel poster
(255mm x 318mm)
Published by London Transport
Printed by the Dangerfield
Printing Company Ltd

insight into how to approach subjects aimed at a female audience. However, women did not only work on products, services and pursuits traditionally reserved for them. The skill of the poster artist, male or female, was to master their subject, which in advertising could range dramatically from one commission to the next. Male designers such as Marty, Herrick and Taylor had approached subjects intended to appeal to women, in the same way that female designers had to take on less familiar subjects aimed at attracting men. Of course, gender does not automatically determines one's interests: when Edward

Bawden was asked by the Underground in 1928 to design a press advertisement for 'Association Football' matches in London, he had never been to a game before, and so made a special trip to make sure he portrayed the scene accurately.

The outstanding range of posters designed for the Underground in the 1920s and 1930s, by men and women, by both established designers and promising newcomers, reflects Ethel M. Wood's belief that 'the best results are obtained by ignoring the question of sex and employing the person who does the job most satisfactorily'.[9]

Notes

1. Rosita Forbes, *Daily Mail*, 2 March 1931.
2. Lord Northcliffe as quoted in A. Bingham, *Gender, Modernity, and the Popular Press in Inter-War Britain*, Clarendon Press, Oxford University, 2004, p.93.
3. Horace Taylor, 'The Selection of Posters', p.186 (ch.XI), in L. Richmond (ed.), *The Technique of the Poster*, Sir I. Pitman & Sons, London, 1933.
4. W.G. Raffé, *Poster Design*, Chapman & Hall, London, 1929, pp 174–5.
5. J. Hewitt, *Design Issues*, vol.16, no.1, spring 2000.
6. E. Wood, *Modern Advertising*, New Era Publishings, 1925, p.121.
7. *T.O.T. Staff Magazine*, March 1932, pp 78–9.
8. *Commercial Art* I, 1923, p.218.
9. Wood, *Modern Advertising*.

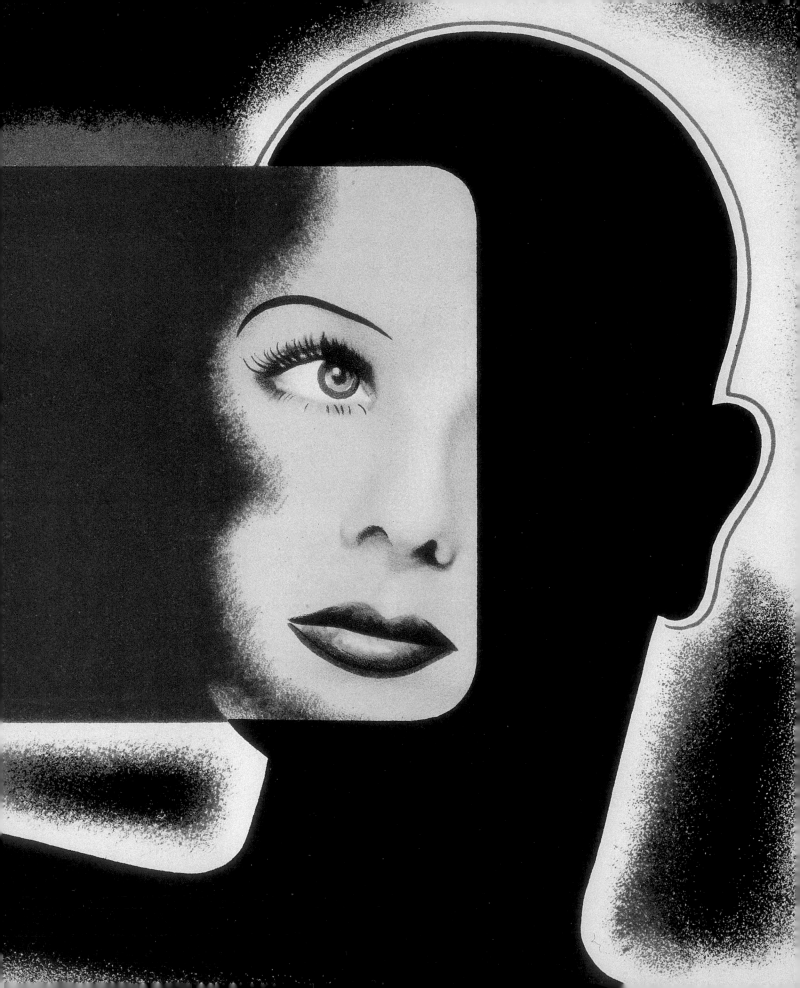

'PICTURES WITH A STING':
THE LONDON UNDERGROUND
AND THE INTERWAR MODERNIST POSTER

Jonathan Black

THE PERIOD BETWEEN the world wars was a high point in the history of quality posters produced by the Underground Electric Railways of London (UERL) and its 1933 successor, London Transport. They commissioned aesthetically challenging poster designs by such leading modernist artists as Edward McKnight Kauffer, Edward Wadsworth, Graham Sutherland and Paul Nash and, from across the Channel, Man Ray, Hans Schleger ('Zero') and, another refugee from Nazi Germany, the Hungarian Modernist László Moholy-Nagy.

The most stylistically challenging posters, however, only constituted a small percentage of the output. It is indeed remarkable that the aesthetically conservative Frank Pick commissioned as many advanced images as he did (see chapters 2, 5 and 6). Pick was always willing to consider using Modernist artists even if their work was not to his personal taste. He was prepared to give them generous latitude to get a design just right.[1]

This minority of Modernist artists rose to the challenge of producing stimulating imagery to promote the most prosaic of subjects, such as the best times to go shopping in central London, the availability of cheap off-peak tickets and the opportunities for advertising on the Underground itself. There

were also somewhat elusive abstract concepts that were difficult to render visually: civil defence, adult education, improvements to the safety of travelling on the Underground and campaigns emphasising the benefits of clean air.

Repeatedly, the posters Pick commissioned provided the opportunity for the latest avant-garde art styles to enter the consciousness of the British public at large. This was invariably many months, even years, before examples of these artists' works were exhibited in London West End galleries. What is remarkable is just how little dilution there was. Certainly, by the 1930s, a number of strikingly abstract posters had been commissioned by London Transport and, what is even more extraordinary, were appreciated by a surprisingly large element among the travelling public. Although the company did occasionally employ artists who had arrived from abroad, it is noticeable how many British artists and designers – including John Myles Fleming ('Beath'), Maurice Beck, Eric Fraser, Graham Sutherland, Paul Nash and Edward Wadsworth, as well as Canadian-born Austin Cooper – confidently worked in such uncompromising Modernist idioms as photomontage and geometric abstraction. Indeed, in 1933, Nash and Wadsworth were founder members of Unit One – perhaps the most important interwar British avant-garde art movement.[2] By the late 1930s, the students of the Reimann School of Industry and Commerce, founded in 1937 by Austin Cooper and supported by Nash and Wadsworth, were producing to order a stream of striking designs for London Transport which were directly informed by the latest visually stimulating developments in European Modernism.

Perhaps a slight loss of nerve is discernible on the part of London Transport towards the end of the 1930s as the political situation rapidly deteriorated. The majority of posters commissioned still depicted traditional subject matter – the countryside of the Home Counties, the London Zoo, the River Thames, London parks, flower shows – but in a more guardedly conventional manner. This trend makes the minority that actively engaged with experimental Modernism all the more eye-catching and deserving of examination.

The Roaring Twenties

Encouraged by established poster designer John Hassall, Edward McKnight Kauffer had caught the eye of Frank Pick as early as 1915.[3] The work he produced for the UERL after the First World War did tend to be more formally daring and challenging: Kauffer was a member of Wyndham Lewis's short-lived Group X, through which he hoped to revive prewar Vorticism with its focus on hard-edged geometric abstraction (see plate 141). Kauffer exhibited with the Group in its sole exhibition held at Heal's Mansard Gallery in March–April 1920, and thereafter his style moved easily between prewar Post-Impressionism (not out of place among any gathering of Bloomsbury Group artists) and more adventurous avant-garde styles such as Vorticism, Cubism and Futurism.[4] The thoroughly industrialised segmentation of time was a particular topic the advertising of which was pioneered by the UERL. Indeed, such advertising introduced the concept of 'peak' and 'off-peak' periods of travelling time. The UERL was especially keen to appeal to the emancipated female shopper with money to spend and freedom to leave the house during the hours recommended by the company.[5]

By the early 1920s a consensus had formed in British art circles that posters could be fully considered 'Modern Art'. There was far more hostility towards 'illuminated signs', whereas *The Times* argued in March 1922 that a 'good poster' added value to the experience for Londoners and foreigners of

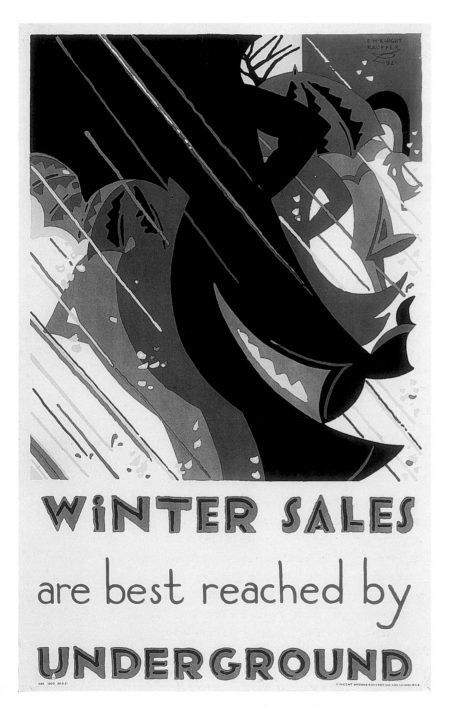

travelling around the capital. Poster art was further
identified as a genre in which British artists shone —
though one of the artists singled out for praise, Kauf-
fer, was, of course, American by birth. Even at this
early juncture, the Underground had been identified
as a patron of the most effective modern poster
design — alongside the London North Western and
Midland railway companies and other commercial
organisations such as the Canadian Pacific Railways,
Derry & Tom's department store, P&O Steamers and
the Royal Mail Steam Packet Company. It was also
argued that the Underground simply had a novel vari-
ety of services, products and technologies to
advertise, as opposed to railway and steamer com-
panies who appeared more focused on promoting
suitably inviting holiday destinations at home and
within the far-flung Empire. There was general agree-
ment as to what now constituted good poster design
of the sort which should be actively encouraged:
'Simple straightforward pattern in a few bright
colours is what is wanted in pictures for display on
the hoardings [inside Tube stations] and there should
be as little lettering as possible on the advertise-
ment.'[6]

In June 1924 an exhibition of recent commer-
cial posters was held at Brighton Art Gallery. Kauffer
was swiftly identified as 'our leading poster artist'.
The reviewer for *The Times* was pleasantly surprised
that 'the English work compares very favourably with
that from abroad'. Kauffer, in particular, stood out
because he kept his designs 'simple and emphatic'
while retaining 'solidity' and 'body'.[7] The following
year, many reviewers hailed Kauffer's solo exhibition
at the Arts League of Service in London. According
to *The Times*, anyone familiar with Kauffer's posters
would have long ago concluded that 'he may be
called a great artist'. He stood out head and shoul-
ders above his contemporaries in the field for his

142 **Imperial War Museum,
South Kensington: The
Vindictive Howitzer**
Edward McKnight Kauffer,
1924
Double royal
(1016mm x 635mm)
Published by UERL
Printed by Waterlow & Sons Ltd

'ingenuity as a designer and his taste as a colourist'. His designs were distinguished by the 'singleness with which he fulfils all the requirements of the poster – arresting interest, meaning, carrying power, formal unity, decorative appeal and memorability – in the style of execution'.[8] A poster Kauffer produced to advertise the Imperial War Museum (plate 142) intriguingly anticipates the *Neue Sachlichkeit* imagery of the German photographer Albert Renger-Patzsch which fetishised machine-manufactured, technological, objects. Kauffer may also have been paying homage to the Royal Artillery war memorial at Hyde Park Corner by Charles Sargeant Jagger, which is topped by a stylized Howitzer in a Modernist idiom.[9]

Other artists working for the UERL were evidently interested in and sought to apply aspects of the prewar avant-garde styles which were slowly gaining some wider cultural respectability, such as Futurism and its French equivalent, known as Orphism (see plates 143 and 144). The implication of such designs is that the underground network should no longer be regarded as simply a form of transport. It was also a source of refuge from the infamous infelicities of the British climate. The Tube as respite from London's climatic rigours later impressed the cynical imagination of Evelyn Waugh, although not in the manner intended by the Underground's publicity men. Writing in 1930, Waugh vividly evokes a wintry London in February 1929: 'People shrank, in those days, from the icy contact of a cocktail glass, like the Duchess of Malfi from the dead hand, and crept as stiff as automata from their draughty taxis into the nearest tube railway station, where they stood, pressed together for warmth, coughing and sneezing among the evening papers.'[10]

By the mid-1920s, some of the younger generation of British graphic artists appear to have become aware of the latest developments in graphic art in the

143 It's Cooler Down Below: Travel in Comfort by Underground
Austin Cooper, 1924

Double royal
(1016mm x 635mm)
Published by UERL
Printed by the Dangerfield
Printing Company Ltd

This design harks back to both the delicate abstraction of prewar French Orphist, Robert Delaunay, and the playful abstraction pursued in prewar Munich by Wassily Kandinsky.

144 Take Cover Underground
Kathleen Stenning, 1925

Panel poster
(298mm x 502mm)
Published by UERL
Printed by Vincent Brooks,
Day & Son Ltd

The vivid lightning flash is derived from an appreciation of prewar Futurism.

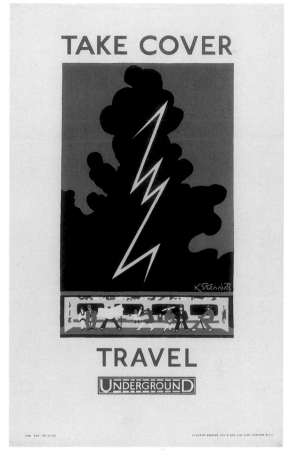

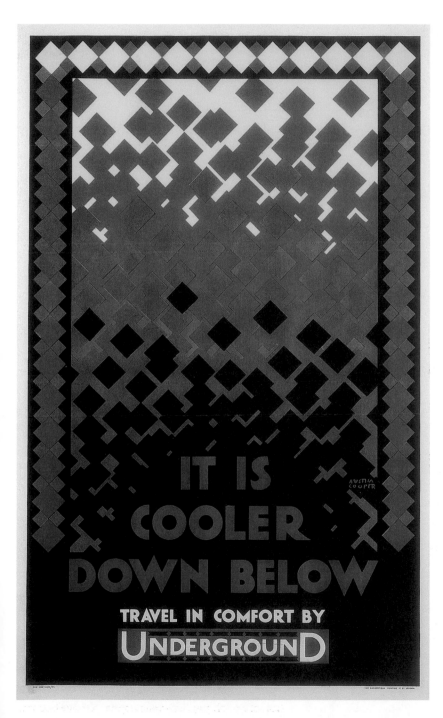

Soviet Union such as the Suprematism of Kazimir Malevich and El Lissitzky and the Constructivism of Alexander Rodchenko. Though it was difficult for a western European to visit the Soviet Union in the 1920s, some examples of Suprematism and Constructivism were exhibited in Berlin, c.1922–8.[11] Thereafter, such abstraction was increasingly frowned upon by the Soviet authorities as 'formalist' and therefore damned as bourgeois. Talented artists Sybil Andrews and Cyril Power (who signed their joint work 'Andrew Power') may well have been aware of Karel Čapek's play *R.U.R.* ('Rossom's Universal Robots'), first performed in English in

London in the spring of 1923, which introduced the word 'robot' to the English language.[12] The costumes for this production were widely discussed at the time and created rather a vogue for the inhumanly mechanical 'robot-man' (see plate 145).

In February 1927 an exhibition of posters commissioned by the UERL, the London, Midland & Scottish Railway (LMS) and the London North Eastern Railway (LNER) companies was held in the Board Room of King's Cross Station. One reviewer of the show observed that the Underground appeared to seek to advertise a much greater variety of subject matter than the other two companies involved, and also seemed more interested in conveying useful practical information to the public. Furthermore, the Underground, unlike the railway companies, generally refrained from employing Fellows and Associates of the Royal Academy. The posters commissioned by

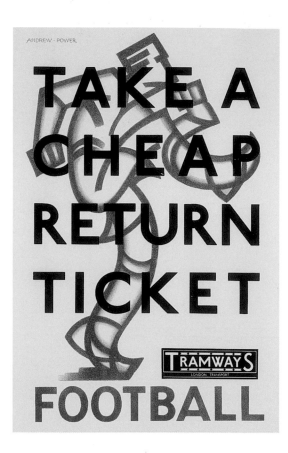

145 **Take a Cheap Return Ticket: Football**
'Andrew Power'
(Sybil Andrews and Cyril Power), 1925
Double crown
(762mm x 508mm)
Published by UERL

146 **The Motor Show, Olympia, October 11th–20th**
Eric Fraser, 1928
Panel poster
(295mm x 465mm)
Published by UERL
Printed by the Dangerfield Printing Company Ltd

Fraser appears to have been aware of recent posters by A.M. Cassandre (the name employed by Adolphe Mouron – a Bulgarian artist based in Paris) evoking the latest in svelte, streamlined, precision-engineered machinery.

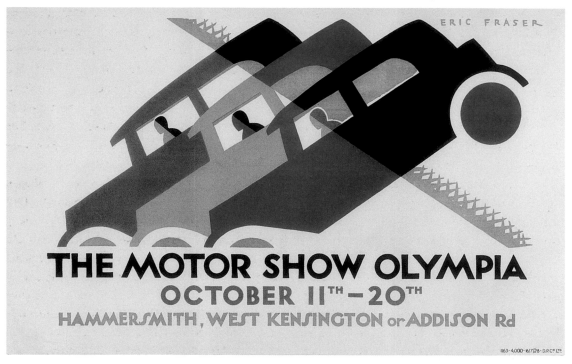

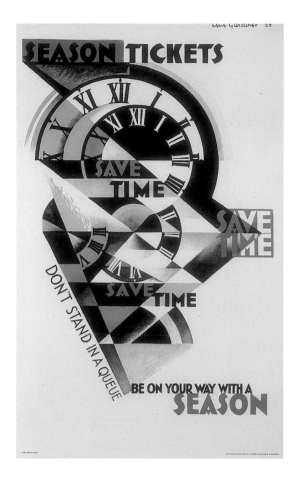

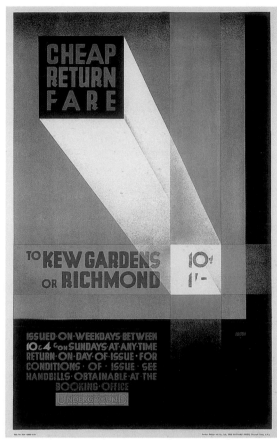

147 Save Time. Be On Your Way with a Season. Save Time, Don't Stand in a Queue
Clive Gardiner, 1928

Double royal
(1016mm x 635mm)
Published by UERL
Printed by Waterlow & Sons Ltd

On the evidence of this composition, Gardiner must have been acquainted with the challenging, geometrically abstract contemporary graphics of De Stijl in Holland and the Soviet Constructivism of Rodchenko and El Lissitzky.

148 Cheap Return Fare to Kew Gardens or Richmond
Austin Cooper, 1929

Double royal
(1016mm x 635mm)
Published by UERL
Printed by the Baynard Press

the UERL, consequently, did not strike the viewer as 'diluted pictures … pictures with the sting taken out'. Additionally, designs prevalent on the Underground suggested the advantage of the more experimental approach, while the 'simplified realism' fostered by the company was equally effective.[13]

In October 1928 the exhibition 'Twenty Years of Underground Posters' was held at the New Burlington Galleries in London. Kauffer was by now ritually singled out as by far the most effective designer, while the UERL was hailed as Britain's most adventurous patron of poster art – though it was acknowledged that the company faced increasingly stiff competition from the LMS and LNER railways, Shell-Mex, the Empire Marketing Board and the General Post Office (GPO). The reviewer was pleased the British artists stood comparison so well with their continental counterparts and argued that 'simplified realism is not enough … there must be some reinforcement

of the design in a formal direction.' Interestingly he also concluded: 'Underground advertising obviously works by suggestion, rather than by direct advice – by inducing a state of mind favourable to travel – and the best posters in this collection may be said to make the use of the Underground almost a reflex action.'[14] Alongside Kauffer, Austin Cooper, Eric Fraser (see plate 146) and Clive Gardiner (see plate 147) were singled out for approbation.[15]

The following year Austin Cooper, identified in *The Times* as a rival in talent to the great Kauffer, produced a series of designs advertising 'Cheap Return Fares' (see plate 148).[16] These constitute some of the most unabashedly challenging, geometrically abstract posters commissioned for the Underground between the wars. They are also as eye-grabbing and compelling as anything produced in the 1920s by Malevich and Constructivists such as Rodchenko in Soviet Russia or any of the artists

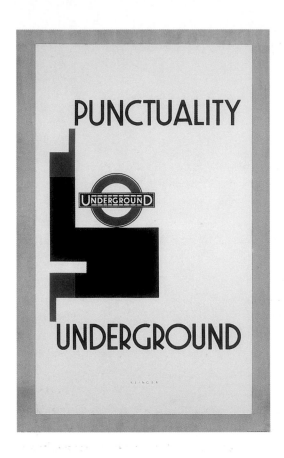

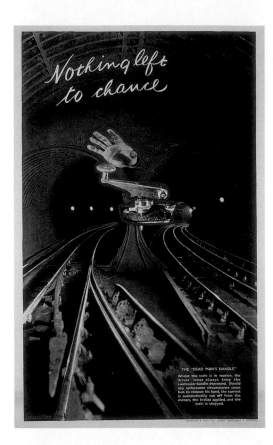

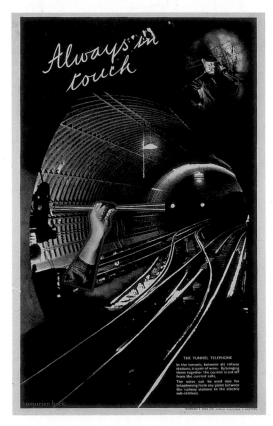

associated with the Bauhaus in Weimar Germany, including Moholy-Nagy, Joost Schmidt, Herbert Bayer and Kurt Schwitters.[17] Meanwhile, also in 1929, the UERL commissioned work for the first time from Julius Klinger (plate 149) – a talented, established, Austrian poster designer who had adapted his own graphic art to the stylistic innovations advocated by the Bauhaus in publications such as Moholy-Nagy's *Painting, Photography, Film* (1925), Jan Tschichold's *The New Typography* (1928) and Werner Graeff's complementary *The New Photography* (1929).

The anxious Thirties

In the period of economic turmoil following the Wall Street Crash of October 1929, the theme of reassurance was, for obvious reasons, the leitmotif running through a series of powerful posters commissioned in 1930 from Maurice Beck, an accomplished photographer with close links to the design world of Weimar Germany and avant-garde art circles in the UK (plates 150 and 151).[18] Although more crowded and 'busy' than Kauffer's compositions,

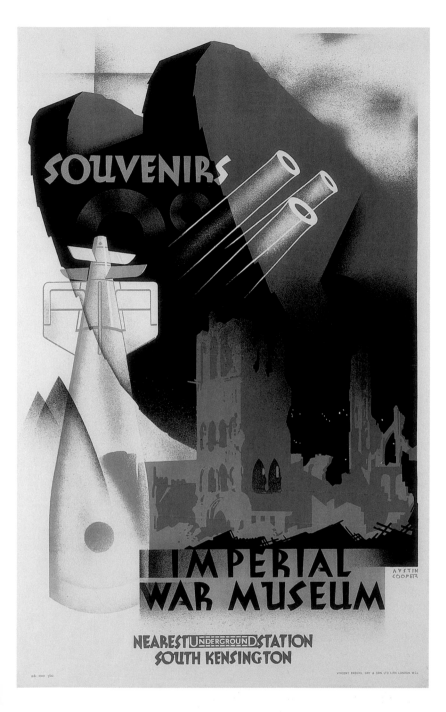

152 Souvenirs: Imperial War Museum
Austin Cooper, 1932
Double royal
(1016mm x 635mm)
Published by UERL
Printed by Vincent Brooks,
Day & Son Ltd

The shape of the bomb in the composition rather chillingly anticipates that of 'Little Boy', the nuclear weapon dropped on Hiroshima on 6 August 1945.

duced to safeguard both the paying passenger and the staff of the company.

Beck's use of photomontage is as effective and assured as the better-known contemporary work by Russian experts in the technique such as Alexander Rodchenko, Gustav Klutsis and Vladimir and Gyorgy Stenberg, all of whom were then employed by the Soviet State to impressively promote what later transpired to be the largely illusory achievements of the first Soviet Five Year Plan.[19]

In June 1931 a 'British and Foreign Posters' exhibition was held at the Victoria & Albert Museum. Contributors included the UERL, the Empire Marketing Board, the LNER and LMS railway companies and the Royal Mail Steam Packet Company. The majority of reviewers argued that the exhibition brought home once again the fact that 'the revival of poster designing in England was due to one business corporation – the Underground Electric Railways Company. Mr. Frank Pick … did not create his artists; he simply allowed the good artists available to do things their own way … .' The UERL could now justly claim a roster of artists – including Kauffer, Cooper and Beck – which 'could not be equalled anywhere else in the world', while the company was further commended for its inventive employment of talent from overseas such as Julius Klinger.[20]

The UERL was also praised for taking a lead in devising different uses for posters, including the promotion of the Underground stations themselves as attractive advertising spaces, and the educational potential for all ages offered by London's museums (see plate 152). Imagery on this theme produced by Austin Cooper also touches on the period's later understandable reputation as an 'age of anxiety', as it effectively anticipates the bombed urban centres that would appear in Alexander Korda's 1936 film *Things To Come* and in newsreels later in the 1930s

Beck organised superbly the combination of text and striking imagery, such as the Surrealist-derived free-floating dislocated hand. Visually stimulating and powerfully evocative of the intriguing interior world of the Underground, these are posters to savour. The technological innovations they promoted appeared, not – as they would so often be shown in the 1930s – as a sinister threat, but as a development intro-

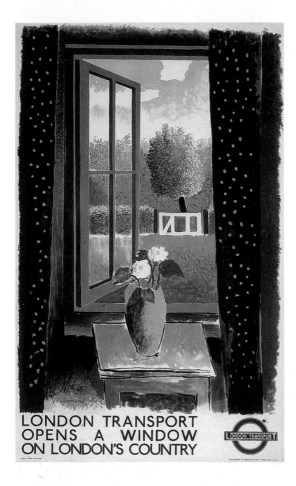

153 London Transport Opens a Window on London's Country
Graham Sutherland, 1933
Double royal
(1016mm x 635mm)
Published by London Transport
Published by UERL
Printed by S.C. Allen
& Company Ltd

abstraction, or, at any rate stylisation ... the concentrated extract of the subject matter that needs to be delivered at a single blow in the design'. Among the great exponents of this general 'boiling down' of the subject matter were, above all, Kauffer, Cooper and a relatively new talent, Graham Sutherland (see plate 153).[23]

London Transport's Publicity Committee first met in August 1933, and within a couple of months had drawn up a clearly focused plan for a campaign which had to take on board the fact that the new organisation's financial situation was still being adversely affected by the economic slump. Even so, the committee could command a healthy annual Publicity budget of some £90,000, with £12,500 reserved for commissioning posters, though larger sums were destined for newspaper advertisements (£40,000) and the production and dissemination of Harry Beck's revolutionary new Tube map (£20,000).[24] The Committee, its decisions largely dictated by Pick, was less interested in recommending particular styles than in emphasising the need for careful standardisation.[25]

From early in its existence the new Publicity Committee was especially keen to commission work from young British artists who had not previously worked for the UERL, such as Christopher Greaves (see plate 154) and Pat Keely, as well as tried and tested individuals such as Kauffer, Cooper, Clive Gardiner and Charles Pears.[26]

Meanwhile, Frank Pick made a conscious effort to publicise London Transport's commitment to modern design. In March 1934 he told *The Times* that he '... deplored the exhibition on public hoardings of posters without ... artistic merit ... Publicity was essential in modern life and must make for itself a permanent place and establish and maintain traditions of its own.'[27] Pick's enlightened approach to

featuring carnage inflicted from the air during the Spanish Civil War (1936–9) and the Japanese invasion of China (begun in July 1937).[21]

The following year, in July 1933, even as the UERL was transformed and enlarged to become London Transport, posters from the Underground won special praise at the 'Art in the Service of Commerce' exhibition held at Olympia. Frank Pick was expressly commended for having the sense to balance the demands of a corporate 'house style' against the reality that, in the posters he commissioned, 'there is room for a wide range of treatment, from comparative realism to severe and concentrated abstraction ... allowing for differences in style, the best contemporary posters are following what ... may be called a normal development: that is to say, in the direction of simplicity, economy, clearness and concentration upon the point to be conveyed'.[22]

Of particular interest was the 'epigrammatic treatment' which compelled a 'certain amount of

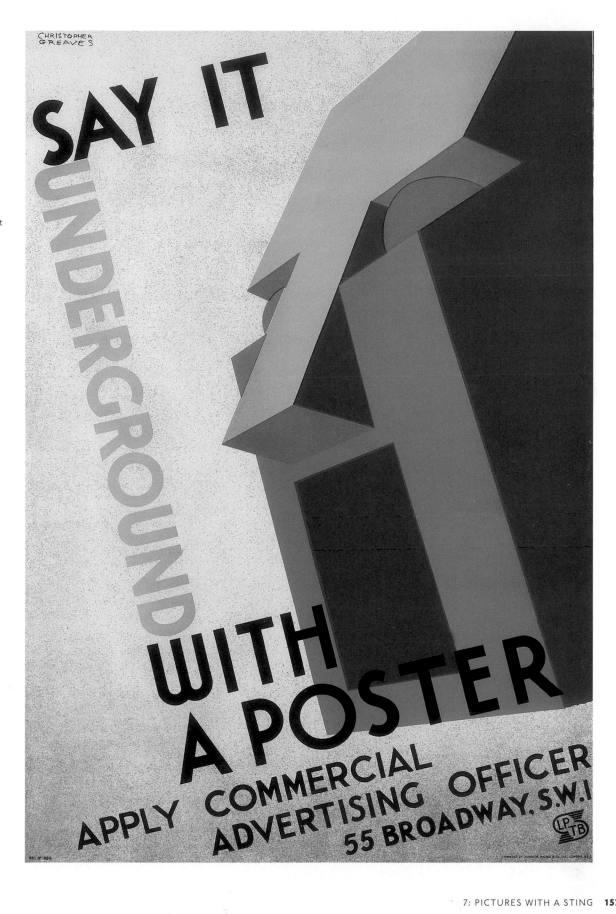

**154 Say It Underground
With A Poster**
Christopher Greaves, 1933

Double crown
(762mm x 508mm)
Published by London Transport
Printed by Johnson, Riddle &
Company Ltd

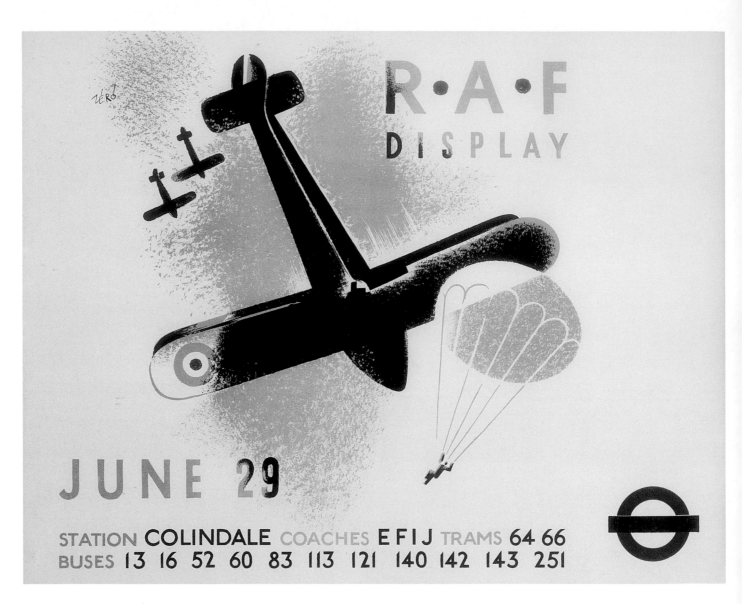

RAF DISPLAY

JUNE 29

STATION **COLINDALE** COACHES **E F I J** TRAMS **64 66**
BUSES **13 16 52 60 83 113 121 140 142 143 251**

poster design, all the more impressive since he harboured strong reservations as to the aesthetic validity of artistic modernism, received a boost with the success of Kauffer's solo show held at the London premises of Lund Humphries in March 1935.[28] By now the reputations of Kauffer, with his 'remarkable gift for "putting it across" in terms that arrest the attention and stick in the memory', and of London Transport were regarded as inseparable – both widely identified as united standard-bearers of modernity and rational mechanical progress.[29]

In May 1935 the Publicity Committee was joined by Christian Barman, formerly editor of the *Architectural Review*, where John Betjeman, in his inimitable way, had dubbed him 'Barmy', on account of his unfettered enthusiasm for Modernism.[30] The following month the Publicity Committee, after a strong representation from 'Barmy', approved a design submitted by German émigré Hans Schleger (who signed his work 'Zero') to advertise the annual Royal Air Force Display at Hendon (plate 155). Within the next eighteen months the aircraft Schleger depicted did not seem quite so innocently admirable, as Italian bombers dropped high explosives and poisoned gas in Abyssinia and German and Italian aircraft ruthlessly attacked civilians during the Spanish Civil War.[31]

In August 1935 the first design by two newly

155 **RAF Display,
June 29th, Colindale**
Hans Schleger ('Zero'), 1935

Panel poster
(252mm x 317mm)
Published by London Transport
Printed by the Dangerfield
Printing Company Ltd

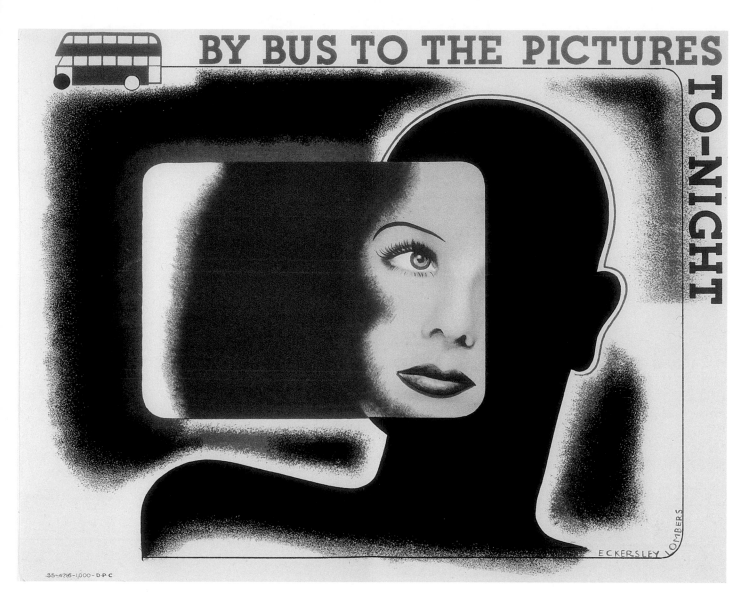

156 By Bus To The Pictures To-night
Tom Eckersley and
Eric Lombers, 1935

Panel poster
(255mm x 305mm)
Published by London Transport
Printed by the Dangerfield
Printing Company Ltd

graduated students from Salford College, Tom Eckersley and Eric Lombers, was submitted to the Publicity Committee (plate 156). In a striking manner, it advertised London Transport's bus services as the easiest way to get to 'the pictures' during an era now regarded as the golden age of cinema-going in the United Kingdom.[32] The design of this panel poster shows the impact of the Bauhaus and the Dutch De Stijl movement and anticipates works featured in the very first UK exhibition devoted entirely to abstract art – 'Abstract and Concrete', which opened in London in 1936. Prior to that date, the average Londoner was far more likely to see examples of the most challenging art in the form of a poster commissioned by London Transport, such as the highly challenging geometrically abstract design supplied by John M. Fleming ('Beath') (plate 157).

In October 1936 Barman submitted two designs to the Publicity Committee by Paris-based American designer/photographer Man Ray, who was closely associated with the Surrealist Movement from its inception. One design entitled 'London Transport – Keeps London Going' was approved.[33] Now regarded as an iconic image for the Underground, the poster version did not actually appear on the Underground for a further eighteen months (plate 158). May Ray wittily transformed London Transport's distinctive 'bull's-eye' logo into the planet Saturn. Was the

157 Electric Illumination, Science Museum
John M. Fleming ('Beath'),
1936

Double royal
(1016mm x 635mm)
Published by London Transport
Printed by Waterlow & Sons Ltd

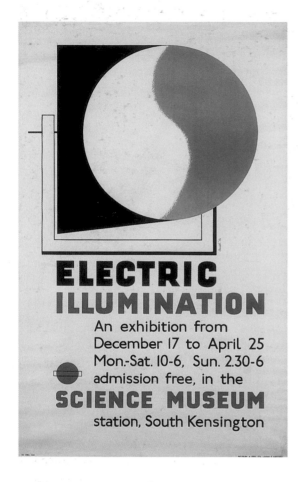

**158 London Transport –
Keeps London Going**
Man Ray, 1938

Double royal
(1016mm x 635mm)
Published by London Transport
Printed by Waterlow & Sons Ltd

Two versions of the poster were
printed: one with the text
'London Transport' the other
with 'Keeps London Going'.
Man Ray's choice of subject
matter may also be related
to his keen interest in
contemporary science fiction:
a wildly popular cinema serial
character of the day was Flash
Gordon, who first appeared on
the silver screen in 1936 with
Clarence 'Buster' Crabbe playing
the title role.

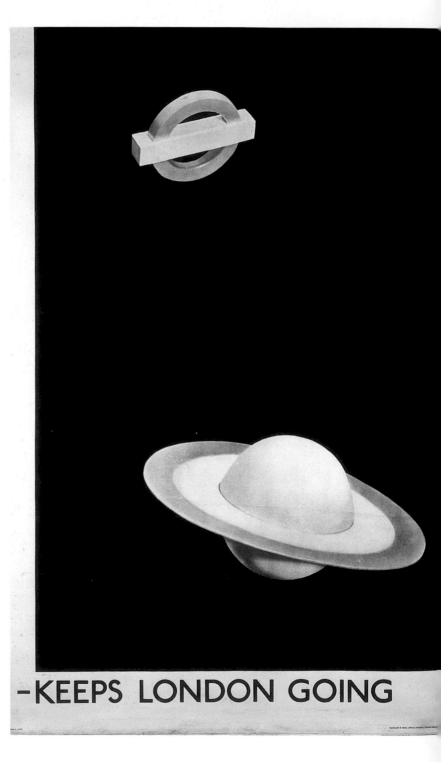

159 Man Ray's 'iconic' posters *in situ* at St Paul's Underground station, January 1939.

160 **Your Fare From This Station: 2d to Burnt Oak, Golders Green**
László Moholy-Nagy, 1936

Double royal
(1016mm x 635mm)
Published by London Transport
Printed by Waterlow & Sons Ltd

artist, perhaps, hinting that contact with the company and its formidable Vice-Chairman had been a somewhat disconcertingly unearthly experience? It would seem, however, that when Man Ray's poster did eventually appear on the exteriors of Underground stations, the London public remained steadfastly oblivious to its provocative avant-garde simplicity (see plate 159).

It had not helped Man Ray's cause that he was based in Paris rather than London. Moholy-Nagy was living in London in 1936 and his boldly geometric design advertising the new twopenny fares (plate 160) was approved by the Committee in December that year. Intriguingly, this decision was made with relatively little discussion.[34] Apparently, Pick did not think much of his work, dismissing him as a 'surrealistic pasticheur' in October 1936 when he vetoed a suggestion that Moholy-Nagy be employed to help design the British Pavilion for the May 1937 Paris International Exhibition. However, on this occasion, he allowed himself to be swayed by Barman's recommendation of the Hungarian.[35] Indeed, early in 1937, Moholy-Nagy was commissioned to produce a series of designs densely enmeshing text and

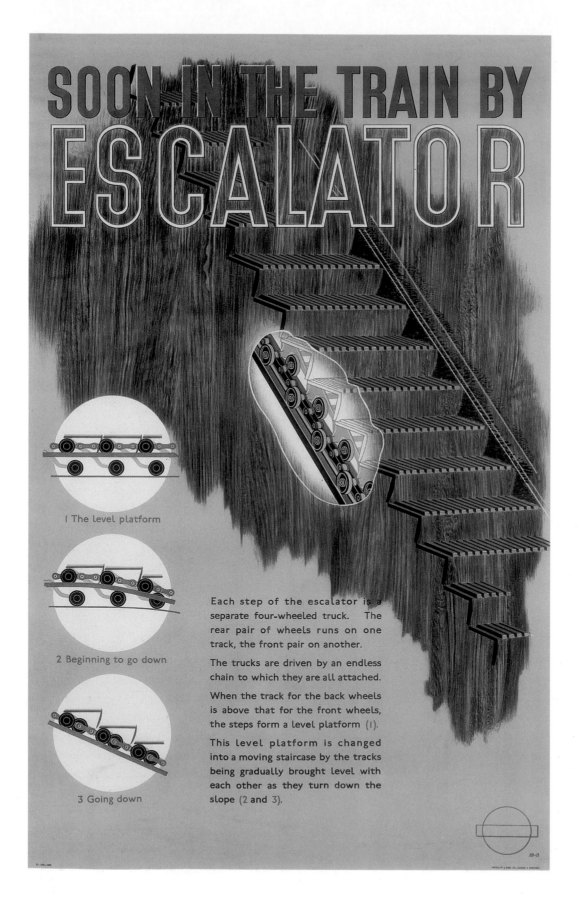

SOON...IN THE TRAIN BY ESCALATOR

1 The level platform

2 Beginning to go down

3 Going down

Each step of the escalator is a separate four-wheeled truck. The rear pair of wheels runs on one track, the front pair on another.

The trucks are driven by an endless chain to which they are all attached.

When the track for the back wheels is above that for the front wheels, the steps form a level platform (1).

This level platform is changed into a moving staircase by the tracks being gradually brought level with each other as they turn down the slope (2 and 3).

161 Soon In The Train By Escalator
László Moholy-Nagy, 1937
Double royal
(1016mm x 635mm)
Published by London Transport
Printed by Waterlow & Sons Ltd

Ironically, the safety-conscious, life-improving technology Moholy-Nagy depicts was also involved at the very same time in the design of Hitler's panzers by Ferdinand Porsche, which would wreak such havoc within just a couple of years.

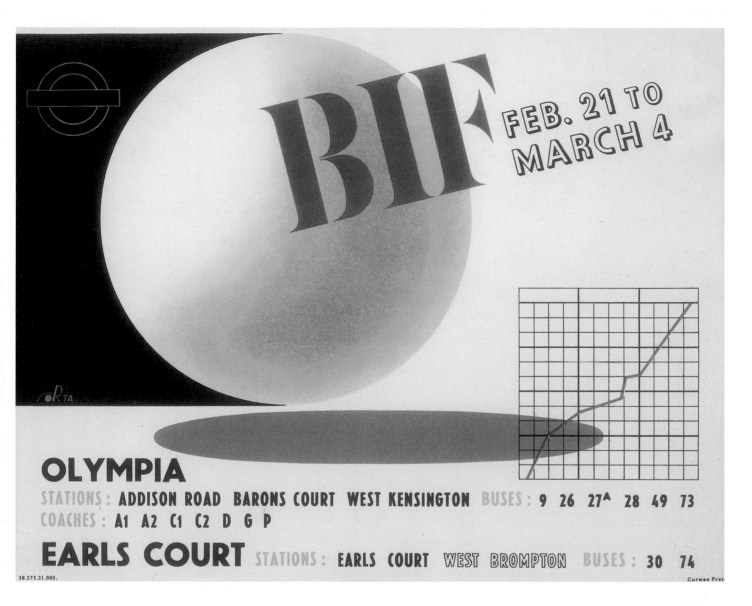

BIF

FEB. 21 TO MARCH 4

OLYMPIA

STATIONS : ADDISON ROAD BARONS COURT WEST KENSINGTON BUSES : 9 26 27ᴬ 28 49 73

COACHES : A1 A2 C1 C2 D G P

EARLS COURT STATIONS : EARLS COURT WEST BROMPTON BUSES : 30 74

38.275.21,000.

Curwen Pres

**162 British Industries Fair,
February 21–March 4,
Olympia**
The Reimann School/'T.A.',
1938

Panel poster
(255mm x 305mm)
Published by London Transport
Printed by the Curwen Press

stylised technical imagery which reiterated London Transport's continuing commitment to safety (see plate 161).[36] Although he established contacts with a number of sympathetic Modernists, such as Wadsworth, Paul Nash and Henry Moore, Moholy-Nagy did not thrive in the UK and in July 1937 moved on to the more welcoming United States.[37]

Probably as a consequence of their contact with prominent Modernist designers, the Publicity Committee – at Pick's urging – decided to establish a formal relationship with the Reimann School of Industry and Commerce. Founded in January 1937 by Austin Cooper, the School set out deliberately to

foster a new generation of Modern British graphic designers and encourage them to embrace the latest techniques (such as photomontage, screenprint and the airbrush) and stylistic approaches practised in mainland Europe.[38] By December of the same year the Committee had commissioned the School to provide panel posters for six major commercial events held annually within the capital: the British Industries Fair (plate 162); the Ideal Home Exhibition; the International Horse Show; the Motor Show; Smithfield Cattle Club; and the Dairy Show.[39]

The majority of posters commissioned by London Transport, however, continued to be executed in

**163 How Bravely Autumn
Paints Upon the Sky**
Edward McKnight Kauffer,
1938

Double royal
(1016mm x 635mm)
Published by London Transport
Printed by the Baynard Press

164 Go Out Into the Country
Graham Sutherland, 1938

Double royal
(1016mm x 635mm)
Published by London Transport
Printed by the Curwen Press

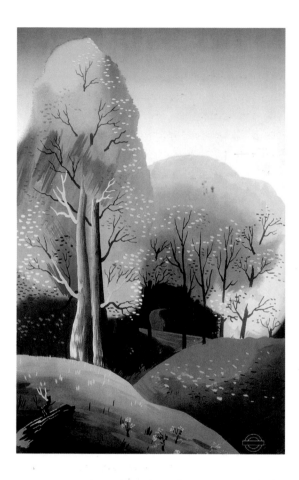

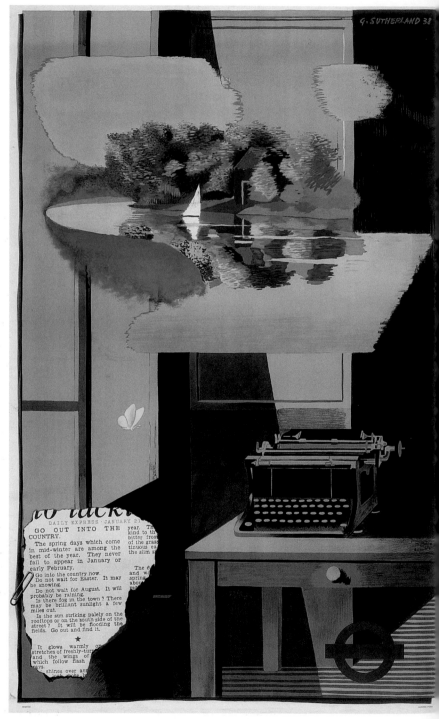

more conventional styles. On the whole this appeared to be exactly what the public preferred. Indeed, in 1937 more posters were sold by the London Transport shop than in the previous four years put together, and the most favoured designs featured landscapes, gardens and zoo animals depicted in a diluted Modernist manner.[40] As the political situation in Europe deteriorated and war loomed, especially in the wake of the Munich Crisis of September 1938, even such cutting-edge designers as Kauffer and Hans Schleger were required to produce imagery that was 'cheerful', reassuring, timeless and more than a little escapist (see plate 163).[41] Meanwhile, Graham Sutherland offered an alluring and

thoroughly updated pastoral idyll, skilfully evoked through photomontage, which urged Tube-users to *Go Out Into the Country* (plate 164).

Within the year Britain was at war, and hundreds of thousands of Londoners, principally women and children, would be evacuated to the countryside to preserve their lives from the widely anticipated German bombing onslaught.[42] For those who could

not, or would not, be evacuated from London the Underground network offered a relatively secure refuge from that very bombing – the epitome of Modernism applied to military technology.[43] The Reimann School – a brief, exhilarating beacon of Modernist experimentation in the UK – was closed for the duration, and the majority of its students con-scripted into the armed forces.

Notes

1. B. Webb and P. Skipwith, *Design: E. McKnight Kauffer*, Antique Collectors' Club, Woodbridge, 2007, pp 14–15.
2. Jonathan Black, *Form, Feeling and Calculation: The Complete Paintings and Drawings of Edward Wadsworth*, Philip Wilson Publishers, London, 2006, pp 89–91.
3. M. Haworth-Booth, *E. McKnight Kauffer: A Designer and His Public*, V&A Publications, London, 2005, p.15.
4. Michael Walsh, *C.R.W. Nevinson: This Cult of Violence*, Yale University Press, New Haven and London, 2002, pp 145–6.
5. C. Ross, *Twenties London: A City in the Jazz Age*, Philip Wilson Publishers, London, 2003, pp 18–19.
6. 'Art in Publicity', *The Times*, 20 March 1922, p.6.
7. *The Times*, 26 June 1924, p.9.
8. *The Times*, 19 May 1925, p.22.
9. The memorial was unveiled in October 1925, though its design had been under discussion for several years previously.
10. E. Waugh, 'Labels: a mediterranean journal', in *Waugh Abroad: Collected Travel Writing*, Everyman's Library, Toronto and New York, 2003, pp 8–9.
11. L. Becker and R. Hollis, *Avant-Garde Graphics 1918–1934*, Hayward Gallery, London, 2003, pp 17–19.
12. Ross, *Twenties London*, p.22.
13. *The Times*, 22 February 1927, p.12.
14. *The Times*, 2 October 1928, p.19.
15. ibid.

16. *The Times*, 29 October 1929, p.17.
17. F. Whitford, *Bauhaus*, Thames & Hudson, London, 1984 (2000), pp 166–74.
18. B. Wadsworth, *Edward Wadsworth: A Painter's Life*, Michael Russell Publishing, Salisbury, 1989, p.177.
19. Becker and Hollis, *Avant-Garde Graphics*, pp 49–51.
20. *The Times*, 22 June 1931, p.17.
21. B. Wasserstein, *Barbarism and Civilization: A History of Europe in our Time*, Oxford University Press, Oxford, 2007, p.240. The phrase was actually coined by W.H. Auden for a poem he wrote in 1947.
22. *The Times*, 20 July 1933, p.14.
23. ibid.
24. Meeting of London Transport's Vice-Chairman's Publicity Committee (VCPC), 9 November 1933, Transport for London Archives, LT 606/07.
25. VCPC, 17 October 1933, LT 606/07.
26. VCPC, 7 December 1933, LT 606/07.
27. *The Times*, 20 March 1934, p.11.
28. Haworth-Booth, *E. McKnight Kauffer*, pp 68–70. Earlier in 1935 Lund Humphries held the first UK exhibition devoted to Jan Tschichold.
29. *The Times*, 15 March 1935, p.12.
30. B. Hillier, *John Betjeman: The Biography*, John Murray, London, 2007, pp 102–3.
31. A. Beevor, *The Spanish Civil War*, Cassell, London, 1982 (2001), pp 242–3. The most infamous case of

early carpet-bombing took place in April 1937 when the German Condor Legion attacked the Basque town of Guernica, leaving 1654 civilians dead.
32. Wasserstein, *Barbarism and Civilization*, pp 233–4.
33. VCPC, 29 October 1936, LT 606/010.
34. VCPC, 24 December 1936, LT 606/010.
35. Terence A. Senter, 'Moholy-Nagy: the transitional years', in A. Borchardt-Hume (ed.), *Albers and Moholy-Nagy: From the Bauhaus to the New World*, Tate Publishing, London, 2006, p.90.
36. VCPC, 7 January 1937, LT 606/011.
37. Borchardt-Hume, *Albers and Moholy-Nagy*, pp 90–91.
38. *The Times*, 13 January 1937, p.7. Doubtless the School's links with London Transport were further strengthened by the fact that Kauffer and Wadsworth sat on its Advisory Board.
39. VCPC, 10 December 1937, LT 606/011.
40. VCPC, 3 March 1938, LT 606/012.
41. VCPC, 31 March 1938, LT 606/012. The Committee decided to ask Kauffer to produce a specifically 'cheerful' British landscape.
42. J. Gardiner, *Wartime: Britain 1939–1945*, Review, London, 2005, pp 16–17.
43. ibid pp 375–7. During the Blitz (September 1940–May 1941), an estimated 177,000 Londoners regularly sought refuge in the London Underground system.

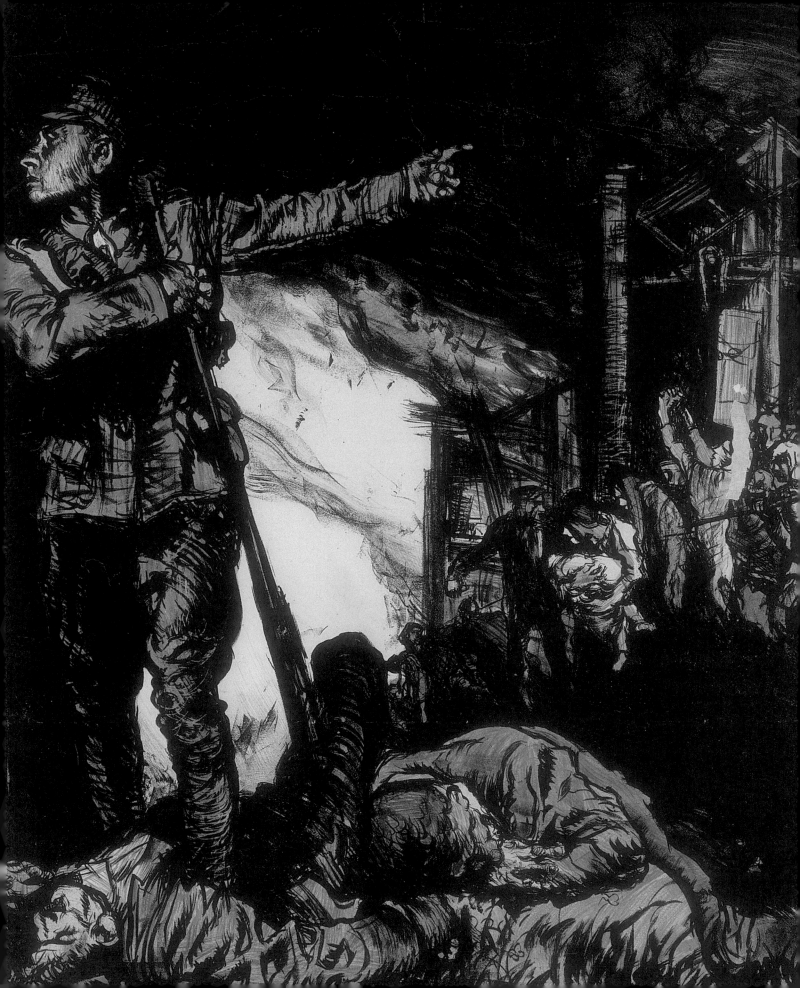

UNDERGROUND POSTERS IN WARTIME

Bex Lewis and David Bownes

LONDON'S TRANSPORT SYSTEM kept the city moving during two world wars. The role played by its staff in both wars had a decisive impact on the ability of government to function, and of civilians and soldiers alike to get to where they were needed. Throughout, posters played a vital role in keeping passengers informed and raising morale.

For an organisation used to selling its services with lively publicity campaigns, the two wars presented unique problems. What was the right tone to convey essential and sometimes frightening information, such as how to behave in an air raid or during the 'blackout'? What role should the company play in supporting government 'propaganda', firstly as a private company in 1914–18, and secondly as a publicly owned body during 1939–45? How could transport posters maintain staff and public morale at a time when the city was coming under regular air attack and hardly anything about London life was 'normal'?

The fact that the Underground Group, and later London Transport, was able to tackle these problems successfully is testament to the skill of its publicity staff and the guiding principles laid down by Frank Pick. Although faced with shortages of materials and manpower, the two organisations managed to maintain exemplary standards of poster design in the most difficult circumstances. In the end, the considerable experience gained selling 'London' to passengers proved an excellent basis for selling war to the public.

The Underground Group during the First World War (1914–18)

The outbreak of war with Germany in 1914 had an immediate impact on public transport. Mainline railways came under government control and were subject to severe operational restrictions in favour of military use. Thousands of trained staff enlisted in the Armed Forces, and many public transport vehicles, including hundreds of London buses, were requisitioned by the army. Station hoardings, too, quickly reflected the changed national circumstances, with army recruitment posters replacing advertisements for leisure travel.

Yet the Underground Group itself remained free from direct state control, and was able to conduct its affairs largely as before. This may explain the continued promotion of holiday traffic by bus and Tube long after railways had abandoned advertising non-essential travel. It also allowed the Underground far greater freedom in commissioning explicitly 'wartime' poster subjects, especially in the early years of the conflict before the formation of the Department (later Ministry) of Information in 1917. After this date, the Government took a keener interest in the use of Underground sites to display official propaganda material, and began hiring space for

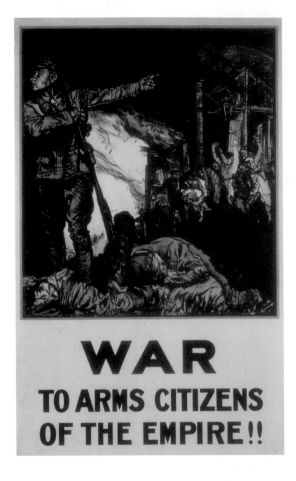

165 **War: To Arms Citizens of the Empire!!**
Frank William Brangwyn, 1914

Double royal
(1016mm x 635mm)
Published by UERL

its own posters, including campaigns to 'buy war bonds', 'eat less bread' and other austerity measures necessary to win the war.[1]

The artistic merit of the Government's early propaganda efforts were questioned at the time, not least by Pick who initially refused to display Parliamentary Recruiting Committee posters at Underground stations because of their poor design. Instead, Pick independently commissioned some of the best artists of the day to produce UERL posters on behalf of the war effort. In doing so, Pick was responding to the almost universal support for the war, which had seen similar initiatives from other private companies.[2] The main difference, however, lay in the quality of the resulting designs, which led V&A curator Martin Hardie to dedicate his 1920 book of war posters to Pick 'in honour of his brave and successful effort to link art with commerce'.[3]

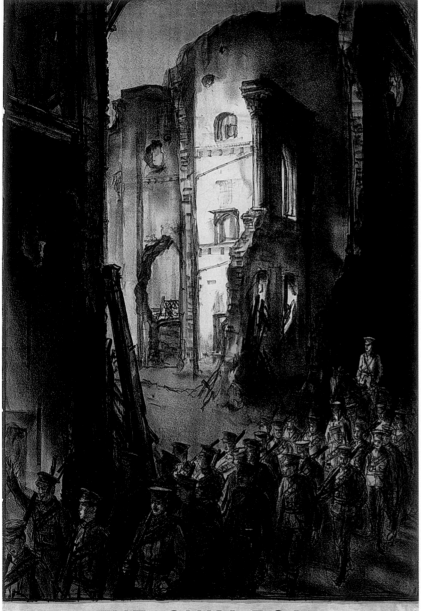

166 The Only Road for an Englishman
Gerald Spencer Pryse, 1914

Double royal
(1016mm x 635mm)
Published by UERL
Printed by Johnson,
Riddle & Company Ltd

Through Darkness to Light

THE ONLY ROAD FOR AN ENGLISHMAN

Through Fighting to Triumph

Helping the war effort: recruitment

During the opening months of the war, male passengers were bombarded with letterpress notices and text-only 'car cards', issued by the UERL, urging the hapless traveller to enlist. Most of these early posters played on rumours of impending conscription (not actually introduced until 1916), claiming that 'willing men make happy fighters' and that 'it is more blessed to go than to be pushed'. Sensing that such crude messages were liable to be counterproductive, Pick enlisted the help of Frank Brangwyn and Gerald Spencer Pryse, already established Underground poster artists, to produce something more dramatic. Both artists favoured a graphic realism shockingly suited to the depiction of war, yet rarely employed in government propaganda. As exponents of autolithography, both men were also used to drawing their designs directly from life onto vast lithographic stones. According to contemporary accounts, Pryse took this approach to the Western Front, where he was supplied with a staff car to transport the stones from place to place.[4]

The result was two of the finest British propaganda images produced during the First World War. The first, *War: To Arms Citizens of the Empire!!* by Brangwyn, was printed in both large landscape format and as a trimmed version for use on the Underground (plate 165). The original shows a displaced family (presumably Belgian) leaving behind the wreckage of their home, indicated by a British 'Tommy' standing among the bodies of civilian casualties. The family is missing from the poster version, although the image loses little of its dramatic impact. Brangwyn was particularly incensed by the German invasion of Belgium, having been born in Bruges and lived there as a boy.

The second poster, by Pryse (plate 166), was also influenced by the Belgian refugee crisis of 1914. Earlier in the year, Walter Spradbery had designed a bus

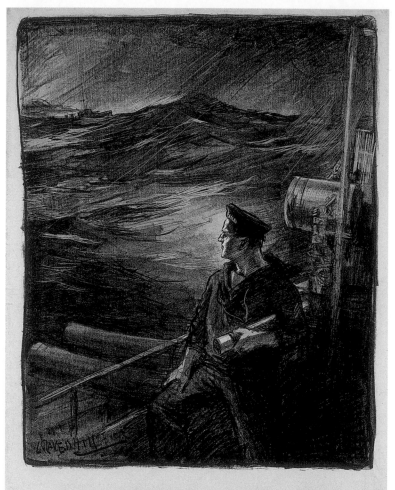

THE WATCHERS OF THE SEAS.

THE NAVY NEEDS BOYS AND MEN FROM
15 TO 40 YEARS OF AGE.

APPLY: 7, WHITEHALL PLACE, S.W.

167 The Watchers of the Seas
Leonard Raven-Hill, 1915

Double royal
(1016mm x 635mm)
Published by UERL
Printed by Johnson,
Riddle & Company Ltd

168 1209 Men of these Companies have joined The Colours
Fred Taylor, 1915

Double royal
(1016mm x 635mm)
Published by UERL
Printed by Johnson,
Riddle & Company Ltd

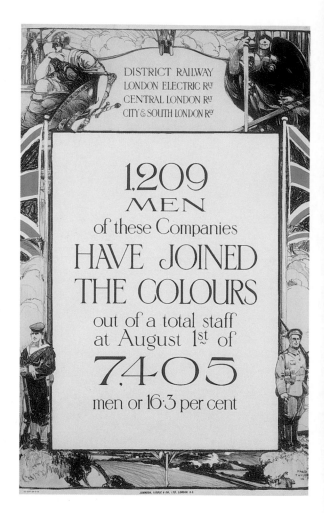

DISTRICT RAILWAY
LONDON ELECTRIC Rʸ
CENTRAL LONDON Rʸ
CITY & SOUTH LONDON Rʸ

1,209 MEN of these Companies HAVE JOINED THE COLOURS out of a total staff at August 1st of 7,405 men or 16·3 per cent

169 England v. Germany
Artist unknown, 1915

Panel poster
(152mm x 438mm)
Published by UERL
Printed by Johnson,
Riddle & Company Ltd

ENGLAND ᵥ GERMANY.

SIGN ON AT ONCE FOR THE GRAND INTERNATIONAL FINAL.

EVERY MAN COUNTS.

170 Join the Army To-day
Artist unknown, 1915

Double royal
(1016mm x 635mm)
Published by UERL
Printed by the Dangerfield
Printing Company Ltd

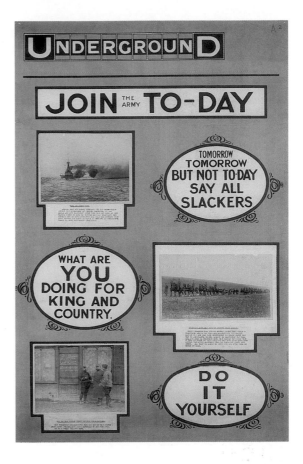

poster for the UERL offering 'The Open Road, Fresh Air and Sunshine' to its passengers. For wartime, Pryse offered 'The Only Road for an Englishman' — a clear, and patriotic, message sadly muddied by the Underground itself which continued to advertise day trips in parallel poster campaigns (see below).

A more conservative pictorial recruitment poster was issued by the UERL in 1915 on behalf of the Royal Navy (plate 167). Leonard Raven-Hill's image shows a stoic seaman surveying a tempestuous ocean. Here, man is pitted as much against nature as against an opposing army. It is an undoubtedly strong image, but lacks the pathos of Brangwyn's and Pryse's depiction of the impact of war on civilian life. Similarly, Fred Taylor's stirring celebration of the UERL's own recruitment record uses traditional devices of flags, armoured warriors and cheerful servicemen, rather than graphic realism (plate 168).

Eric Kennington, an Official War Artist in the First World War who later designed a number of posters for London Transport in the Second World War, considered that both approaches were potentially flawed. If war art tried to be too positive and optimistic, he argued, it would be justly ignored by the increasingly sceptical public. On the other hand, if it was too realistic in portraying the horrendous conditions at the front, it could damage civilian morale.[5]

The Underground Group, too, seemed unsure of the best approach, ultimately reverting to the policy of using cheaper letterpress posters and car cards to encourage enlistment. One series used famous quotations from historical figures to elicit a suitably martial response (a tactic repeated in the Second World War), while a second tried to entice waverers by comparing the war to a football match in the language of *The Boy's Own Paper* (plate 169). One of these even advised that 'the sport of the year [is] hunting the Huns. Get into training and join the team'.

A low point, in terms of design and sentiment, was reached in 1915 with the introduction of photographic posters designed to shame British men into volunteering with implications of cowardice and loss of honour. Those who did not join up were stigmatised as 'slackers', in an approach reminiscent of Government-funded propaganda (plate 170). It is difficult to imagine Pick supporting such an approach, not least because it must have had a negative impact on his workforce. Perhaps fortuitously for Pick's future reputation, the advent of conscription in 1916 brought an end to further posters in this vein.

A reminder of home

With the perceived need to assist recruitment over, Pick turned his attention to commissioning a very different kind of 'war poster' — one intended for the enjoyment of troops serving overseas. The idea was developed from a series of untitled four-sheet posters introduced in 1914 (see chapter 4, plate 71), showing typical scenes in London and the surrounding

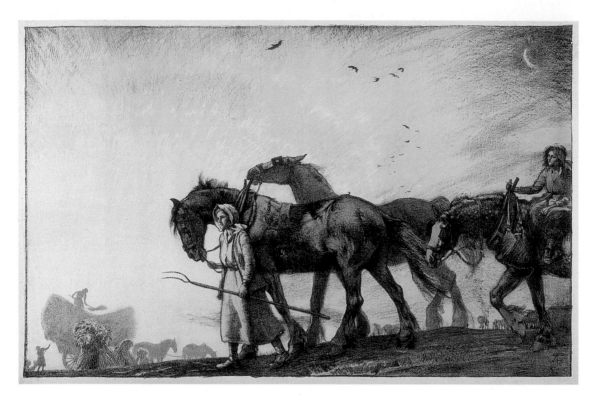

171 Harvest
John Walter West, 1916

Four sheet
(1016mm x 1524mm)
Published by UERL
Printed by Johnson,
Riddle & Company Ltd

172 Song to the Evening Star
F. Ernest Jackson, 1917

Double royal
(1016mm x 635mm)
Published by UERL
Printed by the Avenue Press Ltd

countryside. One of these, *Harvest* by John Walter West (1916, plate 171), was particularly suited for overseas consumption as it showed women workers taking the place of men – a very visual reminder of the impact of war on society and the support of the 'Home Front'. This was followed in 1917 by a series intended *solely* for distribution abroad, designed by West, George Clausen, Charles Sims and Ernest Jackson (see plate 172). Their purpose was clearly stated at the top of each design: 'The Underground Railways of London, knowing how many of their passengers are now engaged on important business in France and other parts of the world send out this reminder of home.' The original artworks were supplied free of charge by the artists and exhibited in a special exhibition held at Heal's furniture store in aid of the Royal Naval Division Comfort Fund for Prisoners of War (June 1917).

The posters were displayed in army billets, Y.M.C.A. huts and elsewhere. They must have received a favourable response, as four more were commissioned in 1918 from Fred Taylor and Emilio Tafani, this time under the heading 'London Memories … with the compliments of the Underground Railway' (see plate 173).

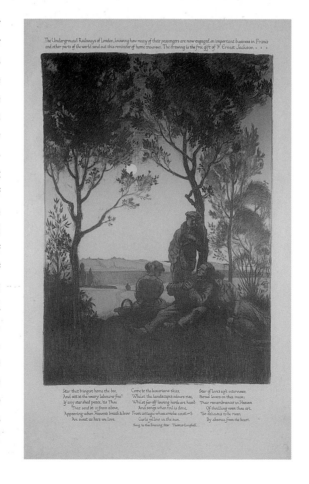

173 **London memories: Wimbledon Common**
Emilio Camilio Leopoldo Tafani, 1918

Double crown
(762mm x 508mm)
Published by UERL
Printed by the Avenue Press Ltd

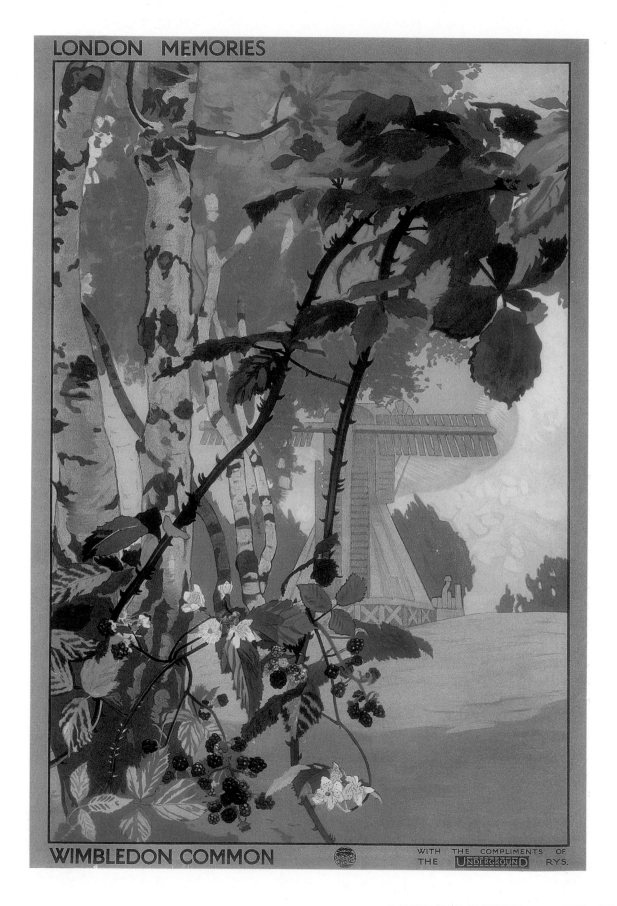

174 Why Bother about the Germans Invading the Country?
Warbis brothers, 1915

Double royal
(1016mm x 635mm)
Published by UERL
Printed by Spottiswoode
& Company Ltd

Invade the country

The overwhelming majority of pictorial posters produced by the Underground during the First World War, however, continued to advertise leisure travel and transport services. In subject matter and execution, these posters were little different from prewar publicity and were designed by many of the same artists.[6] This fact is all the more remarkable considering the severe overcrowding suffered by the Underground as the war progressed, together with bus and fuel shortages. Yet it was not until 1917 that pleasure trips were actively discouraged, at which point the number of newly commissioned posters fell dramatically. This change of policy coincided with a more general tightening of wartime restrictions, caused by shortages of raw materials, which had also resulted in Pick's secondment to the Board of Trade to assist with coal rationing earlier that year.

Until then, most pictorial posters made no reference to the war whatsoever, although uniformed soldiers are occasionally in evidence. A striking exception occurred with the Warbis brothers' design for Easter 1915, which encouraged families to 'invade' the country for themselves 'by Underground and motor-bus' (plate 174). More typically, posters extolled the pleasures of Hampstead Heath, London Zoo, Southend-on-Sea and a host of other destinations for the war-weary Londoner to enjoy. The Underground even continued to promote new residential districts, with posters for the recently completed Watford extension of the Bakerloo line appearing as late as 1917.[7]

Keeping the public informed

The more mundane realities of war, such as information about cancelled trains, delays, and fare increases, were conveyed to the public via letterpress posters. So too was information aimed at the

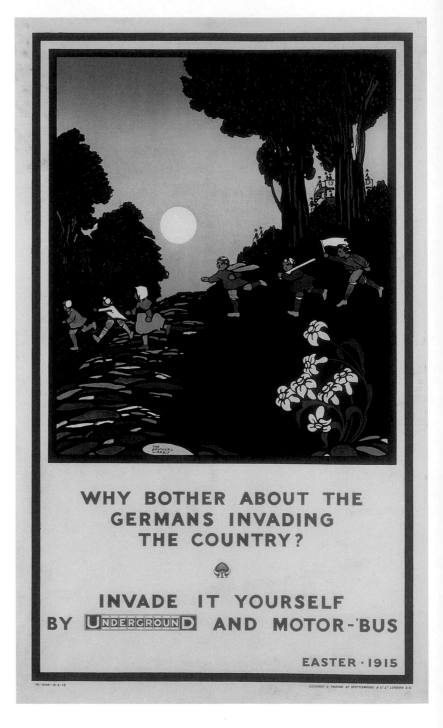

WHY BOTHER ABOUT THE
GERMANS INVADING
THE COUNTRY?

INVADE IT YOURSELF
BY UNDERGROUND AND MOTOR-'BUS

EASTER · 1915

huge influx of soldiers and war workers using the Tube for the first time, as well as campaigns to recruit 'lads' and women to replace male transport workers. In both cases, a very different approach was taken during the Second World War, when female recruitment and Tube 'etiquette' were given far higher status in the poster programme.

PASS RIGHT DOWN THE CAR PLEASE

Every one cannot get a seat at the busy hours but more could get a strap or standing room if the doors were left free from the crush. Think of the others. A door obstructor is a selfish person.

Train delays mean overcrowding.

175 Pass Right Down the Car Please
George Morrow, 1918

Double crown
(762mm x 508mm)
Published by UERL
Printed by Waterlow & Sons Ltd

The First World War also saw the first use of the Underground as a shelter during air raids. This practice was actively encouraged by the UERL, which issued a variety of printed notices on the subject from 1914 to 1917. In an opportunistic play on peacetime posters promising passengers that it is warmer/cooler/brighter Underground (depending on the season), a 1914 letterpress poster rashly advised: 'It is bomb proof down below. Underground for Safety. Plenty of bright trains. Business as usual.' On the overground stretches of the District Railway, notices politely requested passengers to 'keep the blinds drawn at night', lest the light from the carriage should attract the attention of German bomber pilots.

By 1918 the message had changed and passengers were requested to refrain from using the Tube unless necessary, due to overcrowding. For the first time, pictorial posters were used to show the implications of 'selfish' passenger behaviour, which, in a more refined form, has been a recurrent poster theme ever since (see plate 175).

London Transport during the Second World War (1939–45)

London's public transport system was far more prepared for war in the 1930s than it had been in 1914. For several years, London Transport had been working in co-operation with the government and the mainline railways to ensure that the network could cope with wartime conditions. It was natural, therefore, that when war broke out in September 1939 both LT and the private railway companies came under direct government control, exercised through the Railway Executive Committee (REC).

From the perspective of publicity, this meant that LT had less freedom (in theory at least) than it had had during the First World War to produce its own poster designs. Certainly, there would be no more appeals to 'invade the country' before the Germans. Instead, LT was expected to co-operate with the government's 'Holidays at Home' campaign and from the start issued REC notices to that effect at station entrances (see plate 176).

LT was also expected to work closely with the Ministry of Information (MOI), especially in the provision of free display space for its posters. The MOI had been re-formed by the Government in 1935, at which time it had consulted with an illustrious list of publicity experts (including LT, the Post Office and Shell-Mex) regarding poster design. Sensitive to allegations that the Government might be forming a British version of the 'Nazi Ministry of People's Enlightenment and Propaganda', William Crawford (head of advertising agency W.S. Crawford, Ltd) argued that people wanted a ministry 'to give us the facts alone', without embellishment.[8] Even so, crude attempts to censor the press had resulted in media hostility, which ultimately damaged the MOI's reputation.

Perhaps for this reason, LT was effectively left to manage its own publicity, for which it had an

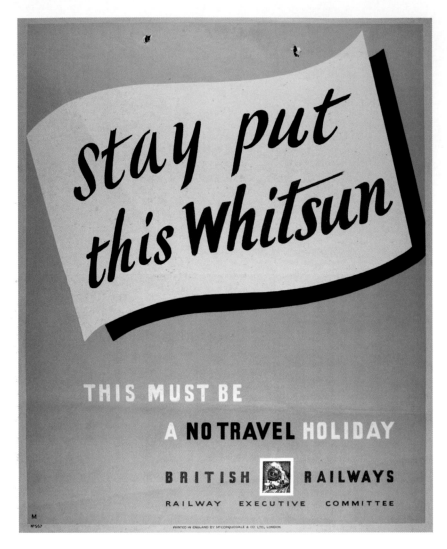

176 Stay Put this Whitsun
Artist unknown, 1942
(635mm x 520mm)
Published by The Railway
Executive
Printed by McCorquodale
& Company Ltd

László Moholy-Nagy, who went to Chicago to set up his US version of the Bauhaus. However, the biggest loss to poster design was Edward McKnight Kauffer – LT's most prolific and Britain's best-known poster designer in the interwar period. As an American, Kauffer was unable to work as a war artist and misguidedly felt he was a drain on British resources. He sailed at short notice for New York on the SS *Washington*, one of the last scheduled liners to leave England in 1940.

Many young British artists were called up to serve with the armed forces, as conscription was mandatory from 1939. Some, including Tom Eckersley and F.H.K. Henrion, worked as government poster artists, while Abram Games was commissioned Official War Office Poster Designer with the rank of Captain. Pick, too, left London Transport in 1940. He spent an unhappy few months with the MOI before his death in 1941, although his influence can be clearly seen in the posters produced by LT during the remainder of the war.

Blackout

One of the immediate effects of war was the nightly 'blackout' which plunged London into darkness. Streets were unlit to prevent enemy bombers using them to navigate, while station signage and vehicle lights were dimmed and shaded. Just catching a bus, or alighting from a train, became difficult and hazardous.

In these circumstances, LT realised that it had to produce instructional posters to prevent passenger injury. At first, letterpress notices were used, but from 1940 high-quality graphic posters were commissioned from Bruce Angrave, Nicholas Bentley, Hans Schleger and James Fitton (see plates 177 and 178). Each poster conveyed a simple message to help passengers use public transport at night, such

excellent reputation. In planning for the war, Pick believed that posters could be used to raise morale and stimulate 'the spontaneous will and vigorous purpose of the people themselves'.[9] When war broke out, plans for pictorial leisure-travel posters were scrapped (although a couple were issued during the so-called 'phoney war' from September 1939 to March 1940).

They were replaced with public information posters, often in support of Government campaigns, which led, inevitably, to press complaints about LT's wastefulness of paper. Indeed, wartime brought new problems for poster production, with shortages of paper, ink and poster designers.[10]

Many European designers 'passing through' had moved to America before the hostilities, including

**177 In The Blackout: Before
You Alight Make Sure The
Train Is In The Station**
Hans Schleger ('Zero'), 1943
(629mm x 502mm)
Published by London Transport
Printed by the Baynard Press

**178 Wear or Carry
Something White**
James Fitton, 1941
(623mm x 502mm)
Published by London Transport
Printed by the Baynard Press

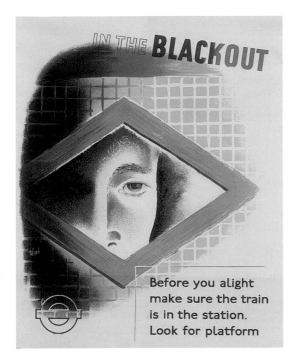

as 'shine a torch on your hand to hail a bus or tram'. Some of the instructions can seem a little patronising today, especially warnings to 'adjust your eyes' when leaving the brightness of the tube for the darkened street. However, the 'common sense' theme was in line with official government messages, and reflects a broader approach to wartime publicity which did not always meet with public approval.

Fougasse and Billy Brown

The problem of how to tell passengers what to do was not a new one. LT had considerable experience of conveying rules and regulations to its customers, often via letterpress notices. This policy worked well enough in peacetime, and continued to some extent after 1939, particularly for information regarding

Tube sheltering during air raids. However, with a plethora of dull government notices to compete with, dire printed warnings against rule breaking were just as likely to be ignored as acted upon. LT turned instead to two popular cartoonists to help with its public information campaigns: Cyril Bird and David Langdon.

Bird, who signed his work 'Fougasse' after a type of landmine, was one of Britain's most influential illustrators. A regular contributor to, and later art editor of, *Punch* magazine, Fougasse had also produced a number of posters for London Transport in the 1930s. His wry, observational style was superbly suited for wartime purposes, where his minimalist designs effortlessly conveyed a simple idea without adopting a lecturing tone. As the war progressed,

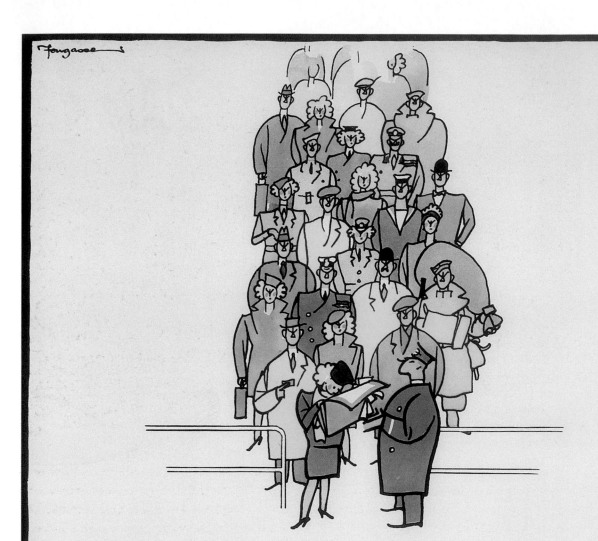

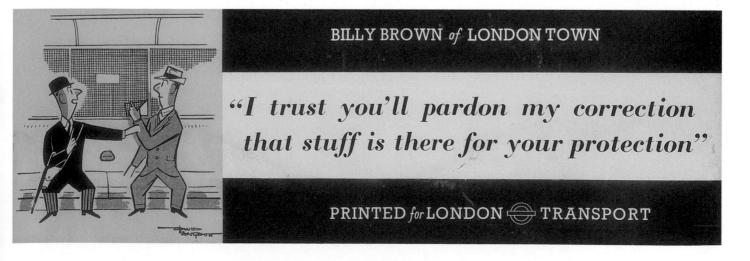

179 Please Have Your Ticket Ready at the Barrier
Fougasse (Cyril Kenneth Bird), 1944

(635mm x 502mm)
Published by London Transport
Printed by Fosh & Cross Ltd

180 The blocked-up Charing Cross Road entrance to Leicester Square Tube station in August 1944, showing two posters by Fougasse (**Please Don't Smoke in a Non-smoking Car** and **Please Pass Along the Platform**), together with a letterpress notice advising passengers of the 'nearest public air raid shelters to this station'. The installation of so-called 'baffle walls' at station entrances was part of London Transport's Air Raid Precaution measures.

181 Billy Brown of London Town: I Trust You'll Pardon My Correction
David Langdon, 1941

Panel poster
(574mm x 254mm)
Published by London Transport
Printed by the Baynard Press

Fougasse produced numerous designs for both the Government and LT, those for the latter focusing on thoughtless passenger behaviour and its effect on others (see plates 179 and 180).

David Langdon described himself as 'a current-affairs cartoonist', citing Fougasse as a key influence. He also contributed to *Punch* and several national newspapers. Like many of the great comic artists to work for the Underground, Langdon was a member of the London Sketch Club, but unlike predecessors such as John Hassall and Tony Sarg, he never produced full-colour posters, preferring instead to retain a distinctly character-based cartoon style. Between 1940 and 1945, Langdon drew a series of cartoons for LT based on the character Billy Brown of London Town (see plate 181). Intended to 'signify pictorially and by use

BILLY BROWN *of* LONDON TOWN

"I trust you'll pardon my correction that stuff is there for your protection"

PRINTED *for* LONDON ⊖ TRANSPORT

182 Billy Brown repurposed as mascot for a Second World War RAF bomber. According to a contemporary account, the slogan 'I trust it suffers no deflection, this stuff is for the Hun's correction' was added later.

183 **Enjoy your War Work**
Artist unknown, 1941
Panel poster
(570mm x 418mm)
Published by London Transport
Printed by the Baynard Press

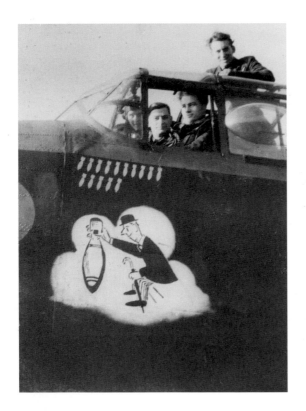

of verse, how the average Londoner should act or re-act under certain circumstances', the series met with a mixed response.[11] It was popular enough, however, to feature on the cockpit of at least one RAF bomber, where the crew depicted the be-suited Brown dropping a bomb on Germany (plate 182).

Female recruitment and staff morale

Women had been employed during the First World War to fill certain types of jobs vacated by male staff. These jobs had been advertised by letterpress notices in a fairly low-key way, although their impact on the travelling public and society at large had been immense.[12] From the start of the Second World War, female recruitment was given a much higher status by LT, although women were still barred from key jobs, such as driving trains and buses.

Enjoy your War Work is typical of the posters produced for public consumption, and gives a rather glamorous impression of the work on offer (plate 183). In contrast, a 1943 staff notice, entitled 'A Word to Women Employees', warned: 'when on duty – for safety first, don't wear high heels, they're quite the worst.'

Women workers also featured prominently in

**184 Back Room Boys ...
They also Serve:
Cable Maintenance**
Fred Taylor, 1942

(622mm x 508mm)
Published by London Transport
Printed by the Baynard Press

**185 Seeing it Through:
Woman Porter**
Eric Kennington, 1944

(812mm x 552mm)
Published by London Transport
Printed by the Baynard Press

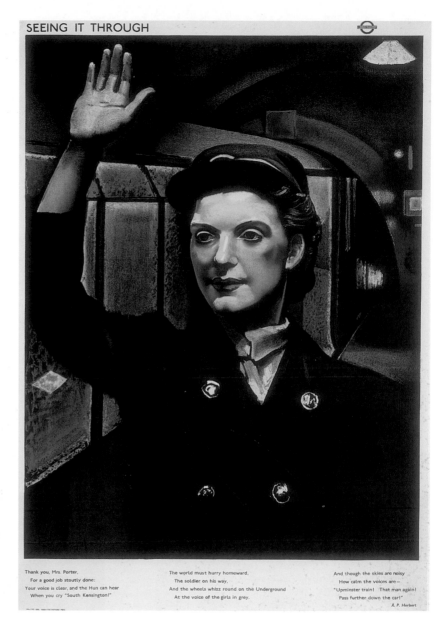

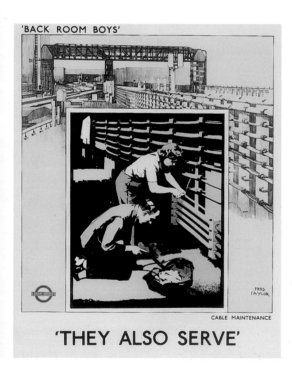

campaigns designed to raise awareness of LT's contribution to the war effort. Misleadingly entitled 'Back Room Boys ... They Also Serve', Fred Taylor's series of eight posters from 1942 features women taking on a number of traditionally male roles (see plate 184). A similar approach was taken in 1944 with a series commissioned from Eric Kennington, with verse text by A.P. Herbert. The subjects, including male train and bus drivers and female conductor and porter, were all based on real employees, although the LT magazine *Pennyfare* noted that the 'whole staff [had] sat for its portrait by proxy'.[13]

As an Official War Artist, Kennington had earlier produced a series of portraits of ordinary soldiers and sailors, all of them in his characteristic heroic and manly style. He did not, however, find it easy to represent civilians, particularly women, as subjects. *Seeing it Through: Woman Porter* (plate 185) depicts Elsie Birrell, a porter at Stockwell Tube station. She was one of the first female porters recruited by London Transport in 1940, having previously worked as a gown cutter in a dressmaking shop. Kennington based his painting on a photograph, although Birrell also modelled in person, causing Kennington much

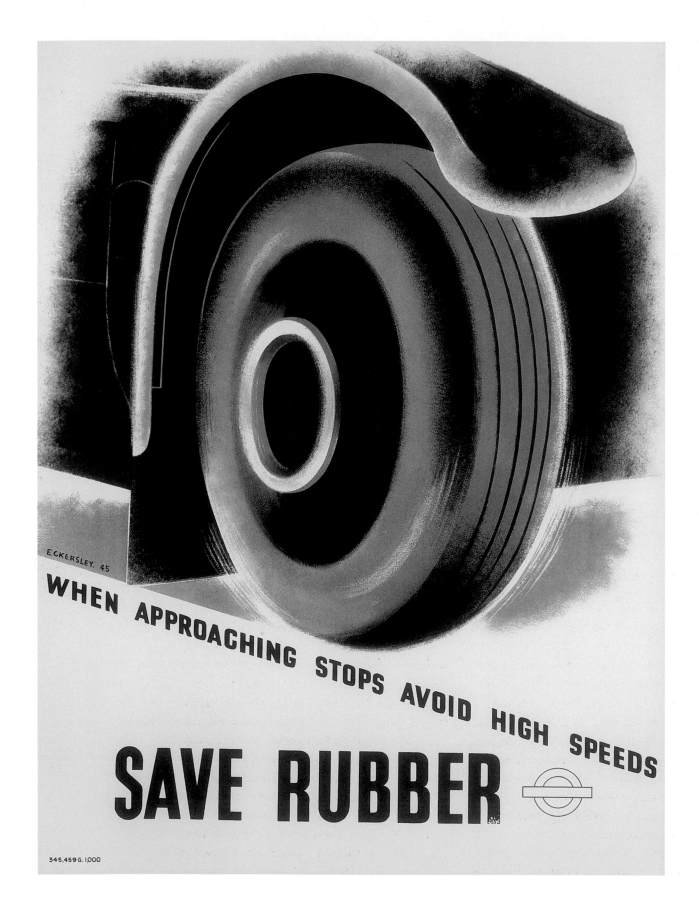

186 **Save Rubber**
Tom Eckersley, 1945
(622mm x 500mm)
Published by London Transport

187 **Our Heritage: Field-
Marshal Haig**
Robert Austin, 1943
(643mm x 508mm)
Unused poster artwork

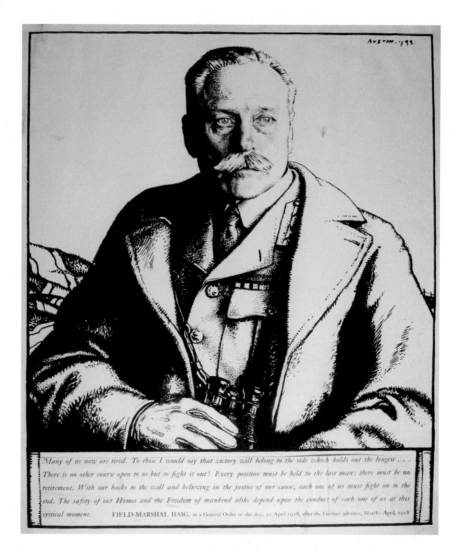

annoyance when she arrived at his studio wearing too much make-up. He later confessed that the finished design made her look like 'an Egyptian Mummy', although he blamed the effect entirely on the sitter's vanity and permed hair![14]

Behind the scenes, at works and in canteens, a different type of poster was aimed solely at the workforce. Absenteeism, wastefulness and poor workmanship were all discouraged as being counterproductive to the war effort. As with the public posters, illustrated workplace notices reminded staff that they were key workers in Britain's struggle against Hitler. Slogans such as 'railway equipment is war equipment' and appeals to 'save rubber' by careful braking accompanied often high-quality designs by well- known artists, including Leslie Carr, F.H. Stingemore, Pat Keely and Tom Eckersley (see plate 186).

Our Heritage

Pick had noted in 1938 that wartime publicity needed to be aimed at a single clear goal. It was all very well promoting certain types of behaviour, but what were we actually fighting for? In April 1943, to counteract the sombreness of other war posters, LT issued a series entitled 'Our Heritage' which dwelt on Britain's victorious military tradition past and present. The series consisted of five small-format posters, printed on poor-quality paper as a war economy. The centrepiece, for display purposes, was the eight points of the Atlantic Charter (the 1941 agreement between Britain and the USA setting out post-war peace aims), 'printed for the information of passengers and staff of London Transport'. Other posters from the series featured famous British war leaders (Nelson, Drake, Pitt and Churchill), accompanied by inspirational quotations.

The designs were commissioned from Robert Austin, who was an Official War Artist, to 'recall other occasions of the nation's will and high purpose'. The poster of Churchill (see chapter 3, plate 54) was based on a well-known wartime picture of him by the Canadian photographer Yousuf Karsh. One design which remained unused depicted Field-Marshal Earl Haig, Commander-in-Chief of the British Armies in France in the First World War (plate 187). Although lionised during his lifetime, his reputation had been indirectly tarnished during the 1930s by the popularity of soldier memoirs questioning the military strategy and high casualty rates of the 1914—18 war.[15] As a result, Haig may no longer have been considered an appropriate inspirational figure, and his image was dropped from the campaign.

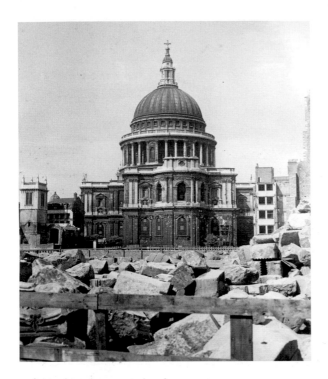

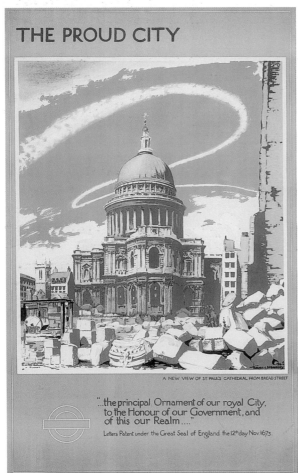

A NEW VIEW OF ST. PAUL'S CATHEDRAL FROM BREAD STREET

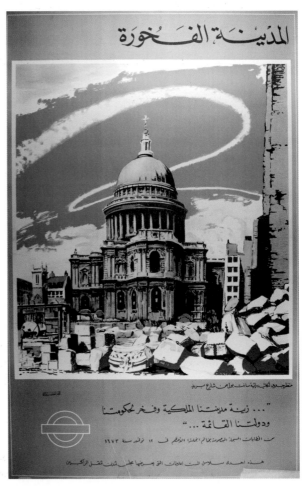

188 The Proud City: St Paul's
Walter E. Spradbery, 1944

Photograph, artwork, English
and Arabic language versions
Artwork (670mm x 565mm)
Each poster double royal
(1016mm x 635mm)
Published by London Transport
Printed by the Baynard Press

The Proud City

The success of 'Our Heritage' prompted a similarly inspirational series celebrating the resilience of London (and, by implication, Londoners) in the face of the Blitz. Commissioned from Walter Spradbery in 1944, 'The Proud City' series featured six images of famous London buildings, based on photographs supplied to the artist by London Transport. Each was to be reproduced in a traditional painterly manner and printed in double-royal format for display at the most prestigious LT poster sites (such as station entrances).

Originally entitled 'The Unconquerable City', Spradbery's brief was to show that in spite of war damage the spirit of London was undimmed, and to select suitable quotes to accompany each image.[16] Fred Taylor had been commissioned to provide a similar series of designs in late 1939 – to include the statue of Oliver Cromwell at Westminster, the Houses of Parliament, St James's Palace, the Horse Guards and the Guildhall. Spradbery's posters, released two at a time, depicted The Tower of London, St Paul's Cathedral, the Houses of Parliament, St Clement Danes Church, Lots Road Power Station and the Temple Church and Library.

As a pacifist, Spradbery wanted to show 'something intangible, something far beyond an actual pictorial record of the damaged historical buildings of London', which would steer well clear of glorifying war.[17] The result was a magnificent group of posters, which manages to capture both the defiance of London and, in Wilfred Owen's phrase, 'the pity of war'. The posters also reveal Spradbery's superb technical skill, confirming his opinion that posters should make an impact from a distance through simplicity, but also be 'able to withstand … close inspection equally well'.[18]

The series was very well received by passengers and critics alike. The *Advertiser's Weekly* described the St Paul's image (plate 188) as having the strongest appeal: 'It is magnificent because the whole picture is symbolic of the spirit of the people, not only of London, but of Britain itself; the spirit of a nation whose head was bloodied and unbowed.' The aeroplane vapour trail giving the impression of a halo is described as a 'masterly touch', imparting a suggestion of righteousness, with the debris scattered around 'giving the impression that the Cathedral is the only building standing'.[19]

'The Proud City' was considered to be so successful that the group was reprinted in several languages – including Portuguese, Arabic and Farsi – for distribution to Allied countries worldwide, via the Ministry of Information. In total, 27,000 copies were printed, over twenty times the normal figure for a London Transport poster. The series was also used to illustrate a Canadian 'tribute to the people of Great Britain', published in July 1945 as a record of the civilian war effort.[20]

Returning from war to peace

The publicity office began preparing poster designs anticipating the end of the war as early as January 1944. LT wanted to ensure that staff and public were thanked for their part in the war effort through stirring designs 'symbolical of the lifting of the blackout'. The resulting posters would, according to the brief:

> … exemplify the sense of relief and the promise of a better world, which the coming victory would afford. A possible design might show a family group passing from a dark foreground in which there would be some symbolical representation of abandoned weapons of war to a countryside scene typifying the dawn of the new world and the arts of peace.[21]

**189 The Day Will Come
When Joybells Will Ring
Again Throughout Europe**
Anna Katrina Zinkeisen, 1944

Double royal
(1016mm x 635mm)
Published by London Transport
Printed by the Baynard Press

190 Rehabilitation
Fred Taylor, 1945

Double royal
(1016mm x 635mm)
Published by London Transport
Printed by the Baynard Press

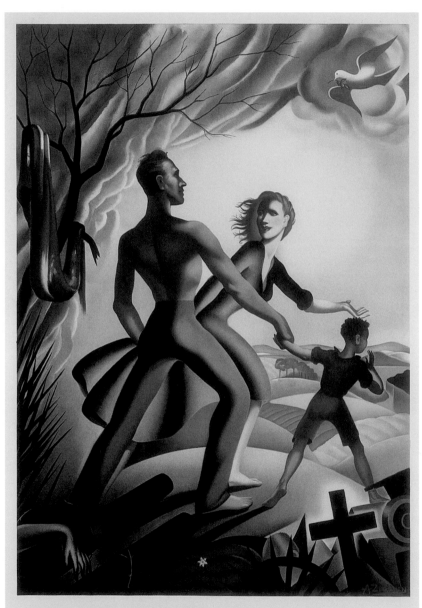

"*The day will come when the joybells will ring again throughout Europe,
and when victorious nations, masters not only of their foes but of themselves,
will plan and build in justice, in tradition, and in freedom . . .*"
The Rt. Hon. WINSTON S. CHURCHILL, C.H., M.P. Jan. 20th, 1940

Anna Zinkeisen, who had produced several posters for LT and the London & North Eastern Railway during the 1930s, was selected for the principal commission (plate 189). Her design, with additional Churchill quotation, fitted the brief admirably, and was distributed towards the end of 1944, along with another by Austin Cooper entitled *Flags of the United Nations*.

The celebratory tone of these posters had to be measured against the reality of life in peacetime London. The war had taken a heavy toll on LT's infra-

structure, and it would be several years before the system could recover fully. Conveying this information to the public would require tact, and in November 1944 plans were drawn up for a poster campaign illustrating the mammoth task ahead, provisionally entitled 'Clearing Up'.[22] After much debate, and the rejection of several designs by H.A. Rotholtz,

the commission was given to Fred Taylor who produced four posters known as the 'Rehabilitation' series (see plate 190). Published at the end of the war, the series generated considerable interest from overseas governments faced with similar problems, and helped prepare Londoners for the years of austerity ahead.[23]

Notes

1. With an average audience of 27,760,000 passengers per month, the government paid the going rate of £40 per month for display of 500 double-crown posters on these themes. London Metropolitan Archives, Acc 1297/UER 4/75, H.L. Sprot, *Advertising, Old & New*, 23 April 1918.
2. For a detailed account of the response of mainline railway companies to the First World War, see: E. Pratt, *British Railways and the Great War*, Selwyn & Blount, London, 1921.
3. M. Hardie and A. K. Sabin, *War Posters Issued by Belligerent and Neutral Nations, 1914-1919*, London 1920.
4. Hardie and Sabin, pp 13-14.
5. J. Black, *The Graphic Art of Eric Kennington*, exh.cat., UCL, London, 2001, p.7.
6. See, for example, F. Gregory Brown's 1916 *Hatfield* poster (chapter 10, plate 217).
7. See chapter 4, plate 88 and chapter 5.
8. 'Propaganda Ministry Not Wanted – Sir William Crawford: But Ministry of Information Might be Welcomed', *Advertiser's Weekly*, vol.103, no.1357, 25 May 1939, p.222.

9. F. Pick, 'The conduct of war', 6 November 1938, unpublished, Pick Archive, London Transport Museum, C44.
10. See: Commercial Minutes, October 1939–May 1940 and Departmental Meeting Minutes, December 1943–January 1946, Transport for London (TfL) Archives, LT/000606/027 & LT/371/022
11. LTM B041, Box 1, 'The Publicity Office since 1939', 1944, p.3. For public response see chapter 10 of this book.
12. H. Wojtczak, *Railwaywomen*, The Hastings Press, Hastings, 2005, chapter 2.
13. Anonymous, 'Seeing it through', *Pennyfare*, no.56, May 1944, War Series, p.442.
14. Letter from Eric Kennington to Catherine Kennington, 10 February 1944, Kennington family archive.
15. These included the autobiographies of Robert Graves and Siegfried Sassoon (*Goodbye to All That*, and *Memoirs of an Infantry Officer*), both published in 1928, which sparked a publishing phenomenon in the early 1930s, referred to as 'the literature of

disenchantment'.
16. Departmental Meeting Minutes, December 1943–January 1946, 28 July 1944, LT/371/022.
17. 'A new LPTB posters series: "The Proud City"', *Art and Industry*, vol.38, no.224, February 1945, p.58.
18. LTM Pamphlet K822 SPR, Acc 1354/92, J. Scott, 'Walter Spradbery', unpublished research, 1992, p.6.
19. *Advertiser's Weekly*, 21 December 1944, p.461.
20. *Their Finest Hours: A Tribute to the People of Great Britain*, W.H. Bosley, Toronto, 1945.
21. Departmental Meeting Minutes, December 1943–January 1946, January 1944 to May 1945, LT/371/022.
22. Departmental Meeting Minutes, December 1943–January 1946, LT/371/022.
23. Minutes of the Public Relations, Press and Publicity Meetings, TfL Archives, LT371/045.

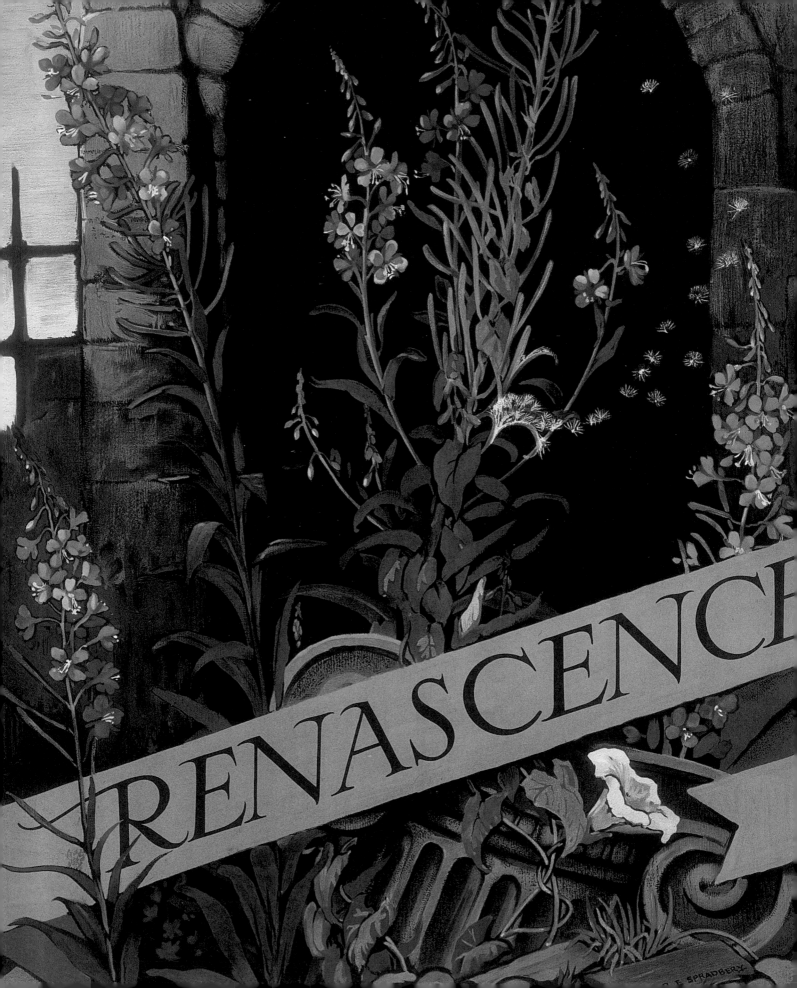

RENASCENCE

THE ROLLER COASTER RIDE:
LONDON TRANSPORT POSTERS SINCE 1945

Brian Webb

AFTER YEARS OF BOMBING and austerity measures, the end of the war in 1945 brought new hope for Londoners, poignantly expressed in Walter Spradbery's last poster for London Transport, *Renascence* (1945, plate 191). But it would be many years before life in the capital, or indeed for LT, returned to normal.

In the immediate aftermath of war, LT's poster output was largely restricted to public information notices, often apologising (in a roundabout way) for the poor quality of its services and overcrowding. There was no dedicated head of publicity, as there had been in Pick's day, and several leading poster artists (including Kauffer and Moholy-Nagy) were no longer working in Britain. Older designers like Spradbery and Fred Taylor were coming to the end of their long careers, while some younger artists, including Eric Ravilious and Rex Whistler (who had designed two striking Underground posters in 1927), had been killed in the war.

For some designers, however, the war had brought opportunities and

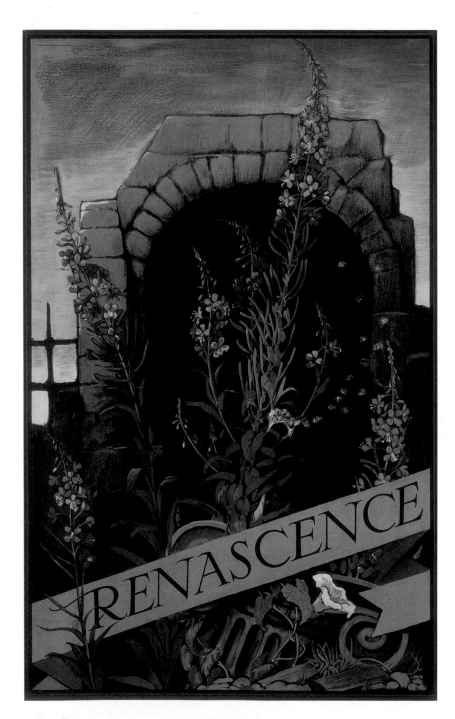

recognition. Tom Eckersley, F.H.K Henrion, Hans Schleger and Abram Games were among those who had benefited in this way and were now eager for new commissions. But there were broader problems which prevented an immediate return to prewar standards of poster production.

The printing industry in 1945 was in a desperate state. Many highly skilled compositors, litho artists and machine operators had not returned from the war. Those who had stayed in work were retiring, and over the previous six years few apprentices had been trained. To make matters worse, oil-based ink was in short supply, paper severely rationed and, ironically, the printing machines that were working and now getting old were mainly German. London Transport itself had very little money to spend on such luxuries, and could face severe criticism from the press when it was perceived to be 'wasting paper' on decorative posters.[1]

Harold Hutchison and the pair poster

A new Publicity Officer was at last appointed in 1947. Harold Hutchison had been a copywriter and the Creative Head at Unilever, and quickly set about reforming the quality and direction of LT's poster programme. His first task was to restore public confidence in the capital's transport system, by explaining the workings of London Transport, its aspirations and its role as dependable service provider for millions of Londoners (plate 192).

But he was equally aware of the urgent need to raise revenue through encouraging leisure travel. In the first of several policy statements issued during his career, Hutchison argued: 'our modern poster art is not merely the framing of an Academy painting and labelling it "Kew Gardens". It must be a visual message.'[2] This message was reaffirmed in his notes for the 1949 poster programme, which defined the aims of the campaign as being firstly 'to encourage as much

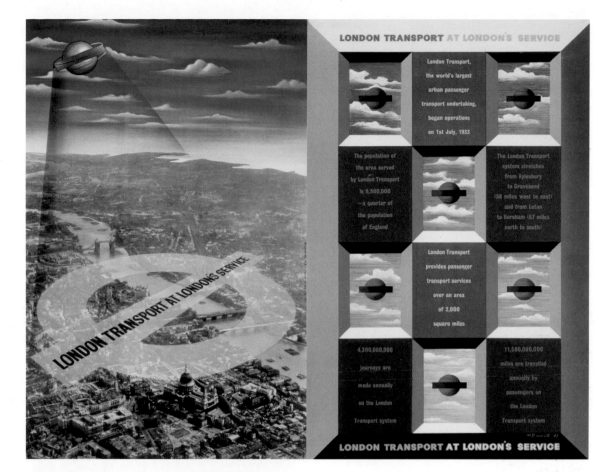

traffic as possible outside the rush hours and especially on Sundays', and only secondly 'to reinforce public goodwill by maintaining London Transport's long tradition of decorating its stations with posters which are part of London's visual education.'[3]

The result was the 'Know Your London' campaign, which built on the success of a similar programme ('London's Open Air') from the previous year and made much use of the 'pair poster' (plate 193). This was an innovative system whereby a poster was designed in two halves: one for an image and one for text. This afforded the designer more artistic freedom and the copywriter sufficient space to explain the commercial purpose of the poster. Designs had been produced as two halves before the war, although they had been predominantly image based. Hutchison standardised the format and positioned examples on prime sites such as Underground station entrances.

The format proved extremely popular with public and critics alike. Neville Wallis, art critic for The

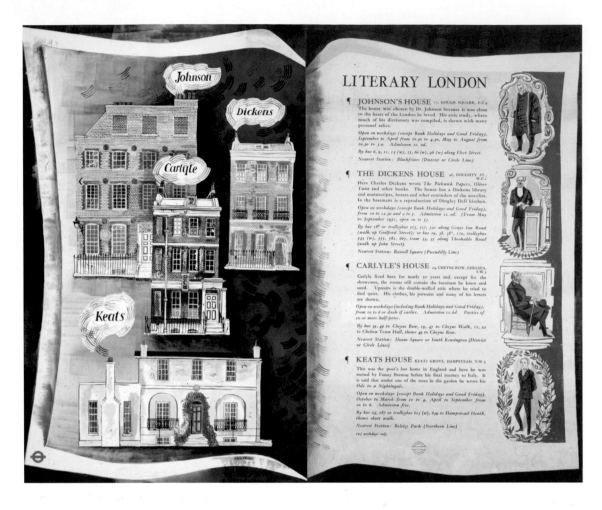

194 Literary London
Sheila Robinson, 1951

Pair poster – each double royal
(1016mm x 635mm)
Published by London Transport
Printed by the Baynard Press

Observer, praised LT's bold approach to poster display, adding that the 'value [of the pair poster] is inestimable'.[4] Hutchison also won praise for his policy of commissioning both established artists and new talent, such as Sheila Robinson (see plate 194), much as Pick had done before.

Unlike Pick, Hutchison also employed advertising agencies to undertake specific briefs, including S.H. Benson, famous for its 'Guinness is good for you' campaign and then one of London's largest and longest-established advertising agencies. Benson was used primarily for press advertisements and posters providing day-to-day information on schedule updates, event arrangements and engineering works. The Clement Dane Studio also produced a number of designs for LT in the twenty years after the war and acted as agents for designers, artists and photographers.

Reflecting on the increased use of advertising agencies as well as on the complex relationship between commissioner and artist, Hutchison explained that:

> ... a set of posters which ultimately carries the name of one artist is really the product of a creative group which includes a copywriter and perhaps a visualiser and a typographic designer inside the organisation, an artist working to a brief in perfect freedom outside the organisation, and a Publicity Officer, with experience of all phases of creative advertising and printing in the closest personal touch with those who actually run the organisation, controlling the whole process from within. The signed poster is therefore apt to be misleading – like a modern film, it should rather carry a long list of credits.[5]

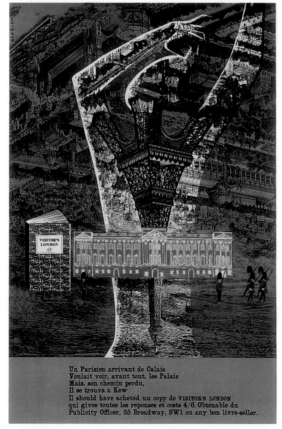

Un Parisien arrivant de Calais
Voulait voir, avant tout, les Palais
Mais, son chemin perdu,
Il se trouva à Kew
Il should have acheté un copy de VISITOR'S LONDON
qui gives toutes les réponses et costs 4/6. Obtenable du
Publicity Officer, 55 Broadway, SW1 ou any bon livre-seller.

The ability of the artist to work in 'perfect freedom' was certainly appreciated by Abram Games,[6] among others, and helped to build a very strong relationship between Hutchison and the designers he commissioned (see plate 195). It also enabled LT to employ some of the most outstanding poster artists of the day, including F.H.K. Henrion, who produced several poster designs during the 1940s and 1950s (see plate 196).

Eckersley and Games

Two names, however, came to dominate this period and beyond in terms of inventiveness and flair: Tom Eckersley and Abram Games.

Eckersley had collaborated with his design partner Eric Lombers on more than a dozen LT posters in the 1930s. At the outbreak of war the partnership split up and Eckersley became a cartographer in the RAF while still designing posters for the war effort. After the war, as well as continuing to work as a designer, Eckersley went into teaching, later becoming Head of Graphic Design at the London College of Printing. His work for London Transport continued into his retirement, eventually totalling almost 80 designs

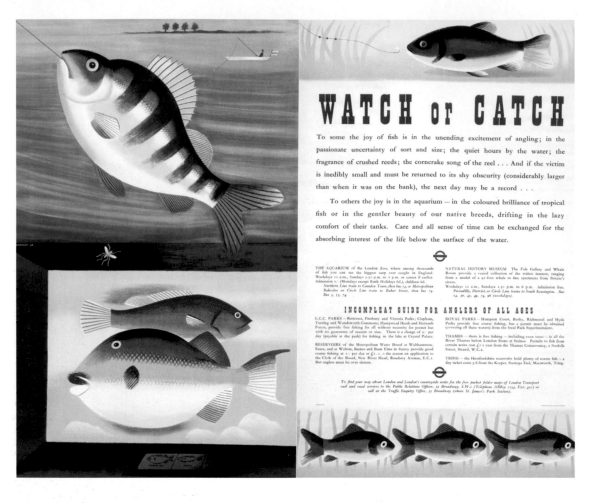

197 Watch or Catch
Tom Eckersley, 1954

Pair poster — each double royal
(1016mm x 635mm)
Published by London Transport
Printed by Waterlow & Sons Ltd

over a fifty-year working relationship (see plate 197).

Games was largely untrained as a graphic designer, but very talented and self-confidently ambitious. After two terms as a student at St Martin's School of Art in London he went to work as a studio boy in a commercial art studio in Fleet Street. His first poster for LT was published in 1937. During the war he was appointed as the first official War Poster Designer (see chapter 8) and worked on more than 100 posters including *Dig for Victory* and *Careless Talk Costs Lives*. After the war he became a visiting tutor at the Royal College of Art, and in 1947 designed a stamp for the 1948 Olympic Games in London. He won the competition to design the symbol for the Festival of Britain (1951), for which he also produced a London Transport travel information poster (plate 198). Like Eckersley, Games enjoyed a long relationship with LT, lasting well into the 1970s and resulting in over 30 posters.[7]

New blood

Opportunities for emerging artists improved after the lifting of restrictions on paper and printing in the early 1950s, while the printing of large-scale posters by the more economical four-colour litho process also reduced costs for LT. Hutchison's department continued to use untried designers as well as established names like Edward Bawden, Enid Marx and Laura Knight. Hutchison also made use of Games's and Henrion's contacts at the Royal College of Art, where they both taught. This web of connections brought about some of the earliest paying commissions for emerging artists and designers such as David Gentleman, Bernard Cheese and Gaynor Chapman.

Gentleman's parents were both artists, establishing a background which led naturally to design. His father, Tom, was a senior designer at Shell.[8] As a treat on Saturday mornings, while his son was still a schoolboy, he would take him to the art studio on the

198 Festival of Britain
Abram Games, 1951

Panel poster
(255mm x 318mm)
Published by London Transport
Printed by the Baynard Press

Games won the commission to
design the Festival of Britain
logo from a short list that
included Robin Day, Tom
Eckersley and F.H.K. Henrion.
In this version, produced
specifically for London
Transport, the Festival logo has
been modified to promote the
Underground's information
bureaux at Charing Cross, with
the roundel taking the place of
Britannia.

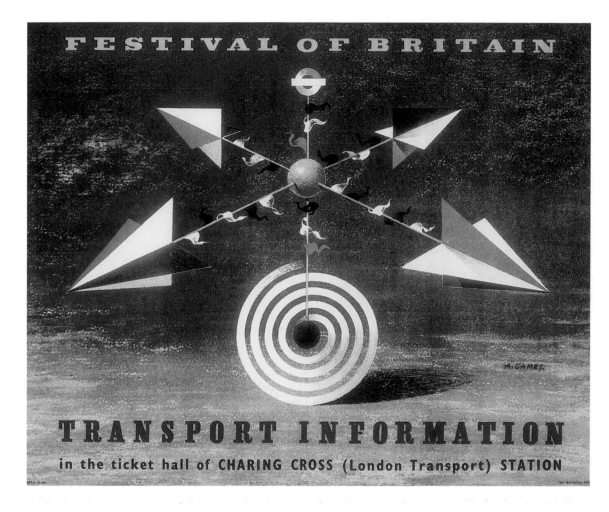

top floor of the company's headquarters on the
Strand. In 1953, David Gentleman graduated from the
Royal College of Art, where he stayed on as a junior
tutor. He received his first commission for a London
Transport poster (plate 199) and began a career as a
freelance designer and artist. He took on a variety of
work including book-cover, textile and wallpaper
design. In 1962, he designed the first of many stamps
for the Royal Mail. Commissions for London Trans-
port posters and Royal Mail stamps were still
considered to be every design student's dream jobs.

While poster design between the wars was

heavily influenced by current trends in the fine arts,
such as Post-Impressionism, Vorticism and Surreal-
ism, a more illustration-based generation of artists
began to emerge in the 1950s.

In 1951, the year of the Festival of Britain, London
Transport showed its continued interest in encouraging
stylistic variety by commissioning new pair posters
from right across the artistic generations. William
Roberts and John Minton, two well-known names in
the art world who, rather unusually, had *not* worked for
LT before, demonstrate this remarkable range.

Roberts, born in 1895, had become a very young

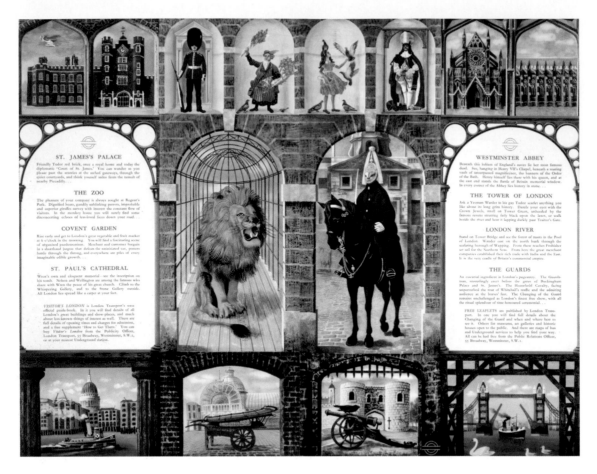

199 **Visitor's London**
David Gentleman, 1956

Pair poster – each double royal
(1016mm x 635mm)
Published by London Transport
Printed by McCorquodale &
Company Ltd

member of the Vorticist group in 1914 and was later an art tutor at the Central School for over 30 years. His striking Festival poster for London's fairs (plate 200) reflects the Cubist influences he had absorbed into his work more than thirty years earlier. John Minton, born a generation later in 1917 and trained in the 1930s, became an art tutor in the 1940s at London's Camberwell and Central Schools and at the Royal College of Art. His work is quite different to Roberts', and is closer to the English Neo-Romantic painting of Graham Sutherland and John Piper. Minton was also a prolific book illustrator, and his 1951 poster for London Transport (plate 201) finds a style somewhere between these two occupations.

By the 1960s, the design philosophy of the Publicity Department had shifted more pointedly towards illustration. Where posters were concerned, the view that 'art moved the heart but illustration moved the wallet' was coming to the fore. Graphic posters came to focus more than ever on telling the

public about London's history and sights, to be appreciated in the commuter's leisure time, rather than reflecting the latest trends in art and design. Predominantly information based, they often promoted London Transport's own publications such as *Open Air London*, *Visitor's London* or *Country Walks*. LT posters lent themselves perfectly to decorative illustration. *A Day on the River* (plate 202), commissioned to advertise a booklet of the same name, was designed by John Burningham, who went on to become one of Britain's most celebrated children's book illustrators.

The artistic quality of London Transport's posters was maintained in the 1960s, but the organisation seemed to lose touch with the latest trends in graphic art and design. Pop Art, adopting brash styles of collage and the graphic features of American comics and product advertising, made no impact at all on London Transport. Not one of the leading lights in early British Pop Art, such as Richard Hamilton, Eduardo

200 London's Fairs
William Roberts, 1951

Pair poster – each double royal
(1016mm x 635mm)
Published by London Transport
Printed by the Curwen Press

201 London's River
John Minton, 1951

Pair poster – each double royal
(1016mm x 635mm)
Published by London Transport
Printed by the Baynard Press

202 A Day on the River
John Burningham, 1965

Double royal
(1016mm x 635mm)
Published by London Transport
Printed by John Swain & Son Ltd

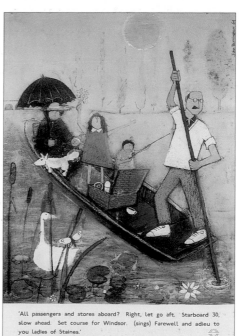

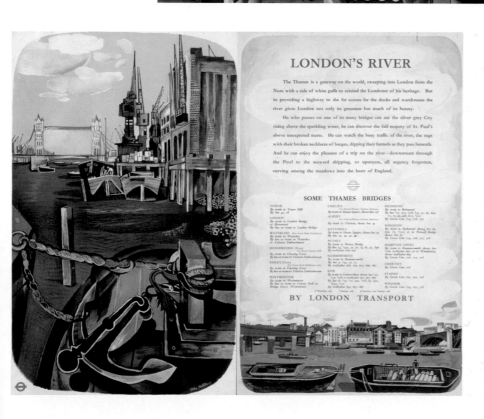

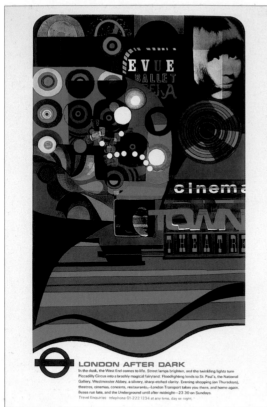

203 London After Dark
Fred Millett, 1968

Double royal
(1016mm x 635mm)
Published by London Transport
Printed by Waterlow & Sons Ltd

204 Art Today
Hans Unger, 1966

Double royal
(1016mm x 635mm)
Published by London Transport
Printed by C.S. & E Ltd

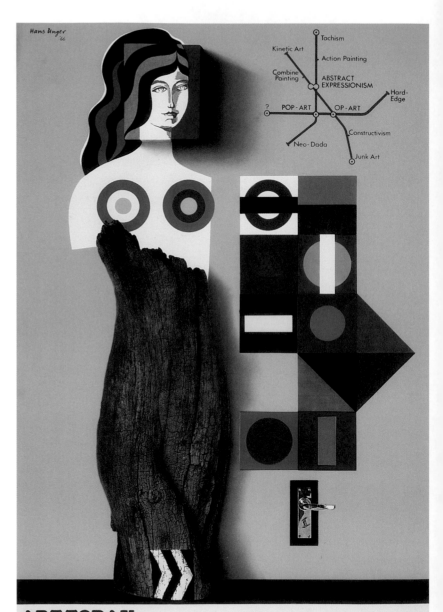

ART TODAY The Tate, re-hung with taste and logic, offers the academically approved, the Whitechapel the young and middle-generation painters. The Greater London Council sets contemporary British sculpture against the simpler pleasures of Battersea Park. Complete your survey with the commercial galleries of deepest Mayfair and Chelsea, and the avant-garde extremes. For all these new frontiers, the explorer's kit is simple—an open mind, Underground and bus maps, and a sense of humour. For The Tate Gallery: Underground or bus to Westminster, then bus 77B. For The Whitechapel Art Gallery: Underground to Aldgate East. For Battersea Park: Underground to Sloane Square, then by bus 137.

Paolozzi or Peter Blake, was commissioned to design an LT poster. Fred Millett's *London After Dark* of 1968 (plate 203) with its multicoloured targets, 'dolly bird' photo in harsh black-and-white, and integrated lettering, is the only London Transport poster at this time to have appropriated the Pop style – and this rather late in the day for Swinging London. LT was now generally more sedate and some way from the cutting edge.

Another design trend that passed London Transport by in the 1960s was the other 'underground', the one fuelled by drugs and rock and roll rather than diesel and electricity. Psychedelic art, album cover designs and posters had grown partly out of a revival of appreciation for *fin-de-siècle* 1890s decadence, which coincided with an exhibition of Alphonse Mucha's languorous Art Nouveau posters at the Victoria & Albert Museum in 1963, and another of Aubrey Beardsley's sinuously erotic black-and-white drawings at the same museum the following year. But these youth-culture and art-school enthusiasms were apparently not for LT.

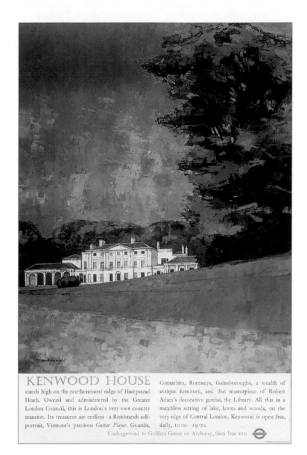

205 Kenwood House
Robert Flavell Micklewright, 1975

Double royal
(1016mm x 635mm)
Published by London Transport
Printed by Leonard Ripley
& Company Ltd

Just one of London Transport's posters from 1966, Hans Unger's *Art Today* (plate 204), took contemporary art as its subject, with a witty 'explorer's kit' incorporating the roundel and an adapted Tube map which anticipates Simon Paterson's postmodern *Great Bear* of 1992. Unger used the geometric form of the map to signal new directions in contemporary art. The frontier stations include Kinetic Art, Combine Painting, Pop Art, Op Art, Neo-Dada, Constructivism and Junk Art. All can apparently be found in one of London's galleries by the explorer equipped with 'an open mind, Underground and bus maps and a sense of humour'.

Unger, who arrived in England from Germany in 1948, had already become London Transport's most prolific and versatile poster designer of the post-war period. In an article in *Art and Industry* in 1953, he explained that his attraction to poster design was its range of expression and the opportunity to exploit colour. Like many poster designers, he found that the medium gave him the chance to experiment with new techniques and textures. 'With the aid of numerous test scribbles I try to find an appealing, forceful, interesting or perhaps humorous way of presenting the point and a single way of interpreting the message in visual terms.' Over-familiar images were ruthlessly cleared away, and conventional approaches discarded, in order to arrive at a personal solution. 'When I have decided on the idea and design, colour schemes and treatment suggest themselves almost automatically.'[9]

Advertising London Transport

Hutchison retired in 1966 and Bryce Beaumont, his chief creative assistant, took over the role of Publicity Officer. Beaumont had joined London Transport as a copywriter in the late 1930s straight from university. As 'general overseer of the written word', he had been responsible for the tone of voice London Transport used in their publicity and for much of the erudite text that often dominated the visual content of LT posters in the 1960s.

By the time Beaumont retired in 1975, and was succeeded by Michael Levey, image-based posters commissioned directly from artists were at an all-time low. *Kenwood House* (plate 205), by Robert Micklewright, is one of the few examples from this period of a traditional painting being commissioned directly from an artist for use on a publicity poster. The following year Abram Games produced *Zoo* (chapter 10, plate 225). This was his last poster for London Transport and can be seen to mark the end of an era in which powerful integrated graphic design led the way in poster publicity. By the late 1970s, almost all of LT's advertising was conducted through agencies, and the pictorial poster programme had shrunk to a small fraction of the organisation's publicity output.

Until the 1960s the big London advertising agencies had been compartmentalised. The copy

206 Fly the Tube
FCB Advertising, Geoff
Senior/Brian Watson, 1977
Double royal
(1016mm x 635mm)
Published by London Transport
Printed by C.J. Petyt Ltd

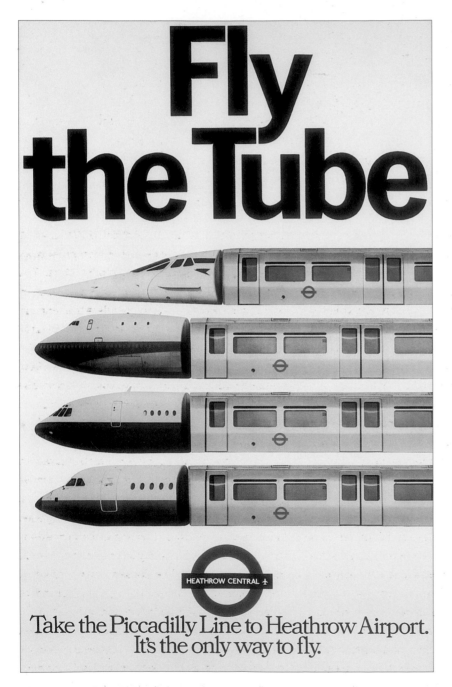

department would write the advertisement and then pass the words on in the internal mail to the layout department, where a visualiser would create a design. By the 1970s, agencies were working in creative teams. Art directors and copywriters would work together on a brief from a creative director. The day-to-day dealings with the client were conducted through an account handler, so the designer and copywriter would rarely even meet the client. Large agencies might have several creative teams competing against each other to produce winning ideas and rarely working for the same client more than once. As a result, building a long-term look and feel to a client's advertising campaigns was very difficult.

The main advertising agency used by London Transport from the late 1970s onwards was FCB (Foote, Cone & Belding). With financial and creative resources heavily weighted towards new advertising media such as radio and television, posters – by this time largely photographic in content – often constituted a secondary outcome of a campaign. More often than not, they would merely feed directly off television or magazine advertising. Inspired poster designs, such as the prizewinning *Fly the Tube* (plate 206), were few and far between, although on occasion a marketing campaign would follow through with a strong creative idea such as the Travelcard ticket promotion in 1986. FCB commissioned mural designer Trevor Caley, who had worked with Paolozzi on his mosaic decorations for Tottenham Court Road Tube station in 1984–5, to produce three mosaic designs as poster artworks for Travelcards. They were produced both as small 'car cards' for display inside Underground trains and as striking giant 32-sheet posters to be viewed across the tracks from Tube station platforms (plate 207).

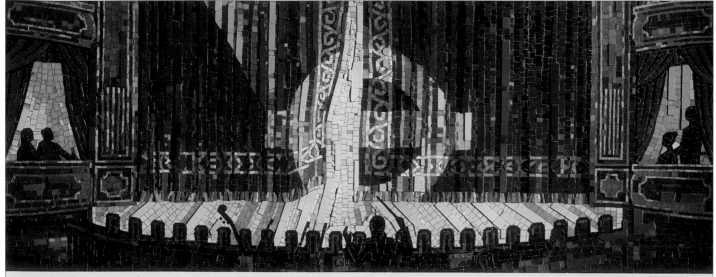

JUST BECAUSE YOU'VE FINISHED WORK IT DOESN'T MEAN CURTAINS FOR YOUR TRAVELCARD.

207 Travelcard
Trevor Caley, 1986

Car card
(603mm x 305mm)
Published by London Transport

The writing on the wall

In 1979 the designers and typographers Banks & Miles, who had worked for London Transport for more than twenty years, were asked to review the organisation's overall publicity. Their report aimed to re-establish a strong, coherent visual identity for LT's publicity and design which would work across the different forms of advertising posters, leaflets and other print. Some promotions worked well in isolation, but overall they felt it lacked a corporate feel and style.

The key issue was whether to abandon or adapt London Transport's iconic Johnston typeface. It was over 60 years since its introduction in 1917, but in some respects Johnston's original lettering seemed no longer fit for purpose. Its use across the full range of modern LT signage and text was neither possible nor appropriate. Although the classic Johnston Sans had been used on the majority of publicity display material since its introduction, and developed in pre-war years by the designer himself, post-war use had become inconsistent. Where damaged or worn wood and metal printing blocks had been redrawn and remade, the original consistency of the letterforms had sometimes been lost. Banks & Miles suggested that, by carefully updating the typeface, it would be possible once again to pull London Transport's identity together 'like a ribbon tying up a parcel'. 'New Johnston' was to retain the spirit of the 1916 original, whilst adapting it for use on modern computer typesetting systems and in smaller print sizes. The recommendation was agreed, but this was no quick-fix solution. It took 12 years to complete the redesign and implement the New Johnston typeface across all areas of the organisation. Transport for London, which took over from London Transport in the year 2000, continues to use the various forms of this unique copyright font for all corporate communications.

Art on the Underground

In 1984 London Transport was restructured to become a co-ordinating, planning and administrative body with two subsidiary operating companies: London Buses Limited (LBL) and London Underground Limited (LUL). All three businesses had to rethink their marketing and publicity strategies in a new climate of competition. The Conservative Government part-privatised or 'outsourced' a growing number of public services in this period, reversing the trends of the 1930s and 1940s towards nationalisation and state control. London's transport services were not immune from this, and a period of political wrangling, financial cutbacks and low investment led to uncertainty and a lack of confident forward planning in London Transport.

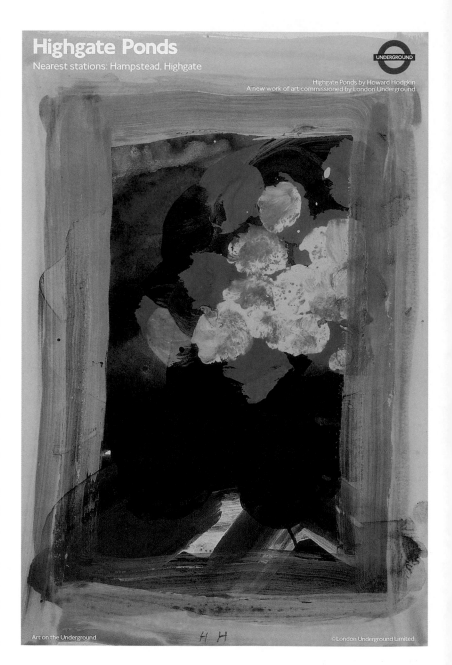

208 **Highgate Ponds**
Howard Hodgkin, 1989
(509mm x 339mm)
Published by London
Underground Ltd

LBL was gradually fragmented by the new bus-route tendering process, and by the early 1990s nearly all bus operation in London was being undertaken on LT's behalf by private companies. LUL initially remained a single entity, and looked to reinforce its corporate identity with a strong emphasis on high design standards in all areas, with a particular emphasis from the late 1980s on communications and the customer environment. The policy of direct poster commissions from artists was revived, but not within the main advertising and publicity strategy. Instead it was launched as a separate programme of corporate fine-art sponsorship called 'Art on the Underground'.

Henry Fitzhugh, London Underground's Marketing Director from 1986 to 1992, introduced the new initiative at the beginning of his tenure in 1986. At its most basic level, 'Art on the Underground' was a way of filling blank, unsold commercial advertising space on the Underground with images which could improve the general appearance of the passenger environment. At the time, unsold poster space on stations was simply covered in black paper, which looked grim and uninviting to customers and did little to assist London Transport Advertising's falling revenue.

Fitzhugh's scheme involved primarily displaying *fine* art in poster form. He began commissioning leading artists of the day, including many Royal Academicians, to produce artworks that could be printed as posters. The subjects were loosely connected with the Underground as potential destinations or leisure activities reached by Tube, but generating travel was not their purpose at a time when passenger numbers were already rising rapidly. This meant that the artists had none of the constraints of a publicity poster design: there was no requirement to communicate a message or encourage an action.

He began by issuing six 'art' posters a year: two 'easy' subjects, two more avant-garde works and two somewhere in between. Sandra Fisher's *Days on the Water* and Howard Hodgkin's *Highgate Ponds* (plates 208 and 209), both commissioned in 1989, illustrate this range well. Six thousand of each were printed and

209 Days on the Water
Sandra Fisher, 1989
Double crown
(762mm x 508mm)
Published by London
Underground Ltd

210 The Tate Gallery by Tube
The Fine White Line,
David Booth/ Shirtsleeve
Studio, 1987
Double crown
(762mm x 508mm)
Published by London Transport
Printed by Print Processes Ltd

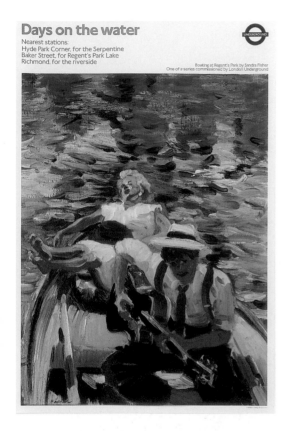

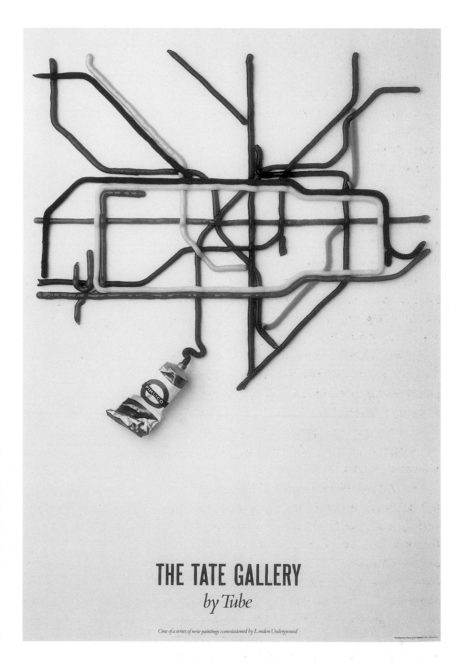

displayed on the system for several months, with copies available for sale.

Fitzhugh announced that he wanted 'to promote art, especially fine art, and its appreciation among our customers and to promote young artists', but was anxious 'not to get so far ahead of our public that we lose it'.[10] Perhaps inevitably, the new commissions were often criticised as bland rather than challenging; but creating controversy was not their purpose. Artistic wallpaper or not, 'Art on the Underground' certainly revived London Underground's reputation as a patron of the arts.

By far the most popular and enduring of the 'Art on the Underground' commissions was one of the very first, created in 1986 and printed in 1987. *Tate Gallery by Tube* (plate 210) was a perfect visual pun, designed by The Fine White Line using a model 'tube' and paint 'lines' to make a three-dimensional Underground map. Unlike most of the new commissions that followed, it was produced by graphic

designers through an agency rather than by a single artist. Nearly all the subsequent posters in the pro-gramme were reproductions of commissioned artworks, normally paintings, to which brief copy had been added outside the artist's image. In that sense they were not designed as integrated posters.

A handful of high-quality designs by prominent graphic artists were still being directly commissioned as part of LT's publicity and marketing in the late 1980s and 1990s. Alan Fletcher, one of Britain's most prestigious designers, was first commissioned in the early 1990s (see plate 211). Fletcher had been one of the founders of Fletcher/Forbes/Gill in 1962, which grew into the multidisciplinary design agency Pentagram. The company worked on a number of later projects with London Transport, but only two of Fletcher's characteristically witty individual designs were printed as posters.

Brian Grimwood is another prominent designer and illustrator who has produced work both for London Transport in the 1990s and, more recently, for its suc-cessor Transport for London. He too has designed posters under his own name, such as *Brick Lane* (plate 212), but also operates through the Central Illustration Agency (CIA), which he founded in 1983. The agency represents a number of artists and illustrators, promot-ing their work through touring exhibitions, seasonal festivals and a company magazine.

Marketing – the temperature gauge of the organisation

As always, advertising and marketing reflect the con-temporary economic climate. By the time Fitzhugh left the Underground in the early 1990s, circum-stances had changed. London Transport Advertising, which managed the commercial poster sites, was pri-vatised and its new owners started selling poster

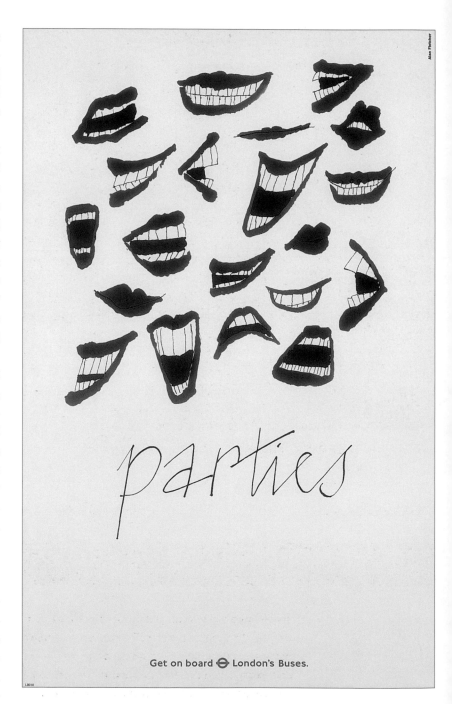

Get on board ⊕ London's Buses.

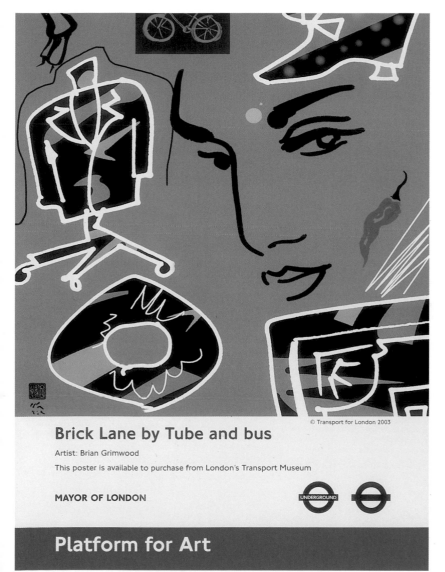

Brick Lane by Tube and bus

Artist: Brian Grimwood

This poster is available to purchase from London's Transport Museum

MAYOR OF LONDON

UNDERGROUND

Platform for Art

© Transport for London 2003

quite literally closed. If art- and design-based pictorial posters were to survive, they would have to be created around a 'go places, do things' message which linked more clearly to specifically targeted marketing campaigns.

Jeremy Rewse-Davies, who had a background in design and television, became LT's Design Director in 1988. He was responsible for Underground identity and customer environments, including all applications of the New Johnston type in corporate communications, from station signage to print. When Fitzhugh left the company, Rewse-Davies took over the programme of commissioning new artworks, though with a reduced budget.

By this time the London Transport Museum had become the principal sales outlet for new posters, as well as archiving and exhibiting the Underground's historic poster collection. Rewse-Davies began working closely with Michael Walton, the Museum's Retail Manager, commissioning new poster artworks. A working agreement was reached with TDI, the company managing the commercial advertising space on the system, to provide display locations for new art posters, which carried the TDI logo.

The long-running 'Simply' series represents the subsequent new breed of the pictorial Underground poster in the 1990s. A diverse range of established and newly discovered artists and designers were individually commissioned over a number of years. Their artworks were reproduced as posters in various sizes for use on station wall sites, bus shelters and escalator panels, but also in many cases on leaflets. They were linked by a 'Simply ...' strapline theme, usually time-off- or leisure-related, which ranged from London music venues to markets. The posters ticked the required commercial boxes by tapping into London Transport's marketing strategy of the time, and all were available for sale in the Museum. This was not

space more aggressively and successfully in a boom time for London's economy. There were no longer blank spaces needing fillers. As the art posters were now in direct competition for positions against commercial advertisers, a new business case had to be made to continue commissioning. The gap in the market for fine-art posters acting as wallpaper had

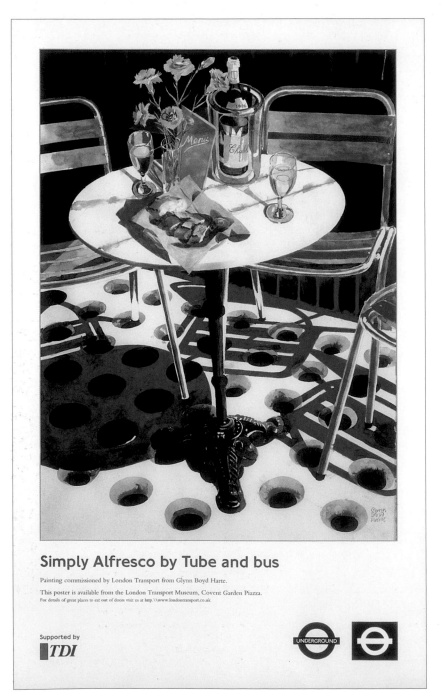

Simply Alfresco by Tube and bus

Painting commissioned by London Transport from Glynn Boyd Harte.

This poster is available from the London Transport Museum, Covent Garden Piazza.
For details of great places to eat out of doors visit us at http:\\www.londontransport.co.uk

Supported by
TDI

art for art's sake, but a new application of high-quality artistic design that would certainly have met Frank Pick's 'fitness for purpose' test.

One of the series, *Simply Alfresco* (plate 213), was designed by the artist and printmaker Glynn Boyd Harte. Taught by Edward Bawden at the Royal College of Art in the 1970s, Boyd Harte championed the tradition of producing lithographs on hand-drawn plates, in the same way as Barnett Freedman and Eric Ravilious before him. His artwork seems an appropriate choice to illustrate the continuity in London Transport's poster tradition.

Transport for London (TfL) succeeded London Transport in 2000, with a much wider remit and responsibility for planning and providing integrated transport in the capital under the leadership of the Mayor of London. Maintaining and developing the revitalised artistic design standards of its predecessor in the new century is still considered important by TfL. Direct poster commissions to individual artists and designers remain occasional but are immensely popular. Paul Catherall's 'Four Seasons' series (plate 214), commissioned for TfL through London Transport Museum, have been used as striking 'filler' images on commercial sites across the network, and have also seen significant sales through the Museum's retail outlets.

Today, TfL issues around 200 posters a year, but will only employ an artistic approach if it is thought to be the most effective means of communicating a particular marketing message. The Boat Race poster for 2007 (plate 215), for example, presented a strong graphic design which alluded to the now iconic imagery used in the classic posters of the 1920s and 1930s. Is this good new poster design or simply the clever use of retro appeal as a marketing tool? Either

214 Four Seasons
Paul Catherall, 2006

Each double royal
(1016mm x 635mm)
Published by TfL

Spring Summer Autumn Winter
**Four seasons of London's famous skyline
by bus, Tube, DLR and river.**

Artist: Paul Catherall

Copies of this poster may be purchased from the London's Transport Museum Shop, Covent Garden Piazza.
© Transport for London 2006

MAYOR OF LONDON　　　　Transport for London

Spring **Summer** Autumn Winter
**Four seasons of London's famous skyline
by bus, Tube, DLR and river.**

Artist: Paul Catherall

Copies of this poster may be purchased from the London's Transport Museum Shop, Covent Garden Piazza.
© Transport for London 2006

MAYOR OF LONDON　　　　Transport for London

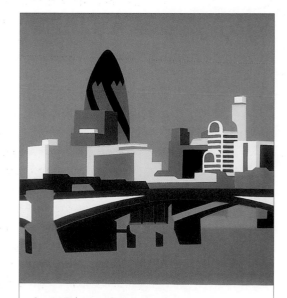

Spring Summer **Autumn** Winter
**Four seasons of London's famous skyline
by bus, Tube, DLR and river.**

Artist: Paul Catherall

Copies of this poster may be purchased from the London's Transport Museum Shop, Covent Garden Piazza.
© Transport for London 2006

MAYOR OF LONDON　　　　Transport for London

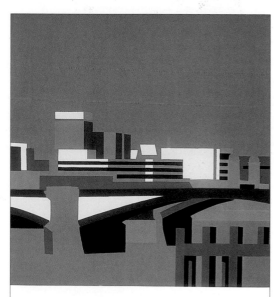

Spring Summer Autumn **Winter**
**Four seasons of London's famous skyline
by bus, Tube, DLR and river.**

Artist: Paul Catherall

Copies of this poster may be purchased from the London's Transport Museum Shop, Covent Garden Piazza.
© Transport for London 2006

MAYOR OF LONDON　　　　Transport for London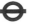

215 The Boat Race
Creator Communications,
2007

Double royal
(1016mm x 635mm)
Published by TfL

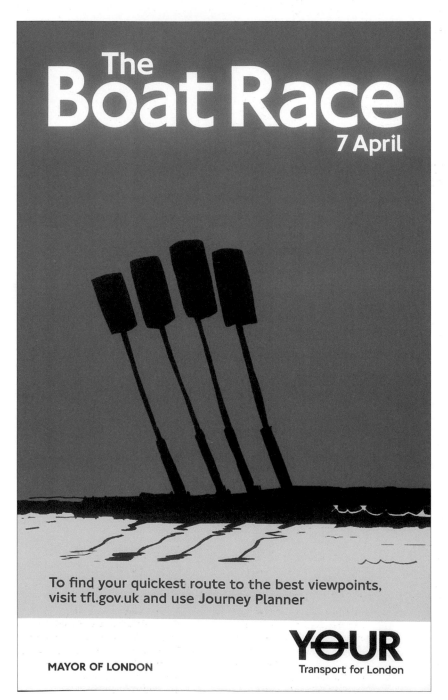

way, the poster injected a welcome presence of strong graphic imagery back into the programme.

The end of the line?

In 1962, in a lecture at the Royal Society of Arts, Abram Games predicted that in the future 'posters will be flashed on plastic television screens every ten seconds'.[11] Now, nearly half a century on, this is becoming a reality. Plasma screens are being trialled across the Underground network and, as the technology becomes cheaper and more sophisticated, integrated screens are seen as the cutting edge of commercial advertising on the Underground. Even so, the traditional printed poster seems unlikely to disappear in the near future.

The Underground's own posters have fulfilled a variety of roles over the last 100 years, from establishing goodwill with the passenger to improving the customer environment, and from soft-selling off-peak travel to direct information provision. In Frank Pick's day, a pictorial poster was the most modern, direct and effective means of communication. As publicity moves on, it is not surprising that the poster has been partially superseded as a medium in some of these tasks. Fortunately, a few enlightened and determined commissioners, following in Pick's footsteps, have clung on for the roller-coaster ride over the last sixty years, and we can all still enjoy the creative work of successive generations of artists and designers. New posters are still being created, and some of them now reflect other artistic media that have been introduced to London's transport environment, such as the imaginative artistic installations and Tube-map covers of the 'Platform for Art' programme launched in 2000 (plate 216).[12] We have not reached the end of the line yet.

216 Tube Maps
Emma Kay, Yinka Shonibare,
David Shrigley, 2004–6

Each double royal
(1016mm x 635mm)
Published by TfL/Platform
for Art

These innovative interpretations
of Harry Beck's famous
Tube map were originally
commissioned for the
cover design of pocket
Underground maps.

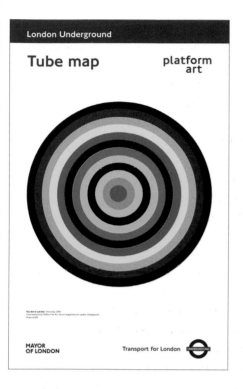

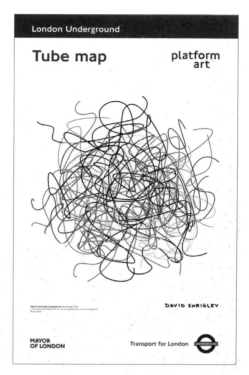

Notes

1. Several examples of press censure and public controversy are recorded in the Minutes of the Public Relations, Press and Publicity Meetings (PRPPM) for the late 1940s in the Transport for London Archives (LT371/019).
2. H.F. Hutchison, 'The policy behind our posters', *London Transport Magazine*, vol.1, no.8, 1947.
3. *Poster Programme 1949*, PRPPM, LT371/045.
4. PRPPM, 218/8/51, LT371/019.
5. H.F. Hutchison, 'Publicity Relations at London Transport', May 1950, draft article for *Art and Industry*.
6. Letter from Abram Games to Harold Hutchison, 22 July 1947, London Transport Museum Archives, LTM 2006/15222.
7. See: N. Games, C. Moriarty and J. Rose, *Abram Games, Graphic Designer: Maximum Meaning, Minimum Means*, Lund Humphries, Aldershot, 2003.
8. From working with Jack Beddington at Shell, Tom Gentleman had been acquainted with both Kauffer and Barnett Freedman. He produced a poster and leaflet design for the Underground in 1932.
9. 'Poster Designer: Unger', *Art and Industry*, May 1953, pp 164–7.
10. Oliver Green, *Underground Art: London Transport Posters 1908 to the Present*, Laurence King, London, 2001, p.16.
11. 'Colour TV for posters, prediction by a designer', *The Times*, 1 February 1962.
12. The work of 'Platform for Art' (renamed 'Art on the Underground' in 2007) is comprehensively reviewed in Tamsin Dillon (ed.), *Platform for Art: Art on the Underground*, Black Dog Publishing, London, 2007.

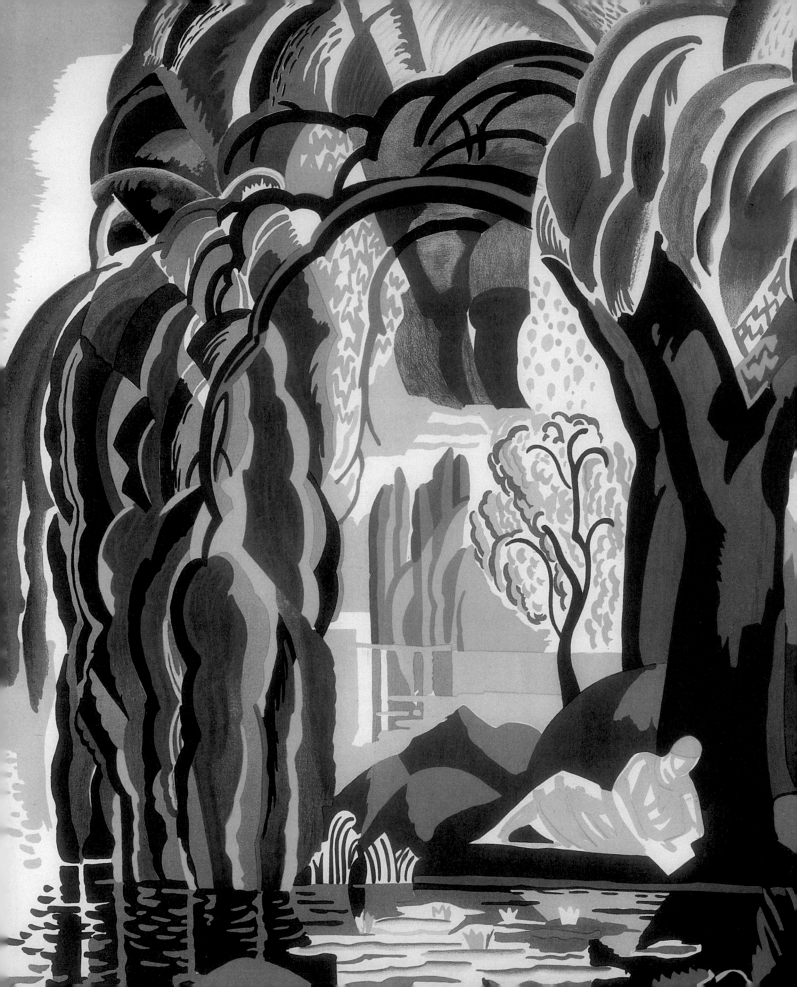

Is publicity of any use? If you ask, for example, whether a particular poster or notice has done any good you can never get an answer, or very rarely. The publicity department tries but it is not successful in producing evidence of the gains which flow from its efforts.

FRANK PICK, 1936[1]

ART FOR ALL?
THE RECEPTION OF
UNDERGROUND POSTERS

Claire Dobbin

ALTHOUGH INDIVIDUAL POSTERS convey specific messages, in a variety of styles, Underground publicity is essentially about getting people to use public transport. The answer to Pick's question really requires evidence of action, rather than reaction. The desired response to posters, in the days before market research, was invariably silent.

This chapter seeks to explore some of the measurable responses Underground posters have elicited over 100 years. Ranging from letters to the Underground and publicity-meeting minutes, to the anonymous graffiti scrawled across posters *in situ*, the range of material available to substantiate a response is far from comprehensive. It also tends to highlight extraordinary cases, rather than representing the norm. Some of the responses in this chapter equate to those rare examples to which Pick refers: when evidence suggests that publicity has done its job. Many, however, are nothing to do with the intentions of a poster, and these are often the most fascinating.

217 **Hatfield**
F. Gregory Brown, 1916

Double crown
(762mm x 508mm)
Published by UERL
Printed by the Dangerfield
Printing Company Ltd

Public response: the reception of posters as publicity

When Frank Pick became responsible for the Underground Group's publicity, in 1908, the pictorial poster was an established and ubiquitous feature of London's cityscape. However, the medium was still developing. The quality of design varied dramatically, in terms of both craftsmanship and how effectively it conveyed information to the public. The next decade saw an unprecedented period of experimentation and creativity, as companies and designers sought new ways to stand out from the crowd.

Respected by his peers and loved by the public, John Hassall was an informed and inspired choice of artist for the Underground's first truly modern poster, *No Need to Ask a P'liceman!* (see chapter 1, plate 11). In September 1908, soon after it appeared outside Tube stations, an admirer wrote to Hassall at his studio:

> I derive so much pleasure from your posters as they appear on the hoardings and railway stations, that I feel I must write a note of thanks and appreciation. They are splendid and have provided much amusement to myself and many friends whose attention I always draw to them whenever I get a chance.[2]

Pick believed there to be great profit in posters that set the passer-by in a pleasant frame of mind. Hassall's trademark cockney humour clearly did just that. Humour, however, did not become a common feature of the company's posters. G.W. Duncan, the Underground's Public Relations Officer from 1929 to 1933, observed in the latter year that: 'Humour in posters is valuable but it must be used in moderation – an amusing drawing or slogan is in most cases

short-lived and the public sense of humour is a very varying quantity.'[3] Humour was employed sparingly, and always at the hand of those established and experienced in the field.[4]

Pick knew that producing posters with popular appeal was something quite different from appealing to popular taste. Humour, catchy slogans and references to fleeting fashions could not pave the way for longevity in the Underground's relationship with the public. Pick clearly defined the objectives of a poster as 'first, to attract attention, second, to hold

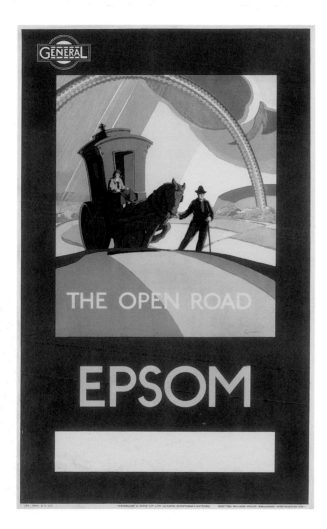

218 **Epsom**
Charles Cundall, 1921
Double royal
(1016mm x 635mm)
Published by UERL
Printed by Waterlow & Sons Ltd

observer'.[6] A poster-artist aesthetic emerged from this powerful treatment of the landscape. Exponents like Gregory Brown (see plate 217) became masters of the technique, whilst others, including fine artist Charles Cundall, readily conformed to its unwritten rules (see plate 218).

The bold new style in poster art clearly made a strong impression on the observer. There was a steady increase in the number of passengers using off-peak services in the 1920s, suggesting that the public was responding to the publicity. A playful reference to the poster artist in a national newspaper, however, also suggested that the public were reacting to the stylistic approach:

Plaint to the poster artist
Oh, I want to see the country
 Like when I was a boy
When the sky was blue and the clouds was white
 And the green fields was a joy
I want to see the country
 But the posters seem to show
The country ain't no more the place
 Like what I used to know
For the sky is pink and the fields are mauve
 And the cottages all turned yellow
And the sheep all green or tangerine
 Enough to stun a fellow
Oh, I want to see the country
 And I wouldn't mind where I went ter
So long as I knoo the trees weren't blue
 And the cows all turned magenta![7]

A cartoon published in the Underground's staff magazine, *T.O.T.* (plate 220), provides another insightful commentary on the perceived public response to the company's posters. The left-hand column shows a series of potential travellers contemplating day trips of

attention'[5] — a simple premise for what was to become a highly sophisticated programme of publicity.

An early manifestation of these objectives at work can be found in leisure-travel posters — in particular, those promoting London's countryside. Through simplified form and exaggerated colour, an image could be quickly grasped and easily remembered. As Pick explained in 1927, 'detail is sacrificed to an emphasis on dominant outline. The work becomes impressionist, because it is indeed essential that it should make an impression on the

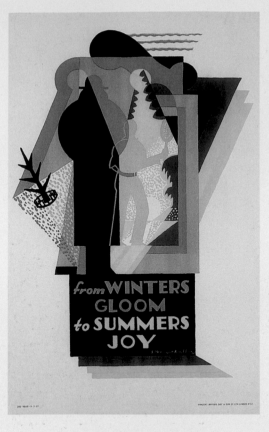

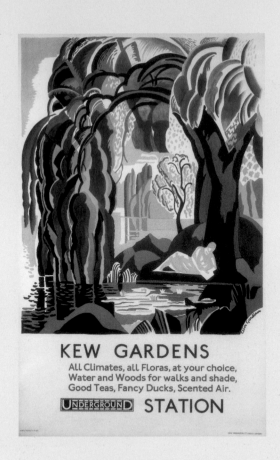

220 *Truth in Advertising* – cartoon published in *T.O.T. Staff Magazine*, October 1927

219 The four posters depicted in the *Truth in Advertising* cartoon:

(top left) **From Winter's Gloom to Summer's Joy**
Edward McKnight Kauffer, 1927

Double royal
(1016mm x 635mm)
Published by UERL
Printed by Vincent Brooks,
Day & Son Ltd

(top right) **Kew Gardens**
Clive Gardiner, 1927

Double royal
(1016mm x 635mm)
Published by UERL
Printed by John Waddington Ltd

(bottom left) **Now's the Time to Seek your Pleasure**
Olive Grace Bourne, 1927

Double royal
(1016mm x 635mm)
Published by UERL
Printed by John Waddington Ltd

(bottom right) **The Quickest Way to the Dogs!**
Alfred Leete, 1927

Panel poster (280mm x 464mm)
Published by UERL
Printed by Waterlow & Sons Ltd

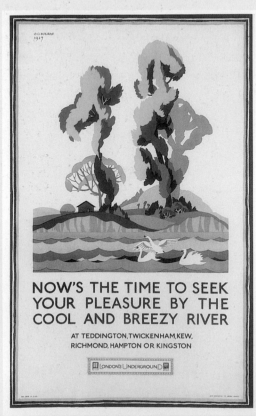

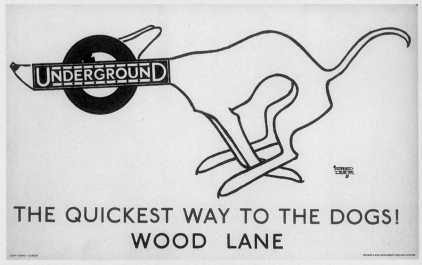

the kind depicted in four posters issued that year. The right-hand column suggests a more downbeat reality.

The posters chosen for the cartoon demonstrate a series of distinct stylistic developments being explored at the time (see plate 219). Earlier that year, in a paper on Underground posters, Pick wrote of his concern that the now customary treatment of

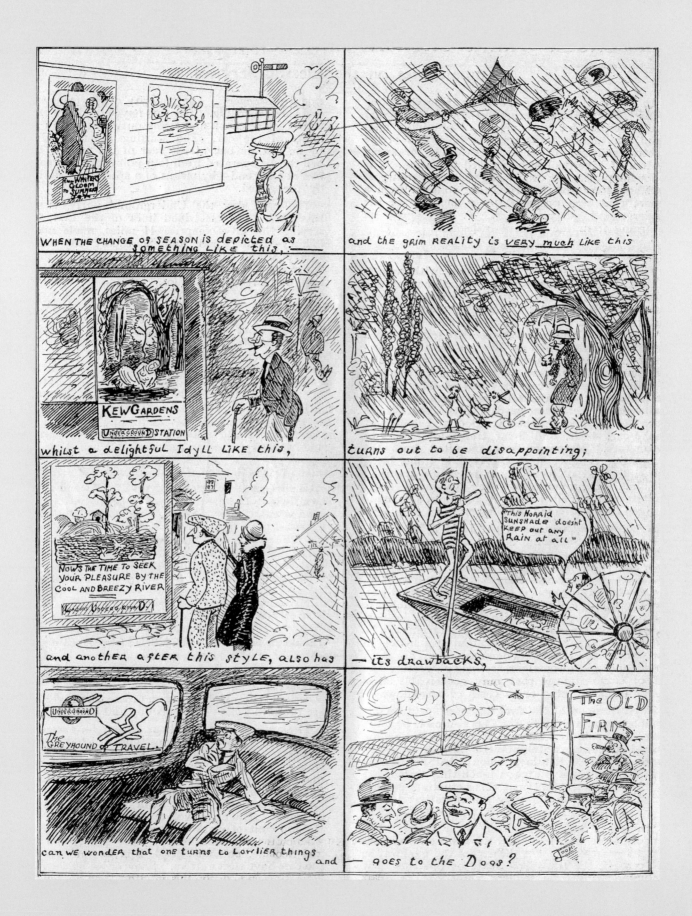

landscape had lost its power to attract public attention. 'The mere emptiness of the countryside that once appealed to the urbanized,' he proposed, 'must be reinforced with fresh interest.'[8] The progressive styles of the posters in the cartoon represent such an attempt to provoke 'fresh interest'.

The *T.O.T.* cartoon undoubtedly pokes fun at the Underground's publicity. However, it is the plausibility of the subject that is being contested, rather than the artistic treatment. It is true that for many people, this progressive style of poster provided their first experience of abstract or Cubist imagery. Interestingly, however, there is little evidence to suggest a negative response to these styles. The cartoonist's appropriation of these particular designs actually implies that they were among the most memorable on the system that year, so as to have resonance with the reader. This would suggest that these four posters had succeeded in not only attracting but also holding public attention.

Another *T.O.T.* cartoon, from 1931, can be seen to represent a less exclusive perspective, as it was submitted by a member of the public (plate 221). The cartoon comments on a more traditional, less challenging style of poster. Again, the objection here is to a rather romanticised portrayal of the truth, rather than its stylistic delivery. This perceived inconsistency, between the rosy images of publicity and a more banal reality, was not a new observation, nor has it ceased today.[9]

In 1936, the fine line between challenging and offending public taste was crossed. All copies of Edward Wadsworth's Modernist poster, publicising that year's Lord Mayor's Show (plate 222), were withdrawn. This was the result of a public outcry, led by and mediated through the press. Wadsworth's design highlights two modern weapons used by the British Army: a Vickers heavy machine gun and a Lewis auto-

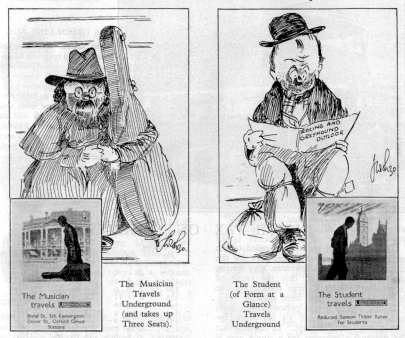

221 *Underground Posters Burlesqued* – cartoon published in *T.O.T. Staff Magazine*, November 1931

The posters referenced in the cartoon are *The Student Travels Underground* and *The Musician Travels Underground*, by Charles Pears, 1930.

matic rifle. Although the theme of the 1936 show was 'Defence and Rearmament', the *Daily Mirror* immediately accused London Transport of promoting 'militarism' through its poster.[10] A reporter from the *Daily Express* claimed that around twenty readers phoned or wrote in to complain.[11] The most pointed criticism came from the *Daily Mirror* journalist 'Cassandra'. 'If we are to show the beauty of the engines of war to a peacefully travelling public,' he wrote, 'why not have the guts to show the effects of these instruments. Or would pictures of bullet-riddled bodies be a trifle unseemly?'[12] The posters were withdrawn the next day, resulting in a follow-up article entitled 'LPTB Bows to Cassandra'. A statement from an official at London Transport was published in the *Evening News*, explaining their actions:

The posters were scrapped as soon as we realised that people might interpret them as glorifying war ... when we found the Lord Mayor's Show was to be a military parade this year we decided to reflect this in the poster. We felt that the design, produced by Mr Wadsworth, was not only a very good design in itself — regarded purely as a design — but was also a grim statement and a grim reminder of the significance of modern warfare. The Board does take extraordinary precautions to avoid error in its posters but it cannot always be successful.[13]

Wadsworth's own views on the misinterpretation of his design appeared in the pages of the *Daily Express*: 'If people object to this poster,' he professed with candour, 'they must object to the Lord Mayor's Show. Better cancel the whole thing.'[14]

This public response underlines that, in certain cases, the way posters were received could be largely shaped by the current social and political context. The prewar climate of anxiety informed both the reaction of the public to the poster and London Transport's counteraction to that response. The media played a significant role in orchestrating the controversy. The level of sensationalism is evident in the *Evening News* headline purporting '6000' posters to have been torn down. In fact, only 5000 were ever printed, and it is unlikely that they all would have been posted.

During the Second World War, David Langdon's *Billy Brown* cartoon was widely used by LT to dispense all manner of advice and information on safe travel. His 'little notes of friendly warning', however, met with a mixed response from passengers. In an early poster, from 1941, Billy reprimands a passenger for trying to remove the anti-splinter netting fitted to Underground car windows to minimise blast damage (see chapter 8, plate 181). A common graffito addition to the slogan 'I trust you'll pardon my correction — that stuff is there

"B.B." *on* ESCALATORS

£10 award for adding two lines to this couplet

Send suggestions which must be on a postcard to 'Billy Brown' London Transport, 55 Broadway, S.W.1 not later than December 19, 1943

The decision of the Board's Publicity Officer shall be final

Here's another
bright suggestion
Standing RIGHT
prevents congestion

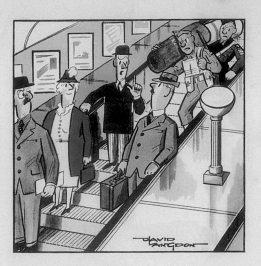

"B.B." *on* ESCALATORS

Here's another bright suggestion
Standing right prevents congestion
On the right it's 'Stand at Ease'
On the left it's 'Quick March,' please

The author of the couplet printed in red has been awarded the £10 prize offered by London Transport for the completion of the verse

223 Billy Brown on Escalators
David Langdon, 1943

Panel posters (578mm x 248mm)
Published by London Transport
Printed by the Baynard Press

for your protection' was: 'Thank you for your information, but I can't see my bloody station!' The *Daily Mirror* published a concluding verse to the same effect:

> … But you chronic putter-righter,
> Interfering little blighter,
> Some day very soon by heck,
> Billy Brown – I'll wring your neck.[15]

In a quest to make Billy's rhyming rhetoric more palatable, London Transport's Publicity Department held a competition, which allowed passengers to author slogans in a more formal and controlled manner (see plate 223). This offered the travelling public a sense of ownership over the slogan. The prize of £10 would also have helped sweeten the reaction to earlier posters in the campaign.

In 1951, the Underground issued a poster by Sheila Robinson entitled *Literary London* (see chapter 9, plate 194). It promoted the houses of Charles

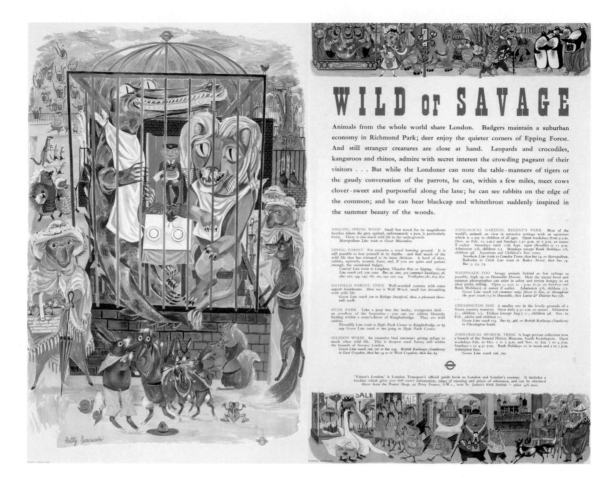

Dickens, John Keats, Thomas Carlyle and Dr Johnson, which were all open to the public as museums. In order to assess the poster's impact, the Publicity Department compared visitor figures for each of the houses between April and July 1951 (when the poster was on display) with those from the same period the previous year. The results showed an overall increase in visitors across the four properties of 65.7 per cent.[16] On presenting these statistics, the Publicity Department was deemed to have been 'successful in producing evidence of the gains which flow from its efforts'.[17] However, this kind of research was clearly only appropriate for some posters, and could only be carried out after they had been commissioned, printed and displayed.

Consumer research was becoming more widely used in the 1950s to inform the way companies used publicity. Harold Hutchison, London Transport's Publicity Officer at the time, was pragmatic in his approach to such practices. Like Pick, he believed that posters should raise the level of public taste:

> By catering for public taste in the same sense of playing down to the lowest common factor of what consumer research indicates as public taste, there is indeed, money to be made, but it is my contention that there is also a great deal of money to be made by refusing to use the muck-rake (or, dare I say it, by refusing to believe our consumer research).[18]

Hutchison was not averse to challenging the public's view through design. Controversy could be an ally to publicity when the result was further exposure. Friendly or even heated debate did, after all, provide a means of attracting and holding public attention beyond the finite period of a poster's display. Unconventional artistic styles, such as Betty Swanwick's (see plate 224), for example, divided public opinion sharply

225 **London Zoo**
Abram Games, 1976
Double royal
(1016mm x 635mm)
Published by London Transport
Printed by Impress (Acton) Ltd

into 'those who smiled and those who frowned'. The positive outcome, for the Publicity Department, was that they were talked about for months.[19]

During the 1960s and 1970s, there was a significant decline in the number of pictorial posters commissioned directly from artists (see chapter 9). Those that did appear tended to be more conventional and less challenging. Hutchison's quest to educate the public prevailed, although this was done predominantly through information rather than challenging art. Apart from the occasional querying of the grammatical or factual accuracy of information, there was very little in the way of response from the public.[20]

By the 1970s, consumer research was common practice in the field of advertising. LT's Market Research Department used customer surveys to inform objective 'Conditions of Acceptance' for all commercial advertisements that appeared on the Underground. There was little need, however, for such analysis of LT's own publicity, as the subject matter was not of an offensive nature and almost all posters were commissioned through agencies, which had their own methods of market research in place.

London Zoo, by Abram Games, was one of the handful of posters commissioned directly from artists during this period (plate 225). London Transport had little cause for concern over how it might be received by the public, as both the subject and the designer were tried and tested. The reception of the poster, however, did become the subject of in-depth analysis, not by a market-research company, but by an art historian.

In his essay 'Image and Code: Scope and Limits of Conventionalism in Pictorial Representation', E. H. Gombrich used Games's poster to illustrate how, in advertising, images are carefully constructed to convey meaning.[21] The interpretation of meaning in Games's poster relies on the observer's prior

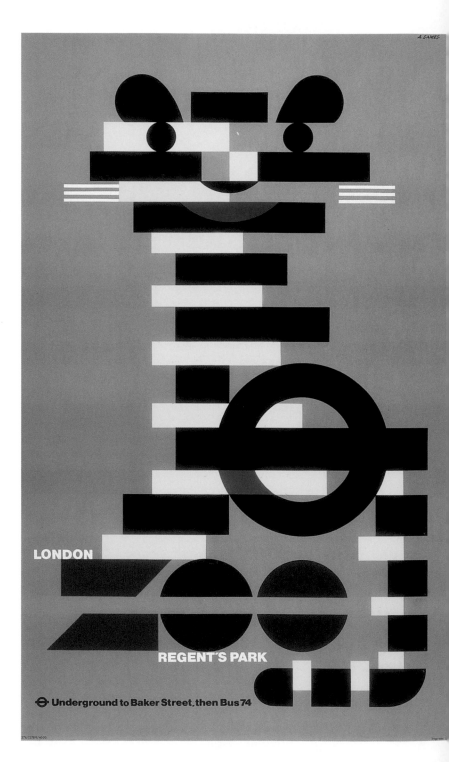

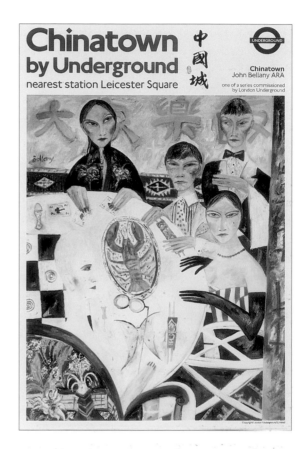

226 **Chinatown**
John Bellany, 1988
Four sheet
(1524mm x 1016mm)
Published by London
Underground Ltd
Printed by Print Processes Ltd

knowledge of London Transport's logo, components of which make up the image of a tiger. This fits into what Gombrich refers to as 'a hierarchy of responses, some of which are easily triggered, whereas we must be conditioned to discover others'.

Chinatown (plate 226), by the critically acclaimed Royal Academician John Bellany, could be considered the most controversial poster ever produced by the Underground. Interestingly, however, the majority of concern was articulated before it was displayed in public. The poster was commissioned as part of the 'Art on the Underground' initiative (see chapter 9). Unlike publicity posters, an artistic treatment was sought in contrast to an advertising or commercial-art approach. Henry Fitzhugh, London Underground's Marketing and Development Director, immediately recognised the commission as a monumental work of art. However, he was well aware that as a poster, displayed in public, Bellany's painting might cause offence.

London Transport's Equal Opportunities Unit and the Commission for Racial Equality expressed concern over the portrayal of both women and the Chinese community in Bellany's poster. Fitzhugh organised two audience research sessions, one with representatives of the Chinese community, the other through a marketing consultancy. The function and funding of the poster was entirely separate from the Underground's marketing poster programme, making these efforts more about damage limitation than market research.

The Chinese focus group considered the image to capture aptly the 'mystique of Chinatown'. It was noted that the seemingly hostile demeanour of the characters could actually be interpreted as expressing how the Chinese kept their reserve. This is supported by the Chinese writing on the window, which translates as 'Everybody Happy Food Shop'.

'Art on the Underground', as a concept, was well received by other focus groups. The report issued by the marketing consultancy SRU concluded that the programme 'reminds people of locations, and that you can reach them by tube. It won't change travel patterns, but it may prompt a visit, and it enhances the environment of the tube'. Only one out of 32 representatives, however, responded positively towards Bellany's painting. The Chinese characters were interpreted as 'scary' and even 'sinister'. Interestingly, however, only one noticed the nude woman unprompted.

The marketing team did not conduct the research to build a case against the public display of Bellany's painting; in fact, quite the opposite. They used the

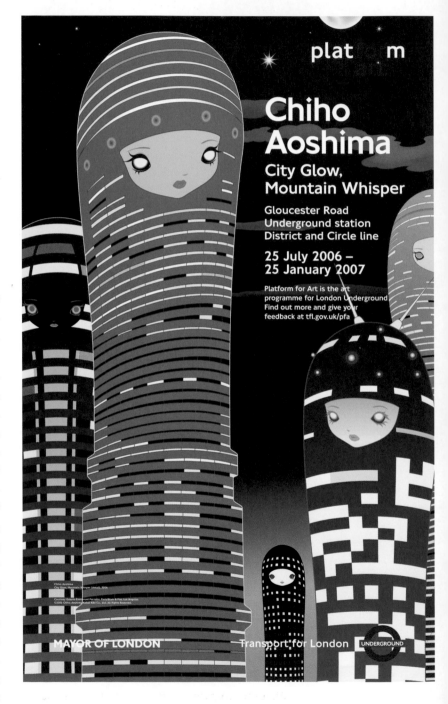

227 **City Glow, Mountain Whisper**
Chiho Aoshima, 2006
Double royal
(1016mm x 635mm)
Published by TfL

information gleaned to build their defence. They wrote a narrative interpretation of the painting, which they then sent to Bellany for approval. It suggested 'the Chinese are turning the tables on the West, as the two cultures are meeting in China Town'. The woman's dress, or lack thereof, 'fits in to that, and is part of the overall story, not directly making a comment about women'.[22] Interestingly, the interpretation seemed to be essentially informed by the representatives of the Chinese community to moderate anticipated complaints.

The poster appeared on the system for three years. The type of response from the public was as expected; the level of response, however, was not. Controversy was limited to two letters to the *Evening Standard* and four to the Underground, all of which echoed concerns for which they were now fully prepared. The 'hostile impact' one letter anticipated simply did not materialise.[23]

Fitzhugh replied to each letter in person, attaching the interpretation. 'Fine art,' he maintained, 'is intended to provoke response, and we have always taken the view that the art that we put up in the Underground will be somewhat better than chocolate box images which serve merely as decoration.'[24]

Research for the Underground's public art programme, 'Platform for Art', revealed that the type of art most requested by the travelling public was in fact contemporary, with fine or classical art the least popular. Although 'Platform for Art' was not a poster initiative, posters advertising art installations on the disused platform at Gloucester Road station operate as an indirect form of company advertising. One of the most popular installations to date is Chiho Aoshima's *City Glow, Mountain Whisper* (plate 227). Among hundreds of admiring letters received in response to the installation, one enthused: 'I've been seeing the posters for this platform art all over

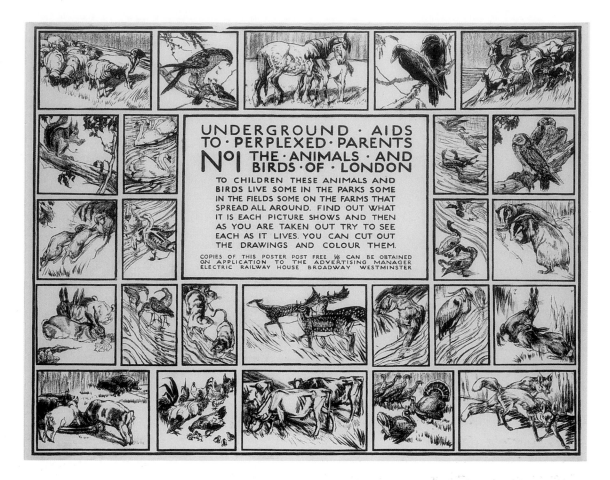

228 Underground Aids to Perplexed Parents
Elsie Henderson, 1917
Quad royal
(1016mm x 1270mm)
Published by UERL

London for months, and every time, they catch my eye … . The images are absolutely beautiful — warm, tranquil, fascinating.'[25]

The variety of responses to Underground posters over the last 100 years is clear, even from just the extraordinary cases. What is also evident is the company's ability to put a positive spin on things. As Harold Hutchison explained in 1947: 'You may not like some of our posters. That is inevitable; art is like music and tastes vary. But one kind of art we cannot afford is the pretty-pretty, which fails to stop you. If it stops you only to arouse you to criticism it will have succeeded.'[26]

Private demand: the consumption of posters as a form of decoration

Pictorial posters are inherently decorative. By the 1900s, posters, en masse, were considered to constitute an 'art gallery of the street'. Their decorative value, however, was also celebrated away from the

hoardings. By the 1920s, public posters had become a popular form of household decoration. This 'unpurchaseable affection'[27] for Underground posters demonstrates a very different kind of response from the travelling public.

Some Underground posters were specifically designed to be bought. *Underground Aids to Perplexed Parents*, by Elsie Henderson of 1917 (plate 228), for example, could be coloured in at home, providing hours of fun for children and hours of peace for parents. Similarly, *Stick to London's Model Bus* of 1927 (plate 229) was one of a number of posters which, as well as being posted for publicity purposes, could be cut up to make models. The poster's dual function is reflected in the clever play on words in the title. For the majority of posters, however, which were designed primarily as publicity, whether they sold well as a form of decoration was somewhat serendipitous.

Kauffer's *Twickenham by Tram* (plate 230) sold more copies than any other poster in 1923.

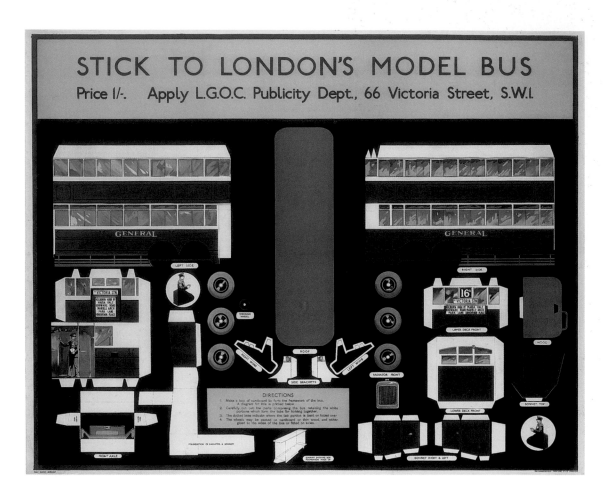

STICK TO LONDON'S MODEL BUS
Price 1/-. Apply L.G.O.C. Publicity Dept., 66 Victoria Street, S.W.l.

GENERAL GENERAL

DIRECTIONS

229 Stick to London's Model Bus
Frank Mason, 1927

Quad royal
(1016mm x 1270mm)
Published by UERL
Printed by the Dangerfield
Printing Company Ltd

This was the only poster
designed for the Underground
by the prolific railway poster
artist Frank Mason.

Significantly, the style is far more conservative than many by the avant-garde designer. A debate on contemporary posters took place at the Arts and Crafts Workers guild in 1923. Speakers, including Kauffer and Colonel Ivor Fraser of the Underground, discussed the significance of public demand for posters, as a measure of success. The Underground's 'best sellers' were compared to the posters which had received the most interest from the art world, revealing very few overlaps. The 'London Characters' series, by E.A. Cox, was cited as the most popular with the public (see plate 231). The most popular with the art critics tended to be more dynamic designs, or those demonstrating a high level of technical skill. These would only have been purchased by a smaller, select group. Whilst studying with Eric Ravilious at the Royal College of Art, for example, Edward Bawden recalls eagerly awaiting the sale of Kauffer's latest poster.

A typical Underground poster print run in the 1920s was around 1000, of which 850 were required for posting purposes. The remaining 150 were made available for sale and distribution.[28] As well as individuals seeking decoration for their homes, requests were received from schools, offices and shops.

In his comprehensive book *Poster Design* (1929),

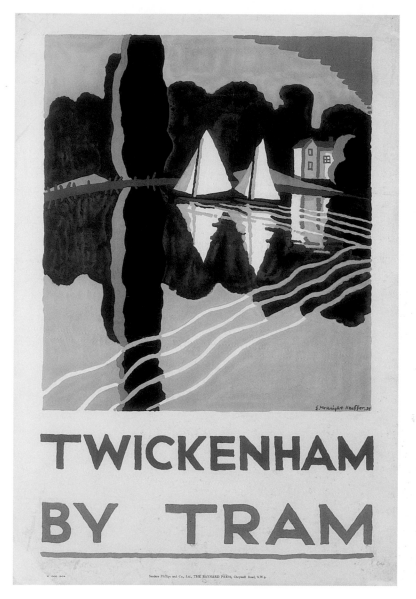

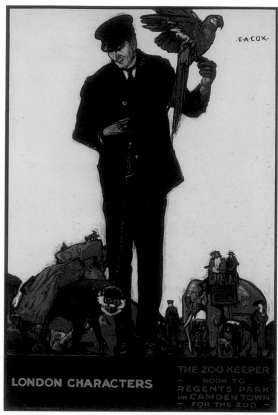

230 Twickenham by Tram
Edward McKnight Kauffer,
1923

Double royal
(1016mm x 635mm)
Published by London Transport
Printed by the Baynard Press

231 London Characters:
the Zoo Keeper
Elijah Albert Cox, 1920

Double crown
(762 mm x 508 mm)
Published by UERL
Printed by Chorley &
Pickersgill Ltd

which covered all aspects of the growing practice, W.G. Raffé credited London Underground as being one of a handful of enlightened advertisers that produced designs that people actually wanted to buy.[29] Raffé was precise to the point of didacticism, giving advice on how to transform pictorial posters intended for publicity into effective decoration. His recommendations included cutting them down to remove unwanted lettering, mounting them on backing board, sealing them with varnish and fastening them to the wall with drawing pins. This may not sit comfortably with today's recommended conservation practice, but it pointedly reinforces the contemporary

response to the poster as an essentially ephemeral form of decoration. This view, unaffected by speculative financial value, is reflected in the prices for which posters were sold at this time – two or three shillings each, dependent solely on size.

In 1921, the furniture shop Heal's included a cut-down Underground poster in one of the photographs in their catalogue (plate 232). The modern landscape was designed by Kauffer in 1915 (see chapter 2, plate 41) to promote trips to the country. Now framed, with the text removed, it was being used to promote something quite different. The carefully constructed bedroom established a certain

232 Illustration from Heal's catalogue, *A Book of Bedroom Furniture*, 1921

233 Exhibition of Underground posters at Burlington House, 1928

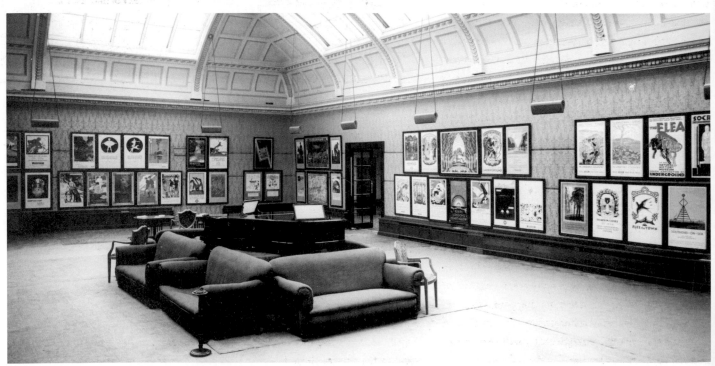

234 'The Posters of the Year' – article published in *T.O.T. Staff Magazine*, March 1932

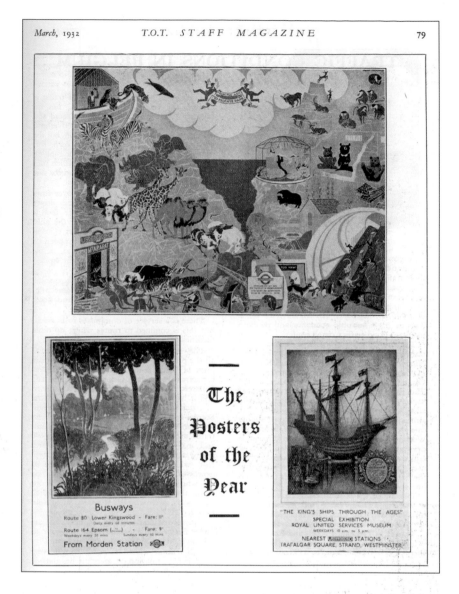

look and feel. Heal's were not merely selling furniture, they were offering a lifestyle choice, in which the Underground poster image played a role. On the top floor of Heal's, the Mansard Gallery held the first known exhibition of Underground poster art in 1917. Later exhibitions, usually of the final posters, were held at stations and art galleries. It is interesting that a venue associated with home interiors led the way.

In 1928 the Underground held an exhibition at Burlington House, celebrating 20 years of posters (plate 233).[30] A number of key Underground poster artists, such as Gregory Brown and Kauffer, were also the subjects of solo shows during the 1920s and 1930s. The public reception of the poster became multifaceted: 'On the hoardings they may examine them casually; in schools they are shown specially what is in them. In exhibitions, adults may also find that there is far more in the design of these printed papers than they suspected.'[31]

Exhibitions provided an additional environment in which to communicate, or re-communicate, a commercial message. The gallery context also stimulated interest in posters from art critics. This was disseminated through the press, which was undoubtedly good for publicity. However, it also helped establish Underground posters as a fashionable, as well as an affordable, choice of household decoration.

The most popular posters of 1931, as judged by annual sales figures, were republished in *T.O.T Staff Magazine* (plate 234). Popularity, in this context, is determined by personal taste rather than how effectively the posters functioned as publicity. The magazine claimed that over 300 copies were sold of each poster, with a staggering approximation of 10,000 posters being sold in total that year. The style of the posters featured reiterates that it was a more conservative poster design that made the most popular form of decoration.

In 1933, the newly formed London Transport opened an official poster shop in their Headquarters at 55 Broadway (see plates 235 and 236). This allowed people to come and choose suitable designs at leisure, instead of having to write in to request posters they may have seen on the system. Poster shop sales soon became a conscious consideration for both the commissioner and the artist alike. Between 1933 and 1936 Herbert Alker Tripp produced six paintings for London Transport posters, which became bestsellers in the shop. In 1937, the Publicity Department decided to commission a new Tripp landscape 'largely with a view to keeping up the stock in the poster shop'.[32]

235 Press advertisement for the poster shop, 1933

236 The poster shop at 55 Broadway, 1935

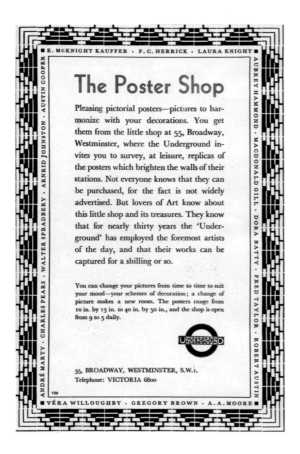

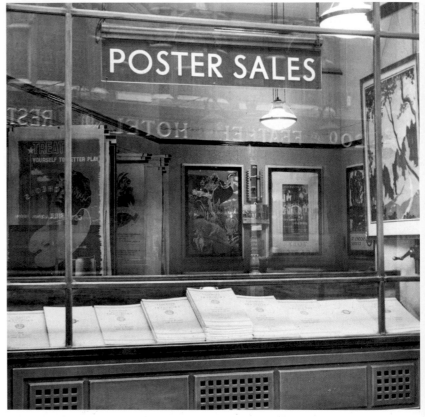

September Freshness by Laura Knight (plate 237) was also designed with sales to the public in mind. This is evident from the triangular symbol introduced to advertise the poster shop, but also from the ready-made frame around the image. Standard double-royal posters, which usually include lettering, would have seemed too large and too commercial for decoration purposes, which is why they were cut down. The lay-out of *September Freshness* actively encourages this practice, which transforms the poster into a traditional landscape suitable in style and size for household decoration.[33]

Due to the impact of Purchase Tax and paper shortages, the LT poster shop closed during the Second World War. Once the war had ended, the Underground's Publicity Department attempted to fulfil a renewed demand for copies of their posters, although it was not always possible. In 1948, they received hundreds of requests for the pair poster *London's Open Air, No.4: Animals*, by Shafig Shawki (plate 238). The demand, in this case, significantly exceeded the print run.

There is little evidence to suggest that the more progressive style of poster was actively sought by the travelling public. Evelyn Waugh's novel *Brideshead Revisited*, published in 1945 but set in the early 1920s, refers to a Kauffer poster being used as decoration. The protagonist, Charles Ryder, proudly hangs the poster in his college rooms at Oxford. Although the poster is not specified in the novel, the television

237 **September Freshness**
Laura Knight, 1937
Double royal
(1016mm x 635mm)
Published by London Transport
Printed by the Baynard Press

238 **London's Open Air,
No.4: Animals**
Shafig Shawki, 1948
Double royal
(1016mm x 635mm)
Published by London Transport
Printed by the Curwen Press

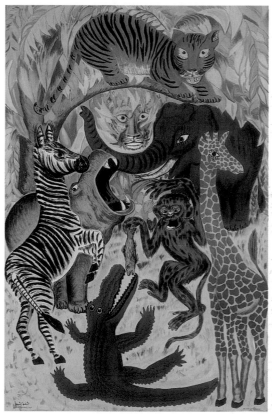

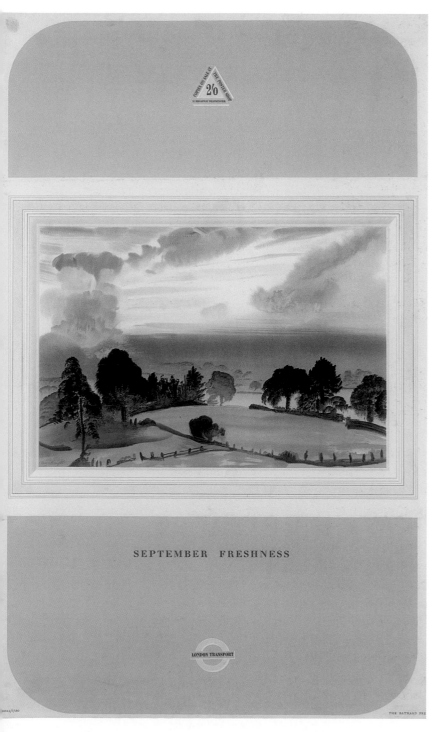

SEPTEMBER FRESHNESS

adaptation (1981) used *Winter Sales* (see chapter 7, plate 141). This was an aptly dynamic, Modernist design to feature in the lodgings of a young student aspiring to a cultured world of contemporary art and literature.

Ryder's room is no more real than that illustrated in the Heal's catalogue. However, in both cases, the carefully constructed space is loaded with meaning, part of which is conferred by the inclusion of an Underground poster. The Heal's bedroom was generic, intended to appeal to a broad audience. This reinforces what we already know from sales figures and contemporary writing – that cut-down posters were a popular form of household decoration. Ryder's room, however, was more specific, contrived

239 The Prime Minister Clement Attlee and the artist Clare Leighton at the opening of the 'Art for All' exhibition, April 1949, Victoria & Albert Museum.

The poster artworks on display include: *Weekend Walks*, by Clare Leighton (1938), *London Transport for all occasions*, by Betty Swanwick (1938) and *Hampton Court*, by Oleg Zinger (1937).

to signify the depths of a unique character. The poster is not cut down, but displayed in its entirety, to symbolise the discerning taste of its owner. In order for this reference to convey meaning to the contemporary reader, there must have been a growing appreciation for the more challenging poster designs of the past.

As early as 1911, Pick had the foresight to send examples of the company's latest designs to the Victoria & Albert Museum (V&A). Many became part of the museum's permanent collection, while others were regularly used by their Circulation Department, which lent contemporary designs to art schools and colleges. This meant that the appreciation of Underground posters, as exemplars of good design, was restricted to a rather exclusive audience.

An exhibition of 125 Underground poster art-

works, 'Art for All', was shown at the V&A in 1949 (see plate 239). This would have greatly widened public appreciation of the company's poster history. It was by no coincidence that the exhibition was opened by the Prime Minister, Clement Attlee. The exhibition, like the post-war Labour government, captured the public mood for change. The title, 'Art for All', reflected the new socialist agenda, with an emphasis on everyman. However, of more significance to the public's response to Underground posters was its labelling of them as 'Art'.

In the 1928 exhibition at Burlington House, there had been no interpretation of the works on display, but simply a notice in the middle of the room, which read: 'There is no catalogue. A good Poster explains itself.' This was very much an exhibition celebrating the art of posters. What was different about 'Art for All' was that the exhibition had become a celebration of the poster as art.

A book accompanying the 1949 exhibition recounted the history of Underground posters. James Laver presented the view of an art critic; Hutchison wrote from the perspective of London Transport continuing a tradition; and Thomas Griffits of the Baynard Press looked at the printing processes involved. The interpretation offered visitors supplementary information on the works displayed. Some artworks were spoken of in terms of monetary values, and designers as 'artists' or even 'celebrities'. In an annex to the exhibition, there was a display of late-nineteenth-century posters, providing the ancestry for this 'now famous collection'. The poster, it would seem, could no longer 'explain itself'.

A press release in the same vein facilitated the spread of this aggrandised interpretation of the poster. The Arts Council organised 50 of the works to make a tour of the provinces, marketed as 'a mirror of London life over 40 years'.[34] The tour took

posters to less familiar audiences, away from their original context and surroundings, and provided guidance to assist the observer in their response.

As a direct reaction to the interest generated by 'Art for All', London Transport started selling scaled-down prints of posters. This service was advertised on bus shelters and elsewhere, with up to 200 copies being sold per week.[35]

The significance of Underground poster design was also becoming more widely acknowledged in art circles. In his seminal book *The Story of Art* (1949), E.H. Gombrich began his introduction by writing: 'There is no such thing as Art. There are only artists. Once these were men who took coloured earth and roughed out the form of a bison on the wall of a cave; today some buy their paints and design posters for the Underground.'[36]

In May 1950, as a result of negotiation with the Treasury, the sale of a limited number of full-size contemporary posters was once more permitted. Sales were restricted, however, to 'cultural organisations',

identified as museums, art colleges and schools. The cost was 5 shillings for a double-royal format.[37]

LT was not permitted to sell posters to private individuals until 1964, when its poster shop reopened. An exhibition of posters at the Royal Institute Galleries in 1963, for the Underground centenary, greatly influenced public demand (see chapter 9, plate 195). More than 150 posters presented a retrospective view from 1908 to the present day. Some of the posters still in the process of production at the time of the exhibition were shown at the design stage. This meant that the public's first experience of them was in an art gallery, with the emphasis on design, rather than publicity.

The public interest in posters of the past was catered for in the new poster shop. Reprints of what were now deemed iconic, historic posters became extremely popular. By 1976, even posters from the 1950s and 1960s were referred to as 'classics'. It would seem that Hutchison had succeeded in his quest to influence public taste. Whilst commissioning these future classics, he maintained that 'the revolutionary impressionism of one generation becomes the easy conservatism of the next'.[38]

A catalogue promoting the full range of posters available in the shop was issued in 1976 (plate 240). Reprints of old posters had become the bestsellers, but there were exceptions, when a contemporary design struck a chord with the travelling public. Games's *London Zoo*, for example, was phenomenally popular (see plate 225). Although available in abundance in the late 1970s, a copy sold at auction for £1000 in 1989, suggesting that relatively new posters were also becoming collectable.

'Art on the Underground', LT's programme of corporate fine-art sponsorship launched in 1986, had a significant impact on the public demand for contemporary posters.[39] The newly commissioned artworks, in poster form, came in a wide variety of styles to suit all

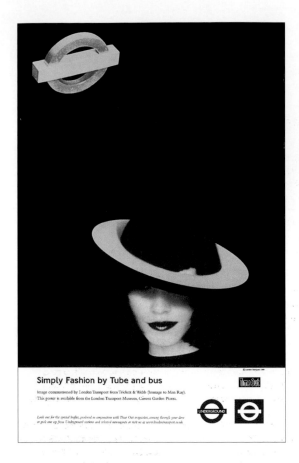

Simply Fashion by Tube and bus

Image commissioned by London Transport from Trickett & Webb (homage to Man Ray).
This poster is available from the London Transport Museum, Covent Garden Piazza.

Look out for the special leaflet, produced in conjunction with Time Out magazine, coming through your door
or pick one up from Underground stations and selected newsagents or visit us at www.londontransport.co.uk

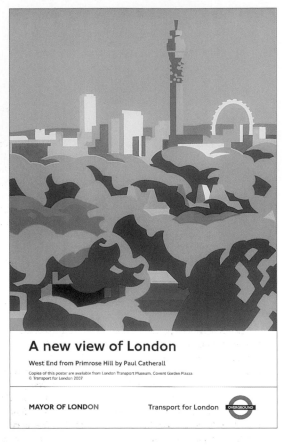

A new view of London

West End from Primrose Hill by Paul Catherall
Copies of this poster are available from London Transport Museum, Covent Garden Piazza.
© Transport for London 2007

MAYOR OF LONDON Transport for London

241 Simply Fashion
Trickett & Webb, 1999

Double royal
(1016mm x 635mm)
Published by London
Underground Ltd

242 Primrose Hill
Paul Catherall, 2007

Double royal
(1016mm x 635mm)
Published by TfL

tastes. *The Tate Gallery by Tube* (see chapter 9, plate 210) became one of the best-selling Underground posters of all time, and reprints continue to sell well today. In the 1990s, the 'Simply' series provided another set of posters which were suitable for sale. Like 'Art on the Underground' posters, they continued the tradition of direct commissioning of artists. However, in order to be more commercially viable, the 'Simply' series complemented the Underground's marketing strategy. When Trickett & Webb were commissioned to design *Simply Fashion* (plate 241) in 1999, part of the brief stipulated that the final design should also be suitable for sale in the shop. The appropriation of Man Ray's iconic poster (see chapter 7, plate 158) provided a powerful metaphor for London's Fashion Week. By using an image proven to be popular with the public, they were also tapping into the buyers' market.

Paul Catherall has produced some of the most outstanding poster designs for the Underground of recent years. Their retro feel has widespread appeal, and their allusion to poster art of the 1920s and 1930s

holds him in favour with the poster enthusiast and design student, as well as with Transport for London.

Autumn, *Winter*, *Spring* and *Summer* make up Catherall's *Four Seasons* series (see chapter 9, plate 214). When displayed in sequence they create a powerful panoramic view of London's city. Interestingly, however, they were only ever displayed on the system individually. The formation of a series was purely to appeal to prospective buyers in the London Transport Museum (LTM) shop. In 2007 Catherall designed a new series advertising Transport for London's takeover of the North London line. Although drawing on traditional techniques, *West End from Primrose Hill* (plate 242) offers a modern perspective upon the tried and tested subject of the West End. Steady sales of Catherall's poster in the LTM shop reflect Raffé's belief, from eighty years before, that 'efficient design is the kind of design that people not only look at, but want to buy and keep; the design that is excellent in form and colour; the design that has human interest and fascination'.[40]

Notes

1. F. Pick, *The First Annual Conference of the Members and Officers*, 12 November 1936, p.30.
2. Letter to John Hassall, 1908, John Hassall Archive, University of Essex.
3. G.W. Duncan, 'The Selection of Posters', in L. Richmond (ed.), *The Technique of the Poster*, Isaac Pitman & Sons, London, 1933, p.114.
4. Artists such as Tony Sarg and Fougasse had already made a favourable public name for themselves from the pages of popular newspapers and magazines such as *Punch*.
5. F. Pick, 'Underground posters', 1927, handwritten paper, Pick Archive, London Transport Museum (LTM), p.2.
6. ibid.
7. Frank Pick retyped the poem, which appeared in the *Manchester Guardian* in the 1920s. The transcript now forms part of Pick's personal archive at London Transport Museum.
8. Pick, 'Underground posters', p.3.
9. In 1907, a cartoon entitled *The Truth of the Poster Artist* appeared in *Punch*. In a similar style to plate 220, a rather harsh reality of Southend is pitted against a typically positive poster artist's view.
10. J. Black, *Form Feeling and Calculation: The Complete Paintings and Drawings of Edward Wadsworth*, Philip Wilson Publishers, London, 2006, pp 104–5.
11. *Daily Express*, 6 November 1936.
12. *Daily Mirror*, 4 November 1936. Cassandra was the pen name, from 27 July 1935 to 1 February 1967, of the *Daily Mirror* journalist William Neil Connor (1909–1967).
13. *Evening News*, 5 November 1936.
14. *Daily Express*, 5 November 1936.
15. D.F. Croome and A.A. Jackson, *Rails Through the Clay: A History of London's Tube Railways*, Capital Transport, Harrow Weald, 1993, p.278.
16. Minutes of the Public Relations, Press and Publicity Meetings (PRPPM), 245/10/51, Transport for London Archives, LT371/019.
17. From the opening quote to the chapter, F. Pick, *The First Annual Conference of the Members and Officers*, 12 November 1936, p.30.
18. H.F. Hutchison, *Design and Public Taste*, Knapp, Drewett & Sons Ltd, London, 1955, pp 8–9.
19. *Notes on Art for All*, 1949, in 'Art for All' exhibition folder, V&A Archive, ED 84/331.
20. Jeff Levy, who worked in LT's publicity department for over 20 years, recalls no controversy over the style of posters in the early 1970s. Personal correspondence with Jeff Levy, 2007.
21. E.H. Gombrich, 'Image and Code: Scope and Limits of Conventionalism in Pictorial Representation', in W. Steiner (ed.), *Image and Code*, Michigan Studies in the Humanities, University of Michigan, 1981.
22. Interpretation of *Chinatown*, 1988, in LTM Archive folder: 'Art on the Underground; Policy, General Correspondence and Copyright', 1986–92, LT2008/962.
23. LTM archive folder 'Art on the Underground; Policy, General Correspondence and Copyright', 1986–92, LT2008/962.
24. Letter from Henry Fitzhugh, 1990, LTM Archive.
25. 'Platform for Art' website, www.tfl.gov.uk, December 2007.
26. H.F. Hutchison, 'The policy behind our posters', *London Transport Magazine*, vol..1, no.8, 1947, p.10.
27. W.G. Raffé, 'Posters as Works of Art', *Poster Design*, Chapman & Hall, London, 1929, p.203.
28. The Underground made no profit on the sale of posters. The nominal fee was to cover printing costs and restrict too many applications. 'The present-day poster', *Commercial Art*, December 1923.
29. Raffé, *Poster Design*, p. 203.
30. The LNER also held their annual poster exhibition there that year. The previous five were held at King's Cross.
31. Raffé, *Poster Design*, p.208.
32. Due to the outbreak of war, the poster was never produced.
33. The cut-down version of Knight's posters appeared in the Victoria & Albert Museum's 'Art for All' catalogue, 1949.
34. Venues for the tour included: Bankfield Museum, Halifax; Pannett Art Gallery, Whitby; Glasgow School of Art; and Wolverhampton Art Gallery.
35. PRPPM, 245/10/51, LT371/019.
36. Gombrich had to change 'Underground' into 'hoardings' for the second edition, lest American readers should suspect him of subversive tendencies. E.H. Gombrich et al., *A. Games: Sixty Years of Design*, Institute of Higher Education, South Glamorgan, 1990.
37. PRPPM, 108/5/50 and 137/6/50, LT371/019. Harrow School was the first to request 'recent posters for educational purposes'.
38. Hutchison, *Design and Public Taste*, p.7.
39. By this time the official outlet for London Transport poster sales was the shop at London Transport Museum, which opened in 1980.
40. Raffé, *Poster Design*, p.203.

BIBLIOGRAPHY

This list is not exhaustive, but a series of pointers for those wishing to investigate further the context of London Transport posters. One of the best sources of information on Underground posters and designers is the magazine *Commercial Art*, published 1922–31, becoming *Commercial Art and Industry* 1931–6 and finally *Art and Industry* 1936–58. Important archival collections relating to LT's poster heritage are held by London Transport Museum (LTM) and Transport for London (TfL) Archives. Images of all posters and poster artworks in the LTM collection, together with background information and artist biographies, can be viewed online at www.ltmuseum.co.uk.

London Transport poster history and designers

Aynsley, Jeremy, *A Century of Graphic Design*, Mitchell Beazley, London, 2001

Backemeyer, S. (ed.), *Picture This: The Artist as Illustrator*, Herbert Press, London, 2005

Barnicoat, John, *Posters: A Concise History*, Thames & Hudson, 1985

Barman, Christian, 'London Transport Publicity', *The Penrose Annual*, vol.42, 1940

Bennett, Compton, *Posters & Showcards: A Guide for Commercial Artists*, W. Foulsham & Co, London, n.d. (c.1935)

Bliss, D.P., *Edward Bawden*, Pendomer Press, Godalming, 1979

Bradshaw, Percy V., 'London's Underground Gallery', *Art and Industry*, vol.61, no.365, 1956

Cole, Beverley and Durack, Richard, *Happy as a Sand Boy: Early Railway Posters*, HMSO, London, 1990

Cole, Beverley and Durack, Richard, *Railway Posters 1923–1947*, Laurence King, London, 1992

Constantine, Stephen, *Buy and Build: The Advertising Posters of the Empire Marketing Board*, HMSO, London, 1986

Cooper, Austin, *Making a Poster*, The Studio, London, 1938

Coppel, S., *Linocuts of the Machine Age*, Scolar Press, Aldershot, 1995

Curwen, Harold, *Processes of Graphic Reproduction*, Faber & Faber, London, 1934

Dillon, Tamsin (ed.), *Platform for Art. Art on the Underground*, Black Dog Publishing, London, 2007

Eckersley, Tom, *Poster Design*, The Studio, London, 1954

Frayling, Christopher, *The Royal College of Art. One Hundred and Fifty Years of Art & Design*, Barrie & Jenkins, London, 1987

Games, Abram, *Over My Shoulder*. Studio Books, London, 1960

Games, Naomi, Moriarty, Catherine, and Rose, June, *Abram Games, Graphic Designer: Maximum Meaning, Minimum Means*, Lund Humphries, Aldershot, 2003

Garton, R., *British Printmakers 1855–1955*, Scolar Press, London, 1992

Gilmour, Pat, *Artists at Curwen*, Tate Gallery Publications, London, 1977

Gombrich, E. H., et al., *A. Games: Sixty Years of Design*, Institute of Higher Education, South Glamorgan, 1990

Green, Oliver, *Underground Art: London Transport Posters 1908 to the Present*, Laurence King, London, 1990 & 2001

Green, Oliver and Powers, Alan, *Away We Go! Advertising London's Transport, Edward Bawden & Eric Ravilious*, Mainstone Press, Norwich, 2006

Griffits, Thomas E., *The Technique of Colour*

Printing by Lithography, Crosby Lockwood & Son, London, 1940

Grigson, G., 'The evolution of E. McKnight Kauffer, a master designer', *Commercial Art*, vol.XVIII, 1935

Guyatt, Richard, 'London Transport: the posters of a public service', *Graphics*, vol.15, no.83, 1959

Hardie, M. and Sabin, A.K., *War Posters Issued by Belligerent and Neutral Nations, 1914-1919*, A. & C. Black, London, 1920

Hassall, John, 'Something about posters', *Pearson's Magazine*, March 1905

Hawkins, Jennifer and Hollis, Marianne (eds), *Thirties: British Art and Design Before the War*, Arts Council, London, 1979

Haworth-Booth, Mark, *E. McKnight Kauffer: A Designer and His Public*, Gordon Fraser Gallery, London, 1979 and V&A Publications, London, 2005

Hiller, Bevis, *Posters*, Spring Books, London, 1969

Hutchison, Harold F. and Laver, James, *Art for All: London Transport Posters 1908–1949*, exh.cat., Art & Technics, London, 1949

Hutchison, Harold F., *London Transport Posters*, London Transport Board, London, 1963

Hutchison, Harold F., *The Poster: An Illustrated History from 1860*, Studio Vista, London, 1968

Johnson, A.E., *John Hassall*, A. & C. Black, London, 1907

Kauffer, Edward McKnight, *The Art of the Poster: Its Origin, Evolution and Purpose*, Cecil Palmer, London, 1924

Kauffer, Edward McKnight, *Posters*, Museum of Modern Art, New York, 1937

Jones, Sydney R., *Posters and their Designers*, The Studio, London, 1924

Levey, Michael F., *London Transport Posters*, Phaidon, London, 1976

Livingston, A. and Livingston, I., *Dictionary of Graphic Design and Designers*, Thames & Hudson, London, 1992

Nash, Paul, *Outline*, Faber & Faber, London, 1949

Pevsner, Nikolaus, 'Frank Pick', in Pevsner, Nikolaus, *Studies in Art, Architecture and Design, Vol.2: Victorian and After*, Thames & Hudson, London, 1968

Price, Charles Matlock, *Posters: A Critical Study of the Development of Poster Design in Continental Europe, England and America*, G.W. Bricka, New York, 1913

Purvis, Tom, *Poster Progress*, The Studio, London, 1938

Raffé, W.G., *Poster Design*, Chapman & Hall, London, 1929

Rennie, Paul and Triggs, Teal, *Tom Eckersley*, LCC, London, 2005

Richmond, Leonard (ed.), *The Technique of the Poster*, Isaac Pitman & Sons, London, 1933

Riddell, Jonathan and Stern, William T., *By Underground to Kew: London Transport Posters, 1908 to the Present*, Studio Vista, London, 1994

Riddell, Jonathan and Denton, Peter, *By Underground to the Zoo: London Transport Posters, 1913 to the Present*, Studio Vista, London,1995

Riddell, Jonathan, *Pleasure Trips by Underground*, Capital Transport, Harrow Weald, 1998

Rogerson, I., *Barnett Freedman*, Fleece Press, Huddersfield, 2006

Saler, Michael T., *The Avant-Garde in Interwar England: Medieval Modernism and the London Underground*, Oxford University Press, Oxford and London, 1999

Sawkins, Harold, 'Gregory Brown. Famous Artists: No.30', *The Artist*, vol.VII, no.4, 1934

Schleger, Pat (ed.), *Zero: Hans Schleger, A Life of Design*, Lund Humphries, Aldershot, 2001

Shackleton, J.T., *The Golden Age of the Railway Poster.* New English Library, London, 1974

Sheldon, Cyril, *A History of Poster Advertising.* Chapman & Hall, London, 1937

Sparrow, Walter Shaw, *Advertising and British Art,* Bodley Head, London, 1924

Spradbery, Walter E., 'Posters from Lino', *Pennyfare*, vol.2, no.8, 1935

Spradbery, Walter 'A New L.P.T.B. Poster Series "The Proud City"', *Art and Industry*, vol.38, no.224, 1945.

Taylor, H., 'The Poster Revival No.1 – E. McKnight Kauffer', *The Studio*, vol.79, 1920

Timmers, Margaret, *The Power of the Poster*, V&A Publications, London, 1998

Webb, Brian and Skipwith, Peyton, *Design: Edward Bawden, Eric Ravilious*, Antique Collectors' Club, Woodbridge, 2006

Webb, Brian and Skipwith, Peyton, *Design: Paul Nash, John Nash*, Antique Collectors' Club, Woodbridge, 2006

Webb, Brian and Skipwith, Peyton, *Design: E. McKnight Kauffer*, Antique Collectors' Club, Woodbridge, 2007

Weill, Alain, *Graphics: A Century of Poster and Advertising Design*, Thames & Hudson, London, 2004

Wrede, Stuart, *The Modern Poster*, Museum of Modern Art, New York, 1988

London's transport history

Barman, Christian, *The Man Who Built London Transport: A Biography of Frank Pick*, David & Charles, Newton Abbot, 1979

Barker, T.C. and Robbins, Michael, A History of London Transport, Volume 2: The Twentieth Century to 1970, Allen & Unwin, London, 1974

Garland, Ken, *Mr Beck's Underground Map*, Capital Transport, Harrow Weald, 1994

Green, Oliver and Rewse-Davies, Jeremy, *Designed for London: 150 Years of Transport Design*, Laurence King, London, 1995

Howes, Justin, *Johnston's Underground Type*, Capital Transport, Harrow Weald, 2000

Jackson, Alan A., *London's Metro-land: A Unique British Railway Enterprise*, Capital Transport, Harrow Weald, 2006

Lawrence, David, *A Logo for London: The London Transport Symbol*, Capital Transport, Harrow Weald, 2000

Taylor, Sheila (ed.), *The Moving Metropolis: A History of London's Transport since 1800*, Laurence King, London, 2001

ACKNOWLEDGMENTS

David Bownes and Oliver Green would like to thank their co-authors, and colleagues at London Transport Museum and TfL Archives. Special thanks are due to Claire Dobbin, who assisted in all aspects of the book's development, Hugh Robertson, Guy Howard-Evans, Beth Mercer, Simon Murphy, Emma Theophilus Wright and Michael Walton. We are also grateful to everyone at Lund Humphries for their unflagging enthusiasm and support, particularly Miranda Harrison, Alex Hitchins and Lucy Myers, together with our skilful editor Abigail Grater and creative designer Nigel Soper.

Picture Credits

All images are from the London Transport Museum collection, with the following exceptions:

Chapter 1
plate 1 (The Stapleton Collection /The Bridgeman Art Library), plate 4 (The Stapleton Collection /The Bridgeman Art Library), plate 5 (Victoria and Albert Museum /reproduced by permission of Elizabeth Banks), plate 7 (National Railway Museum /Science and Society Picture Library), plate 12 (Mary Evans Picture Library), plate 13 (Mary Evans Picture Library)

Chapter 2
plate 35 (National Railway Museum / Science and Society Picture Library)

Chapter 3
plate 56 (Victoria and Albert Museum / The Bridgeman Art Library)

Chapter 4
plate 68 (Central Saint Martins College of Art and Design)

Chapter 10
plate 232 (Victoria and Albert Museum/Heal's Archive)

INDEX

NOTE: Page numbers in *italics* refer to an illustration. Posters are listed against artists' names. Unattributed posters are listed under "artist unknown".